Persia Reframed

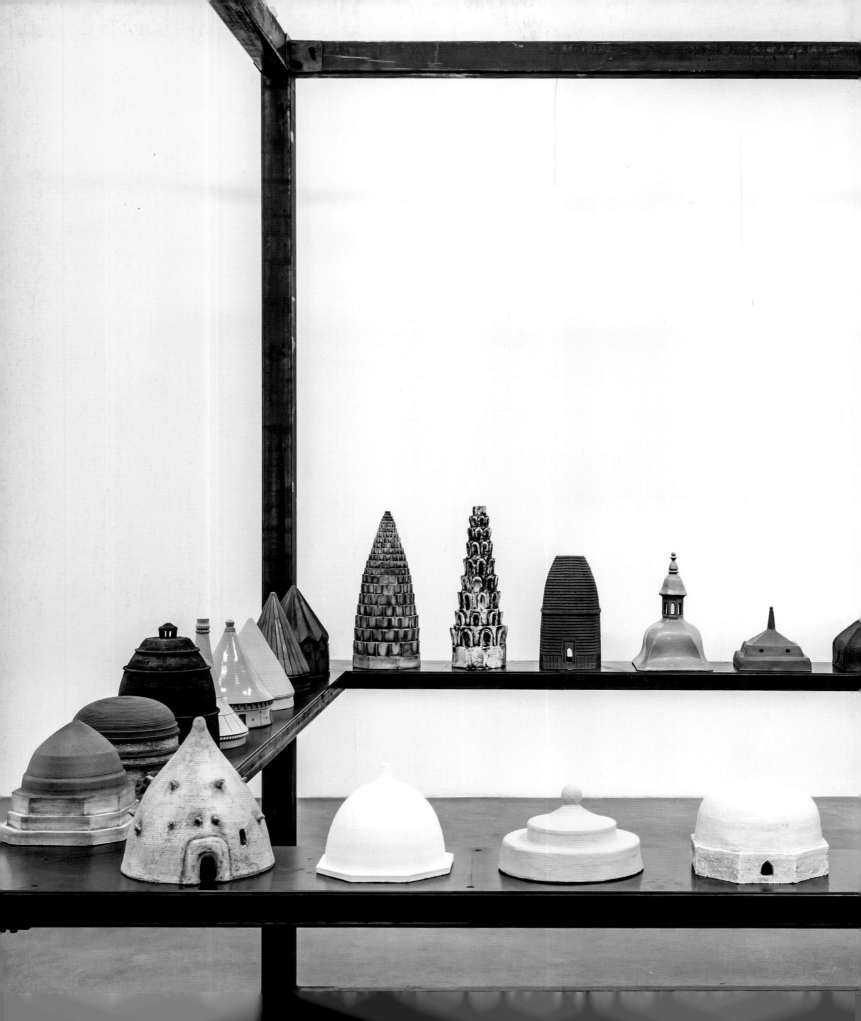

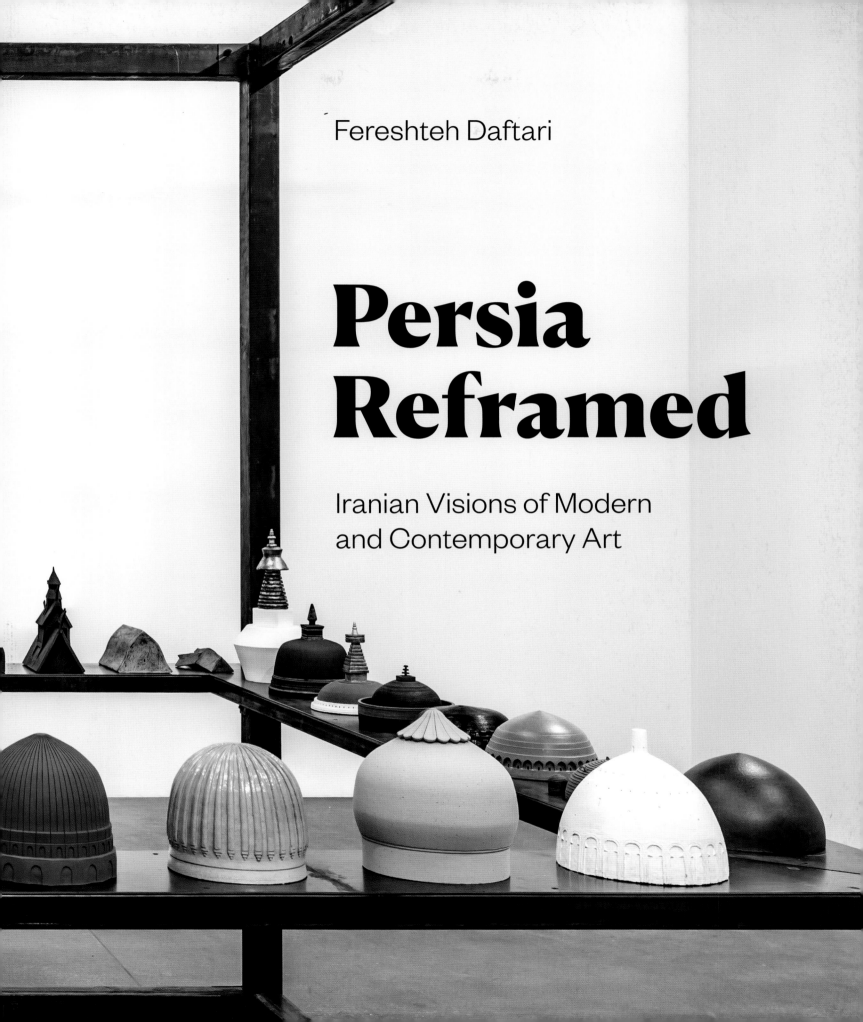

Fereshteh Daftari

Persia Reframed

Iranian Visions of Modern
and Contemporary Art

**To my brother Farhad Daftary
and to Farimah and Yasmine**

Published in 2019 by
I.B.Tauris & Co. Ltd
London • New York
www.ibtauris.com

Copyright © 2019 Fereshteh Daftari

The right of Fereshteh Daftari to be identified as the author of
this work has been asserted by the author in accordance with the
Copyright, Designs and Patents Act 1988.

Every attempt has been made to gain permission for the use of the
images in this book. Any omissions will be rectified in future editions.

References to websites were correct at the time of writing.

ISBN: 978 1 78831 662 0

A full CIP record for this book is available from the British Library
A full CIP record is available from the Library of Congress

Library of Congress Catalog Card Number: available

Designed and typeset in Canela and Founders Grotesk
by Myfanwy Vernon-Hunt, This-Side.co.uk

Printed and bound in India by Replika Press Pvt. Ltd.

Pages ii–iii
65. Shahpour Pouyan
Installation view of *My Place is the
Placeless*, 2017
Courtesy of Lawrie Shabibi and the artist

Pages vi–vii
64. Ali Banisadr
Trust in the Future, 2017
Oil on linen, 208 x 305 cm (82 x 120")
Mohammed Afkhami Foundation

Page x
Foreground: Shiva Ahmadi, *Oil Barrel #13*,
2010; Background: Mahmoud Bakhshi,
*Tulips Rise from the Blood of the Nation's
Youth (Industrial Revolution* series*)*, 2008.
Mohammed Afkhami Foundation. Installation
view of the exhibition *Rebel, Jester, Mystic,
Poet: Contemporary Persians*, 4 February–4
June 2017 Aga Khan Museum, Toronto, 2017

Page 192
From left to right
Mohammed Ehsai, *Mohabbat (Kindness)*,
2006; Parviz Tanavoli, *Blue Heech*, 2005;
Morteza Ahmadvand, *Becoming*, 2015.
Mohammed Afkhami Foundation. Installation
view of the exhibition *Rebel, Jester, Mystic,
Poet: Contemporary Perrsians*, 4 February–4
June 2017, Aga Khan Museum, Toronto

Pages 268
Nazgol Ansarinia
Pillars: Article 47, 2015. Epoxy resin and
paint, 65 x 35 x 35 cm (25 ½ x 13 ¾ x 13 ¾").
Mohammed Afkhami Foundation.

Contents

Acknowledgements

A project that took shape over nearly a decade and was interrupted several times by exhibitions related in topic necessarily draws on the help of a great number of individuals. I would need an entire chapter to express my gratitude but I need to be mindful of the word count. The range of my queries stretched from basic research questions to image requests to editorial issues and intellectual advice. Most importantly, I am indebted to two foundations for generous financial aids: The Persian Heritage Foundation and its former director, the late Dr Ehsan Yarshater and especially the Mehr Foundation. Without their magnanimous support I would not have been able to pursue my research and this publication.

I am most thankful and indebted to the people I am listing here, regrettably, without being able to individually acknowledge the specific help they graciously offered me. In addition, I would like to thank the artists (around seventy) who shared with me mountains of information. Parviz Tanavoli stands out for his patience in answering numerous art historical questions. Many artists generously provided me with images. Aside from the help they have given me, I thank them for giving meaning to my life. Collectors and institutions too need to be acknowledged for images and permission to illustrate works in their collection. In thanking the gallerists I would like to single out Nazila Nobashari for her extraordinary assistance. Last but not least I wish to

thank Iradj Bagherzade, the publisher of the scholarly press I.B.Tauris which is unmatched in the area of Iranian history, society and culture. I feel privileged for the opportunity I have been given to contribute certain insights to the emerging field of modern and contemporary art of Iran. I also wish to extend my special thanks to his team, notably Lizzy Collier, Clare Martelli, Myfanwy Vernon-Hunt and Henry Howard.

Here is the list of people, besides very special anonymous persons, who have supported me in a million ways: Mohammed Afkhami, Mina Atabai, Fereydoun Ave, Negar Azimi, Arne and Edward Balassanian, Katayoun Beglari-Scarlet, Melissa Chiu, Farhad Daftary and his wife Fereshteh, Farimah Daftary Rasmussen, Helia Darabi, Isabella Deocariza, Negi Diba, Maryam Ekhtiar, Michelle Elligott, Goli Emami, Yaghoub Emdadian, Mina and Amir Hossein Etemad, Nahid Evazzadeh, Massumeh Farhad, Marjan Farjam, Kamran Farmanfarmaian, Nima Farmanfarmaian, Suri Farmanfarmaian, Raana Farnoud, Zari Ghassemian, Azarnoosh Ghazanfari, Mitra Goberville, Ebrahim Golestan, Mona Hadler, Kambiz Hashemi, Leila Heller, Leise Hook, Lawrence Hyman, Nima Isham, Rose Issa, Rana Javadi, Abdellah Karroum, Maneli Keykavoussi, Shireen and Reza Khazeni, Shahnaz Khonsari, Nezhat Khosrowshahi, Ahmad Kiarostami, Marion Kocot, Abbas Mashhadizadeh, Salman Matinfar, Armen Melkonian, Shahnaz and Massoud Nader, Afarin Neyssari, Vahid and Mahshid Noshirvani, Sylwia Nowicka (Altour), Rebecca Roberts, Kambiz Safari, Hamid Severi, Rozita Sharafjahan, Pooya Shishegaran, Ben Tear, Jennifer Tobias, Diana C.K. Untermeyer, Hamoun Vaziri, Shaherezad Vishkai, Michelle Wong, Niki Yektai, Hamed Yousefi and Ameneh Yousefzadeh. I have been tremendously fortunate to have known and worked with them.

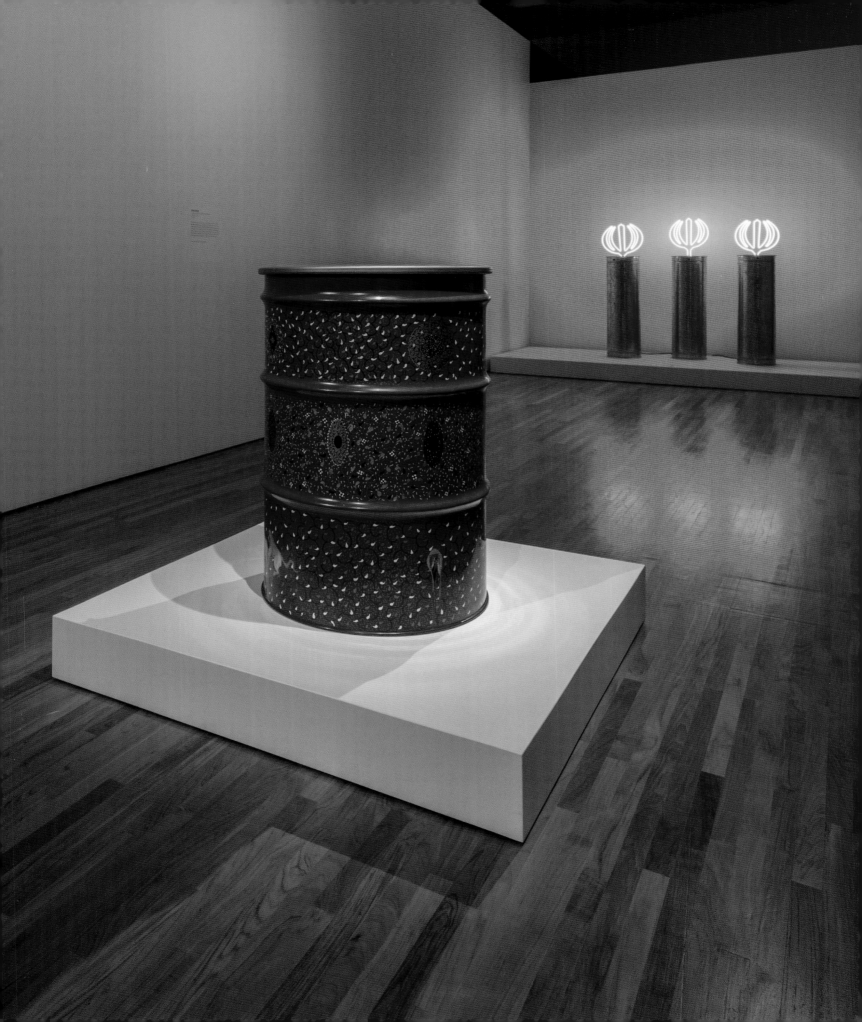

Prologue

Iran has often been perceived primarily through the lens of the repressive regimes which have characterized its history, but the modern and contemporary art of the country and its diaspora tell a different story. Contradicting the prevailing view, the pluralism of artistic voices, and the variety of idiosyncratic means which artists have deployed to navigate recent history, point to the existence of a democratic ecosystem in which modern art was created, as it were one sensibility at a time. In today's climate, contemporary art in Iran continues to be a sanctuary for self-definitions and a platform for a range of assertions including protest.

Approaching art with a faith in its emancipating role, and selecting topics ranging from the specific (for example a slippery concept such as modernism, a single movement, a key exponent) to the panoramic (abstraction, contemporary art), this study proceeds from a belief in aesthetics as a coping mechanism, a repository for confession, aspiration and trauma, and a process through which, against all odds, the self is asserted. Just as the selected topics and approaches are varied, so is the tone. The personal explicitly informs both the prologue and the final chapter, while the tenor of the chapters in between is more scholarly and critical. The media discussed are those standard in the study of modern and contemporary art, including performance, multimedia installation and video, in addition to painting, drawing, printmaking and sculpture.

While this study provides an analytical introduction covering the majority of the key players as well as emerging artists, it is not a comprehensive survey, and the art is not viewed as an illustration of larger sociopolitical conditions. The chapters in this book are an attempt both to explore new themes and to identify certain key issues in need of revision. The book fleshes out the skeleton of existing surveys. The intention is to recalibrate a misconstrued history, revise inadequate narratives, fill lacunae, highlight unexplored themes, provide a road map for the 'contemporary,' and consolidate the lessons of many years of scholarship and curatorial experience. That said, the goal is not to be exhaustive; I have tackled only those areas where I can offer new insight.

On an autobiographical note, I did my graduate training in Art History at New York's Columbia University at a moment when modern art was tacitly understood to be a solely European and American achievement. The same conviction lingered at the Museum of Modern Art, also in New York, where I began working immediately after defending my doctoral dissertation in 1988, and where I remained until 2009. How did this education and professional experience lead me to write a book that validates protagonists from a country until recently admired only for its past? This is a story I would like to tell here, because my trajectory as an art historian and curator parallels the complex historiography of post-colonialism from the 1980s well into the 21st century.

My dissertation was my first serious engagement with the salutary effects of cross-cultural exchange. For the first time, I understood Persian art as a potentially subversive model that permitted a questioning of the conventions of the Western tradition. In that study I investigated the impact of Islamic and ancient Persian art on Gauguin, Matisse and Kandinsky. I argued that Persian art played a liberating role in the development of these key European modernists, each of whom was seeking an alternative to representational European art. I concluded that they derived their innovative styles from features which the Western canon was inhibiting but which they saw as being confirmed and embraced in the East. As perceived by the European painters, these included among other things a devotion to the aesthetics of decoration, a view of the world uninhibited by the laws of observation and visions of paradise or spiritual spheres removed from the reality of the world they observed around them. Such perceived qualities resonated profoundly with their utopian drive and legitimized their unconventional approach to art. To counter the naturalist force in Western art, they resorted to depicting (fabricated) visions of the free, joyful, beautiful, and spiritual world which they associated with the East.

A far different perception of Iran prevailed in the 1980s: demonization had replaced idealization. The West, disconcerted by the 1979 Iranian Revolution, mulled over the 'loss' of the country while clenched Iranian fists and chants of 'Death to America' were broadcast on the nightly news around the world. Soon after, with the Iran hostage crisis (November 1979 to January 1981), shock gave way to outrage and the onset of a cold war that is still ongoing. Earlier tropes in which Iran was the home of spirituality and creative visions unhampered by empirical reality were replaced by another fiction – that of a land of militancy and terrorism.

Iran too embarked on a discriminatory path, purging the 'West' out of its system and embarking on the fabrication of a new Islamic identity. In the throes of a brutal ideological and cultural war against internal enemies and a battle of greater magnitude with the neighbouring nation of Iraq, the ruling Islamic regime tolerated only a visual culture that supported its politics. In Tehran during the last two years of the 1980–88 Iran–Iraq War, besides modest exhibitions in private homes of work with non-confrontational themes (such as still lifes and landscapes), the only publicly visible art I saw echoed and amplified the regime's own propaganda. Art doubled as visual sermon; perceived enemies proliferated. They included art and artists associated with entire periods, from the Qajars and the Pahlavis (the two previous royal dynasties in Iran) back to the Achaemenids of the sixth, fifth and fourth centuries BC – a dynasty from which the Pahlavis sought to trace their royal lineage and historical pedigree. The modernists of the 1960s and 70s retreated as the Revolution progressed. A brand-new roster of younger artists – ideologues supporting the Islamic regime, for the most part unknown before 1979 – took centre stage.

In such a context, my dissertation had no relevance inside or outside Iran. Who could care about a thesis meticulously recording every reference an artist such as Gauguin made to the Achaemenid lion frieze from Darius's palace in Susa, excavated by the Dieulafoys in the 1880s and unveiled in June 1888 at the Louvre, when factions within the contemporary regime were advocating the destruction of Persepolis? In Paris and New York also, few people were receptive to the idea that a country such as Iran, which was now being dubbed as a rogue state, had any influence on the high points of modern Western culture. Yet I stubbornly pursued my detective work in archives and libraries and stitched together every piece of evidence I could find to reconstruct the links between mainstream European artists and Persian art. In retrospect, I see that in the 1980s, a decade marked by anti-Iranian sentiment on the one hand and Iranian fundamentalist xenophobia on the other, my tracing and interpreting the migration of forms and ideas

"ترو ری ست"

خسرو حسن زاده

ملیت: ایرانی

مذهب: مسلمان

سن: چهل ویک ساله

شغل: هنرمند نقاش

مشخصه: بند انگشت نشانه دست چپ قطع شده است.

سوابق: خسرو چند نمایشگاه هنری با موضوع مذهبی وفرهنگ مردمی در ایران وخارج ازکشور داشته است.

او درتهران زندگی می کند وصاحب دوفرزند می باشد.

"TERRORIST"
KHOSROW HASSANZADEH
NATIONALITY: IRANIAN
RELIGION: MUSLIM
AGE: 41
PROFESSION: ARTIST
DISTINCTIVE TRAITS:
MISSING TIP OF LEFT FOREFINGER.
PERSONAL HISTORY: SEVERAL EXHIBITIONS
BOTH IN IRAN AND ABROAD. MOST OF HIS
ARTWORK MAKES USE OF RELIGIOUS MOTIFS

Left
Detail of facing image

Opposite
Khosrow Hassanzadeh
Terrorist: Khosrow, 2004
Acrylic and silkscreen ink on canvas,
250 x 205 cm (98 x 80")
Mohammed Afkhami Foundation

was an instinctual impulse, predating the invasion of post-colonial thinking in academia, and anticipating the essentialist positions I would explicitly reject in the following decades. The dissertation, researched and written mostly in Paris and defended at Columbia University just after the end of the Iran–Iraq War, when the hostage crisis was barely a decade old, was my revenge against the polarizing narratives of the time.

Beginning in the nineties, Iranian art (not unlike the art of Africa and China) slowly gained greater exposure outside the country. For the first time in the modern era, it was no longer exclusively represented by illustrious examples from the past but was, rather, the product of living, contemporary Iranians, first a few in the diaspora and then, especially after the market surge in 2007 in Dubai, by artists residing inside the country. The art world in general was becoming increasingly

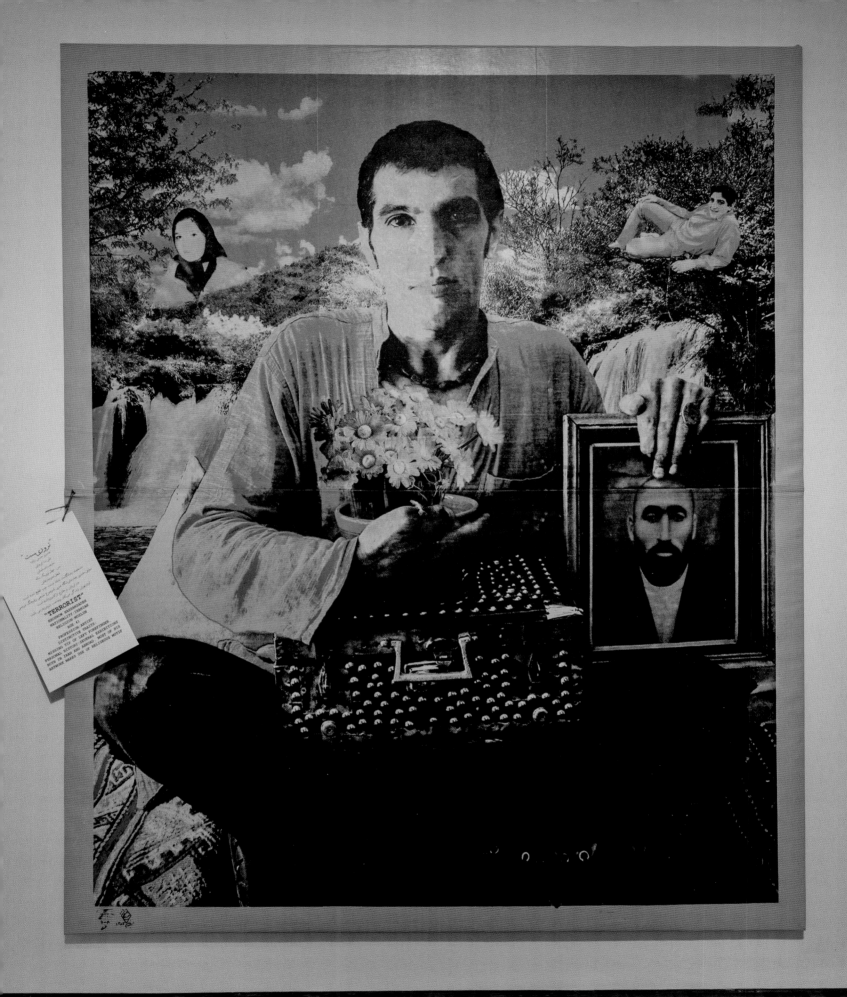

globalized. Would I be able to synchronize the internal metabolism of MoMA, where I was working, with the global pulse, and succeed in bringing the excluded 'other' into the fold? The challenge appeared logical to me, even if too ambitious for someone in my position in the museum's hierarchy. The difficulty was compounded by the fact that MoMA, shaped by its foundational embrace of European modernism and subsequent pivot toward American art, was not an institution conducive to promoting a post-colonial agenda. The flip side to this difficulty, I believed, was the reality that if MoMA were able to make this transition, the results would be far more transformative than if they were realized in a museum specializing in non-Western art. At that time it was MoMA's position that geography should not be a determining criterion in its programming (although the artists it privileged all came from the Western world). I understood MoMA's rationale of dwelling on existing strengths rather than venturing into areas foreign to the collection and the museum's traditional expertise, but I never gave up trying to bring about change. Meanwhile, in 1999, New York University's Grey Art Gallery gave me the opportunity to consider the subject of an alternative modernism, such as that of Iran, and the result was the exhibition *Between Word and Image* in 2002. My colleagues at MoMA visited the exhibition which, I was told, broadened their notion of modernism.[1] It also highlighted and provided the context for some of the artists in MoMA's collection (artists such as Faramarz Pilaram, Parviz Tanavoli, Charles-Hossein Zenderoudi, and Marcos Grigorian) who had been ignored since soon after their works were acquired by Alfred Barr in the early 1960s.

At MoMA, its Projects series of exhibitions, featuring contemporary art, allowed for far more openness and risk taking; it provided a release from the straightjacket of convention. Eventually, my early contributions to Projects outgrew the spatial limitations of the series, culminating in the group exhibition *Without Boundary: Seventeen Ways of Looking* in 2006. The selected artists were mostly diasporic and all (with two strategic exceptions) came from the Islamic world, an area previously represented at MoMA only in its film program. I considered this exhibition to be post-Orientalist: historical art from 'elsewhere' was no longer presented as a source for Western artists; rather, contemporary artists from that elsewhere were themselves the protagonists. The primary intention was to familiarize the general public with marginalized artists; the secondary goal was to question the generalizing descriptor 'Islamic' as applied to contemporary art. Every exhibition I have organized since then has been based on this same anti-essentialist position. My objective was to show that any vision of a monolithic Islamic artistic collectivity, enslaved to tradition, was false. I pointed out ambivalence, ruptures (a prerequisite for innovation), and

subversion rather than the continuation of tradition. Some of the artists were tapping into traditional resources for sure, but they were using them strategically to move beyond expressions identified exclusively with their own cultures. The works spoke of diversity and hybridity and not of conformity to a singular identity and tradition. Pluralism was my weapon in that exhibition and in those I would organize later, after my departure from MoMA in 2009. With *Action Now* (2012), *Safar/Voyage: Contemporary Works by Arab, Iranian, and Turkish Artists* (2013), *Iran Modern* (2013), and *Rebel, Jester, Mystic, Poet: Contemporary Persians* (2017), I endeavoured to expand the story of Iranian art beyond the common clichés of the art market and the popular press.

This book is not a survey of Iranian art. Most authors who have written on the subject have taken such an approach, from Akbar Tadjvidi's *L'Art Moderne en Iran,* published in 1967, to Hamid Keshmirshekan's 2013 volume *Contemporary Iranian Art: New Perspectives.*[2] While giving up on full inclusivity yet starting with a painting dating from the Qajar era and ending with multimedia productions made in 2017 and a few more works from 2018, my focus is centred on art since the 1960s. Structured both chronologically and thematically, the book is composed of six independent essays, each tackled from a unique angle.

Chapter One examines the concept of modernism in different eras and geographical locations and seeks to demonstrate how context determines the varying meanings of this shifting term.

Chapter Two focuses on the first culturally specific modernist movement to arise in Iran – the Saqqakhaneh group of the 1960s – and expands on the inadequate literature on the subject to date. I argue for Saqqakhaneh's connections to, and its critical distance from, the ruling regime's concept of modernization and its version of Iranian identity. In the process I highlight the aesthetics that derive from class consciousness. I maintain that the artists found ingenious ways to build their modernism with local material without ever succumbing to xenophobic nativism.

Chapter Three descends from a bird's-eye perspective of one movement to a closer look at one of its exponents, Parviz Tanavoli, who is known as the father of modern sculpture in Iran – a medium not readily associated with Iranian art.[3] Examining the contributions of this artist to a fundamentally new sculptural language, his ambivalent connections to the Saqqakhaneh movement, and his layered attitude towards history and authority, both sacred and secular, reveals a more complex position than acknowledged so far.

Chapter Four leaves behind the close-up approach and proposes a sweeping view of history. This chapter bridges pre-revolutionary modernism in Iran and the contemporary moment, discussing abstraction to figuration, a virtually unexplored topic,

although one that I touched on in my catalogue essay for *Iran Modern* at the Asia Society Museum, New York in 2013. I contend that abstraction in Iranian modern and contemporary art has not been solely 'art for art's sake,' as post-revolutionary critics understood it.[4] It has, rather, been a form of expression that meanders through a multiplicity of philosophical positions – from an existential humanism, to a language of concealment designed to accommodate both the overt assertion of Islamic identity and divergence from its tenets, to a platform for the expression of spirituality, untainted by politics.

Chapter Five centers on contemporary Iranian art. The period benefits from Talinn Grigor's *Contemporary Iranian Art: From the Street to the Studio* of 2014,[5] in which Grigor uses an anthropological methodology, paying pronounced attention to sociopolitical issues and subsuming art into visual culture. I approach the topic differently. I emphasize art which I do not dilute into visual culture. I focus on dissident aesthetics rather than propaganda art, and introduce noteworthy talents not covered in the existing literature and themes largely uncharted elsewhere. Unlike other studies, I do not conflate contemporary Iranian art with the historical past but define it as the art of the last twenty-five years. Gender, religious identity and diaspora are the major filters through which this period has often been viewed; to these I add other themes (such as the strategic appropriation of tradition), always treated with a keen analytical attention to individual works.

In the final chapter I chart my own efforts at expanding, hence democratizing, exhibition projects outside Iran, and I discuss the various models of exhibitions that have introduced Middle Eastern and Iranian art to the West. With this international perspective in mind, I contextualize my own curatorial experience beginning in the early 1990s, when art from the Middle East was absent from major American and European venues, and I discuss the Iranian artists I introduced at MoMA and at five other institutions in the United States, Canada, and France. Looking back at two exhibitions and essays I wrote on Iranian modernism (*Between Word and Image* at the Grey Art Gallery, New York in 2002, and *Iran Modern* in 2013), I trace the evolution in my thinking from an identity-based approach, in the former, to a broader understanding of Iranian modernism as a pluralist phenomenon created one sensibility at a time. The 2006 group exhibition *Without Boundary: Seventeen Ways of Looking* is treated in light of its main thesis, namely that the religion-based denomination 'Islamic contemporary art' represents a Western-centric viewpoint. To divorce Iranian contemporary art from market forces, I highlight the first exhibition of Iranian performance art ever organized: *Action Now*, which I curated at the Cité Internationale des Arts, Paris, in 2012. In the final section, I recount how Iranian artists have inhabited various roles to tackle

issues of gender, politics, war, religion and spirituality; this curatorial intent was explored in *Rebel, Jester, Mystic, Poet: Contemporary Persians*, a travelling exhibition drawn from the Mohammed Afkhami collection first exhibited at the Aga Khan Museum in Toronto in 2017 and subsequently at the Museum of Fine Arts in Houston.

This book is one more attempt to argue that every Iranian artist negotiates his or her own distinct position, whether aesthetic or political, and does so in a landscape that is either hostile or too receptive (and therefore compromising). The project is anchored in my own roots in Iran but it also draws on the cumulative experience of my nomadic life. It is the fruit of my life's labour. I do not speak for the artists I discuss, but having interviewed many of them over several decades, in Europe, America and Iran, travelled extensively back and forth, organized exhibitions and engaged in scholarly research on Iranian modernism and individual contemporary artists, I feel confident in discussing the art produced both inside and outside Iran.

While politics is key to understanding much of the work and its reception, in my narrative I avoid using art as merely an illustration of sociopolitical history. I negotiate a path between understanding art in its historical context and respecting it as a repository of multifaceted individual voices, as a space of pluralism and democracy. Aesthetics, for me, defines individual visions – how each artist differs from the next. The precious dialogues I have been privileged to have had with artists have opened up for me a more nuanced perception of my own people, which I wish to share with readers both inside and outside Iran.

A critic driving from San Antonio to Houston and back in one day just to see the exhibition *Rebel, Jester, Mystic, Poet: Contemporary Persians* at the Museum of Fine Arts, wrote, 'I'm not sure how you can hate a country and a people after watching an Abbas Kiarostami or an Asghar Farhadi film or listening to the Dariush Dolat-Shahi Folkways album. Iran is one of the most interesting places in the world and has been for about 4,000 years.'[6] There were 23 artists in that show. This book tackles around 70 artists, still a fraction of those active in the globalized art world.

While the form of this book may be scholarly, its underlying message is emotional. Its passion is not driven by political correctness, and the factual discussion of curatorial projects is not motivated by self-promotion. My voice is there to contextualize, tease out, and amplify the non-verbal, oblique messages nestled in the art. I would like to think that the artists, by the sheer force of their intellect, imagination, creative skills, subtle humour, dodging antics/survival strategies, pronounced sense of beauty, and humanity, will act as an antidote to the evil might of ignorance. As an historical witness, the art itself disputes the toxic narratives increasingly disseminated from reactionary pulpits, especially in the US.

Chapter One
Modernism(s): Contextualizing the Terms of Discussion

The mere fact that the Gregorian calendar and the Persian solar calendar do not share the same year zero highlights the difficulty of borrowing Western taxonomies to describe the current and the previous centuries in Iran.[1] The Gregorian calendar's twentieth century (1900–1999), for instance, covers portions of both the thirteenth and fourteenth centuries of the Persian calendar (1279–1378). When referring to centuries, commonly, Iranians use the Gregorian calendar but when discussing decades they revert back to the Persian calendar. For instance the seventies (1970s) are known as the fifties (1350s). There may be no solution to this problem, but acknowledging the discrepancy must inform any venture into chronology. To avert the confusion that might result from a deceptive etymology, terms such as 'modern', 'contemporary' and, especially, 'modernism', as well as the concept of the avant-garde, all being contingent on local timelines, must be revisited and problematized and their reference points exposed.

In periodizing the modern era in Iranian art, the year 1979 (1358 according to the Persian calendar) is a convenient benchmark. It does not evoke any watershed in the West, but in Iran it marks the cataclysmic rupture brought about by a revolution that ended centuries of monarchy. In particular it marked the overthrow of the Pahlavi dynasty (the reign of Reza Shah from 1925 to 1941 and that of his son Mohammad Reza Shah from 1941 to 1979), and the eradication

of its values along with the infrastructure of most secular disciplines, ushering in an ideology and a state anchored in religion: the Islamic Republic. The eight-year war with Iraq that followed, from 1980 to 1988, made art as it had been known before the Revolution irrelevant. Patrons and many artists withdrew or left the country, commercial galleries closed, and many art professors were purged from their academic positions. The fledgling infrastructure for modern art in the nation collapsed.[2]

No single term, whether modern, modernist or contemporary, can adequately describe aesthetic developments before and after the Revolution. Some Iranian authors have opted for the term 'contemporary' as an umbrella descriptor for art on both sides of the divide.[3] This choice is comprehensible in a nation with a history that stretches back several millennia. From such a vantage point, the entire twentieth century and the early years of the twenty-first are all relatively recent, or, in other words, contemporary. To describe the developments of the period preceding the 1979 Revolution I will use the term 'modernism', qualified and tailored for the local scene, for art that embraces aesthetics drastically different from native traditional expressions. I am acutely aware that the term comes with baggage that ill suits it for this task. For this reason I propose to adopt only the shell or husk of the term, emptied of its Western narrative.

For Iranian artists born in the 1920s, 1930s, and 1940s who continue practising today, the distinction between the modern and the contemporary may be almost irrelevant, as their work straddles the eras before and after the Revolution and up to the present day. But for those artists who brandished revolutionary ideals in their work, who gained visibility after the Revolution, or who were born around the time of the Revolution and who engage with newer aesthetics and media, the distinction may be useful.

The term 'contemporary' has often been used in the West to describe the tail end of the modern era (the late twentieth century and the early twenty-first), a period closer to (and generally including) now. I propose to apply the same convention for post-revolutionary Iran, but a question remains regarding its beginning. Should the art of the first decade following the Revolution be filed as contemporary? During the 1980s, the Iran–Iraq War was raging, and the emerging art was propagandistic – a visual sermon in the service of the Islamic regime. In that first decade of Islamic rule in Iran, the pluralism of the pre-revolutionary period barely survived, maintaining a pale, almost invisible existence both inside the country and outside. Initially, art that was informed by leftist ideologies, such as the paintings of Hannibal Alkhas (1930–2010), could intermingle with the rest as long as it hailed the Revolution.[4] Very soon, however, the art discourse encouraged

a collective Islamic identity, and it was defined by a number of state-supported artists, including, for example, Habib Sadeghi and Kazem Chalipa. From today's perspective, that decade's didactic art is part of a narrative that is no longer current but already enshrined in history. This is the only decade whose government-sanctioned art, mostly painting and graphic arts, one might venture to designate as 'Islamic'.[5] The most prominent movement of the 1980s was composed exclusively of Muslim artists, the majority of whom were men supported by the Islamic regime and who followed the same ideology as the state. Alternative practices were timid and conservative, sporadically exhibited in personal apartments or at the homes of Western diplomats. At the end of the 1980s and in the early 1990s, a range of new reactions to the society altered by the Revolution emerged, which continues to grow to this day in art that is often at odds with the official discourse. This is when the contemporary may be said to begin.

As for the term 'modernism', it must be redefined if it is to have any meaningful relevance to the pre-revolutionary art of Iran. As an art historical discourse, modernism was conceived in the West, exclusively about the West, and for the westerner as ultimate reader, spectator, and consumer. Even though it has been adamantly contested and deconstructed and new methodologies questioning the authority of the modernist master narrative have been proposed, as recently as a decade ago the major historians of modernism, Hal Foster, Rosalind Krauss, Yve-Alain Bois and Benjamin Buchloh, showed not the slightest interest in art by those not considered American or European.[6] Their discourse still excludes the voices of the non-Western world and its diaspora, just as these voices were ignored by Alfred H. Barr, Jr when, in 1929, upon becoming the first director of the Museum of Modern Art in New York, he formulated his own highly influential vision of modernism. On the dust jacket of the catalogue for his 1936 exhibition *Cubism and Abstract Art*, Barr traced the evolutionary progression of modernism's 'isms,' starting with the Post-Impressionism of the 1880s, the decade that marks the earliest years covered by MoMA's permanent collection, and culminating in abstraction[7] (fig 1). In his colour-coded diagram, the names of the movements are printed in black ink, but 'Japanese prints,' 'Negro sculpture' and 'Near Eastern art,' three forms of production originating outside the Western world, are printed in red. They are situated as source material for modern art rather than motors of the modern machine or candidates for inclusion in the canon. Millennia of art from Japan, Africa and the Middle East are reduced to generic, ahistorical labels, their presence justified only by their subsidiary function in nourishing the mainstream of Western modern art. According to this chart, Near Eastern art, certainly including traditional 'Persian miniatures', fed Fauvism and Expressionism in Europe.[8]

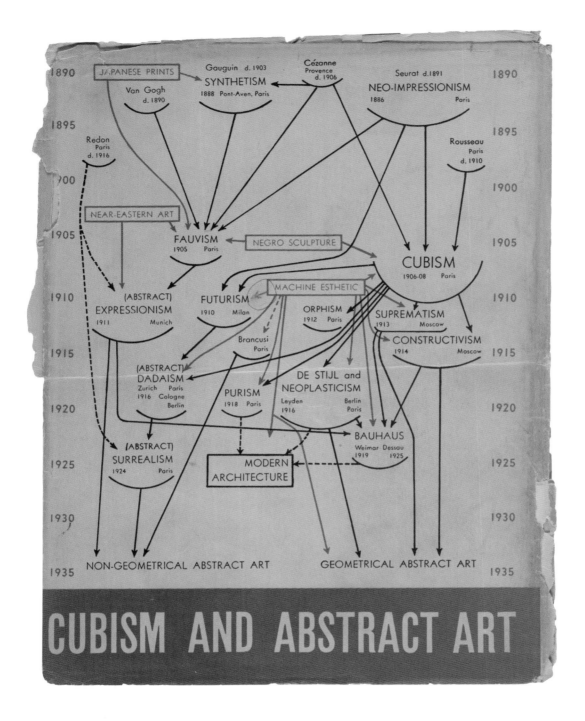

Barr was not a conservative for his time. A visionary, he was in fact far more risk-taking and inclusive than his contemporaries or even many influential curators in major Western museums today. In the 1960s, for instance, he acquired half a dozen works by Iranian artists for the museum's collection.[9] Yet Paris would remain the centre of the modernist geography until it was superseded by New York, in the work of the other major theorist of modernism, the critic Clement Greenberg. In *Cubism and Abstract Art*, Barr summarizes the characteristics of the modern in the Western context. He writes,

'Sometimes in the history of art it is possible to describe a period or a generation of artists as having been obsessed by a particular problem.'[10] He cites Renaissance artists for their 'passion for imitating nature,' but when it comes to 'the more adventurous and original artists of the twentieth century,' he writes, 'the dominant interest was almost exactly opposite.'[11] He describes the new direction as the 'impulse away from "nature."' Eventually, as articulated by Greenberg, a self-reflexive (meaning self-referential) practice focused on the inherent properties of a medium, divorced from any kind of subservience to the outside world, became the end and means of modernist dogma. Reflecting American nationalistic sentiments in the post-World War II period, Greenberg denied the influence of Asian art on the Abstract Expressionist artists he championed, declaring that 'the sources of their art lie entirely in the West.'[12]

Does this concept of modernism as a march towards abstraction, presided over by the likes of Paul Gauguin, among others, find a parallel in the context of Iranian art? Based on this limited formulation, Iran, along with Asian and African nations, either never experienced modernism in art or, if abstraction is the criterion, its art was modernist before the West discovered it. If, however, we begin with a tabula rasa, stripping away the pre-existing Western definition of the concept, we can identify modernism in the pluralistic and complex terrain of Iranian art in the twentieth century.

A comparison of works by two artists, Paul Gauguin (French, 1848–1903) and Mohammad Ghaffari, known as Kamal al-Molk (Iranian, 1848 or most probably 1859–1940), each belonging to a different art historical trajectory, facilitates a grasp on the thorny issue of terminology and helps us contextualize modernism in relation to Iran. Kamal al-Molk's career overlapped two dynasties: late Qajar and early Pahlavi. He made the painting *Hall of Mirrors* (fig 2) in Tehran in 1896, while he was court painter to Naser al-Din Shah Qajar. That same year, in Tahiti, Gauguin painted *Vaïte (Jeanne) Goupil* (fig 3).

Operating on a culturally entrenched assumption that equated Europe with progress, Kamal al-Molk opted for an aesthetic system of European derivation: the Renaissance tradition. This fascination with art based on an impulse towards naturalism (and not away from it, as in the progressive art described by Barr) was radically anti-traditional in Iran. Kamal al-Molk's vision is anchored in realism, in an order of reality belonging to the senses and to the laws of perspective, rather than the Persian predilection for imaginative flights and embellishments with tenuous links to the empirical world. He turned his back on what Iranian mystics call the alam-e methal or *Nakoja-abad*, a concept Henri Corbin translates into Latin as *mundus imaginalis*.[13] To describe the Persian ethos that infuses traditional painting, Morteza Goudarzi,

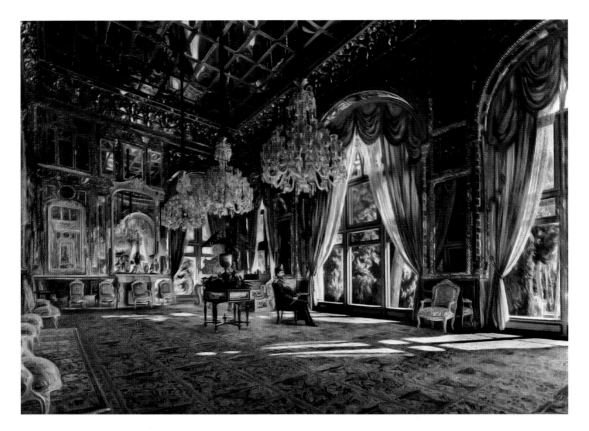

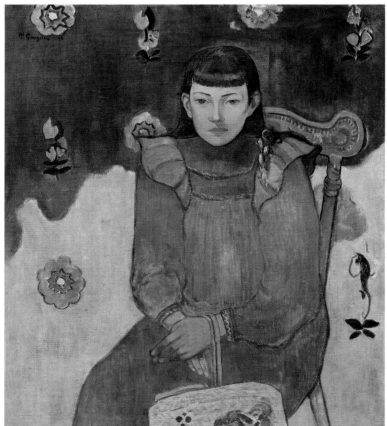

Opposite above
2. Mohammad Ghaffari (Kamal al-Molk)
Hall of Mirrors, 1896
Oil on canvas, 90 x 100cm (35½ x 39 ⅜")
Golestan Palace, Tehran

Opposite below
3. Paul Gauguin
Portrait of a Young Woman. Vaïte (Jeanne) Goupil, 1896
Oil on canvas, 75 x 65 cm (29½ x 25½")
Ordrupgaard, Copenhagen

an Iranian art historian of the post-revolutionary era, invoked the twelfth-century Persian mystic and philosopher Sohrawardi (or Suhrawardi), who articulated the notion of the *Nakoja-abad* as a realm between matter and soul, the internal and the external.[14] The specificity of the location pictured in *Hall of Mirrors* (a salon in the Golestan Palace) and the time of day (afternoon sun floods the carpets) is nothing like the shadowless, gravityless universe of Persian manuscript paintings. Kamal al-Molk was fascinated by Western culture, particularly its Old Master paintings, which he copied and studied in European museums such as the Louvre in Paris and the Pitti Palace and the Uffizi in Florence.[15] He was equally drawn to Western technological advances such as photography. The phrase 'Old Master modernism' aptly describes a trend of which Kamal al-Molk was a part and that he mastered, a trend that is to this day one stream within the pluralist flow of twentieth-century art in Iran. Ali Mohammad Heydarian (1896–1990), one of Kamal al-Molk's best students, carried on this legacy and propagated it through his own teaching. The tradition survives, though greatly transformed and even reconciled with *Nakoja-abad*, in the work of Y.Z. Kami,[16] a New York-based artist (born 1956) who was trained by his mother, Mahine Youssefzadeh, one of Heydarian's students. Old Master modernism, a contradiction from a Western perspective, is a logical proposition in the context of Iran. The novelty (or 'modernism') of the tendency lies in its radical departure from local traditional art, whether manuscript painting or Qajar royal portraiture. Its modernism is further manifested in its alliance with the West and its incorporation of a photographic realism, both of which have operated as signifiers of modernity in Iran.

Modernity, in this context, must be understood not in terms of a fully secular, democratic, technologically advanced society, which Iran was not, but as a characteristic of a society that was awakening to change. In twentieth-century Iranian society and politics, reactions to modernity ranged from an advocacy of an 'unconditional capitulation of Iran to European civilization'[17] to a hostile mistrust, in which modernity was characterized as 'a Western ruse, a veritable Trojan horse used by "colonialists."'[18] Naturally, within the aesthetic domain, modernism involved a complex set of negotiations with these politically and culturally specific tensions. In this struggle between the ways of the Iranian self and of the non-Iranian other, Kamal al-Molk and his followers for half a century opted to relegate content to the former and form to the latter. Form was adopted not from contemporary Europe but from the Renaissance tradition and blended with the science of photography, which was introduced in Iran soon after its invention in 1839.[19] Kamal al-Molk's detailed rendering of the lavish decoration of the Golestan Palace betrays his ambition to rival

the art of photography. Karim Emami (1920–2005), one of the most prominent art critics of twentieth-century Iran, labelled this new type of artist as 'a photographer with a brush.'[20]

Kamal al-Molk embodied modernity in Iran at a time when 'progress' was equated with European civilization, at least by one segment of the population: the westernized elite. The portrait of the Qajar king in the *Hall of Mirrors*, painted before the artist travelled to Europe (1898 to 1901), still hovers between different modes of representation. The heavily tilted ceiling does not fully bow to Western perspectival laws; the desire to pack in more than a single viewpoint is a legacy of traditional Iranian painting.[21]

Kamal al-Molk was the last court painter to the Qajar monarchs and, eventually, the first artist to fully reverse the Persian tendency towards unfaithful representations. In the words of Esmail Ashtiani, one of his students, 'he corrected mistakes, eliminated defects, nature became a model, science the guide. On the whole, during the short period he taught at his school, he brought a revolution in the field of painting, one that relegated traditional styles to the rank of decorative arts.'[22] The school in question was the Madreseh-ye Sanaye'-e Mostazrafeh, in Tehran, which the artist founded in 1911 and directed until 1927 – a school with a far-reaching influence on painting in Iran in the first half of the twentieth century.

Just as Kamal al-Molk was aspiring to Western naturalism, Gauguin was seeking alternatives to the representational tradition of the Renaissance. Persian art is one place where he found it, as did Henri Matisse and Wassily Kandinsky after him. Gauguin praised the arbitrary colours in Persian carpets and the symbolic quality of Achaemenid bas-reliefs and in a famous statement proclaimed, 'Have always before you the Persians, the Cambodians and to a small extent the Egyptians. The big mistake is Greek art no matter how beautiful it is.'[23] In contrast to Kamal al-Molk's long view in *Hall of Mirrors*, Gauguin's *Vaïte (Jeanne) Goupil* is as compressed as the flat decorative fields of the Persian carpets the artist so much admired.[24]

While Gauguin's subject matter is conventional, the Iranian painter's is avant-garde, or progressive in a political sense: the court painter refused to aggrandize the monarch, who is shown as a diminutive figure lost in the profuse ornamentation of his palace. After a long period of restoration, the Golestan Palace, situated in downtown Tehran, is now accessible to visitors. Comparing the painting, which is finally on view, with the actual Hall of Mirrors next door highlights the liberties taken by the artist: he exaggerated the dimensions of the hall, thus diminishing the figure of Naser al-Din Shah. In the process, he turned the page on the tradition of intimidating representations in royal portraiture. In a culture averse

to realism and prone to divinizing its dictators, Kamal al-Molk's sober observation restored the ruler to his human dimensions. Thus, even when on the payroll of the court, the artist could express resistance and even subversion through visual codes, in this case the laws of perspective. Corroborating the evidence of the painting, Kamal al-Molk's political statements speak of his anti-authoritarian and progressive views: such as his admission that, 'after all the painting was an imposition' (a reference to this commissioned portrait),[25] his avowed antipathy for Mozaffar al-Din Shah,[26] Naser al-Din Shah's successor, and, later on, his sympathies with the Constitutionalists who, in 1906, successfully called for the institution of a parliament that would curb the power of the Shah.[27] It is the Iranian sociopolitical context, therefore, that positions this painter as a modern artist.

The choices made by Kamal al-Molk and Gauguin also reveal the identities they were fabricating for themselves. Kamal al-Molk was active at the turn of the twentieth century and well into its first three decades, a period when, in spite of the manipulation of Iranian politics by the quasi-colonial powers of Great Britain and Russia, being patriotic and progressive – being an enlightened Iranian – meant being receptive to European influences. For Gauguin, paradise was elsewhere: his ideal was a 'savage,' anything but a bourgeois European. Neither artist fits into a single teleological narrative of modernism; rather, they belong to a vision of history that is complex and multiple in its definitions.[28]

Using recent Western taxonomy and language, one might be tempted to interpret Kamal al-Molk's practice of quoting older art and his lack of a signature style as a kind of post-modernism *avant la lettre*. (The works he simulated ranged from classical and baroque to the nineteenth-century orientalist realism of Jean-Léon Gérôme.) That categorization might seem forced, but the painter's choices did set the stage for the stylistic versatility that became standard in post-World War II Iranian art – in, for example, the work of the painter Mahmoud Javadipour (1920–2012), who proclaimed that experimentation with different styles is essential to an artist's freedom of expression.[29] Kamal al-Molk's appropriation (a key term in post-modernism) of Western manners, however, is devoid of cynicism regarding originality, and, of course, he did not share the doomsday belief in the demise of painting that characterizes post-modernism today. On the contrary, his work is free of irony, it is optimistic, and it has deep cultural and possibly theological roots in his local culture, which values a great copy perhaps as much as, if not more than, a work displaying originality. This reverence for the replica is exemplified by a comment by Mozaffar al-Din Shah about Kamal al-Molk's copy of a Titian at the Louvre: he claimed that it 'verily did not differ from the original.'[30] Such

reverence has been part of Iranian culture since times immemorial. Mani, the prophet and originator of Manichaeism in the third century AD, was a legendary painter; he is remembered for his extraordinary mimetic ability, which enabled him to capture a magical degree of lifelikeness. [31] Contrary to the thirst for novelty and invention that drives Western modernism, the Iranian ideal resides in an origin, an *ur*-paradigm, whose foundation equals perfection. The goal is a faithful re-enactment of a perfect origin (be it Titian, Rembrandt, or nature). [32] Thus Kamal al-Molk and his students' pictorial documentation of European artistic achievements was an affirmation of their skill, self, and status as modern Iranians – as cosmopolitan artists, nationalists nourished by Western values but rooted in local beliefs.

The debate, however, continues as to whether Kamal al-Molk represents the culmination of a westernizing trend that privileged realism.[33] He was a pioneer in the rupture with the traditional arts, the first to categorically turn his back on the local tradition of abstraction. For this author he is an Old Master modernist. The instability of terms, or the semiotic problem, is evident in the literature produced by Iranians themselves, when they compare Kamal al-Molk's modernity with the Iranian modernism that followed World War II. Who should be considered a modern painter? An artist such as Kamal al-Molk, who borrowed from pre-modern European traditions, or those postwar artists who found their inspiration in prewar European 'isms' considered modernist in the West, albeit ones that had by then expired in their place of origin? In the final analysis, both categories are dependent on a Western-derived language. There is a third category, a modernism brewed locally – a phenomenon, the Saqqakhaneh movement, which will be discussed in the following chapter.

Accepting Kamal al-Molk's modernity and yet qualifying it, Emami writes that in the postwar period 'real modernism intruded onto the scene with the return of a number of foreign-educated Iranian artists from France and Italy in particular.'[34] Reza Giorgiani, one of the first major art critics in Iran, writing in the 1940s; Ru'in Pakbaz, the eminent teacher of Iranian art history; and Javad Mojabi, in his *Pioneers of Contemporary Persian Painting: First Generation* (1998), situate the beginnings of a new art at the inception of the Academy of Fine Arts, founded in 1940 (the year of Kamal al-Molk's death), or in the 1940s in general, a period in which artists were challenging Kamal al-Molk's legacy, which was then seen as a sterile academicism.[35] Akbar Tadjvidi, who wrote one of the first art historical accounts of Iranian modern art (in French), recognizes the painter Jalil Ziapour (1920–1999) as the first to be interested in modern painting[36] – meaning, in this case, Cubism. The artists of this new generation had been born in the 1920s, and they studied at the Academy, which was headed by the French architect and

archaeologist André Godard; many of them studied abroad, mostly in Europe. They were overwhelmed by their sudden exposure to Western modern art. For historians such as Tadjvidi, the true modernists were those who mimicked, appropriated, or adopted the 'isms' of the West: namely Expressionism, Fauvism, and Cubism.

There were those who opposed this relationship. Among the most vehement disparagers of the Western-influenced intelligentsia (including artists) in this period was Jalal Al-e Ahmad. In a publication issued posthumously, in 1993, Al-e Ahmad, pointing to what he believed to be the Iranian intellectual's sense of alienation and loss of authentic identity, wrote, 'Thus the Iranian intellectual turns insane, or a heroin addict, or a phony, or a *modernist* [italics mine], or crazy, or westoxicated [...] a consumer of Western material [...] but not a producer of anything useful to the native.'[37] In analyzing the discourse of Iranian intellectuals in relation to the West in this period, Mehrzad Boroujerdi detects a position he characterizes as 'orientalism in reverse,' which 'embraces orientalism's assumption of a fundamental ontological difference separating [...] the Orient and the Occident [...] a discourse bent on manufacturing difference.'[38] This vision led to 'nativism,' which he defines as 'the doctrine that calls for the resurgence, reinstatement or continuance of native or indigenous cultural customs, beliefs, and values.'[39] In order to arrive at a balanced understanding of what the term 'modernism' could mean when applied to the work of Iranian artists active in the 1940s and 1950s, both its positive and negative connotations need to be kept in sight.

The 1940s were marked by the founding of the Academy of Fine Arts (soon to be attached to Tehran University) but also by the end of an era in politics, with Reza Shah's abdication in 1941. The founder of the Pahlavi dynasty, this monarch had modelled his policies on Turkey's Kemal Atatürk, with whom he shared, in one historian's words, 'nationalist, modernizing, secularizing, westernizing features.'[40] Yet unlike Atatürk, whose popularity did not wane with his death, and in spite of his formidable achievements, Reza Shah's autocratic rule alienated all segments of the society he ruled, including the *ulema* (scholars), the bazaar merchants, the liberals and intellectuals, and his British supporters. He left the throne in favour of his son, Mohammad Reza Shah, whose rule began as a constitutional monarchy. This turbulent decade was marred by a weak government, the occupation of the country by foreigners (British and American troops up to 1945, and by the Soviets, months later, in 1946), and threats of secession stimulated by the Soviet Union (1945–6), until the rise of Prime Minister Mohammad Mossadegh (who would meet his political demise in an Anglo-American-supported coup in 1953). However, it also brought a new sense of liberty to Iranians, through the proliferation of political

parties and an unprecedented freedom of the press (there were forty-seven newspapers in Tehran in 1943; by 1951 there were seven hundred).[41] The pro-Communist Tudeh party was founded in 1941 and remained active openly until 1949, when it was banned due to accusations that its members were linked to an assassination attempt on the young Shah.

The Soviet influence was not without ramifications for cultural life in Tehran.[42] At a time when there were no private galleries in the city (the first, the Apadana Gallery, opened in 1949),[43] VOKS, the Soviet Society for Cultural Relations with Foreign Countries, organized the first important exhibition of modern art in Iran. The year was 1946. Giorgiani reviewed the exhibition in *Sokhan*, the foremost pro-Western cultural journal, published from 1943 to 1972: it was, he wrote, 'the first step taken in the direction of presenting Iranian artists.'[44] The exhibition was widely inclusive and egalitarian in terms of media. It featured a variety of schools and styles, ranging from the 'classical' (Kamal al-Molk, deemed the founder of a new movement in Iran, and his followers) to young painters who 'freed themselves from the classical principles' (Hossein Kazemi, Mehdi Vishkai, and Jalil Ziapour) and, interestingly, embroideries by women (*souzan douzi* by Malek Ara Khajeh Nouri, and Maliheh Saidi), miniature painting (Hossein Behzad), and even caricatures, represented by Frederick Tallberg, a Swedish immigrant.[45] In his review, Giorgiani singled out and illustrated Ziapour's painting *Kaveh's Uprising* as an example of the new trends encouraged at the Academy (fig 4).

The subject of the work comes from the *Shahnameh*, the epic poem written by Ferdowsi between *c.*977 and 1010 AD. In the story, the mythical blacksmith Kaveh heads an uprising against Zahak, the cruel foreign ruler. The theme was popular among Tudeh figures such as the dramatist Noushin, a 'founding member of the Tudeh, [who] was one of the very first to reinterpret the epic as a radical text, denouncing monarchs and instead praising folk rebels such as Kaveh the Blacksmith.'[46] The subject was taken up by other painters, one example being the 1944 painting by Javadipour[47] who told this author that the topic was assigned by teachers rather than proposed by him.[48] Although no record survives as to Ziapour's political affiliations, the painting was created at a time when the intelligentsia was influenced by the political left. In retrospect, and possibly even at the time of its execution, the subject of this expressionist painting, now lost, may be read as a metaphor for rebellion against authority, be it political or aesthetic.[49] In any case, the representation of the subject required an act of imagination, which was encouraged by some of the teachers at the Honarkadeh (Academy of Fine Arts), rather than the mimesis that Kamal al-Molk and his followers had revered.

4. Jalil Ziapour
Kaveh's Uprising, c.1946
Lost. Reproduced in Reza Giorgiani,
'Namayeshgah-e honarha-ye ziba-ye Iran',
Sokhan, 3rd period, no. 1 (Farvardin 1325
[March–April 1946]), p. 24

Thus, the challenge to authority became palpable. The new generation of artists, educated at the Honarkadeh – not quite a Beaux-Arts system, but one that to a certain extent emphasized imagination over rote description – was for the first time exposed to Western modern art, and, in Giorgiani's words, they 'freed themselves' from what can be paraphrased as the authority of Kamal al-Molk. The tendency intensified as artists travelled abroad. Houshang Pezeshknia (1917–1972), who went to Istanbul, and Ziapour, who travelled to Paris, are two among many in the generation of artists that heralded 'real modernism' in Iran. Of the two, Ziapour, possibly because he was a militant theoretician, is recognized as playing a larger role in expanding the public's understanding of modern art. He was among the first graduates of the Honarkadeh. In 1946 he left Tehran for Paris, where he studied at the École des Beaux-Arts and then, upon the recommendation of Manoucher Yektai (born 1920)[50] – a fellow student at the Honarkadeh who was also studying in Paris – with the Cubist painter André Lhote.[51] In 1949, the year after his return to Tehran, Ziapour co-founded a society and a periodical called *Khorous Jangi* (Fighting Rooster), a forum in which to champion his version of modernism.[52] The periodical had a regular run of five issues (1949–50) and additional issues were published in 1951.[53]

The Cubist rooster on the periodical's cover, designed by Ziapour, was an emblematic call to awakening but also a reference to 'cock-a-doodle-do,' the first words published in the journal, the initial line of a poem by Nima Yushij (1895–1959), the exemplary voice of the avant-garde in Persian literature (fig 5). The reference may also be not just to the awakening calls of roosters but also a nod to the Gallic cock, a revolutionary symbol of the French people and a subject depicted by Picasso during the war years. In 1944, two years before Ziapour's arrival in Paris, Picasso had joined the Communist Party. The association of Cubism with Communism, especially as a critique levelled at Picasso in the United States during the Cold War, had a parallel in Iran.[54] As recounted by Mojabi, Ziapour's publication was banned, and he was summoned by the authorities for an interrogation. The session seems to have ended with an apologetic statement by the authorities: 'We thought cubism was the same thing as communism.'[55] Ziapour has been acknowledged for his theoretical championship of modernism, but his role as commissioner of the first delegation of Iranian modernists at the Venice Biennale in 1956 has often been overlooked. Out of the seven artists he selected, two were women (Mansureh Hosseini and Behjat Sadr) and two belonged to the Armenian minority (Alfonso Avanessian and Vasghen Minassian).[56]

Most of Ziapour's early works are lost, including *Kaveh's Uprising* and *Public Bath* (a Cubist painting executed no later than 1948, when it

was reproduced in the first issue of *Kavir*, a periodical affiliated with Ziapour; fig 6). The work may have been exhibited in a 1950 four-man show at the Apadana Gallery. A fascinating review of the exhibition sheds light on the climate in which Ziapour was struggling to promote Cubism.

The reviewer was none other than Al-e Ahmad, who would become identified with a rabid anti-Western position when his book *Gharbzadegi* ('Westoxification') was published in 1962 (though it was not openly distributed until the wake of the Revolution, in 1978). The 1950 exhibition was the third that the Apadana Gallery had hosted. The gallery was a showplace for the new tendencies, including Ziapour's Cubism. It was short-lived, open from September 1949 to July 1950.[57] The review, published in the newspaper *Mehregan* on March 7, 1950, lists

5. Jalil Ziapour
Logo and cover for the periodical *Khorous Jangi (Fighting Rooster)*, 1949

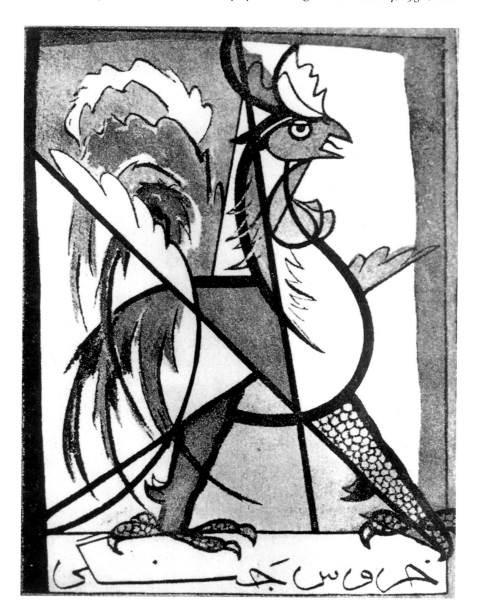

14

6. Jalil Ziapour
Hammam-e omumi (Public Bath), c.1949
Lost. Reproduced in *Kavir*, no. 1, 1949, p. 19

the names of the four modernists who had works on view: 'Pezeshknia, Vishkai, Ziapour and Esfandiari.' The review betrays much about Al-e Ahmad. He complains that a painting entitled *Cord* by Ziapour has no cord in it; instead, it depicts a scene from a public bath featuring both men and women – a feature he likens to pornography. He continues: 'Aside from the bath being for women and men, I don't understand the intention underlying the appearance of these figures portrayed with long necks and big bellies.'[58] The description fits the painting entitled *Public Bath*.[59] In Persian the derogatory nature of the critique is highly pronounced. He praises another work by Ziapour, which represents a mosque: 'It is cubist but its subject matter at least is Iranian.[60] Ziapour later expressed his dismay at the highly negative reception of Cubism in Tehran: 'Our artists for centuries have been involved in creating

geometrically abstract designs,' he said, and he wondered how such aesthetics could be deemed alien to Iranian culture.[61] Opposition to imported idioms came from bureaucrats, traditional miniature painters, the followers of Kamal al-Molk, the members of the Tudeh party of Iran—who divided art into 'art for art's sake,' which they opposed, and 'art for the people,' which they advocated – and critics such as Al-e-Ahmad who opposed Western influences in general.[62]

If the idioms artists borrowed from the West in these years belonged to movements that had passed their peak in Europe, was this art any more modernist than Kamal al-Molk's classicism? Or it should be considered equally retardataire? The answer is just as complex as it was for Kamal al-Molk's work and it again lies in the specificity of the cultural context. Ziapour, just like Kamal al-Molk, perceived his project as progressive. In an interview published by Mojabi in 1998, he claims that he opposed any form of art he considered backward, which for him comprised the ongoing practice of traditional Iranian art, imported academic realism, modernism without local roots, and the kind of retrogressive art (Socialist Realism?) promoted by the Soviet Union.[63] His allegiance was to modern Iran. In his work, the fragmented idiom derived from Cubism progressively gave way to a generic-seeming modernism featuring a ubiquitous grid – possibly a direct representation of tiles rather than a residue of Cubism. His increasing interest in Iranian subject matter led him to investigate local folklore and costumes around the country; in the mid 1960s he was appointed director of the country's ethnographic museum. In his grids he incorporated women in folkloric costumes, an anthropological area of research in which he was joined by others, including Sadegh Hedayat (1903–1951). The two must have known each other since the 1940s, when Hedayat, already recognized as the 'father of Persian modernist fiction,' worked in the administrative offices of the Honarkadeh. Yektai, a fellow student, recounted his morning walks with the older Hedayat to the Honarkadeh, acknowledging his sense of awe at reading Hedayat's *Blind Owl*, which had been written and published in India (it was first published in Iran in 1941, when it was serialized in the daily newspaper *Iran* after the departure of Reza Shah). Ziapour could not have been unimpressed by this modernist in the field of literature. By the early 1960s, the line of thinking exemplified in Ziapour's Cubist approach to art became so contested that Cyrus Zoka proclaimed in 1962 that 'our account is separate from the West. No copy is better than the original.'[64]

While debates in Tehran revolved around the question of the-West-or-not-the-West, artists outside the country had a different experience. Yektai lived in the thick of the New York art world and was viewed by New York critics as an 'Iranian member of the New

York School';[65] his trajectory therefore problematizes discourses dealing primarily with national art. He had begun his art training at the Honarkadeh, but before finishing his degree he set sail on a long journey. He reached New York around the end of World War II (possibly in 1945), and since then has returned to Iran only for brief visits. In New York he enrolled at the Art Students League while also taking classes with the French Cubist and Purist Amédée Ozenfant. Yektai has reported that from New York he went to Paris, where he spent an academic year enrolled at the École des Beaux-Arts (1946–7), while studying with André Lhote (whom he introduced to Ziapour).[66] Then, with the exception of a year or two in the early 1960s when he again lived in Paris, he resided in New York, where he was drawn into the orbit of the most prominent artists and critics: he befriended artists such as Milton Avery and frequented the circle of Abstract Expressionists Willem de Kooning, Franz Kline, Joan Mitchell and Mark Rothko and exhibited with them at the Stable Gallery, in solo shows at the Grace Borgenicht Gallery, starting in 1951, and later at the Poindexter Gallery, among others. His exhibitions were reviewed by critics such as John Ashbery, Hilton Kramer, Annette Michelson, Fairfield Porter, Irving Sandler, Pierre Schneider and Sydney Tillim.[67]

Sifting through articles and reviews of Yektai's work from the 1950s and 1960s, certain points jump out in relation to the attention given in our current time to the national identity of diasporic artists. When Yektai came to the United States, unlike today, there were very few Iranian artists who chose to stay in the West, and, when they did, identity was not an issue to be dwelled upon. A few critics do mention Yektai's Iranian origin. Hilton Kramer describes him as a 'Persian poet who became a New Yorker.'[68] He was a 'Persian-born painter poet,'[69] according to Thomas B. Hess, and a 'Persian American artist,'[70] according to Pierre Schneider, who reported on Yektai's exhibition in Paris. At times an ethnic quality was detected in his work, as when, for instance, a critic mentions this 'talented Iranian member of the New York School' in the following terms: 'One might anticipate an ethnic novelty and it is brilliantly here, in the idiomatic arabesques of grand strokes, taut and arbitrary, and in Yektai's taste.'[71] 'Calligraphy becomes descriptive,'[72] says another critic; according to Hess, Yektai employed 'most of the conventional Western subjects – the landscape, still-life, the nude, portraits – but treats them in odd, perhaps Middle-Eastern ways.'[73]

While Persian art is named by critics as one among many possible sources of inspiration,[74] the paintings do not readily betray Yektai's Iranian heritage (fig 7). The artist himself has expressed equal admiration for the miniature painter Kamal al-Din Behzad (1450–1535), Rembrandt and de Kooning.[75] He maintains that in his poetry, a medium in which he is dependent on his native language,

he is very much Iranian, but in his painting his Iranian nationality is not a pertinent issue.[76] The core of his aesthetics, as perceived by New York critics, is anchored in formal terms, in the context of New York Abstract Expressionism, and in the discourse of the time around abstraction versus figuration and materiality. Sidney Tillim relates that with 'thick, torrential impastos' Yektai 'barely respects the shapes and edges of things.'[77] Michelson, in a laudatory review, formulates the question as an 'attempt to reconcile the aesthetic of the "oeuvre", for itself, and for the "act" or "gesture."'[78] Kramer, writing in 1962, positions Yektai as 'one of the few serious practitioners of figure painting on the current scene.'[79] Yet Yektai refutes the figuration–abstraction binary. He recalled a conversation with Franz Kline in Paris, in which Kline asked him what he was thinking. Yektai answered, 'Ingres.' Kline asked, 'Why Ingres?' to which Yektai replied, 'Ingres is abstraction.'[80] He paraphrased this thought recently, saying, 'I don't think abstraction is not figuration.'[81] Yektai's hallmark is the fluidity in which he navigates between the two modes or, better yet, melds the two into one.

The same chameleon-like quality colours his approach to perspective. The fact that he works on the floor, a nod to Pollock, reveals a great deal about the perspective in his work, which reflects his plunging position vis-à-vis the ground. It also manifests a certain indebtedness not only to a lineage of Western artists starting with the Post-Impressionists (Cézanne's use of perspective) but also to the bird's-eye viewpoints of Persian miniature painters. However, Yektai neither drips his paint onto the canvas nor uses the fine brushes of the miniature painters. Aside from average-size brushes, he uses trowels of different shapes – he has described them as the instruments of bricklayers[82] – which he slides in one direction and then in another, thus creating fluidity and the illusion of motion in the work. He also squeezes paint directly out of the tube into a thick impasto, sometimes signifying fruit and, perhaps, flowers. In addition, he does not shy away from the use of his own fingers to create, for instance, the image of a hand, as in his portrait of the French novelist and film director Romain Gary (1962), for which he combed the paint with his gloved fingers.[83]

While Yektai's oeuvre mainly comprises still lifes, landscapes and portraits, he most often paints from memory. The usual stasis of these conventional choices is subverted by the choreography of the marks, the rhythmic action of his touches and strokes, the varied topography of the surface, and, ultimately, the lack of certainty as to what is being captured. A still life morphs into a landscape, figuration dissolves into abstraction, and abstraction hints at the recognizable. It is not surprising that many of his shape-shifting motifs are not painted from observation.

Yektai has had a long and fruitful career. Writing in 1998 on the occasion of a retrospective of his work, Thomas McEvilley, the fervent

7. Manoucher Yektai
Yellow Still Life, 1954
Oil on canvas, 28 x 28 cm (11 x 11")
Collection Michel Protiva

post-colonial advocate of multiculturalism, characterized Yektai as a nomadic and hybrid artist straddling various cultures: Iranian, French and American.[84] He said it best when he defined Yektai's trajectory as 'a search for Modernism, and for a participation in Modernism, indeed, for a home in it.'[85]

The term 'modernism' has shifted in meaning in relation to Iranian art from period to period and from one geographical context to another. For Kamal al-Molk, in the late nineteenth century, academic realism was tantamount to progressive thinking. For Ziapour, a post-World War II artist residing inside the country, Cubism was the tool best suited to shattering the status quo. And Yektai in the diaspora, a contemporary of Ziapour, unconcerned with local specificity or a national language but engaged in a formalist project, found his home within modernism as it was defined in New York, in Abstract Expressionism, a movement that was of his time but foreign to the compatriots he had left behind. It was not until the 1960s that another kind of modernism surfaced inside the country that was no longer borrowed but was, rather, synchronized with the pulse of Iranian culture: the Saqqakhaneh, the subject of the next chapter.

Chapter Two
Saqqakhaneh Revisited

The Saqqakhaneh movement, until recently unknown to the outside world, is gradually entering the consciousness of global art history. In 2015, for instance, the Tate Modern exhibition *The World Goes Pop* included works by Parviz Tanavoli to demonstrate the worldwide phenomenon of popular culture in art beyond the mostly American and British origins of Pop art.[1] Emerging in the early 1960s, the Saqqakhaneh marked a watershed in Iranian art history. It arrived after more than half a century of academicism and a decade or two of experimentation with various models of European modernism. A young generation of artists (all men), born in the 1930s, came along and invented their own aesthetic language with vocabularies scavenged from local culture and new visions of what modern art could be. Neither an imitation of Western idioms and issues (e.g. Pop art's focus on consumerism) nor a regurgitation of native aesthetic traditions, Saqqakhaneh proposed a way out of the impasse of an East–West binary, which, plaguing discourse about art in Iran, had resulted in the call for 'authenticity.' It was an empowering trajectory of self-discovery – not merely a national project but a pursuit of personal visions. In order to assess the movement objectively, we must look past the demonization meted out to its exponents for being successful under the Pahlavi regime (and all that entailed) while at the same time acknowledging their failures when they indulged in shallow decoration

and banal ethnic expressions, although our discussion will not focus on these. To reach a fuller understanding of this short-lived movement and its contributions, we must separate it from developments contingent on calligraphy and coffee-house painting (a conflation that risks leading to broad generalizations),[2] scrutinize our sources, compare and contrast the movement's agenda with the various prevalent ideologies of the time, and review its history of patronage and exhibition. This examination begins with the cultural context that gave rise to the movement and entails sifting through the misleading labels that have been attached to it from its very inception.

By the late 1950s, rescue from the stifling models of foreign 'isms' had become a necessity for Iranian artists. An urge to consolidate a slippery sense of national identity emerged in the new aesthetic tendency, which was combined with a pronounced sense of class consciousness. The movement was identified and baptized 'Saqqakhaneh' by the prominent critic Karim Emami (1930–2005) in a review published on June 5, 1963, in the *Kayhan International* – the main English-language newspaper of the time.[3] It has never been acknowledged that in 1963, in the same month as Emami's article (Tir 1342), Cyrus Zoka published a review of an exhibition by Faramarz Pilaram at the Talar-e Farhang, in Tehran, in which he too used the term *saqqakhaneh*. While recognizing Hossein Zenderoudi's pioneering position, he praised Pilaram for evoking the atmosphere of *saqqakhanehs* and shrines, which, he maintained, resonate with the 'national conscience.'[4] Zoka contrasted these artists with those who, under the spell of the West, were drowning in a whirlpool of imitation.[5] It was, however, Emami and not Zoka who named the movement the 'Saqqakhaneh school.' Emami wrote his review on the occasion of a one-day preview at Tehran's Gilgamesh Gallery – owned by the Christian Assyrian–Iranian artist Hannibal Alkhas – of works by ten artists selected for exhibition abroad. He singled out 'four youngsters who are riding high on the crest of Iranian painting's latest and strongest trend: Zenderoudi (b. 1937 and not yet known as Charles-Hossein), Pilaram (1937–1982), Mansour Ghandriz (1936–1966), and Behzad Golpaygani (1938–1985).' He added Nasser Ovissi (b. 1934; Oveisi, Ovisi, and Oveysi are alternate spellings) and Parviz Tanavoli (b. 1937) as 'being akin to this group.'[6] Which artists were considered to belong to this movement was never a fixed matter; it varied with each author. For instance, Golpaygani almost vanished from Iranian art history, even from Emami's subsequent writings.[7] On the occasion of the 1977 exhibition at the Tehran Museum of Contemporary Art (TMOCA) that canonized the movement, in an essay entitled 'Saqqakkhaneh School Revisited' Emami revised his original list, expanding it to include Massoud Arabshahi (b. 1935), Sadegh Tabrizi

8. Faramarz Pilaram
Laminations (Les Lames), 1962
Gouache, metallic paint and stamped ink
on paper, 197.7 x 82.7 cm (77 ⅞ x 32 ⅝")
The Museum of Modern Art, New York,
Elizabeth Bliss Parkinson Fund, 1962

(1938–2018), and Jazeh Tabatabai (1931–2008).[8] Saqqakhaneh, however, was not a school, a term that refers to a deliberate coming together of like-minded artists with a manifesto or a programmatic goal. Instead, it was a spontaneous movement that became evident at the third Tehran Biennial, in 1962.

Pilaram and Zenderoudi's submissions to this Biennial announced a distinctively new direction in Iranian modern art, away from generic modernisms imported from the West (fig 8).[9] In their format – flat images with a border – as well as their inclusion of writing and use of paper as medium, they reveal affinities with Islamic manuscripts, but the unprecedented large scale betrays a consenting nod to Western art, digested but not copied. The iconography, such as the hand of Hazrat-e Abbas (see below) and the use of numerological tables and protective prayers, was drastically new and intrinsic to the movement, but, in the case of *K+L+32+H+4. Mon père et moi (My Father and I)*, regrettably not authorized to be illustrated here,[10] the mixing of humour and irreverence into a personal narrative with sexual and astrological dimensions is vintage Zenderoudi.[11] The artist stands stiffly on the left of an X-rated scene performed by mechanomorphic creatures, perhaps surrogate parents, as the title seems to suggest, just above footprints of the type traditionally understood as traces of revered imams and just below the constellation that presides over the scene. Zenderoudi mixes the sacred and the unholy. A year before he executed this drawing he had moved to France, where he was exposed to the concept of aesthetic individuality being a revered value. It is often forgotten that he is a diasporic artist: an Iranian expat, a French *émigré*. The artist's family goes further: they distance him from his origins and prefer to frame him as a French or international artist.[12] But in this work Zenderoudi steered clear of the European perspectival tradition and overloaded the flat surface with markings inspired from augury, numerology, divination, popular objects and prints, to which he added his own coded signs. The overload of markings concealed the salacious graphic imagery and kept the cryptic narrative, fabricated around a private mythology, so close to the threshold of illegibility that it was possible for the work to be entered into the Tehran Biennial and, eventually, the Venice Biennale, where Alfred H. Barr, Jr saw it and acquired it for the Museum of Modern Art.

That same year, a rant against Westernization by Jalal Al-e Ahmad (1923–1969) was published under the title *Gharbzadegi*, or 'Westoxication,' a term invented by the philosopher Ahmad Fardid (1910–1994) but popularized by Al-e Ahmad.[13] Al-e Ahmad had been a member of the Marxist Tudeh Party during the 1940s and subsequently an activist in favour of Prime Minister Mossadegh's campaign to nationalize the oil industry. After the 1953 coup, Mehrzad Boroujerdi

writes, he 'severed all his party ties and concentrated more on his literary interests as a teacher, belletrist, translator, and ethnographer while remaining an independent political activist.'[14] The importance of his *Gharbzadegi* was summarized in 1969 by the literary critic and activist Reza Baraheni:

> Al-e Ahmad's *Gharbzadegi* [...] has the same significance in determining the duty of colonized nations vis-à-vis colonialist nations that the Manifesto of Marx and Engels had in defining the responsibility of the proletariat vis-à-vis capitalism and the bourgeoisie, and that Franz Fanon's *The Wretched of the Earth* had in defining the role of African nations vis-à-vis foreign colonialists. Al-e Ahmad's *Gharbzadegi* is the first Eastern essay to make clear the situation of the East vis-à-vis the West – the colonialist West – and it may be the first Iranian essay to have social value on a world level.[15]

Boroujerdi, who quotes this statement in his book on Iranian intellectuals and the West, adds that '*Gharbzadegi* enunciated a nativistic alternative to the universalism of the Iranian Left [... It] articulated a Third-Worldist discourse very much skeptical of what the West had to offer [...] and called for an awakening and resistance to the hegemony of an alien culture that increasingly dominated the intellectual, social, political, and economic landscape of Iranian society.'[16]

Tanavoli recounts that in the 1950s, before he left Iran to study in Italy, Al-e Ahmad was his instructor in literature at the Honarestan-e Honarha-ye Ziba (frequented by future Saqqakhaneh artists), but he does not credit him as an intellectual influence.[17] Al-e Ahmad himself had come under the Western spell – its most serious manifestation being a fascination with French *engagé* writers such as Jean-Paul Sartre and Albert Camus, whose works he translated into Persian.

In the Tehran art circles of the 1960s some critics had already upheld the merits of national art over Western tendencies – topics that were regularly discussed in interviews, critical writings, and seminars.[18] Al-e Ahmad did not have a direct influence on the Saqqakhaneh artists – blind imitation of the West and resistance to it were already common topics in the critical discourse and causes for tension in the artistic community – but he did diagnose and articulate an epidemic that defined the Zeitgeist. Of course, the desire to protect an Iranian identity had been a perennial obsession. Abbas Amanat has traced the narrative of Self and Other in Iran from pre-Zoroastrian times to the present: the West is the latecomer in a string of 'others' stretching from *aniran* (non-Iran), Touranian, Macedonian, Turk, Mongol and Arab invaders.[19] These unresolved issues surrounding identity continue to

occupy intellectuals to this day inside the Islamic Republic.[20]

Al-e Ahmad's version of cultural authenticity, it has been argued by Ali Mirsepassi, was 'neither local nor authentic [but] grounded in some construction of the local.'[21] The question remains to be asked: was the Saqqakhaneh closer to Al-e Ahmad's position, rejecting the West as a monolith and proposing Islam as the answer, or to the regime's idea of a composite identity, as ancient as the pre-Islamic past and as new as the West? For the Saqqakhaneh artists the answer varies from artist to artist, and nuance is the key. But the one generalization that applies to all is that Saqqakhaneh artists did not harbour any antipathy towards the West, from which they absorbed a great deal. Did their malleability bring them closer to the Pahlavis' fascination with the West? Saqqakhaneh artists cannot be accused of Westoxication (read: being derivative), but they did have to operate within a Westoxicated infrastructure. The very existence of the Tehran Biennials was inextricably intertwined with the identity issues raised by the valorization of the West promoted by the government. According to the mission statement issued by the Fine Arts Ministry on the occasion of the first Tehran Biennial (1958), directed by the artist Marcos Grigorian and reserved for 'modernists' only, the purpose of the Biennial was the promotion of national art coupled with a presence on the global scene – a selection of the strongest works was to be sent to the Venice Biennale.[22]

While the goals of the Venice Biennale and Western legitimization motivated the arts administrators, the Iranian 'avant-garde,' neither imitators of Western paradigms nor rabidly anti-Western, was searching for inspiration inside Iran, in places previously untapped. Ghandriz, Pilaram, Tanavoli and Zenderoudi were drawing from an iconography associated with the lower echelons of society, who were more in tune with religious rituals and liable to circulate around *saqqakhanehs*. In popular Shi'ism, *saqqakhanehs,* often-modest water dispensers found in back alleys, bazaars, and in the vicinity of shrines, have associations reaching back to an episode in the battle of Karbala in 680 – a battle of succession pitting the grandson of the Prophet Mohammad against the Umayyad caliph – in which Hosein, the third Imam, and his followers, including women and children, were cut off from the Euphrates river, the source of their drinking water. Thus, providing free drinking water is not only a charitable deed; it is an act of religious remembrance. *Saqqakhanehs* can vary from small niches, to what look like shopfront façades, to discrete architectural units (fig 9).[23] Their paraphernalia includes a grill, such as those found in shrines (to which strings of cloth and locks may be attached as indicators of vows, pleas, wishes and prayers), candles, calligraphic verses of the Qur'an, portraits of the Karbala martyrs, and stylized

9. Jassem Ghazbanpour
Saqqakhaneh, 2013
Formerly in Hamedan, housed in a building
destroyed during the Iran–Iraq War, currently
in Tehran

representations of the severed hand of Hazrat-e Abbas (fig 10) whose
intention of fetching water to quench the thirst of the Karbala martyrs
was brutally aborted.[24]

The assertion of the self was broader than references to
the culture of the working class. It was receptive to the pluralistic
nature of Iranian history, past and present – Zoroastrian, Islamic,

27

10. Faramarz Pilaram
Mosques of Isfahan (B), 1962
Ink, watercolour, gold and silver paint on
paper, 116.2 x 88.3 cm (45¾ x 34¾")
Grey Art Gallery, New York University Art
Collection. Gift of Abby Weed Grey, 1975

secular, Western: all these ingredients inform the works in different proportions. For instance, Arabshahi navigated within the Zoroastrian sphere of signs and mythology; Tanavoli's dual vision conflated the ancient with the present popular culture; Pilaram combined the high (Islamic architecture and manuscripts) with the 'low' (*saqqakhaneh* motifs); lovers, a theme straddling the secular and the spiritual, was taken up by Ovissi and Tabrizi; Zenderoudi remained within the orbit of proletarian visual culture while giving expression to personal narratives. It should be noted that, traditionally speaking, the concept of 'high' and 'low' is not pertinent to Iranian or Islamic art. The status of 'Fine Arts' (the Beaux-Arts hierarchy of subject matter executed in the media of oil on canvas or bronze and marble) privileged over minor arts is foreign to artists who, in the West, would be esteemed as craftsmen engaged in minor or decorative arts. According to this viewpoint 'Islamic art' is bereft of Fine Arts. As relayed to me by Bijan Saffari (a multitalented intellectual who, among his various activities, went on to become a key figure in the development of avant-garde theatre in Iran), who taught the Saqqakhaneh artists at the Art Institute for Decorative Arts, the curriculum deliberately stressed the teaching of decorative arts (e.g. graphic design, book illustration, fabric design). The rationale was to provide students with certain skills enabling them to make a living. It may be questioned if a pedagogy that legitimized decorative arts in modern times might have influenced the production of stylized imagery so widespread in the works of Saqqakhaneh artists.

Given the pluralism of the movement, the term Saqqakhaneh is a misnomer, as most such appellations are. Strictly speaking, the kind of Shi'i iconography that decorates a *saqqakhaneh* is present only in some of the early works (from 1961 to around 1963) of Zenderoudi, Ghandriz (who died young in a car accident), early Pilaram and, sporadically, Tanavoli. By the mid 1960s, for instance, Zenderoudi and Pilaram were turning to a different source, the tradition of calligraphy – which need not be tethered to or conflated with *saqqakhaneh* just because written prayers or invocations, in one form or another, are sometimes to be found on these water sources. These artists, along with non-Iranian artists from the Middle East and North Africa, were turning to a broader tradition rooted in Islamic art, termed 'calligraphic modernism' by Iftikhar Dadi.[25]

If used in the strictest sense, the term Saqqakhaneh would also preclude certain early works by Tabatabai and Zenderoudi that refer to yet another separate aesthetic: so-called coffee-house paintings. Still made today, this is a type of folk art executed by artists without institutional training. Their subject matter derives either from religious episodes, such as the Karbala tragedy – a Shi'ite iconography they share with Saqqakhaneh – or literary sources, such as Ferdowsi's

national epic, the *Shahnameh* (Book of Kings). Painted on fabric or linen that could be unrolled (hence the term *pardeh*, or curtain), the works, sometimes compartmentalized almost like graphic novels, would accompany the recounting of the stories in declamatory performances.[26] The earliest modernist revision of this tradition I have found in my research is a 1957 tempera on rolled canvas by Tabatabai, which was inaccurately, in my view, included in the *Saqqakhaneh* exhibition at TMOCA in 1977.[27] Another example, Zenderoudi's linocut *Who Is This Hossein The World Is Crazy About?*, stands out as an inventive revision of coffee-house painting. Marcos Grigorian should be credited with the re-evaluation of coffee-house painting (he called their creators 'troubadour painters'[28]) and the printing techniques, including linocut, that he taught in the 1950s both in his Esthétique gallery and at the Honarestan. Zenderoudi was among his students.

With his typical humour, though atypical for traditional works with a religious content, Zenderoudi's title refers by name not merely to the Imam Hosein but to the artist too. This undated linocut on canvas was created in an edition of two and exhibited in 1960. One of the prints has found a home at the British Museum and, though not illustrated in the catalogue, it was shown in the exhibition *Iran Modern* at the Asia Society in New York in 2013. Uncensored in spite of the nudity of its martyrs, a version was included in *Religious Inspiration in Iranian Art*, an exhibition held in 1978 at the Negarestan Museum in Tehran, guest curated by Laleh Bakhtiar.[29] In the catalogue it is dated *c*.1960. That same date appears in the artist's retrospective catalogue at TMOCA held in 2001.[30] In 2011 one of the linocuts was acquired by the British Museum whose website gives the date as '1958 (or 1959).' The black-and-white palette, the stark simplification, the lack of modelling (possibly an effect of the linocut technique), the humour and the irreverence endow Zenderoudi's work with a modernity absent in coffee-house paintings.

It would be more accurate to consider the coffee-house-inspired linocuts as pre-Saqqakhaneh. While they share with Saqqakhaneh an interest in religious subject matter, they rely on a well-established genre of folk art painting, distinct from the new iconography that popped up a year or two later. The appearance of motifs related to *saqqakhaneh* and the style inspired by the popular culture ephemera unearthed in south Tehran is not recorded anywhere in the literature or in art before the 1962 Tehran Biennial.

Zenderoudi's work became Saqqakhaneh proper when he turned towards new sources: the mundane visual vernacular he picked up in areas populated by the working class and in bazaars, street culture and its ambulant entertainers,[31] religious prints, amulets, apotropaic charms, talismanic artefacts, astrolabes, props used in mourning processions, carved and printed prayers, zodiac signs, and more.[32]

11. Print with religious and talismanic prayers, mid-twentieth century
23 x 18 cm (9 x 7 ⅛")
Collection of Parviz Tanavoli

With mostly ballpoint pen and some watercolour, he transplanted this repertory onto the unprestigious medium of paper, sometimes even using common wrapping paper.

The application of the label Saqqakhaneh to artists such as Arabshahi, whose interest revolved around ancient Mesopotamian and Iranian art and religion, and Tanavoli, whose use of *saqqakhaneh* motifs was sporadic, is convenient but equally inaccurate in a literal sense. Others, such as Tabrizi and Ovissi, who found their inspiration mostly in the themes of lovers and riders abounding in tiles, glassworks and even paintings of various periods from the Seljuks to the Qajar period, have also been attached to the movement. Their interpretation of such themes appears to be secular. What binds all the so-called Saqqakhaneh artists together is the turn of their gaze in the direction of the local: local art, artefacts, popular culture and informal language. The latter, especially in Zenderoudi's ordinary (non-calligraphic) handwriting, benefits from his intimacy with the culture of the working class. Zenderoudi freely used infantile and unrefined colloquialisms in his texts.[33] Tanavoli's treatment (discussed in the next chapter) is more complex. It began with an unremarkable handwritten script but developed into a highly elaborate new language, both modern and ancient in appearance, with an alphabet entirely of his own invention.

Western motifs and ideas, however, were not banished but rather seamlessly incorporated into the Iranian panoply. Ghandriz, for instance frequently used motifs taken from metal standards carried in religious processions (such as the hand of Hazrat-e Abbas) and is thus hailed as one of the quintessential Saqqakhaneh artists; but his repertoire includes not only Shi'i references but also forms derived from pre-Islamic Luristan bronzes and a regimen of signs derived from Paul Klee and Joan Miró (fig 12).[34] Tanavoli adapted in his own work the cheerful gaze of Pop artists towards the common and the banal. Zenderoudi adopted the style of religious popular prints (fig 11) which are usually small in scale, enlarged it and instilled it with the personal, an approach to art that was not local. Culturally specific but not culturally circumscribed, the Saqqakhaneh artists enriched their expression with strategies and references they learned from art in the West.

Some authors have suggested that the term Saqqakhaneh be replaced with 'neo-traditionalism'.[35] While this new term would accommodate the pluralism within the movement, from the use of

12. Mansour Ghandriz
Untitled, 1962
Coloured chalk and crayon on paper,
100 x 76 cm (39 ⅜ x 29 ¹⁵⁄₁₆")
Collection of Shireen and Reza Khazeni

ancient Iranian sources to Qajar motifs, the pool of artists would be extended to include so many tendencies, inspired by such a wide range of traditions, that it would become meaninglessly diluted. Above all, the novelty of Saqqakhaneh would be diminished. Its exponents were the first to introduce into Iranian fine arts a vernacular vocabulary in circulation in the less affluent parts of the metropolis and its outskirts, a visual language and culture belonging to the proletariat – a political baggage too little recognized. Scouring that aspect of popular culture for inspiration or material was not an aesthetic 'tradition' to which the Saqqakhaneh artists were returning. On the contrary, they were treading an unbeaten path in a direction that was 'homely' yet 'exotic'[36] because unfamiliar in the fine arts. The crudeness of the works' execution and their humble materials reinforce the sense of modest origin that emanates from them.

The movement, in the hands of Zenderoudi, himself a child of the working class and one of its most creative exponents, gave voice to habits, rituals, religious practices and imagery found in a disregarded facet of Iranian culture, in the 'dispossessed' sections of society, and not within the lingua franca discourse of the westernized elite. Contradicting the gravitas intrinsic to traditional representations of religious subject matter and shedding the melodramatic tone of religious rituals and performances, Zenderoudi instills into his work the notes of humour that characterize not just Western Pop art but also Iranian popular culture.

In addition to Saqqakhaneh and neo-traditionalism, 'Spiritual Pop' has been suggested by Kamran Diba as a name for the movement.[37] It resonates insofar as it incorporates a cross-cultural sense of parallel developments in global art, highlighting the diversity of popular cultures that infiltrated the fine arts in the 1960s, but it, too, is problematic in that the representation of relics of religion does not amount to a spiritual quest. The movement was by no means about the glorification of Shi'ism, not even about spirituality in general. Looking for irreverence is to find it in nooks and crannies that it may not always be prudent to discuss. Zenderoudi was the only artist in the group openly drawn to religion, albeit in its cultlike cryptic form, but even he, at times, would derail into irreverence – not to say subversion – as when depicting naked martyrs or using nonsensical words or nursery rhymes in close proximity to religious references and even, at times, words that border on profanity. Mischief rather than subversion of religion appears to characterize Zenderoudi's sensibility. Humour, a trait shared by many Iranian artists but rarely recognized, is playfully apparent in the early works of Zenderoudi and Tanavoli, who is discussed in the next chapter.

Patronage and exhibitions: the politics of representation

Saqqakhaneh received as much attention as other veins of modern art, including the support it was offered by the official authorities, especially by Queen Farah Pahlavi. Nevertheless, it is often alleged that the movement is somehow tainted politically. This critically acclaimed movement emerged at a time when the public was barely beginning to be sensitized to the importance of modern art, Saqqakhaneh or otherwise. Talking of the 1960s, it would be premature to speak of 'collectors.' Buyers of art were mostly fellow artists, intellectuals and friends. Later, especially in the 1970s, when the Saqqakhaneh evolved in directions that would make the term no longer strictly applicable, the circle of collectors widened to eventually include the Behshahr Group, a company belonging to the Ladjevardi family. According

33

to its website, by 1977 this thriving private company had amassed 132 paintings for its headquarters and had commissioned murals and sculpture by artists formerly associated with the Saqqakhaneh, including Arabshahi, Tanavoli, and Zenderoudi.[38] Before the 1979 Revolution, the Behshahr collection was the largest private collection of Iranian modern art inside the country. As for TMOCA's collection, which was not formed before the mid 1970s, to this day, sadly, it remains limited in the representation of Saqqakhaneh; the museum's holdings of American Pop art, a movement contemporaneous with Saqqakhaneh, is far richer.

Early on, the only person showing interest in Saqqakhaneh who could be properly called a collector was, paradoxically, an American: Abby Weed Grey of Minnesota (1902–1983), who from 1960 to 1973 travelled all over Asia and the Middle East to promote cross-cultural exchange. She arrived in Tehran in 1960 just in time for the second Biennial.[39] Grey's collection would grow to include around 200 works of Iranian modern art, including early Saqqakhaneh works on paper, especially by Zenderoudi[40] and Pilaram, which perfectly suited her predilection for this medium. Of all the Saqqakhaneh artists, however, it was Tanavoli who found in her not only a patron but a mentor. She invited him to Minneapolis, first as a visiting artist at the Minneapolis College of Art and Design and eventually as a teacher. They met in 1961 on Grey's second visit to Tehran, the last stop of a travelling exhibition of her Minnesota Art Portfolio. The meeting took place in an exhibition which, in her own words, 'had come about in an unconventional way. Six or seven artists whose work was considered too innovative to be supported by the Iranian Fine Arts Administration had received permission to hang a show in the foyer of a new bank building,' the Saderat Bank.[41] Grey was instrumental in giving the American public its first encounter with Iranian contemporary art. Having organized 'the first exhibition of contemporary work by Americans to be shown in the Middle East'[42] (a portfolio of prints exhibited in Tehran at the Iran–America Society in June 1961), the following year, in 1962, she helped bring Iranian art to the United States.[43] With her assistance, an exhibition was organized by the 'International Relations and Publications Department of the Fine Arts Organization with the cooperation of the Iran–America Society and the American Friends of the Middle East' to travel to various American cities. Tanavoli oversaw the project. Of the fourteen artists in the show, four (Ghandriz, Ovissi, Zenderoudi and Tanavoli himself) were associated with the Saqqakhaneh.

No collection of Saqqakhaneh rivalled Grey's, which until very recently was the largest collection of Iranian modern art outside Iran. In 1974 she donated it to New York University, establishing the Grey Art

Gallery and Study Center, where the collection was exhibited in 1975. A selection from this collection, with particular emphasis on Saqqakhaneh, was presented in the same location in 2002, in *Between Word and Image*, an exhibition co-curated by this author and Lynn Gumpert.[44] This show, albeit modest in scale, and the more ambitious representations of Chinese and African contemporary art in New York around the same time, signalled the dawning of a post-colonial awareness that was beginning to seep into art exhibitions in the United States.[45]

Returning to the 1960s and 70s, the first exhibition at an institutional venue to include (though not focus on) Saqqakhaneh artists was held at the Iran–America Society in Tehran in 1965.[46] The point of this exhibition and those that travelled abroad was to present the diversity of modern movements in Iran and not to highlight Saqqakhaneh.

It is undeniable that travelling exhibitions at venues outside Iran were initiated by officials in Tehran (the Ministry of Fine Arts and Culture, first, and then the Private Secretariat of the Queen) and by one Iranian in New York: Ehsan Yarshater, director of the Center for Iranian Studies at Columbia University, who organized the first major exhibition of Iranian contemporary modern art outside Iran, at Columbia University in 1968. Again, Saqqakhaneh artists represented one of the many showcased tendencies.[47]

Before this exhibition, the Ministry of Fine Arts and Culture (which also organized the Tehran Biennials from 1958 to 1966) appointed curators ('commissaires') – first Akbar Tadjvidi and then Marcos Grigorian – to send contemporary art, including works by artists associated with Saqqakhaneh, to international biennials, such as those in Paris (1961), Venice (1962), and São Paulo (1963). In addition to the work by Zenderoudi, Alfred H. Barr, Jr acquired a work by Pilaram for MoMA from the Venice Biennale in 1962.[48]

In Paris, in the 1970s, the French critic Michel Tapié directed the Galerie Cyrus at the Maison de l'Iran (1969–2005). The institution was a public relations operation, both commercial and cultural. Its director was Mehdi Bouchehri, who had married the Shah's twin sister. Tapié's interest in Art Autre had led him to promote the Japanese Gutai group of artists and the Iranians in Europe. Pilaram, Tanavoli, and Zenderoudi, all with a Saqqakhaneh past, were among the artists he featured in the gallery. Tapié also introduced Zenderoudi to the Stadler Gallery, where the Lettristes were exhibiting.[49]

In the 1970s, the Private Secretariat of the Queen also generated travelling exhibitions of works by the artists associated with Saqqakhaneh, mixed with other modernists. Married to the Shah in 1959, Queen Farah Pahlavi took on the role of patron of arts, and the effects of her patronage reverberated deeply in contemporary art in Iran. Records show her attending an exhibition opening at the Fine Arts

School of Tehran as early as 1960, where Zenderoudi's *Who Is This Hossein the Word Is Crazy About?* was on view.[50] In 1961 she visited Tanavoli's Atelier Kaboud, which would become the epicentre of Saqqakhaneh activities.[51] By recognizing the value of modern art, she set in motion the mechanism that eventually resulted in the creation of TMOCA in 1977.

TMOCA was too new to have planned travelling exhibitions in this period, but it did lend a few Western works to American museums.[52] In the mid 1970s, the Queen's secretariat organized an exhibition that went to Europe. It consisted of some forty contemporary works (including ones by Arabshahi, Ghandriz, Pilaram, Zenderoudi, Tanavoli, and Tabatabai) along with twenty-five coffee-house paintings and thirty-five Qajar paintings. The exhibition travelled to the Salon d'Automne in Paris (17 October–19 November 1973), the Musée des Beaux Arts in Brussels (4–30 December 1973), the Musée d'Art Moderne in Belgrade (23 May–10 June 1974), and, finally, two venues in Turkey: in Ankara and Istanbul (both in 1974).[53] Two more exhibitions were initiated by the Secretariat to launch contemporary Iranian artists abroad: in 1976 the Basel International Art Fair, which included six Saqqakhaneh works,[54] and the International Art Fair in Washington, DC in 1977, which included none. In these exhibitions the agenda was always to promote the totality of Iranian art and its pluralism.

Such initiatives are today mythologized by some contemporary Iranian artists as commendable models instituted by the Queen to launch Iranian art abroad. In reality, when government-generated exhibitions, organized by amateurs and bureaucrats – whether before or after the Revolution – lack a solid curatorial point of view, they are doomed to failure. The clear evidence is that, despite all these shows, before the Revolution the only Iranian artists known (in other words collected, discussed and exhibited by museums) outside Iran were Siah Armajani, an artist of the diaspora – ironically, unknown to Iranians in Iran until very recently – and, to a lesser extent, Yektai. Almost certainly this is because both artists were living in the US, and their work could be easily integrated into narratives of American art.

Kamran Diba, architect, painter, collector, and first cousin of the Queen, was the first director of TMOCA, appointed in 1976 and in place until the autumn of 1978,[55] when the Revolution picked up momentum. Building on the earlier substantial efforts undertaken by a number of individuals, in particular Donna Stein working at the Private Secretariat, Diba veered the collection towards a greater representation of contemporary rather than historical modern art. He was another supporter of the Saqqakhaneh and a collector of their works.[56] In 1966, along with Tanavoli and Roxana Saba, he opened a club in Tehran, Rasht 29, which became a hub for these artists and even an exhibition site. As the director of TMOCA, he initiated

13. Cover of the Tehran Museum of Contemporary Art's *Saqqakhaneh* exhibition catalogue, October 1977

the canonical exhibition *Saqqakhaneh* in 1977; he suggested the idea and Nahid Mahdavi organized the show (fig 13).[57]

In the 1980s and 90s, neither inside Iran nor outside do we encounter initiatives to present Iranian modern art. Rose Issa's *Iranian Contemporary Art*, mounted in 2001 at the Barbican Art Galleries in London, broke the ice.[58] The selected works dated from the 1960s to the 1990s and included a few Saqqakhaneh-influenced works by Ghandriz, Tanavoli and Zenderoudi.

In the new millennium, *Between Word and Image*, the 2002 Grey Art Gallery show, was the first exhibition of Iranian modern art in the US, one that featured highlights of the Saqqakhaneh. It was followed in 2013 by *Iran Modern*, the first major international loan exhibition and the first to acknowledge the politically critical aspect of artists associated with Saqqakhaneh.[59] Again, both exhibitions underscored the diversity of Iranian modern art.

Since the emergence of Saqqakhaneh in the early 1960s, only two exhibitions have been exclusively devoted to the movement, both at TMOCA. In addition to the 1977 exhibition (mentioned above) organized under the direction of Kamran Diba, *A Retrospective Exhibition of Works of Saqqakhana Movement*, guest curated by Mehdi Hosseini (painter and university professor), opened in summer of 2013.[60]

The artists associated with this movement were swept aside by the Revolution. Figuration, derived either from Mexican mural painting, socialist realism, or a grotesque vein of Surrealism, replaced the vocabulary often suffused with Shi'ism that, ironically, had been dug up by the Saqqakhaneh artists from the culture of the very dispossessed who were championed by the Revolution. It took almost two decades for their contributions to be recognized again by Iranian officials. The reformist government of President Mohammad Khatami (1997–2005) and his appointed director of TMOCA, Alireza Sami-Azar, honoured the Saqqakhaneh artists with individual retrospectives, such as those organized first for Zenderoudi (2001), next for Arabshahi (2001), and finally for Tanavoli (2003).[61]

It may be worth adding that in 1987, in preparation for an article that was never published, I met in Tehran with a number of artists, known as the 'painters of the Revolution' (Kazem Chalipa (b. 1957), Hosein Khosrojerdi (b. 1957), and Iradj Eskandari (b. 1956) to name

a few) who were working at the time with the Art Bureau of Islamic Propagation, locally referred to as the *howzeh*. I inquired why they were adopting a Western-derived language and not building on the Iranian/Islamic foundations of developments before the Revolution. Their justification relied on the notion that Islam does not recognize national boundaries but rather espouses the idea of an Islamic *ommat* or community. Even if the style is derived from the West, they said, as long as the proper models or archetypes of the Islamic man and woman are represented, figuration is an appropriate conduit for the propagation of Islamic messages.

Unedited History: Iran 1960–2014, an exhibition held in Paris in 2014, with Catherine David as its lead curator (assisted by a number of young, intelligent Iranian curators, scholars and artists), was noteworthy for the total absence of Saqqakhaneh.[62] Why begin an exhibition in 1960 if the hallmark of that decade is conspicuously edited out? *Iran Modern*, which took place a year before the Paris exhibition, had put to rest accusations that Saqqakhaneh was merely frivolous or decorative ethnic art. Therefore, questions remain. Why would what was in my reading a Marxist project instead highlight politically neutral works by Behjat Sadr and Bahman Mohassess? The deliberate erasure is regrettable for missing Saqqakhaneh's political complexity, its emancipatory effect, its democratic impulse, and its ingenious response to an internalized cultural colonialism. In other words, the exhibition ignored artists who tapped into the culture of a neglected class and countered the plague of Westoxication.

Plausibly, a desire to disregard artists perceived to have been co-opted by the Queen might have been the motivation – in which case all modern art of that period should be ostracized. Maybe the currently flourishing market for these artists' works (certainly not in existence in the early 1960s) appeared in the eyes of the organizers as complicity with the commodity-based capitalist system. Regarding the first concern, Bahman Mohassess, profusely represented in the Paris exhibition, was just as 'contaminated' by official support as any other. He received a number of commissions from the state – for instance, a public statue in front of Tehran's City Theater and a sculptural portrait for the royal family.[63] In any case, acceptance of support from the Queen in the form of personal or museum acquisitions, exhibitions, or commissions need not be equated with endorsement of the regime.

As to the second concern, it would be tantamount to projecting today's notion of art as commodity onto a period when the art market in Tehran was in its rudimentary stage. Half a century ago, painting and sculpture were perceived by Iranians as challenging media waiting to be reinvented. These were fertile sites where one could freely exercise one's individuality (often suppressed in rigidly patriarchal societies)

and not targets of criticism. The barely emerging market and galleries, such as the Borghese in Tehran, where Saqqakhaneh works were exhibited, provided a meagre source of income. The conditions that cultivated institutional critique in Europe or Japan were absent in Iran. TMOCA probably did not attract critique on a major scale because its life was too brief under the Pahlavi regime, but also, perhaps, because it fed into sentiments of national pride. Blatant and direct institutional critique arrived forcefully after the 2009 election, when artists began boycotting TMOCA, a phenomenon not acknowledged in the *Unedited History* exhibition. Unlike Kazem Chalipa in the 1980s (profusely represented there), who along with other 'propaganda' artists of the Islamic regime were on the (albeit modest) payroll of the Organization of Islamic Propagation, no Saqqakhaneh artist was ever employed by the Pahlavi regime or was in the service of propagating its dogma.

The Queen's aspiration to construct and promote an Iranian identity, her desire to honour the past and its traditional arts, including her unorthodox, not to say subversive, interest in the art of the Qajar period – an era which had been swept aside by the Pahlavis – was wedded to a belief in the importance of Western-style modernity. Keeping this narrative in mind, in conclusion I provide one more answer to the question of how close the Saqqakhaneh artists were to the regime's ideology: I maintain that, on closer examination, Saqqakhaneh appears to have distanced itself from the Pahlavi agenda, which sought to underplay the culture of the dispossessed and highlight the country's march towards a 'Great Civilization.' Neither xenophobic, like Al-e Ahmad, nor elitist and discriminatory, like the regime's predilection for the pre-Islamic and the modern West, Saqqakhaneh highlighted those undesirable facets of the Iranian identity and culture the elite had disparaged or historical periods it did not favour. At times the movement appears critical even of the culture permeating the proletariat and its blind submission to religion. Such messages hide in the art in allusive references where they shall remain for now. In summary, in spite of its occasional derailments in the direction of excessive decoration, kitsch, and ethnic clichés – excluded from this chapter (and from *Iran Modern*, as well) – Saqqakhaneh remains admirable for its free-spirited adventuring into areas not intrinsic to the Pahlavi regime's narrative, for tapping new sources of inspiration, for the visibility it gave to a maligned segment of popular culture, for its distance from xenophobic pronouncements by the local conservative intelligentsia, for its formal inventiveness, for its implicit criticality, and for the idiosyncratic solutions it found to the quagmire of identity politics.

Chapter Three
Tanavoli in Context

In 1959, when Parviz Tanavoli (b. 1937) returned from his studies in Italy, he laboured under a double challenge. In navigating the issue of Westoxication discussed in the previous chapter he took on the task of creating, almost from scratch, a vocabulary of modern sculpture for Iran. Of the prominent sculptors of the time, Bahman Mohassess (1931–2010) – also a painter trained in Italy – was unconcerned with an identity-inflected or national idiom. He borrowed his conservative figurative language from the European masters. In the United States, Siah Armajani (b. 1939), the other illustrious sculptor – better known in Minneapolis, New York, and even in Europe than in Tehran – evolved his sculptural practice entirely in the diaspora. Abby Weed Grey of Minnesota collected his work in the 1960s[1] and the 1970 exhibition *Information* at the Museum of Modern Art established him as a conceptual artist.[2] The third major Iranian sculptor (also a painter) of the pre-revolutionary period, Mohsen Vaziri Moghaddam (1924–2018), only began creating his practically unprecedented interactive sculpture in 1970.[3] In the late 1950s and early 1960s, therefore, Tanavoli was essentially alone in his line of struggle in Tehran.[4]

Examining Tanavoli's contribution to a new sculptural language, his ambivalent connection to the Saqqakhaneh movement and his layered attitude towards history and authority both sacred and secular reveals a more complex position than has been so far acknowledged.

In addition, a discussion of Tanavoli inevitably draws attention to his activities as a collector and a scholar of the visual arts, both past and present – areas of practice that have enriched the iconography of his art and informed his readers about new subjects, such as locks, keys, and kohl holders, not to mention a range of unconventional figurative and abstract minimalist rugs and textiles.[5]

Tanavoli and Farhad: the mythical context

The proscription against three-dimensional figural forms after the advent of Islam in the seventh century stifled the development of sculpture in Iran.[6] Given such a vacuum, it is no surprise that Tanavoli has had to fabricate an aesthetic lineage for himself. He has done so by looking back to the ancient era, to the mythical mountain carver Farhad, who, according to legends developed in the literature, had the audacity to fall in love with Shirin, an Armenian princess pursued by none other than the Sassanian king.[7] Tanavoli uses this genealogical construct to explore his aesthetic affiliation with ancient times and also hint at class empathy, identifying with a commoner who was also a sculptor. The legend of Farhad and Shirin derives from various Persian literary sources postdating the Arab invasion, sources such as the *Shahnameh* (Book of Kings), the national epic by the tenth-century poet Ferdowsi, and *Khosrow and Shirin*, a romance by the twelfth-century poet Nezami Ganjavi (1140/41–1203).

Both the ancient period, from the Achaemenid to the Sassanian dynasties, and the 'Islamic' era, triggered by the Arab conquest of Iran in the seventh century, inform Tanavoli's consciousness of a traumatic history, still divisive on account of ethnicity, religion and politics. The coexistence of these temporalities, eternally present in the Iranian psyche, is semantically and aesthetically encoded in Tanavoli's work. No other artist has underlined the ancient-versus-Islamic dichotomy, the national dualism, as he has. Tanavoli's response to this historical and spiritual heritage, as we will see in this chapter, has been to present it with humour and satire as much as with gravitas and awe.

A new vision for sculpture

Public sculpture in Iran in the late 1950s, when Tanavoli began his career, was academic in style and focused on kings and poets. In his survey of Iranian sculpture, Tanavoli reproduces Antoin Sevruguin's photograph of an equestrian statue of Naser al-Din Shah Qajar which could have been modelled after any generic Western academic-style public sculpture.[8] Such conventional approaches persisted for decades, exemplified in statues by Abolhassan Sadighi (1894–1995) of the poet

Above
14. Abolhassan Sadighi
Statue of Ferdowsi, c. 1960
Ferdowsi Square, Tehran

Above right
15. Parviz Tanavoli
Poet with Locks, 1972
Bronze, 280 x 240 x 105 cm (110 x 94 x 41")
City Theatre, Tehran

Ferdowsi – one version, showing the poet holding the *Shahnameh*, was installed in Tehran in the late 1950s or very early 1960s[9] (fig 14); another version, from the 1960s, was installed at the Villa Borghese in Rome.

Tanavoli's public sculpture *Poet with Locks*, of 1972, drastically transforms the majestic image common to this tradition into something decidedly eccentric: an ambiguously gendered figure wearing a skirt and constructed in a radically new language, still anthropomorphic but composed of elements borrowed from the non-human world, from the repertory of rudimentary locks and keys (fig 15). Standing rigidly and seeming to guard a ceremonial object that is not easily identifiable at first, the statue has as its head an oversized lock, and its garment is studded with more locks (currently holes as, sadly, the locks have been torn away). The poet carries a gigantic key, which Tanavoli has identified as similar to those from the Safavid period, of the sixteenth and seventeenth centuries,[10] which he illustrated in his 1976 publication *Locks from Iran: Pre-Islamic to Twentieth Century*.[11] The bulky muscles of the figure's shoulder, flanking the head, are pierced with several more locks, pointing, perhaps, to the practices of dervishes and mystics, who might impale themselves or pierce their bodies with skewers and locks.[12] Tanavoli has written:

Why a man would submit to have his skin and flesh pierced by metal raises numerous questions whose answers we cannot easily fathom today. For instance, is there any connection between the lock hanging from the tomb [grillwork of a shrine] and the one hanging from the body? By hanging a lock from his body, is man trying to project a living image of the Imam and his tomb? Or is he transferring all the problems and hardships from the tomb on to himself? Is he trying to draw closer to God through penance and hardship?[13]

This text, like much in his oeuvre, reveals Tanavoli's ability to endow a sign with multiple meanings; as, for instance, in his sculpture of the poet, the lock signifies the figure's head but also doubles as a cage and a shrine. This poet figure, with its pronounced muscles, refers also, according to Tanavoli, to the athletic Farhad, the legendary sculptor, and – with its attached and embedded locks – to a penance-seeking mystic or prophet. When asked about his concept, Tanavoli, while acknowledging the layered meaning of the work, identifies the figure as Farhad presenting the key to Shirin, the only person able to open the locks that are confining his existence.[14]

For Tanavoli, prophets, poets, lovers, seekers and the sculptor Farhad have fluid, interchangeable identities. When combined, the poet-prophet-Farhad/sculptor represents, in the final analysis, the artist himself, as a fettered Farhad seeking release and a prophet or messenger of a new aesthetic language, offering a vision of a multilayered narrative of sculpture.

Belying the evocation of emaciated dervishes or ascetic prophets, the sculptor's bulbous forms create a whimsical representation of a plump humanoid displaying the hieratic gravitas of a ceremonial gesture. Tanavoli's rigid human surrogates almost always seem to inhabit a militaristic milieu. Seeming to face an invisible but intimidating authority figure demanding decorum, they mimic or at least recall the official creatures of the Pahlavi era: bombastically pompous, frozen into rigid militaristic poses, and therefore somewhat risible. *Poet with Locks* was commissioned by state officials for the public space in front of Tehran's City Theater in 1972, its meaning(s) remaining a puzzle to the press. As for the public's reaction, Tanavoli explains that, a couple of weeks after the statue was installed, he went to the site to take some pictures and was surprised to see ribbons attached to the statue – ribbons like the ones devotees attach to the grillwork in shrines. The statue had been perceived as an apparition with holy connotations.[15]

Below
16. Emilio Greco
Anna, 1954
Bronze, 63.5 x 21.5 cm (25 x 10½")

Below right
17. Parviz Tanavoli with *Shirin: The Venus of Iran*, a sculpture in reinforced concrete (current whereabouts unknown), and visitors at an exhibition organized by the Bureau of Fine Arts in Tehran, 1959

Beginnings

Before maturing enough to formulate such a personal vocabulary and mythology, Tanavoli pursued his studies first in Tehran, from 1953 to 1956 at the Honarestan-e Honarha-ye Ziba, soon renamed Honarestan-e Honarha-ye Ziba-ye Pesaran (School of Fine Arts for Boys). His teachers included the Cubist painter Jalil Ziapour (1920–1999) and the colonel Reza Riahi (1918–2016); the latter had just returned from Brussels, where (according to Tanavoli) he had been sent by the military authorities to learn how to sculpt so that he could make statues of the king.[16] Tanavoli's serious artistic training, however, began in Italy, first in Carrara (1956–7), where he studied with Ugo Guidi (1912–1977), and then in Milan (1958–9), where Marino Marini (1901–1980) was among his teachers. In Italy he became acquainted with figurative and primitivist works (looking back to Etruscan art, for instance). Emilio Greco (1913–1995) had just left the Accademia di Belle Arti di Carrara as a teacher when Tanavoli arrived, but his influence lingered (fig 16). Tanavoli's very early sculpture, executed in 1960 after his return to Iran, reflects the primitivizing aesthetics he had encountered in Italy combined with the curvacious lines he admired in manuscript paintings by Reza Abbasi (c.1565–1635). Tellingly, he entitled an early nude *Shirin: The Venus of Iran* (1960, fig 17).[17] But the Italian aesthetic idiom and the nude genre could not possibly find a deep resonance in Iran. Tanavoli pivoted towards a different path, formulating his own kind of

primitivism from the local popular vernacular, excavating his own ancient heritage, and substituting keys and locks for naked body parts.

His first attempts at forging a new vision for modern Iranian sculpture took place in Tehran in the early 1960s, as the Saqqakhaneh movement was beginning to brew. Critics were condemning imitations of the West and clamouring for something more Iranian, more 'authentic'—not 'Westoxicated,' to use Al-e Ahmad's terminology. However, Mehrdad Pahlbod, the influential minister of culture and the arts, who had granted Tanavoli a scholarship to study in Italy, 'had expected that after mastering stone carving and returning from Italy, I would sculpt a marble bust of the Shah or one of the great poets. In his mind he had wanted to make of me a minor Michelangelo, an official court sculptor,' Tanavoli has written.[18] Pahlbod, the Shah's 'Westoxicated', progressive brother-in-law, was instead offered a different kind of work. One example is *Farhad and the Deer* (1960, fig 18), a sculpture made of metal scraps found in a junkyard and in the less affluent parts of the city (in the south of Tehran), and in coppersmiths' workshops in the bazaar. Tanavoli placed the sculpture on the balcony of his studio, which also operated as a gallery called Atelier Kaboud;

Above left
18. Parviz Tanavoli and his 1960 scrap metal sculpture, *Farhad and the Deer*, 1960
Destroyed. Original dimensions: 300 x 150 x 60 cm (118 x 59 x 23½")

Above
19. *Darius Fighting the Lion*
Detail from the west entrance to the Palace of Darius the Great, 550–486 BC
Stone. Achaemenid period (550–330 BC)
Persepolis, Iran

the work was visible from the street. This studio would become the exhibition space for the most experimental expressions of the time, especially those of the artist Zenderoudi, and, in the early 1960s, the breeding ground for the Saqqakhaneh movement.[19]

Tanavoli's *Farhad and the Deer* was not inspired by common religious imagery, like the image of the hand of Hazrat-e Abbas that became identified with the Saqqakhaneh. Instead its inspiration came from the Achaemenid bas-relief of *Darius Fighting a Lion* at the Palace of Darius in Persepolis (fig 19); Tanavoli turned frequently to this glorious ancient period. The combination, notable in this work, of the crude and humble (in the materials and technique) with the lofty pre-Islamic past would mark Tanavoli's art for years to come. Here, even at this early stage, the combination conveys a political commentary: an ambitious regime, measuring itself against glorious moments in the past while marching towards modernity, is hampered by the dismal reality of pre-industrial technology. Tanavoli's work expresses an interest in Iran's Achaemenid heritage, which he shares with the regime, but he executes his homage with the tools available to the working classes in southern Tehran. He distanced himself from the classical Western tradition of refined marble sculpture as well as the primitivizing tendencies he had been exposed to in Italy.

Tanavoli and the Saqqakhaneh

Tanavoli has been classified as an artist of the Saqqakhaneh, and, along with Zenderoudi, is considered as one of the exponents of the movement, although Shi'ite motifs entered his art later, and rather sporadically. His own particular use of popular culture, he has written, 'embraces the collective actions of the average people on the street to produce and market their wares, to make a living, and even to rejoice during happy occasions and mourn during sorrowful ones.'[20]

An interest in the low and the humble did surface early on, in a 1964 work Tanavoli sarcastically entitled *Innovation in Art*. This assemblage may not be Saqqakhaneh in a pure sense, for it differs drastically from the works of his colleagues. It is devoid of reference to the motifs that adorn a public water fountain, or *saqqakhaneh*, from which the movement got its name (fig 20). One of the most abject items imaginable in Iranian culture is the *aftabeh*, the equivalent of toilet paper. Islamic hygiene requires washing after using the toilet, and the *aftabeh* is the vessel that holds the water. Placed at the very centre of a composition created from a found medallion rug – cut, painted, and transformed into a prayer rug – the object takes on an emblematic role, evoking the pedestrian Islamic culture of contemporary religious society. Imitating Persian carpets' border decorations, Tanavoli

replaced what is often an innocuous floral or geometric design with a series of candy-coloured *aftabehs*. A sash of pumpkin seeds above the central emblem gives further local flavour. With this satirical statement, Tanavoli turned the spotlight on habits and mores kept under cover in the stride towards modernization, while at the same time commenting, perhaps, on the innovations in art initiated by the Saqqakhaneh, which were closely linked to a visual culture coloured by religion.

It is likely that the assemblage has one more layer of meaning. Tanavoli has said that he created this piece during a difficult period in his personal and professional life.[21] *Innovation in Art* expressed, in a sense, his rebellion against Tehran's parochial art world; at this time he was teaching at Tehran University, an institution antiquated in its pedagogical system, a pseudo-Beaux-Arts method honouring the Western classical tradition. Ali Mohammad Heydarian, a conservative painter who had been a student of Kamal al-Molk , was teaching his students to copy 'busts of Venus and Hercules or, occasionally, a live model,' Tanavoli has written.[22] He himself had just returned to Tehran after three years in the US, where Pop art had unleashed an egalitarian approach to objects. According to Tanavoli, Pop art gave artists the permission to use the banal in their work.[23] He used its strategy as a cry of outrage or, in today's parlance, as a kind of institutional critique, which was, no doubt, perceived as irreverence and transgression. Tehran's Borghese Gallery exhibited *Innovation in Art* for a few days and then asked the artist to remove it from the show. A few days later, the entire exhibition was closed down. The reception had been negative. Karim Emami, the eminent critic – deep down a formalist, appreciative of craft and not conceptual work, and disapproving of transgressive art – exclaimed, 'Anyone, even a carpenter, could have put together this "tableau."'[24] From a broad art historical perspective, the *aftabeh* points to the legacy of Duchamp and his urinal, inherited by the artist through the lineage of Pop art. *Innovation in Art* was not exhibited again until I selected it for the exhibition *Iran Modern* at the Asia Society Museum, New York, in 2013.

While this piece touches on aesthetic innovation in a developing country, the work Tanavoli paired it with – *Invention in Industry* (1964), which features a mechanized *aftabeh* – satirizes Iran's industrial progress. In the two works, complex sociopolitical issues, broader than mere institutional critique, are touched upon with a great deal of humour, and are cleverly woven into the art. In a culture that was still very much under Western influence, the homely exoticism of mundane utensils broadened the aesthetics of the Saqqakhaneh movement and endowed the art of that time with a critical viewpoint. Where do such works stand in relation to the Pahlavi modernist project? In my view they debunk that project by highlighting aspects of culture the regime was sweeping under the carpet.

20. Parviz Tanavoli
Innovation in Art, 1964
Mixed media, 154 x 115 x 20 cm
(60⅝ x 45¼ x 7⅞")
Guggenheim Museum, Abu Dhabi

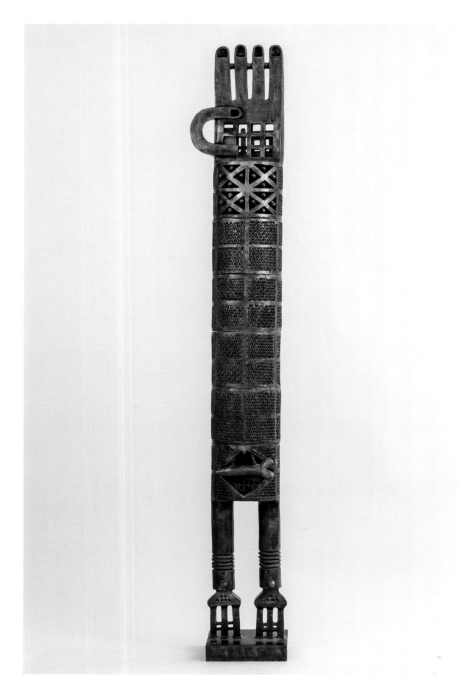

21. Parviz Tanavoli
The Poet (Standing Figure with Heech II), 1973
Bronze, 211 x 18 x 30 cm (83 ¹/₁₆ x 7 ¹/₁₆ x 11 ¹³/₁₆")
Collection of the artist

Tanavoli's 1973 sculpture *The Poet*, previously entitled *Standing Figure with Heech II*, features motifs that are more closely associated with the Saqqakhaneh than *Innovation in Art*, even though it was executed in the 1970s, after the movement's prime years had passed (fig 21). The figure's head is also the hand of Hazrat-e Abbas, a hand that is always shown severed. In this version, the hand, insidiously penetrated with the word *heech* ('nothing' or 'nothingness,' in Persian), is attached

to an erect, militaristic body, evoking a medieval weapon or arsenal and featuring bullet-shaped forms on top. The bullets, the artist explains, 'guard the chest of my poets.'[25] In the work's general configuration, Tanavoli addressed the two major intimidating agents of the era: the military and religion. The anatomy of the figure, identified by the title as a poet, is gendered male, with a low-tech door lock serving as surrogate genitals. The locking up of sexuality, which was prohibited in representation and circumvented in society, is a concept frequently evoked in Tanavoli's work, sometimes by means of surrogate genitals, as in this instance, or, more directly, with a severed phallus incarcerated in a cage, for example, as in *We Are Happy Locked Within Holes*, a 1970 sculpture now in the collection of the Grey Art Gallery. Tanavoli does not openly engage in militant ways with sensitive issues such as sexuality, politics, and religion but rather through playful allusions, metaphors, irony, and subdued humour – with critique as a possible hidden subtext (although he may disagree with such an interpretation).

Also in 1973, Tanavoli made *Heech Tablet* (fig 22), a very different type of sculpture: not anthropomorphic or constructed in the round but designed to be viewed from the front and the back, the sides neglected. Tanavoli learned this approach to sculpture from ancient Persian and

Right
22. Parviz Tanavoli
Heech Tablet, 1973
Bronze on travertine stone base,
181.6 x 47 x 30.2 cm (71½ x 18½ x 11⅞")
Grey Art Gallery, New York University Art Collection, Gift of Abbey Weed Grey, 1975

Far right
23. *Law Code of Hammurabi, King of Babylon*, 1782–1750 BC
Diorite, height of stele *c* 200 cm (84")
Musée du Louvre, Paris

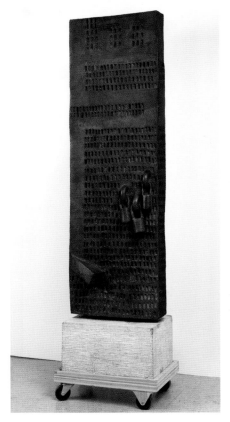

Mesopotamian art, such as the Babylonian Hammurabi stelae at the Louvre (fig 23), of which there is a replica at the Iran Bastan Museum in Tehran. *Heech Tablet* initiated a series of sculptures named *Walls of Iran*.

The work shares a coarseness of execution with the most thoughtful and class-conscious works of the Saqqakhaneh movement, but it is also a testimony to Tanavoli's breadth of vision, confined neither to Shi'ite iconography nor ancient culture, but encompassing both. The surface marking – while referencing the grillwork seen on *saqqakhanehs* (fig 24), with the locks that people of faith attach as an indication of their prayers and wishes – parodies, in an abstract manner, the ancient cuneiform inscriptions found in Persepolis (see fig 27). Tanavoli harmoniously blends two eras and stamps them both with the shadow of his secret weapon, the word *heech*, which cryptically wraps around the sculpture.

No domain of authority, be it sacred or secular, has escaped this artist's attention. Does the decision to lash the two sides of this

24. Saqqakhaneh in Qazvin, photographed by Parviz Tanavoli

tablet with the word 'nothingness' indicate a lack of allegiance to an imperial ideology, or is it a statement on the futility of certain religious practices? Perhaps he was claiming faith in a different kind of belief system, one with the mystical dimensions that the word 'nothingness' evokes. Revealed and concealed, present and absent as the idea of being and not being, the message is neither Manichaean nor fully transparent. *Heech* remains slippery in meaning and its form here indecipherable and perhaps intentionally esoteric. No matter what message was intended, the tablet stands as a memorial to the dual vision (ancient/Islamic) that is endemic to the collective memory of Iranians. Politicians have stressed one or the other, depending on their agenda, the Pahlavi regime privileging the era that preceded the Islamic period; the clergy, on the other hand, downplaying that history. In this work Tanavoli confronts the viewer with the coexistence of the twin facets of Iranian identity and perhaps, through the mystical concept of nothingness, provides a way out of the political binary.

All three sculptures, either in their iconography or in the interest they express in the marginal visual culture of a certain class, position the artist close to the Saqqakhaneh. But Tanavoli's broader interest in history and politics, rather than a purely decorative approach to art, distanced him from the movement he sympathized with and helped to develop, but that he also implicitly criticized especially, in my view, when he began producing his three-dimensional *heech* works.

Text and politics

In the literature on modern art in Iran, the use of writing is closely – but erroneously –associated with the Saqqakhaneh. Calligraphy belongs to an extended tradition separate from Saqqakhaneh, to which it is not even central but rather one among a variety of elements. Tanavoli has not confined himself to the kind of calligraphic modernism that flourished from the mid 1960s onward. His exploration of script has been far more inventive. Like Zenderoudi, in the 1960s he wrote on his works in a deliberately unremarkable handwriting; the words were legibly Persian. But soon his repertoire expanded to include cuneiform-like markings, invented ideograms, hieroglyphs or pictographs, including the appropriation of the *nasta'liq* script in his three-dimensional *heech* sculptures. Throughout, he has incorporated coded messages on authority and history and on the increasing hegemony of calligraphy.

In *Heech Tablet* Tanavoli combined abstract marks recalling cuneiform writing with the Arabic script for the word *heech*. Another kind of textual exploration may be found in a 1967 embossed relief by the artist, entitled *Confrontation*, in which two characters enact a

narrative of confrontation between Moses and the Pharaoh (fig 25).[26] Drawn from an Old Testament episode, the pseudo-pictographs or hieroglyphs refer to the miracle of the cane, in which Moses's staff wondrously morphed into a serpent, thereby demonstrating to the Pharaoh the supremacy of an authority higher than his own. In this way *Confrontation* re-articulates the 'nothingness' of earthly authority in a whole new idiom. Even though there is no indication that Tanavoli intended to link this episode to contemporary politics, nonetheless, executed as it was in the decade when the Shah was consolidating his power with his pre-emptive 'White Revolution', the relief gains in topical significance.

Above
25. Parviz Tanavoli
Confrontation, 1967
Hammered copper, 69.9 x 69.9 cm (27½ x 27½")
Grey Art Gallery, New York University Art Collection. Gift of Abbey Weed Grey, 1975

Opposite
26. Parviz Tanavoli
Oh Persepolis, 1975
Bronze, 181 x 102 x 23 cm (71¼ x 40³⁄₁₆ x 9 ¹⁄₁₆")
Collection of the Mathaf: Arab Museum of Modern Art, Doha, Qatar

By 1975, when Tanavoli made his major sculpture *Oh Persepolis* (fig 26), the characters seen in works such as *Confrontation* had proliferated and grown into a fully fledged alphabet.[27] In *Oh Persepolis* Tanavoli left the crudeness of his earlier execution behind, opting for polished bronze. He might have been prompted to do so by Arnaldo Pomodoro's examples of bronze sculpture where smooth surfaces crack and break down into jagged cuneiform signs.[28] It is unclear whether the 'Oh' in Tanavoli's title denotes awe or sarcasm, but the references may offer a clue in deciphering this glittering text. While the concept echoes ancient cuneiform tablets (fig 27), the direct source, according to the artist, are the bas-reliefs on the Apadana staircase in Persepolis (fig 28).

In the sixth and fifth centuries BC, Persepolis was the ceremonial capital of the Achaemenid empire. From 1967 to 1977 it was one of the venues used to stage cultural events for the annual Shiraz Festival of Arts,[29] and in 1971 it was the location of an ostentatious display of imperial power, when world dignitaries converged there to celebrate 2,500 years of the Persian monarchy. Both events were controversial. The composer Iannis Xenakis, for example, who participated in the festival three times, stated in an open letter to Farrokh Ghaffary, the festival's director in 1971, 'Faced with inhuman and unnecessary police repression that the Shah and his government are inflicting on Iran's youth, I am incapable of lending any moral guarantee, regardless of how fragile that may be, since it is a matter of artist creation.'[30] The American theatre director Robert Wilson, on the other hand, characterized his experience at the Festival as 'one of the highlights of my career.'[31]

Perhaps in a parody of the rows of subjects who came to Persepolis millennia ago from the twenty-three nations of the empire to pay homage to the Achaemenid king – an event re-enacted in 1971 as a parade watched by the Shah, the Queen, and international dignitaries from the Emperor Haile Selassie to Princess Grace Kelly – Tanavoli's golden bronze sculpture evokes narratives of power, tablets and lofty edicts delivered by visionary autocrats from Cyrus the Great to His Imperial Majesty, Shahanshah Aryamehr (the Light of Aryans), Reza Shah Pahlavi. Does *Oh Persepolis* innocuously signify pride in an ancient heritage? More importantly, does it glorify the power of monarchy, or is it a critique of the spectacle of power?

A second version, created after the Revolution, confirms that politics were not absent from the artist's thinking. *Oh Persepolis II* (1975/2008, fig 29) is enclosed by a protective frame, and a new character in the shape of an *aftabeh* punctuates the sentences. A trivial sign, the voice of a different era, has infiltrated to destabilize and disturb the ostentatious signifier. According to Tanavoli, you frame what is precious.[32] Why this impulse to protect a metaphor for

Opposite top
27. Cuneiform inscriptions from Persepolis, 522–486 BC, Achaemenid period

Opposite below
28. Bas-relief from Persepolis, *c.* 6th–5th centuries BC, Achaemenid period

Persepolis in 2008? It will come as no surprise to hear that the Islamic regime that succeeded the Shah had a different perception of the ancient site. Vilified as a palace of royal ceremonies, Persepolis was threatened with destruction.[33] In addition, the closing of borders and the absence of tourism had led to neglect and a lack of proper

conservation. Might one surmise that Tanavoli, who was nourished by Achaemenid art, was not indifferent to the disregard of that ancient heritage? Perhaps *Oh Persepolis II* is an epilogue to the artist's narrative of power, now turned around to invoke protection from a malevolent threat in the decades following the Revolution.

While inventing elaborate scripts, Tanavoli has also appropriated *nastaʿliq* calligraphy for the *heech* works he continues to produce. In this ongoing series, the word appears as a three-dimensional object in every medium, colour and scale, ranging from larger-than-human-size to a ring worn on a finger. First painted in yellow at the centre of a red medallion in 1964, the word migrated from painting into sculpture, from barely decipherable concealed positions to grand declamatory statements, as a single word occupying a space of its own. Chameleon-like, the word fades into the background of *Heech Tablet* (see above, fig 22), and it is hidden inside the 1973 *Poet*'s head/hand (in part disguised as a thumb; see fig 21). But the word has also come out of hiding. The free-standing *heech*, divorced from historical and religious contexts, asks to be read clearly and loudly (fig 30). What could it be proclaiming, aside from its mystical associations or possibly the political messages suggested in connection with *Heech Tablet*? The artist has often confessed his aversion to calligraphy and the art market's insatiable thirst for it. In strategic disguise, the word *heech* may be calligraphy's Trojan horse. To enunciate calligraphy's triviality, its nothingness, Tanavoli penetrates its curvilinear form in its most seductive *nastaʿliq* manifestation to deliver his blow from within. Disseminated as a virus, mutating in size, colour, and dimension (just as in paintings by calligraphic modernists), it thrives, circulating from commercial galleries to museums, from public to private spaces.

For Iranians and, increasingly, for others, the sign *heech* is becoming as iconic and idiosyncratic as Robert Indiana's *Love*, a comparison first established by the curator and critic Daniel Belasco, who has framed Tanavoli's work in the context of international Pop art.[34] While Pop's serial production has something in common with Tanavoli's production of *heech*, the meaning Tanavoli's work conveys is worlds apart. Indiana's *Love* is a straightforward iconic image of the 1960s, the love decade, while Tanavoli's *heech* shifts its target each time it is encountered. It would be odd if it were genuinely celebratory of nothingness. Particularly Iranian in its cautious lack of clarity, its convoluted and plural meanings, and its dependence on context for its message, the word *heech* inhabits the spiritual sphere, the treacherous terrain of politics, the aesthetic domain of calligraphy, and the commercial spaces where it has thrived. Offering a very different interpretation, an anonymous critic around the time of the Revolution condemned Tanavoli's three-dimensional *heech* as formalist,

'decadent imperialist art,' 'art for art's sake' or 'art for nothing.'[35]

 Of all the artists associated with the Saqqakhaneh, Tanavoli has the repertoire richest in its reach and grasp of Iranian history and in its complex understanding of contemporary popular culture. He acts as a seismograph, recording and interpreting an ongoing present that in Iran is intricately intertwined with the past, glorified and perennially invoked, as if licensed to absolve contemporary deficiencies. He is the inventor of a language that is still being deciphered to this day and of a sculpture for a modern Iran. His project was not nostalgic of ancient times nor neo-traditional in the sense Saqqakhaneh art has been viewed, yet it is impregnated with the architectural ambitions of ancient monuments imprinted with historical narratives and reflective of the tensions of the time. His achievements strike a balance between an Iranian Pop art and the kind of representation history painters excel at: the triumphs and failures of culture and politics on a grand scale.

Opposite
30. Parviz Tanavoli
Heech (Nothing), 1972
Bronze on wood base, 56.5 x 30.5 x 20.3 cm
(22¼ x 12 x 8"); base: 12.7 x 12.7 x 12.7 cm
(5 x 5 x 5")
Grey Art Gallery, New York University Art
Collection. Gift of Abby Weed Grey, 1975

Chapter Four
Abstraction to Figuration: The Politics of Morphology

For the artists and critics who surfaced immediately after the pivotal political shift in 1979, art – especially abstraction – produced during the *ancien régime* was considered to be reactionary, merely formalist, and subservient to Western models. Such generalizations were imbued with the populist revolutionary zeal of the time, and they advanced an internal division between 'us' and 'them.' This eventually resulted in a polarizing, Manichaean vision – a highly simplistic assessment uncorroborated by the complexity that had existed before 1979 or, for that matter, in any period, including the post-revolutionary era.[1] As expressed by the anonymous text in the catalogue of the first exhibition mounted at TMOCA after the Revolution, only art by those who had 'not sold themselves' to the Pahlavi regime and who reflected in their works 'the pains, the hopes, the struggles, the courage, and the self-sacrifices of the current dispossessed and heroic generation' was politically tolerated; figuration was the only admissible aesthetic expression.[2] Didactic narrative representation was glorified at the expense of its nemesis, an abstract 'art for art's sake' that was deemed incomprehensible to the masses.

The most cursory overview of abstraction in Iranian art, however, from its modernist manifestations before 1979 to its current expressions in the diaspora, yields a much more nuanced narrative. For some critics, such as the anonymous author mentioned above,

abstraction before 1979 reflects the kind of cosmopolitan modernism or 'westernization' pursued by the Pahlavi regime and thus is evidence of contamination. Its practitioners, however, perceived abstraction differently, as the language of their time, a language they felt connected to, one that was entitling and empowering. To complicate the matter further, not all of these modernists adopted the global language of abstraction. Some revised the abstraction embedded in local traditions, categorically invalidating the notion of servitude to Western paradigms; others practically reinvented the genre in ways that cannot be linked to anyone's past or present. They harvested references cross-culturally from the East to the West (or from neither, when tied to ideas such as the element of chance in art creation). Later, after 1979, abstraction carried additional connotations. It became allied to strategies that were polar opposites: it was a veiled form of dissent against the official aesthetic of figurative propaganda and, conversely, it was an affirmation of an Islamic ideology. And when this cipher for 'Westoxication,' Iranian identity, Islamic identity, individualism, resistance and collaboration was infused with mysticism, it fully transcended all divisive ideologies, whether before or after the Revolution.

Abstraction has been a chameleon, shifting meanings not just in Iran but also in the West. As articulated by American art historian Mona Hadler, discussing the post-World War II era,

> Today, abstraction is rarely held to convey only aesthetic concerns, and conversely realism is no longer viewed as the sole purveyor of social or political messages. In the postwar era, depending upon country and time, realism and abstraction could shift as signifiers of the right or the left, of freedom or repression, of the new or the old. By the fifties in America, for example, some saw realism as a throwback to the leftist concerns of the thirties; others saw it as connected to the Soviet regime or even to the legacy of a Nazi, antimodernist aesthetic. Others praised its existential humanism. Conversely, while some viewed abstraction as representing the individualism of the 'free world,' some others considered it a regression to the leftist goals of the twenties, and still others viewed it as the epitome of prevailing Greenbergian aesthetics.[3]

Who owns abstraction? In Iran this question has long been part of the aesthetic discourse. The perception that abstraction was a Western model sheepishly followed by Iranians echoes (internalizes?) the Western conviction that abstraction was a European invention – a view that lingers to this day. This latter contention, however, has been vehemently attacked in the United States by voices critical of cultural

and corporate colonialism – most recently on the occasion of *Inventing Abstraction, 1910–1925*, an exhibition held at the Museum of Modern Art, New York, in 2013. In his review of the show in the *Huffington Post*, G. Roger Denson argued that 'disavowing abstraction of its global and ancient origin' amounts to 'Eurocentric myopia and hubris [and it is] historically incorrect.'[4] Denson points out that Thomas McEvilley, objecting to modernist Eurocentrism, proclaimed as early as the 1980s that European modernists were 'preceded by abstract artists of the Paleolithic, Neolithic and Bronze Ages and by later Tantric and Islamic artists.'[5]

That Western scholars or curators of modernism ignore the precedence of abstraction in other cultures and periods speaks perhaps of self-involvement or self-interest, or simply of parochial short-sightedness. It is equally myopic for critics and artists in Iran to ignore the Iranian/Islamic cultural provenance of certain trends and characteristics of abstraction. Historically speaking, traditional abstraction in the region grew out of Islam's aversion to idolatry and, by extension, to figuration. Abstraction has been one of the building blocks of the traditional arts in Iran, whereas elsewhere its introduction has meant a break away from the aesthetics established since the Renaissance. In Iran it permeated every medium and was neither intended to be nor perceived as elitist or as the marker of any class, at least not until the importation of Communist thinking in the 1940s and European-style abstraction after World War II.

Indeed, in the late nineteenth century, the adoption of European academic realism in Iran – epitomized by a painter such as Mohammad Ghaffari, known as Kamal al-Molk, was nothing if not motivated by a 'progressive' desire to see the world rationally, scientifically, like Europeans.[6] And after the Revolution, during the Iran–Iraq War of the 1980s, when xenophobia prevailed, Islamist artists did not shy away from adopting blatant Christian iconography, such as the Pietà, to elevate and encourage martyrdom. Supporters of the Revolution adopted figurative idioms borrowed from Mexico, the Soviet Union, and European figurative art from the Renaissance to twentieth-century Surrealist painting. Thus, if abstraction draws criticism in Iran for being a foreign language, the same accusation may equally, perhaps more forcefully, be made of figuration. The important point, as I shall demonstrate in this chapter, is that neither is inherently tainted nor inherently pure. In essence, neither is ontologically ideological. Both are amenable to a variety of positions.

Since many of the modernists freely moved back and forth between abstraction and various degrees of figuration, a discussion of abstract art cannot be radically divorced from figuration, all the more so because in Iran the term abstraction refers not always to pure non-representational art but sometimes to various degrees of distance from perceived reality.

Four abstractionist artists

The work of four iconic modernists born in the 1920s highlights the various directions abstraction took before the Revolution. Monir Farmanfarmaian[7] (b. 1924) is a prime example of an artist who, in spite of her periodic but extensive sojourns in New York and its surroundings (first in the 1940s and 50s and again from December 1978 until 2004), did not base her abstraction directly on Western models. The geometric patterns, the technique of mirror work, and the artisanal execution encountered in Iranian architectural decoration found a fertile ground in her brand of ornamental abstraction, which remains free of any Adolf Loosian anxiety.[8] In the United States in the 1940s and 50s, Farmanfarmaian was first a student of fashion illustration and then a freelance illustrator, collaborating on some projects with Andy Warhol. From the mid 50s on, when she returned to Tehran and began collecting popular paintings (coffee-house and reverse glass paintings) and ethnic jewellery, she has been inclined more towards the so-called decorative, applied, or minor arts rather than the fine arts, a distinction that is, however, alien to the central core of traditional (so-called Islamic) art, where ornament is not stigmatized and where visual art is not divided into 'high' and 'low'. From an art historical perspective, Farmanfarmaian's exploration can be viewed as an attempt to create modernism with local iconography, materials, and technique. It is, however, quite different from the identity-driven products of Saqqakhaneh artists and devoid of the sociopolitical references strategically concealed in some of their works.[9]

In spite of her deep roots in Iranian culture, Farmanfarmaian is absent from texts by Islamist art historians, such as Morteza Goudarzi, writing in the last couple of decades.[10] Goudarzi, a fervent advocate of the Islamic Revolution, devotes meagre space to the discussion of women artists in general and condemns the abstraction practiced before the Revolution altogether, in part because he detects the influence of Queen Farah Pahlavi in that work, and her aspirations towards an international culture and a 'modernity derived from the dominant global capitalism.'[11] Farmanfarmaian, whose abstraction was neither influenced by any official agency nor consciously engaged in any global/local discourse, is absent also in the narrative presented by Ru'in Pakbaz. Pakbaz is a revered self-taught art historian with a more balanced view of art in Iran. In the few pages he devotes in his general survey to contemporary art, regrettably, women artists do not fare any better.[12]

Farmanfarmaian's indebtedness to traditional architectural decoration is self-evident, and it has been pointed out by many writers (fig 31). It may be prudent, however, to note that its role has been overemphasized at the expense of the artist's own

Opposite
31. Monir Farmanfarmaian
Eight Times Eight (renamed *Geometry of Hope*), c.1975
Mirror, stainless steel and paint, 129.5 x 129.5 cm (51 x 51")
Collection R. & F. Issa, London

creative innovations. She divorced the mirror-work technique from subservience to architecture and married it to elemental geometry (the triangle, square, pentagon, hexagon, heptagon, octagon, nonagon, decagon and circle), with its infinite possibilities and configurations, and at times has juxtaposed mirror work with reverse glass painting (a sculpture–painting hybrid). The results are autonomous objects – abstract reliefs or sculptures[13] – unprecedented in either traditional or modern art in Iran. 'I made classical mirrorwork modern,' the artist has declared.[14] She blurred the line between painting and sculpture and privileged the decorative. The latter was stigmatized in the West until the emergence of Pattern and Decoration in the 1970s, a New York-centric movement that ignored non-Western artists while it acknowledged the 'Islamic' influences on American artists such as Miriam Shapiro and Joyce Kozloff.[15]

Farmanfarmaian's oeuvre is restricted neither to geometry nor to mirrors. She has been sensitive to all kinds of abstract patterns, including the image of a heartbeat made by electrocardiography (exemplified by a work in the collection of her daughter, Nima Isham, generously loaned for the exhibition *Iran Modern* at the Asia Society, New York in 2013 (fig 32) and gestural painting behind glass (also exemplified in *Iran Modern*).[16] She has also turned to representational imagery, for example, a jewellery box.[17] *The Lady Reappears*, her only depiction of a female figure, is in the Mohammed Afkhami collection.[18] She has drawn flowers and created monotypes on canvas, glass, and paper. In addition, she has constructed wooden boxes and, finally, an imposing abstract panel punctuated with flying birds, all made of fabric and glitter glued onto a canvas – a commission executed for Jeddah Airport in 1981.

But of the diverse works Farmanfarmaian has created, her mirror abstractions have attracted curators and collectors the most. The date of their genesis has been disputed. Farmanfarmaian recalls sitting in the Shah Cheragh shrine, in Shiraz, with its spectacular environment of mirror works: 'A mosaic of tiny mirrors cut into hexagons, squares and triangles.'[19] Dazzled by the sight, she has written, 'I imagined myself standing inside a many-faceted diamond and looking at the sun.'[20] (This is the only metaphor I have encountered in her statements about her art.) The artist dated this epiphany to the 1960s when, she has said, she visited Shiraz in the company of two American artists, Marcia Hafif and Robert Morris.[21] Reference to curator Donna Stein and her correspondence with Hafif has revealed, however, that the visit in fact took place in 1975, later than Farmanfarmaian's first mirror works;[22] but in any case Farmanfarmaian need not have visited Shah Cheragh to learn about mirror works. Any inhabitant of Tehran would have been familiar with this traditional practice, either from historical palaces in

32. Monir Farmanfarmaian
Heart Beat, 1975
Mirror, reverse-glass painting, and plaster
on wood, 90 x 120 cm (35 ⁷⁄₁₆ x 47¼")
Collection Nima Isham

the city, the homes of the newly rich located uptown,[23] or the crude
imitations at the other end of the economic ladder, in the *cheloh kababi*
restaurants in the bazaar, frequented by common folk.

There are writers who link this artist's abstraction to Sufism.
Many point to her knowledge of Nader Ardalan and Laleh Bakhtiar's
The Sense of Unity: The Sufi Tradition in Persian Architecture (1973), a book
in the artist's library.[24] The artist herself has denied the links to Sufism.[25]
Farmanfarmaian does not seem to have any interest in the esoteric, in
metaphors, in sacrality, or in ruminations on being and cosmos. With
her, to quote her American friend Frank Stella describing his own work,
'what you see is what you see.'[26] And what you see in Farmanfarmaian's
abstract mirror works are geometric shapes mostly made of mirror and
reverse glass painting, separated from any functional properties. The
experience is tantamount to an encounter with a field of light in which
geometry dissolves in favour of an ever-shifting play of fragmented
reflections and multiplied illusions, disturbing the viewer's grasp of
figure versus ground, depth versus surface. Their aesthetic quality

depends on the sense of beauty they exude, the fractured images they partially reflect, the transparency they deny, the play of light they echo, and the surrounding movement they reflect in repetitively multiplied forms. They are devoid of Sufi metaphorical signification as described by the authors of *The Sense of Unity*. Farmanfarmaian liberates decoration from its traditional subservience to religious, palatial, and vernacular architecture. Thoroughly secular, Farmanfarmaian's mirror works are released into the white cubes of modernist art galleries. These offspring of traditional architectural decoration take on a modernist status and initiate a new kind of Iranian formalism – but with a caveat. Farmanfarmaian is not devoted to medium specificity; her work collapses traditional art historical divisions. She combines many elements traditionally segregated in Western modernism and reconciled in post-modernism. For instance, she merges geometric and expressionist forms (gestural in the way she paints the reverse side of the glass), at times weaves representation into abstraction, and focuses on handicraft yet relegates its execution to professional craftsmen.[27] She thus simultaneously invites and defies categorization such as modernist, Islamic, post-Islamic, and – in our new formulation – Iranian formalist.

Her achievements as an abstractionist were neither fully nor globally celebrated until very recently. In the pre-revolutionary era, recognition was minimal, even though she began exhibiting in the 1950s (an abstract work shown in the first Tehran Biennial in 1958 earned her the gold medal)[28] and received solo exhibitions at the Iran–America Society in Tehran, in 1973 and 1976. She did not fare any better in revolutionary times, when her last name (that of her second husband, who, as the artist has proudly stated, was a Qajar prince) was sufficient to alienate her from the self-proclaimed representatives of the 'dispossessed,' for whom the work had no didactic message but who, if not treated condescendingly, would perhaps have found in them retinal delectation (an experience not restricted to the middle and upper classes). Her collection was confiscated when she left the country in 1978, in the early turbulent years of the Islamic Revolution. It is a historical irony, however, that her most creative impulse was rooted in her experience of the Shah Cheragh shrine, a pilgrimage site sacred to Shiʻi Muslims, and that her decision to return to Iran in 2004 and open an atelier, with a team of mirror-work specialists under her direction, has led to works which have earned her global recognition. Recognition has also arrived in her native country. Under the auspices of the University of Tehran, the first official permanent space dedicated to a female artist opened in the Negarestan Museum on 15 December 2017. Paintings by Kamal al-Molk and his followers occupy the other halls of this museum.

As for Farmanfarmaian's early representation in Europe, her

1977 exhibition at the Denise René Gallery, in Paris, stands alone.[29] The work, which was exhibited by Denise René in New York the same year, resonated with the gallerist probably because of her interest in the geometric abstraction of the Western Op artists she championed. Later, Rose Issa, an independent curator and gallerist in London, was instrumental in bringing the artist's work to the attention of Europeans and beyond with exhibitions she mounted in London in 2001,[30] 2008, and 2010 (the last two were solo exhibitions) and with the publication of Farmanfarmaian's first monograph, which accompanied her first retrospective in Iran, in 2006.[31] This exposure eventually resulted in commissions of mirror-work murals by the Victoria and Albert Museum, London, in 2006, and the 2009 Asia Pacific Triennial in Brisbane, Australia. Eventually, Issa's painstaking groundwork led to the artist's canonization by Hans Ulrich Obrist, the grand master of global contemporary art.[32]

In the United States, Farmanfarmaian had her first commercial solo shows in 1975 and 1977, at the Jacques Kaplan Gallery and the Denise René Gallery, respectively, both in New York. Her work was rarely seen in non-commercial spaces; it was first exhibited in that context at Columbia University in 1968[33] and then shown on at least two occasions as part of Abby Weed Grey's collection (her founding gift to the Grey Art Gallery at New York University), once in 1975 and again in 2002.[34] As co-curator of the latter exhibition – *Between Word and Image: Modern Iranian Visual Culture* – I borrowed a work (fig 31) from the artist to boost her representation, which is slight in the Grey Art Gallery's collection.[35] In the accompanying publication I explained that 'the advent of Pattern Painting in the 1970s and most recently the exoneration of the concept of beauty (which is greatly indebted to Dave Hickey's essays) allow for a more positive assessment of works such as Farmanfarmaian's, which renew one's faith in visual pleasure.'[36] While an exhibition of recent acquisitions at the Metropolitan Museum of Art, New York, in 2010–12[37] featured one new work by the artist, the first museum exhibition in the United States in recent times to present a relatively in-depth assessment of her work and its variety was *Iran Modern*, in 2013. The focus was on the range of her abstraction, from her gestural reverse glass painting, to her Op art-style geometric abstraction, to her kaleidoscopic orgies of colour, to her interest in patterns (such as the heartbeat electrocardiograph), to her mirror balls, which express her sensitivity to everyday life.[38] These latter works were not inspired by the disco balls of the 1970s. Farmanfarmaian has said, 'I don't know about disco balls,' but she vividly remembered children playing football in the street, which prompted her to fill footballs with gravel and cover them with mirrors.[39] The Andy Warhol Museum in Pittsburgh has one of Farmanfarmaian's mirror balls. Until I explained

the provenance, the museum was unaware of where the object had come from and who its maker was. It was a gift from Farmanfarmaian given in exchange to Warhol during his visit to Tehran in 1976. The friendship between the two artists went back to the 1950s; in one instance in that period, Farmanfarmaian worked on the layout of an advertisement for which Warhol provided the drawing of the shoes.[40]

An exhibition of Farmanfarmaian's mirror works and drawings, which travelled in 2015 from Porto (Portugal) to New York, finally provided a truly in-depth exposure of these objects to the American public. Regrettably *Heartbeat* and the untitled work of 1977 in the collection of Zahra Farmanfarmaian were not included.[41] Appropriately, the New York venue for the show was the Solomon R. Guggenheim Museum, an institution with a historical interest in non-representational art and a current pioneer in exhibiting art by non-Western artists.[42] The city, for the first time, hosted a substantial exhibition by an Iranian artist.[43] This recognition of Farmanfarmaian can be credited not to a more open embrace of decoration but rather to the greater visibility of Middle Eastern artists, especially women, and the increasing recognition by museums of a need for inclusiveness.

Recognition has come late to Farmanfarmaian, but it has arrived. Abstractionists who do not overtly display a Persian cultural provenance have not yet enjoyed the same degree of recognition on the international scene. Behjat Sadr (1924–2009) and Mohsen Vaziri Moghaddam (1924–2018), in Italy spelt Vasiri, commonly referred to as Mohsen Vaziri) exemplify this situation. Soon after their separate arrivals as students in Rome in 1955 (Sadr was the recipient of a scholarship from the Italian government, Vaziri travelled with personal savings[44]) they opted for non-representational art, which at the time was being hailed as a reaction against provincialism and the representational art previously promoted by the fascist regime in Italy. Many interpretations could be attached to this predilection of Iranian artists whose initiation into abstraction took place in Italy. Could it be (as it was for certain black artists in America) that abstraction represented an emancipation from subservience to ethnic origins? Abstraction, the painter Piero Dorazio maintained, was the progressive form of avant-garde art in Italy.[45] Did its absorption turn Iranian students into emulators of a Western model, or was theirs the logical adaptation of a popular global language as much their own as it was the visual heritage of young artists in Europe and the United States? Sadr's and Vaziri's comments on these matters point to the latter. Sadr, addressing the influence of European abstraction, such as the work of Pierre Soulages, as well as Islamic calligraphy (both of which have been brought up in discussions of her work),[46] maintained that given the level of 'communication in the twentieth century it is not only

our traditional culture that influences us, but also we are under the influence of a multicultural world.'[47] These words echo those of Akbar Tadjvidi, one of the earliest historians of Iranian modern art, who, writing in the 1962 catalogue of the first exhibition of Iranian art in the United States, maintained, 'If some of the works show an inclination towards "informel" or "abstract" style, they should not be considered as an imitation of Western art, but rather, it should be borne in mind that we, too, are living in the Twentieth Century.'[48] Sadr is also noted as saying that 'art has no boundaries,'[49] and 'international art can turn into national art and the national into the personal.'[50]

Similarly, Vaziri is not concerned with the national ownership of aesthetics or with identity politics, although he has acknowledged that abstraction can be found in traditional Iranian art.[51] For Vaziri, what matters in art is not a Persian accent but the making visible of the invisible, a concept he says he discovered in the work of Paul Klee (he would eventually translate into Persian Werner Haftmann's *The Mind and Work of Paul Klee*).[52] This concept, Vaziri has claimed, is responsible for individual creativity and defines the nature of abstraction and modernism.[53]

Vaziri, profoundly dissatisfied after an early success with paintings he has described as 'half Eastern half Western,' paid careful attention to his teacher, Toti Scialoja, who advised him to steer clear of both facile ethnic art and pseudo-Western art. Scialoja told Vaziri that if he wanted to become a real artist, he would need to start from zero.[54] Vaziri found his ground zero in the vicinity of Rome, in the dark sands of the lake in Castel Gandolfo. The year was 1959. Clawing the sand by chance, he left traces evocative of a primal search for something fundamental. He replicated the gesture in his paintings by spreading sand on a flat surface and running his fingers through it, then pressing the surface of a glue-covered canvas onto the sand. With these performative works, Vaziri was searching for something deeper than an assertion of cultural difference, nationalism, or internationalism: he was aiming for an existential humanism, something he has called the 'human signature' (see fig 35).[55]

Returning to Sadr and the genesis of her abstraction, a chance occurrence awakened her to its possibilities (not unlike Wassily Kandinsky's accidental misperception of a Monet Haystack or one of his own paintings for an abstract work). Roberto Melli, writing for the artist's first solo exhibition, in Rome in 1957, quoted Sadr: 'One day going home, at the moment of entering my room I let a long piece of string fall to the ground. On the geometric tile of the floor it drew a web of knots which coiled and recoiled creating such complex configurations that it pleased me and made me decide to paint the interlaced forms several times in order to discover their secret world

33. Behjat Sadr
Untitled, 1977
Oil on canvas, 53 x 70 cm (20 ⅞ x 27")
Collection Mitra Hananeh-Goberville

with its reliefs, depths, and fantasies.'[56] Thus the element of chance was a fundamental factor in directing the paths of both Sadr and Vaziri towards abstraction. (One might add that chance has no ethnicity.)

Soon the whirling expressionist brushstrokes of Sadr's early work yielded to the ebb and flow of gesture, to criss-crossing patterns and waves of marks travelling across the canvas (fig 33). She relished experimentation with the material and the process of sign making, sometimes shaping the paint she had poured onto her support, sometimes removing it from the surface in an action she called 'negative painting.'[57] Using a variety of instruments (a spatula, razor, trowel, and palette knife) she allowed her material, the oil paint, to evoke the dryness of tree bark, the fluidity of water, the nervous energy of an electrical current, or the viscosity of industrial oil. At times, motion was the subject matter and nature the inspiration. In other moments, the geometry of architectural decoration, such as the brick patterns of the Friday mosque in Isfahan, took centre stage. Typically, her palette was austere, and even the blue and green she picked up when she studied Persian ceramics (for a commission to decorate the façade of the Hilton Hotel in Tehran) are invested with a certain gravitas; in their dark turbulence they recall oceans. Occasionally she used bright colours such as red and yellow. The supports she selected varied from canvas to paper to aluminum to ready-made objects such as window blinds; in these latter works, the blinds open to reveal imagery other than what appears when they are shut.

Several commentators have remarked on the 'virility' or 'masculinity' of Sadr's brushstrokes.[58] Without any feminist agenda or particular social engagement, Sadr nonetheless exclaimed, in a language belonging to her generation, 'As a woman, I had the vigor of men.'[59] Forough Farrokhzad, a free-spirited poet retrospectively considered to be a feminist figure, was a close friend. Both intimately identified with the vitality of nature, an organic force that contradicted the artificial constructs of social and religious decrees.

In Sadr's work, abstractions tied to a visceral identification with nature gave way to its literal representation in photographic images. In 1980, when she permanently settled in France, she began incorporating the photography she had pursued throughout her career into collages where abstract markings, without losing their prominence, recede to the periphery to allow photographic images a central place; abstraction and photographic realism coexist. During her self-imposed exile in Paris, she was diagnosed with cancer, and it is hard to abstain from constructing a narrative of illness and displacement around the artworks. The artist attributed the change of medium and style to her illness, which forced her to work sitting down, but the dislocation she experienced when she moved from a Tehran in turmoil to Paris seems

to have seeped into the iconography.[60] These collages are composed of photographs – often a picture of a place left behind or a desolate view of the River Seine near her apartment – framed with strokes of oil paint (fig 34). Sadr remarked, 'One should not forget that I created these photo-paintings during periods of illness. In such a situation, the very act of cutting and pasting was an important activity with significant meaning'[61] – metaphorically rephrasing the experience of a scarred body and an uprooted life.

Works from this late phase of Sadr's oeuvre enrich the pluralist terrain of Iranian art in the 1980s, a perspective that remains absent in the one-dimensional treatment of the period in exhibitions such as *Iran: Unedited History, 1960–2014*, held in Paris. These wistful collages were made in diaspora, contemporaneously with the propaganda art of the Revolution that was raging in Iran. Contrary to the bombastic tenor of paintings and posters that glorified war, revolution, and martyrdom, Sadr's collages emanate a longing for peace and serenity. They present a sharp contrast to the violent daily news of executions and war that refugees and diasporic Iranians received in Paris in that decade. Additionally, Sadr's late interest in narrative and the hybridity of media speaks to a trajectory straddling modernism and post-modernism.

Vaziri also cannot be restricted to the post-World War II European landscape of abstraction. His practice was not limited to his sand paintings, an example of which was acquired by the Museum

34. Behjat Sadr
Les Dangers, (*The Dangers*), 1985
Oil on canvas and photograph
52 x 66 cm (20½ x 26")
Private collection

35. Mohsen Vaziri Moghaddam
Untitled, 1962
Sand and synthetic polymer paint on canvas,
100 x 180.3 cm (39⅜ x 71")
The Museum of Modern Art, New York.
Helmut Bratsch Fund, 1965

of Modern Art in 1965 after being exhibited at the 1964 Carnegie International in Pittsburgh (fig 35).[62] Just as Sadr made a form of kinetic art with her paintings on window blinds, Vaziri devised an entirely new concept for mutable sculpture, inviting viewers to intervene in the work by manipulating its configuration (figs 36; see also below, fig 116). Such participatory art is closer to contemporary relational aesthetics than to the art of around 1970. The work of the Brazilian artist Lygia Clark might be the only precedent, albeit in a different fashion, on a different continent, and totally unknown to the Iranian artist.[63] In harmony with his interest in the elemental (in the 'human signature'), his abstract sculptures may be extended in configurations that resemble the tentacles of primordial creatures or recoiled to appear in a dormant

36. Mohsen Vaziri Moghaddam
Untitled *(Forms in Movement)*, 1970
Wood and metal. Closed: 100 x 50 x 50 cm
(39¼ x 19¾ x 19¾")
Collection of the artist

state. In their innovation, such works categorically belie the notion that abstraction is necessarily subservient to Western models; in their embrace of the new, they make the question of 'authenticity' irrelevant. In a very different context, writing about novelist Haruki Murakami, Steve Erickson stated that 'authenticity is the enemy of audacity.'[64] It is audacity that motivated Vaziri's explorations and led him to innovative results.

The fourth prominent abstractionist of the generation born in the 1920s was Marcos Grigorian (1925–2007). He combined a strong interest in the local with experiences from his itinerant life. Grigorian was a rooted nomad[65] – a globe-trotter who remained attached to the land that fed him. Life's trajectory took him from his birthplace in Kropotkin, Russia to Tabriz at the age of five, then to Tehran, Rome, Minneapolis, New York, and his final resting place of Yerevan, Armenia, his ancestral home. He did not conceive of origin in terms of traditional aesthetics but found it in the earth, the human habitat, and, often, the rural landscape, which he privileged as the location of peasant labour. He thoroughly digested the various models of art making he was introduced to on his extensive sojourns in Italy and the United States; the results were a very personal vocabulary and a unique narrative.

Artist, teacher, art critic, gallerist, collector, actor and curator, Grigorian wore many hats. He pioneered important new trends and activities in Iran, identifying the importance of traditional coffee-house paintings, teaching linocut printing for the first time, and curating the first Tehran Biennial in 1958. Abstraction was not the only mode he chose to work in. Both in figurative paintings (such as the multi-panel work *The Gate of Auschwitz*)[66] and sculptural reliefs (such as the *sangak* [Persian bread] and *abgoushteh dizy* or *dizy abgousht* [a Persian dish] he created in several versions),[67] he resorted to the appropriation of actual objects or materials such as ashes. He is best known, however, for his abstract earth paintings. In a dedication, handwritten in the copy of the monograph on these works that he gave me in 1990, he wrote 'A Journey to the Land.' His work evokes an arid land, sun-beaten, cracked and parched, that indubitably brings to mind the desert landscape of Iran.

Grigorian was staunchly critical of traditionalists, be they advocates of traditional Persian painting such as Hosein Behzad (1894–1968) and Mahmoud Farshchian (b. 1930) or followers of Kamal al-Molk's academic manner. He also opposed the imported version of Cubism transplanted from Paris to Tehran. His trajectory reflects the search for an expression that is modern but not borrowed. His abstract subjects range from close-up views of the parched Iranian landscape, to aerial perspectives of what might be ploughed fields, to cosmic visions of Earth or maybe views from Earth to a planet above

37. Marcos Grigorian
Untitled, 1963
Dried earth on canvas, 84.9 x 80.9 cm
(33½ x 31⅞")
The Museum of Modern Art, New York.
Gift of Dr and Mrs. Alex J. Grey

(fig 37). More often than not, however, the angle of vision is from a point above, plunging down, intimating distance between viewer and the space of the work.[68] He explained to the art critic Janet Lazarian that the first time he became aware of his interest in earth was during a trip to the desert when he stopped to check the leaking oil under his car.[69] Grigorian's interest in prosaic media such as soil, mud and straw is also a testament to his awareness of international movements, from the European Arte Povera (or, even before that, the gritty materials of Jean Dubuffet) to Earthworks in America, but his works retained an accent that is indubitably Iranian. He harnessed his metaphysical vision to a handmade or homemade geometry less rigid than that which he had observed in Minimalism. At the same time, he did not shy away from the opposite aesthetic pole, Pop art. His appropriation of *sangak* and the proletarian dish called *dizy abgousht*[70]– iconographically the Persian equivalent of Andy Warhol's Campbell's Soup cans and formally of Daniel Spoerri's assemblages of meals and table settings – reveals his knowledge of Western idioms as well as his deep ties to a popular culture fully infused with Iranian flavour. Iranian identity in art

is often equated with calligraphy and miniature painting, but Grigorian proves that one can be local without being reductively ethnic, and global without being derivative. One of his earth 'paintings' (fig 37) was acquired by the Museum of Modern Art from an international group exhibition held at the Jason Gallery, New York in 1965. It should be noted that from 1962 to 1971 Grigorian lived in the US, in New York and Minneapolis where he exhibited with the Iranian artists Abby Weed Grey supported.[71] He returned to New York around the time of the Revolution.

There can be no greater contrast between the opaque dirt and the rustic, unassuming materials that locate Grigorian's work within the purview of peasant life, and Farmanfarmaian's cut mirrors evoking the pomp of palatial decoration or the sacred aura of shrines where revered saints lay buried. Earth and light, twin concepts perennially found in the Iranian worldview and philosophical thinking, were palpably apparent in the installation of one of the galleries in *Iran Modern*. As I finished placing Grigorian's work on the wall facing Farmanfarmaian's pieces, I noted the reflection of the crude soil in the luminous mirrors and was reminded of the title of a film by Ebrahim Golestan, *Khesht va ayeneh* (Mudbrick and Mirror). Golestan identified the title's source as a verse by the Persian poet Attar (c.1145–1221).[72] In the film director's translation, the poem reads, 'What youth sees in the mirror, the elder sees in the raw mudbrick.' ('*Ancheh dar ayeneh javan binad – Pir dar khesht-e kham an binad*'). This anecdote illustrates how such matters and coded materials are deeply ingrained in the Iranian psyche.

Although he was a cosmopolitan urban dweller, Grigorian remained anchored in the earth, both as subject and medium. His abstractions derived from nature, with a deep acknowledgement of peasant life and labour[73]. Grigorian built an abstraction whose subject remains within the boundaries of the horizon or of a village whose dwellers work in the fields and inhabit mudbrick homes. In works such as his performative photographs of himself, buried in dugout cavities – the ultimate resting place that will eventually envelop us all – he assumed a darkly existential role by closing the parenthesis of life on Earth in an intimate physical contact with earth, his preferred medium.[74] His statement that 'humanity is pasted to the earth'[75] reveals the philosophical dimension of his attraction.

As intimated, Grigorian's abstractions were not immune from politics. Within the landscape of Iranian modernist art, he offered another way, quite distinct from Saqqakhaneh, to enfold the aura of the working class, more specifically the rural perspective, into art. In his youth in Iran, along with the younger Armenian artist Sirak Melkonian (b. 1931), he had been a member of Mshakuyt, the Armenian society that would be closed down after the 1953 coup and clampdown

on leftist organizations in Iran.[76] Melkonian, whose later abstractions were equally inspired by nature, especially the expansive landscape of Baluchistan, which he visited in 1972, has explained that in the circle of artists associated with Mshakuyt, nationalism was not the most important issue; internationalism was of greater importance. Melkonian, however, has denied the importance of politics in his own art, which to this day remains attuned to an abstract vision melting

38. Sirak Melkonian
Untitled, 1976
Oil on canvas, 110 x 110 cm (43½ x 43½")
Tehran Museum of Contemporary Art, Tehran

nature with the body: nerves, sinews, and bone structures delineating what may be read, perhaps, as the scaffolding of mountains and valleys (fig 38). Although Grigorian avoided bombastic rhetoric and visual clichés, his politics are visible in his crude medium, his interest in the marginal, the impoverished, the rural, and the coarse. Pure abstraction may not be the ideal conduit for overt political content, but Grigorian stands out as one of the few modernist exceptions who channelled his solidarity with the working class through his signature medium.

The Azad or independent association of artists

Grigorian was one of the few artists to channel politics through abstraction, but he was not alone. He was a founding member of the 'Azad' (independent or free) association of artists, along with the younger artists Melkonian, Gholamhossein Nami (b. 1936), Massoud Arabshahi (b. 1935), Faramarz Pilaram (1937–1982), Abdolreza Daryabeigi (b. 1931), and Morteza Momayez (1935–2005). A highly heterogeneous group, these artists, the majority of them steeped in abstraction, either organized or participated together in six exhibitions between 1974 and 1977. According to Nami, the association was a reaction against the mindless abstraction in vogue at the time.[77] The group and their exhibitions merit a separate, in-depth scrutiny. It is important, however, to at least acknowledge in this context some of the political works these artists produced. Nami, a student first of Ali Mohammad Heydarian and then of Vaziri, is best known for his abstractions, but, in rare instances, politics seems to have informed his work. He, too, arrived at his formal abstraction fortuitously. Once, running to answer the phone, he left a stretched canvas lying on a table, the corner of which pushed against the back of the canvas, creating volume on the surface. Seeing this, he realized that by allowing an ordinary object, such as a plate, to press against the back of the canvas he could hint at three-dimensional space without resorting to illusionism: with painting, he could create sculpture. In Nami's shaped and stretched canvases of the 1960s and 70s, protrusions create shadows that change with the position of the lighting, implicating time as an element in addition to space and keeping the works unfixed from a single reading (fig 39). In the Azad group's 1975 exhibition at the Iran– America Society in Tehran,[78] Nami showed *Hajm-e Ghadamgah* (Volume of Holy Footprints), a large white cube (fig 40). Embedded in its four vertical sides is a coded lexicon of incarceration, pain and obstacles. On one side is the trace of a foot that evokes the footprints of saints, a ubiquitous image in traditional Persian painting and at religious locations such as the city of Qom, where the artist was born. Formally

speaking, the footprint, as a negative space, alludes to volume, the theme of the show. On an adjacent side of the cube, Nami carved a knot, which refers to any kind of unresolved issue. Another side bears a representation of a shrine, a prison-like space enclosing a bundle of barbed wire reminiscent of a human head. The final scene is a homage to a South African female poet, a dissident feminist who is represented by a poem, prison bars, and the figure of a woman with her hands thrown high as if in protest.[79] Read together, the abstract images weave a narrative of dissent and repressive enclosure, not without a nod to religion.

In the same exhibition, in a darkened room Grigorian presented a chair tied up with ropes, one leg missing, and a slide projection of himself sitting on that unstable chair, reminiscent of interrogation

39. Gholamhossein Nami
Untitled, 1971
Acrylic on canvas, 122 x 122 x 20.3 cm
(48 x 48 x 8")
Tehran Museum of Contemporary Art,
Tehran

40. Gholamhossein Nami
Hajm-e Ghadamgah (*Volume of Holy Footprints*), 1975
Wood, fiber, sponge, glue, clay, electrical light, barbed wire, aluminium and synthetic polymer paint, 175 x 75 x 75 cm (68 x 29 x 29")
Boom Gallery, Tehran

sessions by the secret police (fig 41). Grigorian's contribution to an earlier exhibition by the group (entitled *Blue* and held in 1975 at the Takhteh Jamshid Gallery, considered by Nami to be the beginning of conceptual art in Iran) was based on a vulgar proverb involving faeces,[80] and it drew the ire of the Minister of Culture and Art. At the fifth exhibition of the group, *Volume and Environment II*, held in 1976 at the Saman Gallery in Tehran, Melkonian showed a shiny chrome cube, made that same year, which contained a tangle of dark, rusty wires in its core, perhaps a metaphor for the regime's concern for surface appearance at the expense of substance – a reading the artist may or may not subscribe to. In the same exhibition, Momayez planted knives in pots (violence having supplanted growth?),[81] placing them hierarchically on ascending stairs; the top object was in gold, a not-so-

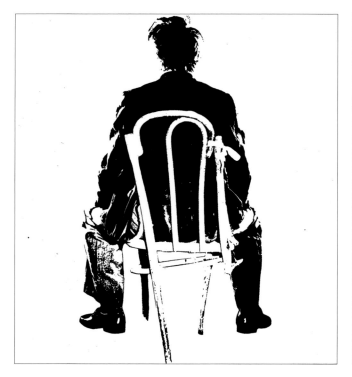

veiled political metaphor for monarchy. But if this exhibition remains controversial in the annals of Tehran exhibitions, it is because of a work by the Assyrian-Iranian artist Hannibal Alkhas (not part of the Azad group of artists), who at the last minute planted a shovel (he must have been familiar with Duchamp) in a container and wrote on it *akh*. The word means 'ouch,' but if it is pronounced after the word *beel*, for shovel, the result is *beel-akh*, the verbal equivalent of giving the finger. Using a conceptual language, Alkhas targeted the conceptual art on view. Communist in his politics, Alkhas remained conservative in his aesthetics; he was in awe of figurative art, such as Mexican mural paintings. The Azad artists, especially Grigorian, took the gesture personally, and a physical fight ensued at their next encounter.[82] In the same exhibition, Daryabeigi, best known for his lyrical abstract paintings, showed a work representing a map of the United States (supporters of the Pahlavi regime) in metal but with the stars exploding out of its surface (fig 42).[83] The formalist theme of this exhibition – volume and flatness or surface – turned out to be a subterfuge for a number of not-so-veiled political expressions using the languages of abstraction and representation in line with conceptual art.[84]

Even though a couple of the artists from the Azad group, including Momayez, had been questioned by the Shah's intelligence service, the SAVAK, the sixth and last exhibition of the group (all men, with the exception of Nazi Atri) was organized by the Queen's Private

Above left
41. Marcos Grigorian
Condemned Chair, 1973
Reproduced in the 1975 *Volume and Environment* exhibition catalogue held at the Iran–America Society

Above
42. Abdolreza Daryabeigi's *American Flag*, a metal sculpture
Reproduced in the 1976 *Volume and Environment 2* exhibition catalogue held at the Saman Gallery

Secretariat, which does not seem to have exercised any censorship. It took place in the context of the 1977 Wash Art fair, in Washington, DC. Momayez hung his knives from the ceiling, and Ahmad Aali presented a self-portrait photograph in which he is shown swallowing a real three-dimensional stovepipe linked to a stove, a work which, according to the artist, dates to 1964 (fig 43). The date is highly unusual for this type of conceptual work, which began to be discussed and displayed in Iran a decade later, when the Azad group was formed.[85] The artist has denied that there is any political message in the work and has explained it in formal terms (as demonstrating that photography can be extended into three-dimensionality),[86] but it is difficult not to read the image as a metaphor for suffocation, a term that in Persian denotes repression. Wash Art was held two years after the Rastakhiz Party was founded in Iran as the sole (mandatory) political party; the only other option was exile. The compulsory membership of all Iranians intensified the level of resentment towards the regime. Regardless of the date the work was executed and of Aali's intentions, the fact that the image was not rejected by the Secretariat speaks to the complex history of art and censorship in Iran before the Revolution. And this was not a unique case. In 1976, the Secretariat borrowed two works by the activist painter Nicky Nodjoumi (b. 1942) for an exhibition of Iranian modern art in Basel.[87] Were the art specialists at the Secretariat simply ignorant of the loaded meaning of such works? Or were they subversive themselves, not necessarily pro-Pahlavi in their hearts? (Firouz Shirvanlou was in charge of the artistic activities of the Secretariat and a major figure in the Institute for the Development of Children and Young Adults; he is said to have been a dissident who was allegedly co-opted and silenced. Or was he?) Or more likely, censorship of the fine arts was not as strict as it was for cinema and literature. Even for the latter media, escaping censorship was not an uncommon phenomenon. Samad Behrangi's *The Little Black Fish*, an anti-establishment children's book, was published by the government-sponsored Institute for the Intellectual Development of Children and Young Adults.[88] It was illustrated with drawings by Farshid Mesghali.

The Azad group aside, the political ramifications of abstraction in pre-revolutionary Iran are complex and slippery. Abstraction was never perceived by the Pahlavi regime as an act of defiance, nor was it intended as such by artists such as Sadr and Vaziri.[89] However, it might have worked, in a general way, to open up space for the freedom of expression. In that way, in a country where authoritarianism – be it exercised by the state or inside the homes of a paternalistic society – inhibits self-expression and the growth of individuality, it would have been, if not subversive, at least emancipatory.

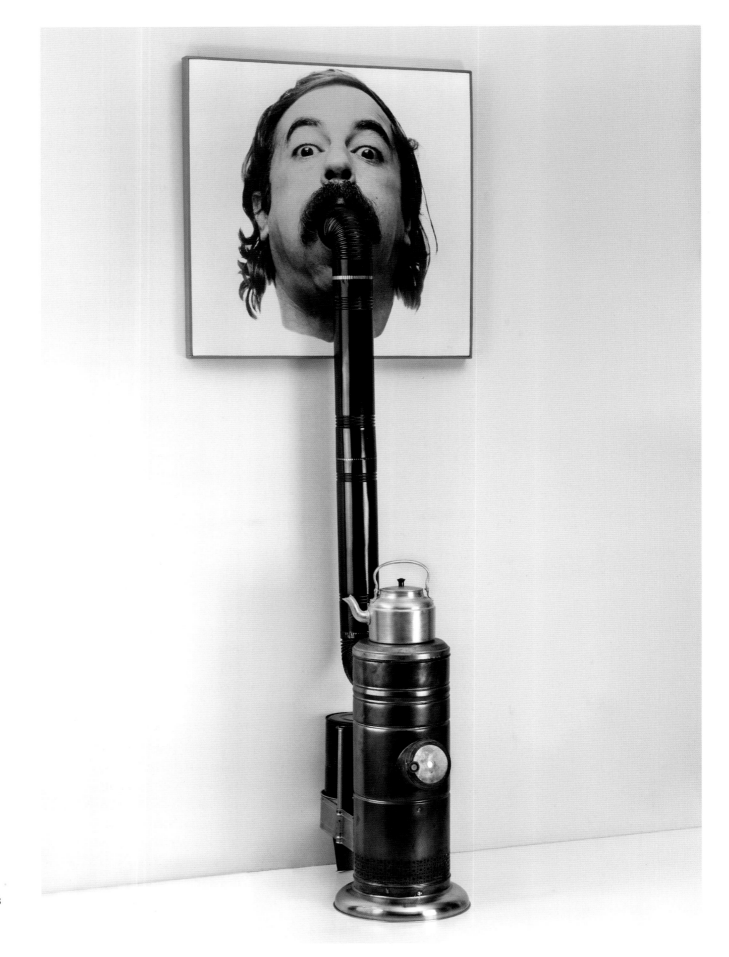

Opposite
43. Ahmad Aali
Self-Portrait, 1964
Reconstructed in 2010. Mixed media,
214 x 76.8 x 61.6 cm (84¼ x 30¼ x 24½")
Aaran Gallery, Tehran

Climate of dissidence and ambiguities

The history of dissent by painters and sculptors before the Revolution is a highly complex matter and is in need of much greater research and objective scrutiny than has been provided. *Iran: Unedited History, 1960–2014* exposed dissent during the Pahlavi regime as expressed in media other than painting, which was the privileged medium of the time. While it left out political paintings by artists such as Nicky Nodjoumi,[90] it managed, however, to simultaneously acknowledge some of the refined ambitions of the regime – as expressed at the Shiraz Arts Festival (1967–77), where both traditional and global avant-garde performances were showcased under the patronage of the Queen – and offer a critique of them, by also exhibiting a series of photographs by Kaveh Golestan (1950–2003), a photojournalist who probed the squalid living conditions of prostitutes in the red-light district of south Tehran.[91]

As indicated in the anonymous catalogue text for the 1979 exhibition at TMOCA, within the political sphere accusations and questions surfaced after the Revolution about the ethical integrity of artists. For example, a controversy brewed around the question of whether artists should have boycotted government institutions (first the Private Secretariat of the Queen and then TMOCA, when it overtook the Secretariat's acquisition program). Should those who didn't resist be considered collaborationists, as post-revolutionary critics suggested? My own position here is not to be an apologist for either the regime or the artists, some of whom, as I show in this book, created works of coded dissent, but to try to nuance some of the strident criticism of this period. In the foreign press, TMOCA has almost always been condemned for whitewashing the Pahlavi regime – a criticism that, even if legitimate, reveals an Orientalist bias because it denies Iranians the right of access to the international art of our time. The same criticism is not directed at certain government-supported American museums when American foreign policy favoured repressive regimes and regime change. According to one critic, the American sculptor Claes Oldenburg 'as a matter of principle opposed any of his works entering TMOCA's collection,'[92] but he does not seem to have objected to his works entering the Smithsonian. To be fair, American museums are mostly privately funded. As for the Smithsonian and all of its museums and collections, they are owned by the United States Government, acting in trust for the American people, to whom they truly belong. The Government covers about seventy percent of the total costs. Public programs, exhibitions, and special events are almost completely reliant on private (non-government) funding.

Some, I recall, argued (absolving Iranian artists) that the decision

to build a museum of modern and contemporary art in Tehran instead of spending petro-dollars to acquire military equipment from the United States was among the positive decisions of the Pahlavi regime. Such an institution, built with the nation's oil income, should also be considered to belong to the people rather than to the royal family, in opposition to what some foreign reviewers seem to suggest.[93] No matter what the final judgment, one further dimension of the issue needs to be taken into account. In my hours of conversation with a wide range of artists, many divorce the Queen's account from her spouse's. Acknowledging her contributions towards the validation of modern or contemporary art inside Iran and its visibility outside was not, and is not, an endorsement of the Shah. And, needless to say, the acquisition of a work by the government need not infuse the work with the regime's agenda.

Written testimonies by Iranian modernists would help in understanding their political mindset, but they are rare. Frank interviews are difficult to obtain because the Queen, to whom many artists feel indebted, is still alive, and the current administrators of TMOCA (and of the country) are watching. Writings by and interviews with more traditional, figurative artists do exist, however. Kamal al-Molk's sentiments towards two Qajar kings for whom he painted commissions in the late nineteenth century are well documented.[94] So are those of Bahman Mohassess, whose sculpture of the royal family was personally rejected by the Shah in the 1970s. 'In the group *Imperial Family*,' Mohassess stated, 'I accentuated the "grotesque" even more than what Goya had done with his *Royal Portrait*. Those of that time did not accept the work; these of now consider it as praise. It means that those before were the lesser imbeciles!'[95] In that same decade, Warhol created several portraits of the Iranian royals in different media, but not many Iranian painters, it seems, took on that project.[96] Mehdi Vishkai (1920–2006), a portrait painter, was among the few exceptions. Not a politicized artist,[97] or at least not antagonistic to the monarchy, Vishkai recounted how he was summoned to the court in a story highly revelatory of the climate of apprehension and paralyzing tension around the royal couple. In an interview conducted after the Revolution (it is important to mention), Vishkai presented a contrast between the haughty, awe-inspiring personality of Mohammad Reza Shah and the more down-to-earth, kindly behaviour of the Queen.[98] The first time he was summoned, thinking he was being driven to the palace in Tehran, he dressed in formal attire, only to find himself taken to a beach resort, where he stood in unbearable summer heat ignored by the Shah until the Queen intervened. He described in the same interview another occasion when officers called at his home while he was on a visit to his brother. When no one answered the door, they

stormed his house, almost breaking in. The doorman then let them in with his key to reassure them that the painter was not hiding. When they finally found him, Vishkai feared they had come to arrest him. He was not informed that he would be painting a portrait of the Queen of Thailand or the destination of the ride, once in their car, until he heard one of the guards tell the driver to go to the Golestan Palace. Artists such as Oldenburg or Jean Tinguely, who opposed the Shiraz Arts Festival, operated free of risk, without any fear of retaliation. Their decision to boycott the regime does not elevate them ethically over Iranian artists who chose differently, as those latter artists had to worry about the consequences of their decisions.

Apolitical formalism

Before the Revolution painters such as Naser Assar, Sonia Balassanian, Kamran Diba and Maryam Javaheri, to name a few, were engaged with non-repesentational abstraction. There were others who, strictly speaking, were not abstractionists and whose work too was not informed by politics. Theirs was an art of figuration but with a fundamental concern with formalist abstraction. Manoucher Yektai, discussed in Chapter One, is one artist who rejected the abstraction–figuration dichotomy; Leyly Matine-Daftary (1937–2007) was another. As explained in *Iran Modern*, for her, 'abstraction was a goal and figuration the means of achieving that goal [...] Fereydoun Ave, an artist, graphic designer, influential art impresario, curator, gallerist and close friend of Matine-Daftary to the very end when she lived in exile in Paris, succinctly summarized the core idea of her oeuvre when he stated that the abstract division of space was her main concern.'[99] Whether painting objects, nature (fig 44) or people, such as the portrait of Lydia Sitbon (fig 45), she focuses on extreme simplification of form, freshness of colour, and the reduction of space into flat areas, free from subservience to the logic of positive volume inhabiting a negative space. Right after the 1953 coup that removed her grandfather, the prime minister Mohammad Mossadegh, Matine-Daftary, who was studying in England, entered the Slade Academy of Art (1954–9) where Lucian Freud was one of her instructors; she always shied away from political themes.

Figuration and abstraction as conduits of Islamic identity

In the decade after the Revolution, when the Islamic Republic was consolidating itself and the Iran–Iraq War was raging, art inside Iran

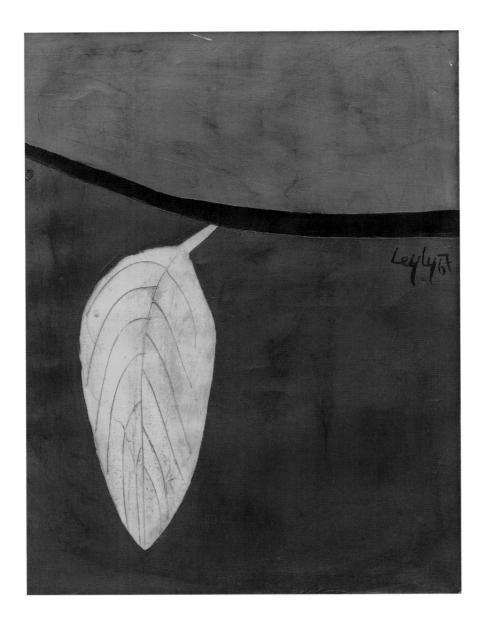

Left
44. Leyly Matine-Daftary
Still Life, 1967
Oil on canvas, 78 x 58.5 cm (30¾ x 23")
Mohammed Afkhami Foundation

Opposite
45. Leyly Matine-Daftary
Lydia, 1975
Oil on canvas, 130 x 97 cm (51³⁄₁₆ x 38³⁄₁₆")
Centre Georges Pompidou, Paris

took on a propagandistic turn and a figurative style purportedly accessible to the dispossessed masses. Didactic figurative art was not privileged just by the regime; it was also demanded by the Left. The leftist poet Ahmad Shamloo, for instance, is said to have issued a proclamation stating that any art that did not revolve around the human figure and condition was invalid.[100] Options such as those offered in the earlier twentieth century by the avant-garde post-revolutionaries in the Soviet Union – the Constructivists and Suprematists – were unavailable to Iranian artists. A group of artists born in the 1950s became affiliated with the Art Bureau of Islamic Propagation, simply referred to as *howzeh*, the main artistic voice of revolutionary aesthetics.[101] Kazem Chalipa (b. 1957), for one, exemplifies

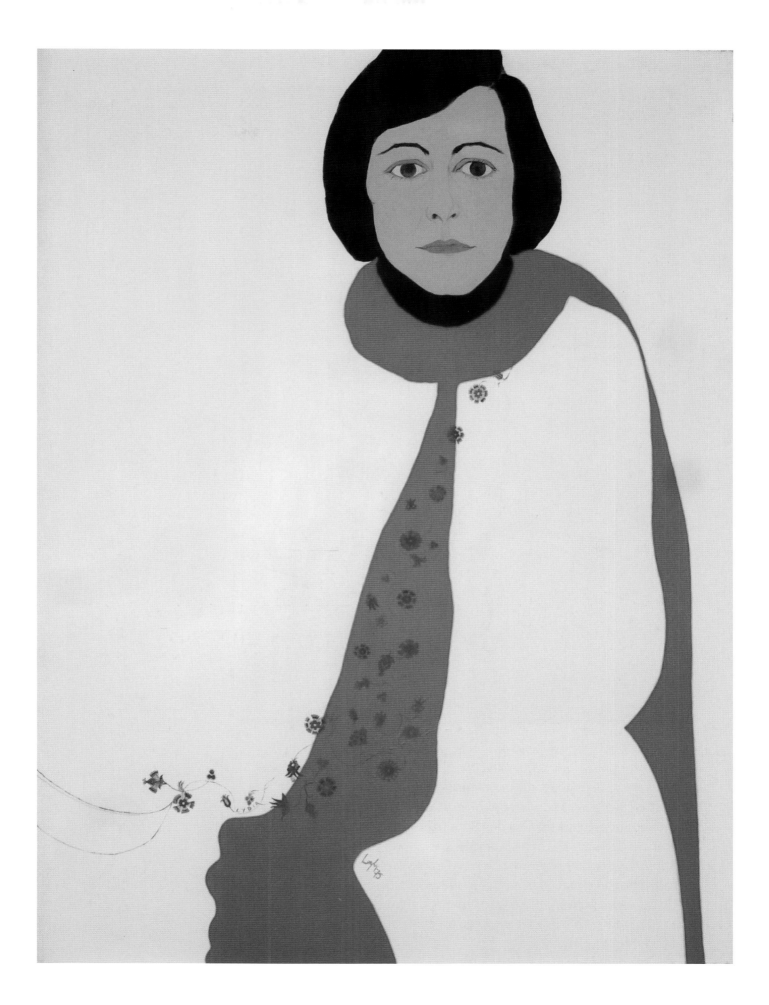

46. Kazem Chalipa
Self-Sacrifice, 1982
Oil on canvas, 300 x 200 cm (118 x 72")
[Dimensions taken from postcard published
by the Bureau of the Islamic Propagation
Organization]

this type of artist. His anti-monarchist beliefs and his glorification
of the Revolution, the war and the martyrs, along with his didactic,
moralizing parables and his devotion to Islam and the Islamic regime
make him a quintessential 'Islamic' artist, a term I have opposed when
applied indiscriminately to anyone from the vast region stretching from
Indonesia to Morocco from the seventh century until today.[102] This
art, though appropriately termed Islamic, is, paradoxically, anchored
in a figurative style heavily indebted to Western representation. For

example,[103] Chalipa's *Self-Sacrifice* (fig 46), which dates from 1982, presents, like a myriad of Occidental Christian paintings, a scene divided into the earthly and the otherworldly realms. The central representation depicts the proud grieving mother of a martyr from the Iran–Iraq War, a theme derived directly from Christian representations of the Virgin Mary cradling the lifeless body of Jesus Christ. The rest of the iconography is fabricated to suit the discourse propagated around the war: the Mahdi, a luminous rider on a white horse, soars in the ethereal sphere above, which is inhabited by what appear to be shrouded martyrs. Believed to be protecting the warriors, he presides over the bloody battlefield in the infernal scene below. The only aesthetic element recalling traditional art is the medieval arch framing the scene and the calligraphic writing citing passages from the Qur'an regarding the fight for God and the promise of paradise.[104]

Not all supporters of the Revolution, however, turned to representational art. Two artists, the married couple Mir Hossein Mousavi (b. 1942) and Zahra Rahnavard (b. 1945), engaged in abstraction, a trope congenial to the aesthetic tenets of Islam. As reported in an enlightening documentary prepared by Hamed Yousefi for the BBC Persian service, Mousavi was an artist deeply allied with the Islamic regime – as Prime Minister from 1981 to 1989, he was part of the ruling elite – but one whose aesthetics diverged from the other Islamic revolutionaries.[105] He embarked on abstraction in the 1960s. Early examples of his work, from 1967 and 1972, are in the collection of the Grey Art Gallery, and later examples, from 2005, are owned by TMOCA (fig 47).[106] His writing, a window into his thinking, is exemplified by an essay he wrote in 1967 (1346) for the thirty-sixth solo exhibition mounted at the Talar-e Ghandriz (originally named Talar-e Iran). This gallery was founded by Mousavi with Ru'in Pakbaz, Mohammad Reza Jodat, Morteza Momayez and Mansour Ghandriz.[107] As Yousefi has pointed out, a striking note in this essay is the elevation of chance, or what Mousavi calls 'accident,' an idea he seems to connect with Taoism and Zen. Yousefi has speculated that Mousavi might have known about John Cage's interest in chance and Eastern philosophy.[108]

Mousavi's style has evolved, but his embrace of 'accident' is visible in his recent works, some of which were exhibited at the Berliner Akademie der Künste in 2013. In his documentary, Yousefi has used footage of Mousavi at work that clearly illustrates the artist's technique. The artist drops geometric-shaped metal plates covered with paint on white paper to create forms in blazing colour whose contours dissolve in smoke. The process is enhanced by the application of a heat source on the back of the metal plates. By the time the Berlin exhibition, entitled *Meditationen der Freiheit* (Meditations on Freedom),

Opposite
47. Mir Hossein Mousavi
Untitled, 2005
Oil paint on paper, 85 x 55 cm (33 x 21")
Tehran Museum of Contemporary Art

Below
48. Zahra Rahnavard
Untitled, 2005
Mixed media, 120 x 65 cm (47x 25")
Tehran Museum of Contemporary Art

opened, Mousavi had become renowned as the opposition leader who, after the controversial 2009 election results, was under house arrest in Tehran. The exhibition placed his drawings and his use of abstract writing in a formalist line parallel to Western modernists such as Cy Twombly, Yves Klein and the Arte Povera group.

Rahnavard was also a supporter of the Revolution, and she also followed the path of abstraction, at least in some mixed-media works housed at TMOCA; whereas in her sculpture, such as the mother and child figures located in a Tehran square, she did not.[109] Little information is available on her art, and she, too, has been under house arrest since the 2009 election. In 2002, however, she edited the book *Contemporary Art and the Islamic World*, which was published by Tehran's Al-Zahra University, a school for women, where she held the position of chancellor. A short biography in that publication states that 'she has

published 18 books in the fields of the Quranic studies, art criticism, art theories, women studies, and political sciences [*sic*],' and that she has taught at Tehran University.[110] Her adoption of abstraction may be explained by some of her statements in the book, statements that may also reflect her spouse's approach towards aesthetics. She argues that 'today the attempt to preserve Islamic identity, by taking advantage of artistic traditions and at the same time adopting innovation, determines the status of Islam and Islamic arts in the confrontation with the said mega-trends and helps it to play a leading role at a global level.'[111] For her, the important point is to not abandon the Islamic part of the equation, which she models after 'the Qur'anic concept of the "bond between heavens and the earth."'[112] Thus the 'ideal' would be a bond between the invisible and the visible world,[113] a communication that abstraction can facilitate.

A 2005 untitled mixed-media work by Rahnavard in TMOCA's collection (fig 48) features a series of ascending circles, perhaps a constellation, which climaxes in a circle vaguely suggesting human – female, I would say – facial features. Mousavi has also made use of circles, and some of his works feature a sketchy ladder – perhaps a symbolic element linking the worldly and heavenly spheres. Contemporary artists such as Mousavi and Rahnavard defy the equation of abstraction with westernization. They also debunk binary oppositions between Islam and modernity and between formalist or symbolic abstraction and politics. Their work bears out the idea, maintained, for example, by the anthropologist Fariba Adelkhah in her *Being Modern in Iran*, that if modernity is not equated with westernization, progressive practices can be detected inside the Islamic Republic of Iran.[114]

Abstraction and figuration as resistance and critique after 1979

Mousavi and Rahnavard, insiders in the Islamic regime, not only did not find abstraction objectionable on political grounds but they may have enlisted it as a conceptual conduit through which to affirm their Islamic identity. Others, not aligned with the state ideology, pursued various degrees of abstraction as a refuge from the new repressive propagandistic norm. Abstraction protected such artists from subservience to rules such as the Islamic codes of representation for women, and it allowed them to avoid the collective thinking and the ready-made iconography promoted by the Islamists and the leftists alike, who merged, at least at the onset of the Revolution. Raana Farnoud (b. 1953) and Farideh Lashai (1944–2013), two women who

had both been imprisoned during the Pahlavi regime for their leftist sympathies, were too independent to submit to partisan politics after the Revolution.[115] Discombobulated by the Revolution, they chose a self-imposed silence for a while, followed by a metaphorical form of dissent in the guise of abstraction or semi-abstract figuration which, however, veered away from sloganeering tendencies. Farnoud, an articulate and astute observer of the post-revolutionary artistic scene, has explained that during the decade or two after 1979, when the country was isolated from the world and from the various aesthetic languages of identity politics current abroad, a number of artists inside Iran leaned towards abstraction, without totally purging it of representational ingredients. It was an outdated tool, but the only one at their disposal with which they could affirm a passive-aggressive resistance to mandated forms of illustrational identity. 'Contrary to any ideological authority,' Farnoud has said, they followed a 'path which allowed individuality, a notion frowned upon by the collective thinking of both the Islamists and the leftists.'[116] Individualism continues to be frowned upon by Marxists and post-Marxists of our day, 'not least because,' Claire Bishop has written, 'the commercial art system and museum programming continue to revolve around lucrative single figures.'[117] In discussing the immediate aftermath of the Revolution, when galleries closed, art patrons fled the country or were rendered impotent, and dissenting voices were silenced, this line of criticism does not apply. Under authoritarian regimes, which crush individualism, defending it becomes a vital necessity, a strategy for survival. In Abbas Milani's words, empowering the individual, individualism, is a cardinal element of modernity.[118]

Farnoud asserted hers by turning first towards representation, but with apolitical subject matter, and, later, in the 1990s, to abstraction. By 1988 she had exhibited her representational works at the Seyhoun Gallery; she moved to abstraction in the mid 1990s. In stark contrast to the glorification of war and martyrdom advocated by the revolutionary propaganda machine in the 1980s and early 90s, Lashai and other artists, as well as filmmakers such as Abbas Kiarostami (1940–2016), turned their gaze towards life-affirming subjects and sublime beauty, whether in nature or in the magnanimous deeds of human beings. Before turning to a pronounced abstraction such as that on display in an untitled work of 2009 (fig 49), towards the end of the Iran–Iraq War in the late 1980s Lashai painted ethereal flower vases. Even earlier than Lashai, starting in 1978, Kiarostami, turned his gaze in his photography away from the cacophonous urban scene, with its violence and revolutionary slogans, to focus on trees and the silent beauty of nature (fig 50).[119] As 'dépassé' as these images were in terms of iconography (to use Farnoud's terminology), they may be interpreted

49. Farideh Lashai
Untitled, 2009
Oil on canvas, 200 x 200 cm (78 x 78")
Private collection

50. Abbas Kiarostami
Untitled (from the *Snow White* series),
1978–2016
Silver gelatin print on paper and ink print
on canvas, in 3 panels, each 100 x 189 cm
(39½ x 74")

as ciphers of resistance because of the artists' refusal to dwell on death and destruction and other themes either with a propagandistic baggage or an overt political content. In an expression of passive defiance, they contradicted the pervasive anti-aesthetic stance and instead offered lyrical imagery as an antidote to the unsightliness of war and a social life drained of colour. In his 1987 film *Where is the Friend's Home*, Kiarostami glorified loyalty and friendship in a period when the regime was encouraging the opposite: turning in anyone, even friends and family, for dissident activities.[120] Casting children allowed Kiarostami to bypass the adult dress codes mandated by the regime for the field of representation; it is also a metaphor for innocence and noble intentions, contradicting the imposed ethics of the time.

Lashai, late in her life, began adding figuration as a layer projected onto her abstractly painted canvases. She drew inspiration from literature and appropriated images from foreign films and Persian B movies. As a disciple of 'doubt and uncertainty,'[121] she found figuration suitable for challenging fixed meanings. The hybrid

51 a–c. Farideh Lashai
Luncheon at Mellat Park, 2010
Oil, synthetic polymer paint and graphite
on canvas, 176 x 235 cm (69 x 92")
and video projection
The Farjam Foundation

medium of painting and video allowed her to tackle representation in a Brechtian vein, for instance in her *Déjeuner au Parc Mellat* (2010, figs 51 a–c). Based on Manet's *Déjeuner sur l'herbe* – itself based on Marcantonio Raimondi's print after a Raphael painting, itself inspired by reliefs from antiquity – the piece obliquely draws attention to gender relations, a sensitive and controversial issue in contemporary Iran. The image of Manet's painting fades away and slowly morphs into a photograph of three contemporary Iranian youths, two men and a 'badly hejabed' (the phrase used in Iran) woman. An interval of almost 150 years separates the two images. Manet's painting shocked its audience in 1863, when, rejected by the official Salon, it was exhibited at the Salon des Refusés. Rehabilitated in the West, Manet's painting shocked the censors in post-revolutionary Iran, where it has not escaped intact in art history books and magazines (fig 52).[122] The contemporary image in Lashai's *Déjeuner*, that of a young woman (head unveiled and legs exposed) socializing with two young men, defiantly challenges the mandated codes of behaviour in both Iranian reality and the field of representation there. Lashai staged a situation that is clearly a construct. As such it contains the seeds of change – or at least permission to envision change, to imagine the passage of time erasing prevailing values. Projections that come into focus, dissolve and reappear as new images were Lashai's tools in narrating instability and shifts in meaning. These were not merely wishes for change but a political agenda – one, however, that remained devoid of certainties and was as fleeting as the images she projected.

52. Illustration of Manet's *Déjeuner sur l'herbe*, in *Mofid*, no.7 (1366 [1987]), p. 43

53. Nosratollah Moslemian
Untitled, 1992
Acrylic on canvas, 120 x 120 cm (47 x 47")
Tehran Museum of Contemporary Art

Nosratollah Moslemian (b. 1951), choosing abstraction, the '*dépassé*' generic modernist language, has translated the ravages of war and its brutality into entangled knots of lines without any representational reference.[123] In other instances, when he found inspiration in Persian aesthetic traditions, he has scattered into a landscape of colourful forms and autonomous lines (in the vein of Kandinsky's abstractions) figurative debris, such as cypress trees, ubiquitous in 'Persian miniatures', and a severed hand, a reminder of the ongoing war (fig 53). The result is a space of paradoxes and fragmentation, not unlike Iranian society, then and now, torn between contradictory claims and definitions, at times looking for local 'authenticity,' at other times escaping from it.

Kourosh Shishegaran (b. 1944) began as an activist, producing bold graphic posters in celebration of freedom. At times they featured a different vision for the future from the Islamic regime's. He was arrested and incarcerated from 1982 to 1983.[124] His concern was to make his work accessible to the masses, hence his adoption of posters as a mode of production.[125] Starting in the mid 1980s, he focused on linear abstractions painted on canvas (fig 54). While abstract, the intimation

54. Kourosh Shishegaran
Hanged Man, 1985
Oil on canvas, 185 x 185 cm (72 x 72")
Collection Laleh Javaheri-Saatchi and Cyrus
Pouraghabagher, New York

of a hanged figure, clearly spelled out in the title, aligns Shishegaran's abstraction with dissidence. Cynical critics, overlooking the political content of Shishegaran's abstract paintings of the past three decades, may view the artist as having surrendered to the lure of the market, but this may not be a verdict beyond a reasonable doubt. His linear abstractions remain anchored in his graphic art. His signature writhing, intertwined tangles dominate the field, but the restricted palette of the posters has been expanded and the representational element has vanished or is elusively evoked. Is abstraction in this case a strategy of concealment for a silenced artist whose posters mythologized Mossadegh (1979), trumpeted peace for Lebanon (1976) and freedom of the press (1979) – a means to continue the outcry without the clear articulation of the cause? Or is it simply a capitulation? The organizers of the *Unedited History* exhibition in 2014 did not entertain this doubt. They displayed the graphic art, not the abstract paintings.

55. caraballo-farman
Stills from *Reason Is A Name Given to Collective Thought*, video, 2002–3

Abstraction and figuration in contemporary art

The abstraction-to-figuration continuum did not become less political in the new millennium. Seamlessly, abstraction and figuration merge in works by a younger generation of artists, in the contemporary moment outside and inside Iran in a range of media: for instance in a video projection by the collaborative duo caraballo-farman, earlier on based in New York; the sculptural installations by Peyman Shafieezadeh (b. 1983) living in Tehran; and a series of artist's books by Asareh Akasheh (b. 1984),[126] who was educated in Tehran, where she continues to live. The collaboration between the Argentinean-born Leonor Caraballo (1971–2015) and the diasporic artist Abou Farman, who was born in Iran in 1966 but educated in Switzerland, Canada and the United States, dates from the year 2000. Obviously, the social context of this collaborative partnership differs drastically from that of artists who live in Iran, yet the art is not without resonance with the discourse at hand. In *Reason Is A Name Given to A Collective Thought* (2002–3, fig 55), filmed in a stadium in Argentina, Caraballo and Farman capture the behaviour of a crowd as it morphs, fades and dissolves from distinct individuality into an abstract and amorphous entity.[127] At first the work is silent and appears to be a still colour photograph; then the sporadic movement of a few heads signals that one is watching a moving image. Gradually the muted crowd and pregnant stillness turn into a crescendo of collective jubilation and mass euphoria, culminating in a spectacular explosion of energy. Finally, abstraction, drained of colour, prevails over the earlier realism of figuration. While Farman's background in anthropology informs the project, the political implications of the transformation of individual conduct into mass behaviour – a conspicuous phenomenon in the early days of mass demonstrations in Iran and somewhere present in Farman's consciousness – are implicit in the work. In discussing the project, Farman has invoked sports fans but also the popular uprisings that followed Argentina's economic collapse: 'In Argentina football fans also are a political constituency – we filmed lots of protests in Buenos Aires and we filmed stadiums as well – the collective can have two sides, it can empower the individual and it can eliminate the individual and the two things are not opposites.'[128]

Peyman Shafieezadeh too looks at individuals and crowds, but in the context of the Islamic Republic. His installations, at first glance, look like ordinary scaffolding and railings, both inside and outside the gallery space (fig 56). Imagery is deliberately obfuscated. On closer scrutiny, the poles reveal in some cases revolutionary slogans executed in a calligraphic manner, crowds of demonstrators, and barely decipherable faces etched into the metal (fig 57). These

faces are reductive versions of the most ubiquitous portraits of leaders and dignitaries of the Islamic regime displayed on gigantic billboards. Relegated to peripheral vision, reduced to illegibility, to abstract markings, not only are these icons of authority deflated in importance and denied of omnipresence, but they invite fresh readings of overexposed representations of power. To paraphrase the artist, for him the images, even though practically invisible, are engraved in the subconscious like a pattern.[129] Anonymous crowds adorn other sections. In one of his installations, framing the path of viewers in the gallery, Shafieezadeh portrayed the masses that proceeded along the main arteries of the city during the election protests in 2009. In other works, such as an empty frame composed of poles, Shafieezadeh pushes the idea of representation-versus-abstraction to such a degree that instead of a portrait existing within the frame he offers an empty negative space, a kind of invisible mirror metaphorically reflecting all viewers, confined by poles etched with elongated and distorted faces of high-ranking individuals. Figuration plays hide-and-seek with abstraction in a game imbued with a phenomenological, psychological and political agenda.

Problematizing realism and abstraction continues in Akasheh's work. For her artist's book series, she uses manipulated and altered

Opposite top
56. Peyman Shafieezadeh
Installation view of *Negative Positive Space*
exhibition at Etemad Gallery, Tehran, 2016

Opposite below
57. Peyman Shafieezadeh
Untitled (from the *Negative Positive Space*
series), 2015
Engraving on aluminium pole, 200 x 5 cm
(78 x 2½")
Collection Simin Dehghani

photography, drawing on the intimate register of family life and autobiography. She began her parodies of family albums, entitled *The Lack of the Other: Tehran, circa 1360* [1981], (figs 58–60) in 2015. As you leaf through their pages, the veiled imagery oscillates between hazy figuration (mostly body fragments) in vaguely suggested scenes and close-ups blown up to abstraction. Defaced and erased with paint thinner, neither photography nor drawing, the unfixed imagery evokes time past and a murky atmosphere, favouring questioning and uncertainty over factual recording of past moments. Akasheh has described her work: 'In size these images do not conform to the standard of printed photographs. Nor are the sides even. The corners too are at times torn. They look deliberately handmade.'[130] The images mimic photography in its recording role, but withdraw when it comes to yielding a clear-cut narrative. Most of the images belong to a time before the artist was born or when she was too young to remember. Some revolve around her mother's wedding, an occasion of joy, glimpsed through detail after detail of a raised hand intermixed with abstract imagery, then perhaps a vague profile (the bride's), clapping hands, then the face again (this time as a black stain), and more fragments of the dancing body of the bride. Others mark the artist's birth at the hospital lying on the bed with her joyful mother or a dead corpse, it is not clear which. More images capture a classroom with children; yet others, taken with a cell phone during a visit to a prison or *bazdashtgah* (detainment centre) – set up under the Pahlavi regime, continuing to operate as such under the Islamic Republic, and in 2003 turned into the Ebrat Museum – provide the lexicon for a gruesome storyline of pain that remains unspoken. The images divulge little: the headboard of a bed the spread legs of a raped woman culled from the Internet, the aura or ghost of a figure shifting between presence and absence, an embrace of two figures, and many close-ups of indecipherably abstract imagery perhaps of use only as forensic clues or representing sensed but as yet unarticulated memories.

While she conjures a time of innocence, of her beginnings, she conflates it with an era in recent history steeped in violence. In the 1980s, the twin wars the regime waged – against Iraq and, internally, against opposing ideologies – resulted in a dark reign of terror that affected many lives, including the psyche of a child. In a collusion of abstraction and figuration, each obscuring or cancelling out the other, Akasheh brings the personal and the political together, sieves them through her faded memory, and renders them amorphously present. Not unlike the Belgian painter Luc Tuymans, who never speaks directly, Akasheh revisits a politically troubled era as sensed by a confounded child. With images that offer few clues, she pieces together an elusive narrative in which the aftertaste of trauma lingers on.

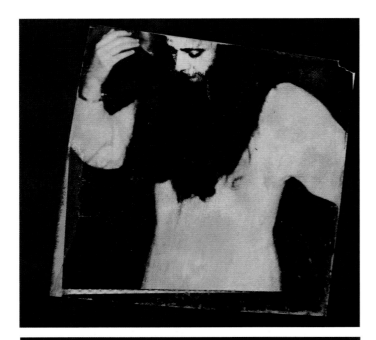

58–60. Asareh Akashi
The Black Book (from *The Lack of the Other* series), 2015
Transfer image, oil, petrol and varnish on paper, 32 x 32 cm (11½ x 11½")
Collection of the artist

Abstraction beyond politics: spirituality before and after the Revolution

When abstraction fuses with mysticism it deliberately transcends politics. Just as Kandinsky equated representation with materialism and abstraction with spirituality, Iranian artists fed on poetry by mystics left the verifiable world for one constructed through various degrees of abstraction. Among them are two painters who were friends: Sohrab Sepehri (1928–1980), a poet and a mystic himself, and Abolghassem Saidi (b. 1926). Both came to prominence before the Revolution and neither is wedded to full non-representational abstraction. Sepehri viscerally identified with nature. He painted floating, telegraphically indicated marks that stand for trees. The works nod with admiration at the Zen-like simplicity of Japanese monochrome ink paintings and drawings, which the artist could have seen in Tokyo in 1960–1 when he studied woodblock printmaking there. A native of Kashan, a small town on the edge of the desert, Sepehri translated the austerity of his native landscape into a sparse, minimalist aesthetic free of distraction (figs 61 a–c). In contrast, Saidi has concocted lush constellations of floating flower-like motifs that seem to propose a vision of paradise in its bountiful fecundity (fig 62). Aydin Aghdashloo, writing on Saidi's often rootless imagery, regards the work as 'bringing news from a familiar place,' which he identifies with 'our *neyestan*,' or land of the reed – a direct reference to the first verses of Rumi's *Masnavi* and the Sufi belief in banishment from home, a separation from origins, or an incompleteness remedied with a return to one's divine essence.[132] Both artists intimate weightlessness. Lashai talked about weight and lightness as formal considerations,[133] but weightlessness may also be considered through the prism of spirituality. It enables the passage from here to there, from matter to spirit, and thus lends itself to the quest for transcendence. Saidi, when asked how important spirituality is in his work, has confirmed its importance only 'if by spirituality you mean transcendence.'[134] Living in Paris, to this day he perseveres in his quest with the same kind of imagery.

Pooya Aryanpour (b. 1971), from a much younger generation and living in Tehran, pushes abstraction to ethereal dimensions. Ghostly, immaterial vapour, swirling and fleeting, inhabit the spaces he created in the 2000s. He is best known for his red and white paintings.[135]

Enhanced abstraction, a channel to spiritual transcendence, reaches unprecedented heights in the hands of Shirazeh Houshiary (b. 1955), a contemporary diasporic artist living in London. (She is discussed at greater length in the following chapter.) Houshiary began her mature work in the 1990s, by which time she could have observed from a distance how politics and religion had torn her native country.

111

61a–c Sohrab Sepehri
Untitled, 1967
Oil and charcoal on canvas, triptych,
100 x 300 cm (39½ x 118") each
The Farjam Foundation

She embarked on a project of erasing from her work any sign marking ethnicity, gender, culture, nationality and politics, which she considers divisive. Instead she conjures a vision that embraces all humanity.

As demonstrated in this chapter, in the work of Iranian artists abstraction is fixed neither in form nor in meaning. It transitions easily into figuration and meanders through a multiplicity of philosophical positions. Its fluidity allows it to articulate a myriad of affiliations stretching from the local to the global, and beyond into the spiritual. It may refer to tradition, just as it can supersede tradition and give birth to new visions. It coincides with the secular aspirations of one regime as well as those of its revolutionary nemesis. While it may expediently camouflage self-censorship or signal apathy towards politics, it can also be a subterfuge, a safe haven for political critique. And finally, artists have easily switched to figuration and effortlessly returned to abstraction. Just as realism and figuration have the ability to navigate different political landscapes, abstraction, too, has had a peripatetic trajectory. Whether a site of personal or cultural identity, a place of political resistance or neutrality, or a space for meditation, abstraction in Iran and its diaspora should be considered for its ability to convey a variety of ideological positions instead of being simplistically condemned as art for art's sake.

62. Abolghassem Saidi
Untitled, 1973
Oil on canvas, 200 x 200 cm (78¾ x 78¾")
Collection Sam Bayat and Charlotte
Denise Madeleine Bayat

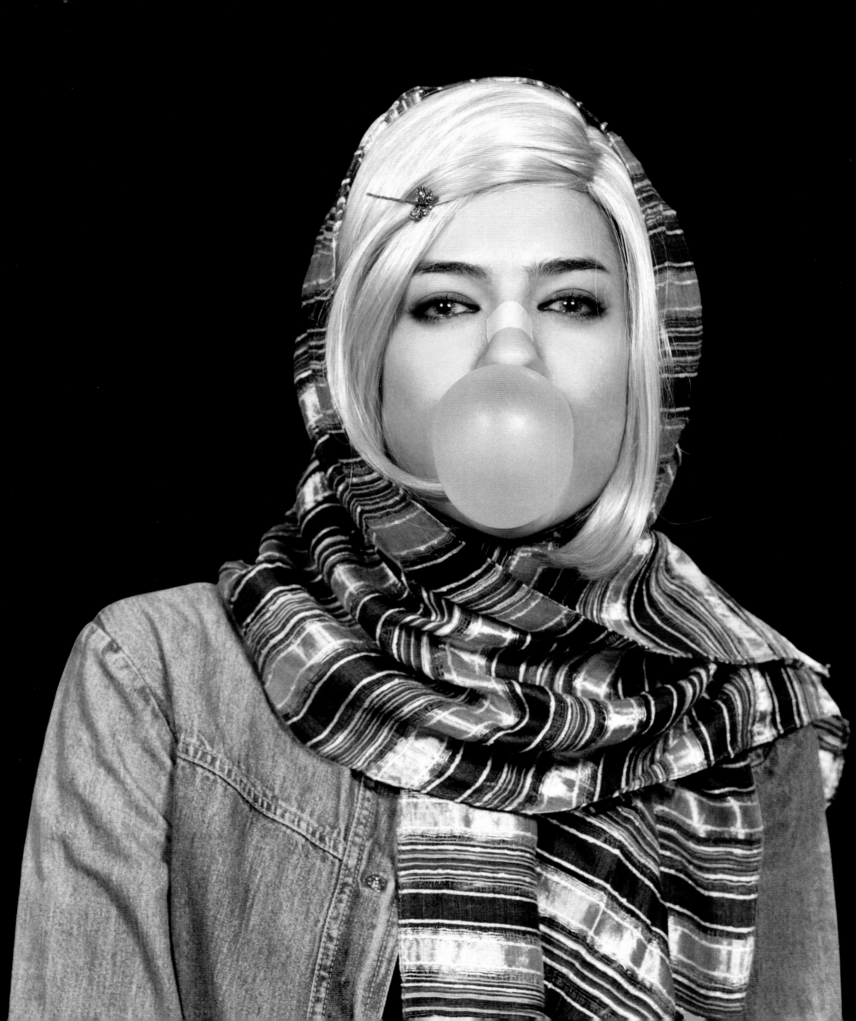

Chapter Five
The Tip of the Iceberg: Contemporary Art in and out of Iran

The term 'contemporary' is elastic in its meaning and slippery in its origins.[1] It generally signals the tail end of the modern era (a convention now globally adopted), a period closer to the present, and, in Iran, new aesthetics and concerns that were mostly absent before the 1979 Revolution. Its onset is by no means clear-cut. Our use of the term here shall exclude the modernist art of the pre-revolutionary era, discussed elsewhere in this book, but also the 1980s. That turbulent decade, presided over by a two-term president, the conservative cleric Ali Khamenei (1981–1989), introduced ideologically partisan and didactic painting that trumpeted Islamic values and glorified the martyrs of the Iran–Iraq War. From today's perspective, that kind of aesthetics is already historical. For this author, art, to be considered contemporary, must involve itself with issues that are still relevant today. As I maintained in Chapter One, the contemporary period in Iranian art begins in the 1990s, with the gradual shift to subversive art inside Iran and the emergence of new artists in the diaspora.

With the proliferation of exhibitions, picture books and monographs, the literature on Iranian contemporary art is rapidly expanding.[2] During the preparation of this book, two scholarly publications on the subject appeared in English that are noteworthy for their exhaustive research. While the intention here is not to offer a critical review, some differences in viewpoint may be noted. Of the two, Hamid Keshmirshekan's 2013 survey appeared first.[3] It is

enlightening especially for its abundant use of sources published in Persian, which are more easily accessible to scholars living in Iran and are therefore highly valuable. In this survey, entitled *Contemporary Iranian Art: New Perspectives*, Keshmirshekan (contrary to the periodization I follow) conflates under the rubric 'contemporary' the modernism of the 1940s and 1950s, the Saqqakhaneh movement of the 1960s, post-revolutionary art, and the discourses of the mid 1990s onward. In this respect, he follows the practice of his undergraduate teacher Ru'in Pakbaz, the prominent art historian who has influenced a great number of students in Iran. Pakbaz, too, labels the entire twentieth century as contemporary.[4] In his investigation of what I consider to be contemporary art proper Keshmirshekan privileges the Reformist era. This period began in 1997, when Mohammad Khatami (1997–2005) succeeded Akbar Hashemi Rafsanjani (1989–1997) as president, bringing about the easing of restrictions. Focusing mainly on sociopolitical context, Keshmirshekan's narrative revolves around the shifting political and commercial realities that influenced the infrastructure for the arts and the growth of contemporary art: the relatively more open political climate inside the country during the Khatami presidency, the expansion of the art market (both globally and locally), and the proliferation of exhibitions in galleries and especially at the Tehran Museum of Contemporary Art (TMOCA). This institution was reinvigorated under the reform-minded director Alireza Sami-Azar (1998–2005). Keshmirshekan does not, however, focus on the emergence of dissident art in the period following the reformist presidency of Khatami, after 2005. With a few exceptions, artworks themselves – while profusely illustrated and the names of the artists listed – do not receive a level of analysis and attention comparable to socio-economic issues.

The other recent publication, *Contemporary Iranian Art: From the Street to the Studio*, by the architectural historian Talinn Grigor, provides an original angle, astute observations, and ample sociopolitical context for readers who are unfamiliar with the contemporary history of Iran, and it makes for most engaging reading.[5] In Grigor's view, the 1979 Revolution ushered in the contemporary period. I take issue with this chronology on the basis that both the art and the discourses of the 1980s, the period of the Iran–Iraq War, have long been surpassed. They occupy a substantial part of her book. The change from the days of Ali Khamenei's presidency, in the 1980s, to Hassan Rouhani's today is perceptible even in the official rhetoric of Tehran mural paintings: earlier militant imagery has been painted over with bland pastoral landscapes inspired by classical Persian painting. In my own treatment, the contemporary postdates the 1980s.

In her prologue, Grigor candidly exposes the various obstacles any historian (or curator, I might add) of Iranian contemporary art

encounters. Among them self-censorship is the most serious concern, and it is a consideration that, I confess, informs my project. While the Pahlavi regime is by now fair game, the Islamic regime is not. Criticizing it carries serious consequences. And even the vanished *ancien régime* cannot be fully dissected under the Queen's gaze. Furthermore, if it were to be, that criticism might be misconstrued as giving credit to the regime that followed. To Grigor's list of obstacles I might add the very subject under examination: the contemporary. In the fast-changing zone of contemporary art, what is written today may appear obsolete, irrelevant or historical by the time it appears in print.[6]

Grigor attempts to remedy what she calls the 'pulverized'[7] nature of the Iranian art world by relying on whatever data she could excavate in field trips carried out between 1998 and the tumultuous days of the presidential election in 2009, and widening (but also diluting, in an anthropological sense) the definition of art, levelling it to include all kinds of visual imagery – street mural paintings, billboards, agitprop in general, funereal paraphernalia found in cemeteries, stamps, kitsch or 'bad art.'

Without any claim to comprehensive inclusiveness, I am less inclined to view the contemporary art scene as 'pulverized' or as secondary to panoramic accounts that privilege sociopolitical context or, unlike Keshmirshekan, to homogenize the artists in diaspora around the issue of identity.[8] As it will become clear reading the present chapter, a great number of artists living inside Iran remain 'other' to the values of the establishment, and therefore the issue of identity (estrangement, a form of exile at home) is not absent in their work. Broadly speaking, the question of defining the self has preoccupied Iranian artists throughout the twentieth century and, indeed, since the dawn of Iranian civilization.[9] Grigor, too, allots one chapter to 'Exile.' It is puzzling in that it includes artists who live and work in Tehran – artists such as Siamak Filizadeh, Mahmoud Bakhshi, Shirin Aliabadi, Farideh Lashai and Shadi Ghadirian, to name a few. Unlike Grigor's, my account focuses on the arts, including performance, rather than on visual culture in general. From the examination of the work, which I conceive as a repository of individual voices, several key themes have emerged, and they form the linchpins of this chapter.

Taking a thematic approach has yielded significant results, allowing me to jettison certain stultifying binaries, such as global/local or traditional/new media. As a methodological framework it has opened the door to new connections between many voices, established and emerging, inside and outside, and the opportunity to highlight varying approaches. The picture that emerges is not a pulverized situation but one in which diversity and pluralism connect within an overarching sociopolitical logic. I need to emphatically stress

that my interpretations are mine alone. While I have consulted with the artists, my reading may not always coincide with their intentions. Retaining the flavour of the slide lectures I have given at various institutions since 2011,[10] my analysis circles around a limited number of artists, artworks and themes and necessarily does not provide an exhaustive narrative or a comprehensive treatment of individual artists.

Problematizing categories

'Iranian' itself is a contested category. In a book claiming to deal with artists from Iran, introducing the topic with artists whose 'Iranianness' is in question is a deliberate act. Artists prefer to be viewed as simply artists, operating in a global framework. My intention is not to repudiate ethnic or civilizational affiliations but rather to defend artists' membership of the larger human community. We therefore begin with the universal perspective Ali Banisadr (b. 1976) offers (fig 63). He is a painter whose vision is broad and his actors are humanity itself. The previous chapter, where the blurring of the line

63. Ali Banisadr
It's in the Air, 2012
Oil on Linen, 208 x 305 cm (82 x 120")
Museum of Contemporary Art, Los Angeles.
Gift of Thaddaeus Ropac, Paris

64. Ali Banisadr
Trust in the Future, 2017
Oil on linen, 208 x 305 cm (82 x 120")
Mohammed Afkhami Foundation

between abstraction and figuration was discussed, could have easily accommodated Banisadr. His paintings could hold company with the video by caraballo-farman or the installation by Peyman Shafeeizadeh, dealing with crowds blurred into near-invisibility or abstraction. But he could also be considered along with artists influenced by Persian painting, although in his case that would have been reductive. Or we could have proposed another theme: war and its impact on art, which could include the many artists of his generation who experienced the Iran–Iraq War as children. His art, however, is not nation-specific. He is not painting just Iran; his locations consist of 'generic' land and some sky. He is not appropriating traditional vocabularies to attack contemporary politics, nor is he engaged in transcending them. Yet politics inform the battles he depicts in his work, and transcendence is portended in occasional beams of light showering down from above. The panoramic vistas he brushes on his canvas are imagery recorded by the psyche, an internal chaos impressed by danger, experienced first in a war zone and then reinforced by history and the continuing presence of conflict around the world and throughout the ages. In this carnivalesque procession, Banisadr's reach is encyclopaedic and his

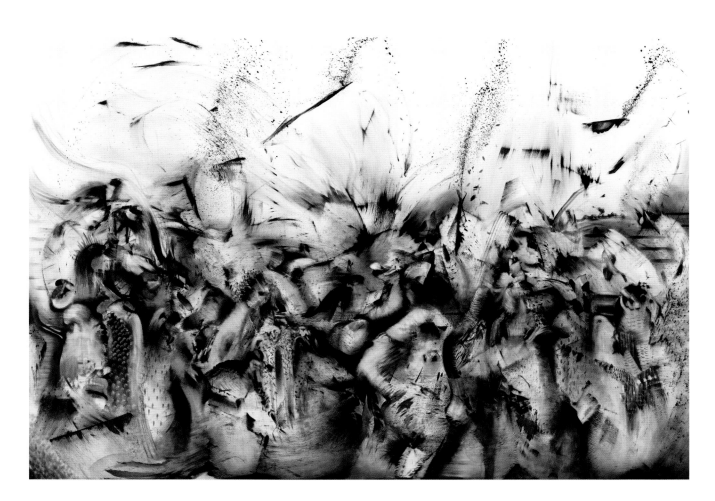

stage is the world. His protagonists, like marionettes parading in his mind, are vaguely human. Deformed in the hustle and bustle of war and through the cumulative effect of piled-up aesthetic memories, they could be combatants in medieval battles, confronting camps in Persian painting, or echoes of Albrecht Altdorfer's epic spectacle of war. At the same time they evoke the processions or mass uprisings envisioned by James Ensor. Banisadr's less-than-human creatures compete with inhabitants of the kind of hell imagined by Hieronymus Bosch. They may be adversaries in theological strife, merchants wreaking havoc in the financial battlefield, or even the victims of a science-fiction apocalypse. Banisadr is a devoted student of art history but also a close observer of films such as *Star Wars*.[11] Increasingly, in his recent paintings the characters (now larger and more distinct) intimate the dehumanized plight of sea-drenched refugees huddling intimately together, perhaps on a cold foreign shore (fig 64). In the dead of the night or in the heat of the battle, in scene after scene conflict is the norm. He populates his stage with creatures that at first glance may be mistaken for mere brushstrokes but that under scrutiny disclose a debased kind of affinity with humankind. Compared to an artist such as Y.Z. Kami (discussed below), whose scenarios also involve all humanity, the facial features of the inhabitants of Banisadr's land are half remembered, half censored, half other than human. Turning from Kami to Banisadr is like moving from quietude to an orchestrated chaos, from distinct faces to a concoction of flying human debris caught in the whirlwind of history, of colour and clashing brushstrokes.

Nonetheless, the puppeteer of this tumultuous masquerade is an Iranian whose psyche was deeply marked by the short period he lived in Iran. Banisadr was three when the Iran–Iraq War broke out. In 1988, when the war ended, he left the country for good, aged twelve. Nearly thirty years later, the trauma is relived in his art, the internalized spectacle of disaster churned and spewed on each canvas. In the cacophony of internal voices and the critique of a species run amok, the redemptive salvation the work proposes seems to be the faith in art, a faith Banisadr shares with others born in a land of immense potential, vast horizons, aborted dreams, and a voracious appetite for survival and growth.

Shahpour Pouyan (b. 1980) takes a different approach to porous or fluid boundaries, leading to a universalism of another kind. He chose the words 'My place is the Placeless,' an elegy to common humanity attributed to Rumi, as the title of both a 2017 exhibition and its centrepiece, at the Lawrie Shabibi Gallery in Dubai, where he displayed an array of ceramic domes within the minimalist skeleton of an open, cage-like cube (fig 65). Pouyan based each dome on the architecture of a region that the testing of his own DNA has linked him to. A body impregnated with genetic material originating from

65. Shahpour Pouyan
Installation view of *My Place is the Placeless*, 2017
Courtesy of Lawrie Shabibi and the artist

multiple regions – now countries as diverse (and at times politically opposed) as India, Pakistan, Bhutan, Turkmenistan, Turkey, Armenia, Iran, Iraq, Syria, Saudi Arabia, Israel, Sweden, Denmark and Norway, among others – belongs to no single ethnicity and thus complicates nationalist discourses that cultivate racial purity and essentialism. Pouyan is one among several contemporary artists who, in a change from the earlier, pre-revolutionary period (see Chapter Two, on Saqqakhaneh), in which the gaze was turned towards the self, deliberately expands the discourse on ethnicity. Rather, with each dome Pouyan articulates the contaminated promiscuity of the genetic material he then ironically frames within a minimalist geometric structure that, art historically, signifies purity.

Tehran

From the expansive vision of Planet Earth portrayed by Banisadr and the negation of racial purity in Pouyan, let us descend to the specificity of a single location: the capital city, Tehran. A protagonist in many Iranian films, it is increasingly emerging as an important theme

for visual artists working in a variety of media.[12] While it is currently asserting itself as one among many world centres of art production, challenging antiquated art histories that favour Paris and New York, Tehran is mainly known in the United States through media images rather than as a theme in contemporary art. This chaotic metropolis has been the capital of Iran since 1795. In the contemporary era it has been a site of clashing ideologies and an arena in which to exhibit faith and politics. This is testified by the many images of the city that appear on TV news and on the Internet, most recently of the 'green movement' demonstrations after the results of the 2009 presidential election were announced and Mahmud Ahmadinejad (2005–2013) was elected for a second term. Tehran has many faces. There is the cool Tehran, with its galleries, malls, cafés, avant-garde theatre productions, contemporary dance (yes), and occasional music concerts, attended by notably attractive young people. There is also a darker side, where survival by any means is the only goal. The underbelly of this chaotic city has been described in a collection of short stories aptly titled *Tehran Noir*, edited and translated by Salar Abdoh, himself a

66. Pantea Rahmani
Tehran 2: The Day Waltzes Into Gray With Far Lights And Further Pavements, 2011–12
Gesso, ink and synthetic polymer paint on canvas, 175 x 500 cm (68 x 16'4")
Salsali Private Museum, Dubai

contributor and author of another work of fiction: *Tehran at Twilight*.[13]
In film, Ali Soozandeh's *Tehran Taboo*, released in 2018, plunges the
viewer deep into the desperation experienced by the underprivileged
inhabitants entrapped in this broken city. Tehran has been the stage
for a people's aspirations as well as its traumas, and representations of
the city have been sites on which to project emotions and ideologies at
different moments in its history.

The detailed painted portraits of Tehran by Pantea Rahmani (b.
1971) are panoramic vistas, empty of people and drained of colour but
saturated with thick pollution that blocks the view of surrounding hills
and mountains (fig 66). Each of the two labour-intensive portraits she
has made took her a full year to complete. With a clinical gaze and fine
brushes, Rahmani painstakingly redraws Tehran from photographs she
commissioned from a professional photographer. In shades of grey
she pushes realism to convey an ominous, post-apocalyptic vision of
the beloved city in which she lives, a city eroded by many agents, from
pollution to the fear of foreign military intervention to, she adds, the
earthquake that may one day strike Tehran.[14]

In 2009, when demonstrations were clogging Tehran's main arteries, Arash Fayez (b. 1984) began a series of twelve works titled *My Expired Utopia*. He concluded the project in 2011 and then moved to the US. Each of the twelve works in the series consists of a Polaroid picture taken by the artist juxtaposed with an aerial photograph of Tehran purchased from a state-affiliated institute known as GIS. In *My Expired Utopia: Azadi Square* (2009–10, fig 67), using semi-transparent tape the colour of blood, Fayez indicated on the aerial image the itinerary of the demonstrations that immediately followed the 2009 elections; they encircled Azadi Square, which is depicted in the Polaroid image next to it. During the Pahlavi regime, both the square and the monument it houses, a symbolic gate to the city, were known as Shahyad (memorial to the king). After the Revolution, the square was renamed Azadi, or 'freedom.' It has been the stage for numerous demonstrations, and for the artist it is redolent with invisible stories that live in the collective memory.[15] 'Tehran is a city without a sky,' he wrote in a leaflet in 2010 explaining his project. 'But I love it, because it belonged to me.'[16] Further along in his text he explains that from a distance

67. Arash Fayez
My Expired Utopia: Azadi Square (2009–10)
Polaroid Sx-70, paper, tape, and plexiglass,
34.5 x 46 cm (13½ x 18⅛")
Private collection

Tehran can belong to anyone, as maps and aerial photography may be easily purchased. But from an intimate distance, through his Polaroid camera, Tehran 'is no longer mine; that is they have taken it away from me. I want to frame the picture but it is difficult because I am inside my car and I no longer know if this "right" is mine or not [...] my instinct tells me no, not yours.' Given the surveillance prevailing in public spaces, a close-up picture of the Azadi monument cannot be an innocuous snapshot. A clandestine moment furtively captured by the artist from his car, the picture is just as pregnant with politics as the aerial map indexing the protests. The Polaroid signals the tacit prohibition on the gaze of individual citizens in the so-called Freedom Square, while the mapped-out bloodline spilling around the monument reveals the strident public outcry of the mass of demonstrators.

The emotional toll of that post-election political moment obliquely seeps into the personal narration of Jinoos Taghizadeh (b. 1971) in her video *Fatness*, created in 2010 (fig 68). An image of Tehran, displaying the Milad Tower and the Elborz Mountains in the north, is printed on a cake, which the artist, whose presence is indicated by her voice and her hand only, digs into with a fork. 'I have gained thirty kilos in the last year and I don't know why,' she exclaims. By the time the video is over and the cake devoured, without being given any direct explanation viewers have come to understand that the artist's eating disorder is linked to a depression triggered by the 2009 elections.

Around the same time, in 2009, Arash Hanaei (b. 1978), who now lives in Tehran and Paris, began a series of images entitled *Capital*, a

68. Jinoos Taghizadeh
Fatness, 2010
Video

You'll know what you want from the point when you know what it is that you don't want

designation with a double meaning: a reference to Tehran as a capital city and also as a site of capitalist consumption.[17] The focus of these works is the signage, advertisements and political propaganda that are ubiquitous in the city, from billboards to murals painted on the sides of buildings. In a hybrid style that combines photography and computer-generated drawing, Hanaei pares the cityscape down to its ideological armature. Restricting the palette and deleting unnecessary details, he allows the public signs to reveal their state-ratified narratives. Trained as a photographer, Hanaei extends the tradition of documentary street photography into a critical vision of clashing messages,

69. Arash Hanaei
Prisoners of War in the Hands of their Enemies are Songs of Freedom and Free Spirits Whisper these Songs
(from the *Capital* series), 2009
Paper, 162 x 108 cm (63 x 42")
Additional edition printed on Backlit film and presented as Lightbox
Private collection

70. Arash Hanaei
*A Notebook for Every Iranian, Digital,
For Sale* (from the *Capital* Series), 2009
Paper, 80 x 61.32 cm (31 x 24")
Additional edition printed on Backlit film
and presented as Lightbox
Private collection

glorifying an Iranian prisoner of war in one work (fig 69), for instance, and advertising a digital notebook in another (fig 70). The series, an ongoing project, was subsequently amplified to include Paris, the traumatized city to which Hanaei temporarily relocated for a residency at the Cité Internationale des Arts in 2016–17.

Hanaei's anaemic depictions of Tehran are derived from images shot around the city and manipulated on a computer. Paper-thin, they remain uninhabitable and almost unpopulated. Two other photographers provide idiosyncratic accounts of the plight of individuals in this monstrous and yet fascinating megalopolis: Newsha Tavakolian and Mitra Tabrizian. Tavakolian (b. 1981), who lives in Tehran, is able to circumvent the restrictions imposed on photojournalists like herself by resorting to staged photography.

71. Newsha Tavakolian
Look, 2012
Inkjet print, 106 x 142 cm (41 x 55")

72. Mitra Tabrizian
Tehran 2006, 2006
C-type light jet print, 101 x 302 cm (39 x 118")

For her series *Look*, exhibited in New York at the Thomas Erben Gallery in 2013, she photographed family and friends in her apartment, which has a view onto a dreary building complex outside (fig 71). Vince Aletti, reviewing the exhibition for the *New Yorker*, noted, 'Whether anguished, anxious, or simply lost in thought, all of these men and women appear suspended, stunned, as if their future were as limited as their view outside.'[18] These are portraits of what Tavakolian describes as 'the nation of middle-class youths who lack hope for the future and are constantly battling with themselves in isolation.'[19] While the sitters' expressions and body language convey the low register of emotion, bordering on depression, that is shared by many young Iranians, they are at the same time evocative of universal conditions of alienation in modern urban settings.

In *Tehran 2006* (2006, fig 72), Tabrizian expressed the isolation and alienation of a cross section of urban dwellers in a carefully choreographed crowd scene shot on the outskirts of Tehran.[20] Staging an image in that city's public space is fraught with perils that Tabrizian managed to circumvent. The artist, who lives in London, flew to Tehran to make the work, spending days of research to find the right location. 'The actual photo is the composite of three photos, shot in

three days at the same time' in order to keep the shadows consistent, she has reported. [21] Each character, oblivious of the others, harbours a sense of solitude. The tableau claims no allegiance to documentary photography or to the spontaneity of street snapshots; rather, its truth resides in its artifice: it is a calculated enterprise, an elaborate stage set for a film with mute players frozen in paths that do not intersect and that are bereft of control or purpose. The only unmanipulated elements in the image are the bleak high-rise apartment complexes in the background. The billboard stood on the site but as yet not bearing the image; the artist was told it would be of the two successive 'supreme leaders,' an image ubiquitous in the city. Tabrizian inserted the image, including the text that proclaims, 'We shall continue the path of the martyrs of the Revolution.' The diktat towering over the lost souls below defines a road map, a future that may not be consensual.

To fully grasp the plight of these ordinary people 'who play themselves,'[22] the year 2006 in the title must be understood. In April of that year, Iran announced that it had succeeded in enriching uranium, bringing the threat of covert action by the Bush administration into the already toxic cold war relations between the United States and Iran. Tabrizian's characters are caught between revolutionary goals perhaps

become irrelevant and the impending doom of intervention by hostile foreign powers.

In Tabrizian's photograph the billboard displays the spectacle of the regime's authority. In other works by another Iranian artist, influenced by the Situationists, images of the opponents or victims of the regime have replaced those of ruling officials in contexts such as these.[23] Such *détournement* (hijacking or rerouting) of signs derives directly from the European strategies advocated by the Situationists and, before them, the Letterist International.

Shahab Fotouhi (b. 1980), turns Tehran into an exhibition space, a performance stage and, above all, an arena for activism. In 2009, the year of the infamous contested elections, the artist presented his project *By the Horses Who Run Panting*, erasing the boundary between art and political activity by turning a Tehran gallery into the campaign headquarters for one of the presidential candidates. The posters produced for the campaign (which ultimately failed) spilled into the streets, among the politician's supporters. The image, created in green (the symbolic colour of the political movement), circulated throughout the city.

Fotouhi has incorporated the city in a variety of ways. In 2003 he and a collaborator, Neda Razavipour (b. 1969), took over an empty building, which they animated with staring faces that lit up and then faded in each window. Secluded in the interior spaces of the building, these apparitions were vigilant witnesses of events outside the domestic zone they inhabited.[24] This urban installation was best viewed while driving along the main road below.

Gender

While Tehran, as a theme, has not been treated in the literature on contemporary Iranian art, gender has received profuse attention both inside and outside the country.[25] Before the Revolution, the condition of women was tackled by very few visual artists. The caricaturist Ardeshir Mohassess,[26] who devoted himself to exposing social and political ills, was one; Nahid Hagigat (b. 1943) was the only woman artist who delved into this subject systematically.[27] Hagigat is from the Jewish minority community, and it is possible that her position as an outsider gave her clearer insight into the patriarchal society of Iran, where, in spite of the vast improvements in legal rights, women have suffered from the prevailing mentality of machismo.[28] In 1936 Reza Shah abolished the wearing of the veil, but with time women were allowed to choose how to appear in public. Following the Islamic Revolution, the wearing of the hejab became mandatory for women. Restrictions on women's rights by the male interpreters of Islam who

had come to power led to an increasing outcry by women, first in demonstrations protesting the imposition of the hejab and then as subversive insubordination to the mandated dress codes.[29] The hejab, however, remains a barometer of the intensive struggles Iranian women have engaged in for most of the twentieth century. After 1979, among the losses of their rights and far more serious than the imposition of the hejab was the new penal code sanctioning stoning of women for adultery, the lowering of the minimum age for marriage of women from eighteen to nine, and the punishment by lashes for those who defied the dress code.

In 1980, another artist from a minority community, the Armenian-Iranian-American artist Sonia Balassanian (b. 1942), who left Iran around the time of the Revolution, became the first artist to question the treatment of women inside the country. Unfortunately, New York in the 1980s was not yet attuned to messages delivered by diasporic artists. In the next, more propitious decade, beginning in the 1990s, she was eclipsed by Shirin Neshat (b. 1957). Balassanian deserves to be recognized as the pioneer who introduced the veil into contemporary aesthetic discourse, and who did so without any intention of orientalizing the subject. Balassanian's practice of building her artworks out of her empathy for victims began with a collage series she exhibited at New York's Elise Meyer Gallery in 1980,[30] followed, in 1982, by the exhibition of a work displaying her personal identification with Muslim Iranians and war martyrs at the Franklin Furnace, Martha Wilson's alternative gallery space in downtown Manhattan. Wilson's archives included a 1983 artist book by Balassanian, which was donated to MoMA's library in 1988.[31] In it, Balassanian, in an act of solidarity, appears veiled in a series of performative self-portraits defaced with writing (fig 73). Crossed-out Arabic script in Persian alternates with typed English words such as 'Stoned,' 'Stoning,' and 'Rape.' Reacting to rumours that women prisoners (members of the Mujahideen, who were fighting the Islamic regime) had been raped by their guards as a pious deed before their executions, and to the reinstatement of stoning in Iran as a legal punishment for female adulterers, Balassanian's protest was directed against breaches of human decency. These works from the 1980s are examples of a political art very different from the art produced inside the country at that time and supported by the establishment.

This body of imagery was easily available to Neshat. As Wilson said, recalling Neshat's exhibition at Franklin Furnace in the early 1990s, the artist 'lived nearby in Chinatown, so she came by to the gallery pretty much every day to tweak the film being projected in the dark space she had created in the mezzanine.'[32] The date of her exhibition's opening was April 2, 1993. Coincidentally, the following day, April 3, was the opening of the group exhibition *Readymade*

73. Sonia Balassanian
Portrait #14, 1982
Digital reproduction of collage on paper in
Portraits by Sonia Balassanian (New York:
Sonia Balassannian, 1983), n.p.

Identities, [33] which I curated at MoMA. It featured, among other works, Balassanian's installation *The Other Side II* (1993; fig 109) of a mirror facing a crowd of tall figures whose entire bodies and faces are hidden under black chadors and whose presence is almost obliterated by the blinding spotlights directed at viewers entering the space.

Balassanian's investigations on the layered meaning of the chador paved the way for Neshat, and her work is an indisputable historical precedent that is often absent in the literature. [34] Balassanian, however, was not a Muslim and, unlike Neshat, she did not dwell on the subject of women under the Islamic banner for very long. Neshat was better positioned to be received as a native informant in the West, even though, with the exception of a few sporadic visits, she had not lived in Iran since 1975, when she left the country at the age of seventeen. The artist herself has contested her reception as an ambassador. In

74. Shirin Neshat
I Am Its Secret, 1993
Gelatin silver print and ink, 48 x 31.9 cm
(18¾ x 12½")

1993, three years after her brief visit to an Iran presided over by the clergyman Akbar Hashemi Rafsanjani (1989–1997), she embarked on her photography series *Women of Allah*, in which she decorated her sitters' exposed skin with handwriting in Persian, including her own portrait, veiled as in Balassanian's work a decade before. Knowledge of Persian is crucial in understanding the meaning of the work, for Neshat delivers her message through the quotations she superimposes on her subjects' faces and hands. The texts she transcribed – sometimes progressive, sometimes fundamentalist – contribute to a portrayal of a complex society with contradictory impulses. For those who cannot read Persian, however, these images might not offer any nuanced opposition to the prevailing stereotype of the oppression of women by monolithic Islamic societies. In her retrospective at the Hirshhorn Museum and Sculpture Garden, in Washington, DC, Neshat listed many sources for her imagery: her trip to Iran in 1990 was one, as well as her collection of images of newly empowered militant Iranian women wearing headbands with writings and holding rifles.[35] In the early days, she presented herself more as a poetic reporter of a diverse political spectrum rather than the activist she is now claiming to be.

The first image in Neshat's *Women of Allah* series is a veiled self-portrait tattooed in the artist's handwriting with a poem by Forough Farrokhzad (1935–1967), a highly revered feminist literary figure frowned upon by conservatives for her free-spirited art and life (fig 74).[36] Neshat encodes this symbolic self-portrait, *I Am Its Secret*, with diametrically opposed systems of meaning: the veil points to regime-sanctioned appearance, make-up and poem to the resistance to it. The critical impulse and subversive message were amplified when, in 1999, Neshat used the image for the banner I commissioned for her exhibition at the Museum of Modern Art (fig 111).[37] Veil and banner merged, fluttering on the facade of the museum, a location ordinarily reserved for the logo of an institution with a strong inclination towards Western art.

Opposite
75. Shirin Aliabadi
Untitled (*Miss Hybrid 3*), 2008
C-print, 154 x 123.5 cm (60 x 48")
Mohammad Afkhami Foundation

During the 1990s and into the first years of the new millennium, Neshat's photography and video installations catapulted her into a celebrity status never before attained by an Iranian artist abroad. The topicality of her work's subject matter – women, Islam, and exile – contributed to her status and to the monopoly her work held in the discourse for much of that period. The eager reception in the West of all things Middle Eastern helped, though possibly for the wrong reasons. Overexposure of the work, the fluid realities in Iran, and the emergence of a new generation of artists and critics are now affecting critical thinking about her work. She is facing a backlash inside Iran as a purveyor of what the artist Farhad Moshiri has derisively called 'chador art,' and outside the country her work has been critiqued for what is perceived as facile branding, a false sense of martyrdom, and an art 'pitched on the abyss of cliché' – words used to describe her 2015 retrospective at the Hirshhorn.[38]

Moving from Balassanian's subdued identification with political victims in the 1980s to Neshat's bold images of Muslim women demanding social and aesthetic visibility in the 1990s, we arrive at a very different historical moment, one captured by Shirin Aliabadi (1973–2018) in her series *Miss Hybrid*, an ongoing project begun in 2006 (fig 75). Aliabadi lived in a Tehran that is very different from the city Neshat visited in 1990. Depicted in photographs staged in her studio, Aliabadi's women are inspired by the young urbanites engaged in the 'Lipstick Jihad,' a phrase coined by Azadeh Moaveni in her memoir of that title.[39] These are children of the Islamic Revolution, but they do not relate to a revolution they did not generate. Their childhood was spent under the deprivations created by the war with Iraq, but they also experienced a hint of freedom during the reformist presidency of Mohammad Khatami (1997–2005) and the ray of openness brought about by the arrival of the Internet. Even when fined and punished for violating sartorial codes – the harshness of the punishment depending on the administration in charge – they persevere in their resistance. With their hair dyed peroxide blonde, a nose job apparent from a plastic strip and blue contact lenses, Aliabadi's subjects' carnivalesque rebellion against sanctioned codes of public appearance deny an Islamic or even an ethnic or national identity. In the hands of today's youth, so-called Westoxication is a weapon against the currently imposed edicts. With this series, Aliabadi claims, 'cultural rebellion meets Christina Aguilera.'[40]

In one memorable evening performance in a Tehran Gallery, on 19 January 2010, Bita Fayyazi (b. 1962) presented a peek into the psyche of a woman living in Iran (fig 76). In a baroque theatrical setting, the artist, who was impersonating a pregnant woman, sported an elaborate and giant wig or headdress that did not reveal her hair

(so that censors could not object to it). Her character could be read as
a fertility goddess, a crucified victim, a white *div* (a horned monster),
a regal Marie Antoinette-like queen and a woman in the act of giving
birth while subjected to abuse. She appeared passive as she offered
her ripped-open belly to her abusers, the spectators. She exposed
this 'symbolic womb,'[41] as she called it, to the public, which was invited
to dig into the caesarean wound, reach inside the cavity, and retrieve

Opposite
76. Bita Fayyazi
Performance 1388/2010, January 2010
Tehran

Below
77. Jinoos Taghizadeh
Goodnight, 2009
Video

objects attached to umbilical cords: hearts of babies and adults, handcuffs, pliers and other ominous instruments. All the while, frozen like a scarecrow, she stared passively, yet actively as a witness to these acts of transgression against her body. Could this be a cryptic performance of an intimate personal trauma or a representation of the mother nation giving birth to atrocities? If the latter, gender is used as a tool in a broader political metaphor.

Another eloquent example of this is the 2009 video *Goodnight*, by Jinoos Taghizadeh (fig 77). It was created for an exhibition that took place on the thirtieth anniversary of the Revolution and five months before the 2009 elections. A mother's arm is seen rocking a baby's crib while she sings a lullaby. The scene is divided between the red of the ground, the bright white light of the area where the baby sleeps, and the green of the background wall – the colours of the Iranian flag. For the soundtrack the artist lifted melodies and lyrics from hymns

Blood, death, and rebellion!

sung by a chorus of the male revolutionaries who toppled the Pahlavi regime. The magic of the early revolutionary hymns, however, has worn off. The baby, symbolizing the future generation, remains heedlessly asleep. Taghizadeh replaced the male singers of thirty years ago with a woman's voice, a voice that is now barred from public spaces. Instead of inciting the masses against the demonized Pahlavi regime, as the song was originally intended, the words 'your raised fist is your vote' resonated with a very different message at a time when an unpopular administration was soon to be tested in new elections.

Clearly motherhood, when represented by the allies of the regime, can be used to uphold very different politics, as testified by official city murals. One by Kazem Chalipa (see above, fig 46), for instance, glorified the mother of martyrs; another, representing a Palestinian woman with a rifle and child, asserts, 'I love motherhood but I love martyrdom even more.' These images of mothers as revolutionary heroes have been in the past few years replaced by neutral landscapes inspired by traditional Persian paintings.

Pushed under the carpet, or deep behind the veil, the taboo subject of female sexuality is the centre of a work by Parastou Forouhar (b. 1962), the daughter of political activists assassinated in their home; she now lives in Germany.[42] In *Friday* (2003, fig 78, see also fig 132), named after the day of prayers and rest, the gentle curves of a black-on-black floral patterned curtain (reminiscent of a chador) fill four photographic panels. In this sharply focused colour photograph, a titillating body part is exposed in plain view. It is a hand, clasping the

78. Parastou Forouhar
Friday, 2003
C-print mounted on aluminium.
4 panels, 170 x 86 cm (66 x 33") each
Mohammed Afkhami Foundation

veil, but its morphology allows for a metaphoric identification with the most transgressively abject and abhorrent object of representation a fundamentalist man and mind can fathom. Confining a woman's existence to a domestic space behind closed curtains, and edicts prohibiting the visibility not only of the sexual organs of a woman but also her entire body, not only do not eradicate the eroticism that lives in the imagination, the work seems to suggest, but they expand the erogenous zone to include the hand, which would otherwise be considered innocuous. Forouhar's representation is even more astute than the yearning of many artists to tear off their clothes in protest – a desire expressed by both male and female artists. Forouhar's veiled metaphor does more to reveal the psychology of shrouding a woman from head to toe than any picture of a nude.

Not all artists have resigned themselves to keeping the female form out of the field of representation. Some of those who have claimed such rights are not necessarily addressing the male gaze but rather are interested in exposing the physical hazards a woman can be subjected to. Mania Akbari (b. 1974), an artist and filmmaker who no longer lives in Tehran, decided to record her mastectomy following her cancer diagnosis at the age of 30. In a series of photographs she showed me in 2010 she said 'In the absence of breasts my body moved beyond gender.'[43] To bury the pain of her new anatomy, she said, or perhaps to allude to a breastless body better suited for burial, she interred her body in chalk and cement. Another artist, Neda Razavipour, found inspiration in an eighteenth-century print by the French anatomist Jacques Fabien Gautier d'Agoty where a layer of a woman's back is peeled away to expose her internal anatomy. In one photograph from the series titled *Flayed Angels* (2007–9), she portrays a woman from the back (a position or angle with a vast art historical heritage); she has shed her clothes to expose traces of her physical scars. The body is wrapped with an invisible plastic string to convey lacerations or some other physical trauma which she carries with grace. In these instances, the image is not about eroticism; clothes are stripped off to unveil the pain. Both artists avoid the gruesome by cultivating aesthetic beauty: Akbari by using decorative motifs placed in strategic places, Razavipour displaying a physically ravaged woman posing with defiant pride and elegant poise.[44]

A radically different message informs the hejab in *Terrorist: Nadjibeh*, a portrait by Khosrow Hassanzadeh (b. 1963) of his mother (fig 79).[45] This large silkscreen is one of seven unique prints, each in a different colour: a series the artist has sarcastically named *Terrorist*. An attached tag or certificate (missing in illustrations made available to this author) reaffirms the identity of the sitter as such:

Opposite
79. Khosrow Hassanzadeh
Terrorist: Nadjibeh, 2004
Acrylic and silkscreen ink on canvas,
320 x 200 cm (125 x 78")
National Museum van Wereldculturen,
Amsterdam

'Terrorist': Nadjibeh Barazandeh
Nationality: Iranian
Religion: Muslim
Age: 84
Profession: housewife
Distinctive traits: unusually tall for a Middle Eastern Woman
Personal history: widowed at fifty years of age. Succeeded in raising her six children alone and under difficult circumstances, thanks to her deep religious beliefs. Lives in Tehran.

Nadjibeh Barazandeh's identity as a Muslim is upheld with pride in opposition to the 'terrorist' label affixed by Western leaders to adherents of Islam who are, after Christians, the second largest religious community in the world. The mother, dressed and veiled in colourful Turkmen fabric, sits modestly on the floor. For the backdrop Hassanzadeh has conjured the religious imagery that is integral to his mother's faith and culture. To the right, Hazrat-e Abbas appears on his white horse in Karbala; to the left, above the portrait of the artist's brother, is a picture of Imam Ali, pictured on a *danbal*, a traditional piece of equipment used by athletes in the *Zur-khaneh* (literally 'house of strength,' the traditional sports arena) while singing praises to Imam Ali, whom they revere.[46] The date is important. George W. Bush, who labelled Iran as part of an 'axis of evil,' and by extension deemed all Iranians terrorists, was the President of the United States when the series was created, in 2004. Harassment at airports, where suspicion of terrorism hovers around Middle Eastern men, has further fuelled Hassanzadeh's defiance.

As a representation of a mother, the portrait of Nadjibeh Barazandeh contrasts starkly to the depiction of a militant Palestinian mother on the Tehran billboard a decade ago. It differs equally from Chalipa's mural image of the mythologized mother of a martyr and the subversive portrayals discussed above. Barazandeh is merely an ordinary citizen of religious faith and modest background. Her ordinariness is the strongest critique of the vilifying and homogenizing categorizations cultivated by hostile, sometimes Islamophobic, foreign powers.

Testosterone-related trials and tribulations occupy Shahpour Pouyan. He focuses on male destructive power, which is in full display in wars.[47] He uses its paraphernalia to create series of objects he has entitled *Projectiles* (composites of medieval armour and modern drones), *Failed Objects* (some mimicking hand grenades), and *Still Life* (artillery shells, phallic in appearance and impotent in practice; fig 80). Of Pouyan, Amei Wallach insightfully states that, 'In his sculptures, this son of a general persistently conjugates forms of power and of powerlessness, sometimes conflating them.'[48] Pouyan immerses himself

143

in thorough research of warfare, and imbues his gendered objects with seductive beauty.

For his *Projectiles*, equally phallic in form, Pouyan collaborated with the professional metalsmith Ostad Ensaf Manesh, in the south of Tehran.[49] For his ceramic works, such as his *Failed Objects*, he went to California to study with the brothers Guangzhen and David Zhou after completing his studies at Pratt University, in New York.[50]

To avoid misrepresenting Pouyan, it needs to be stated that his target is broader than one gender or a single culture; he spots the will to power wherever it is divulged, whether in aspirations to immortality or veneration of authority (sacred and earthly), as manifested in monuments or in the paraphernalia associated with war.

Rokni Haerizadeh (b. 1978), the bad boy of contemporary Iranian art, now lives communally with his brother Ramin (b. 1975) and Hesam

80. Shahpour Pouyan
Still Life, 2014
Glazed ceramic and acrylic, dimensions variable
Courtesy of the artist

81. Rokni Haerizadeh
Ramadan/Palm, 2009–18
Oil on canvas, 220 x 200 cm (86½ x 78 ")
Courtesy of the artist

Rahmanian (b. 1980), a childhood friend, in Dubai and collaborates with them in creating messy, gender-bending, immersive multimedia installations.[51] Rokni's sensitivity to the power relations between the sexes was apparent in the early works I saw in his studio in Tehran in 2007. In one of them the legendary Shirin, traditionally represented as a coy diminutive feminine figure, becomes a muscular woman towering over the intimidated man who pursues her. With the acute sense of humour that informs his entire production, in 2008 Rokni satirized the gender segregation imposed by the regime in a painting titled *Typical Iranian Wedding* (fig 82). Like many other Iranian artists, Haerizadeh weaponizes humour to speak truth to power.[52] In this tableau the women revel on the left panel of the diptych; on the right, the male guests dance and some engage in their own flirtatious activities.

Haerizadeh now applies his keen social observations to Dubai, an Islamic society different from the one he left behind. One painting, begun in Tehran in 2009 and completed in Dubai nine years later, initially revolved around the 'sacrifice feast,' displaying a slaughtered animal. It evolved into his *Ramadan/Palm*, of 2018 (fig 81), in which famished Muslims break the fast. The focus is not only on food and a religious ritual but also on the heterogeneous make-up of Dubai, as reflected in the mosaic of ethnicities in the image (European tourists, traditional and modern Arab families, Iranians, South and South-East Asians). According to the artist, the cooks are Indian, Filipino

82. Rokni Haerizadeh
Typical Iranian Wedding, 2008
Oil on canvas, diptych, 200 x 300 cm
(78 x 118") each
Private collection of HH Sheikh Zayed bin
Sultan bin Khalifa Al Nahyan

and Pakistani, and the setting is the Palm Jumeirah.[53] Each individual exists in a separate island of its own. Isolating them even further is the presence of smartphones, which absorb the young and the adults alike.

Returning to the domain of gender apartheid, Shirin Neshat's *Turbulent* (1998) has now achieved the iconic status of a contemporary classic (fig 83). In this video, too, the genders are segregated. A double-screen video installation of a male singer who sings to an all-male audience faces another screen where a female singer performs in an empty hall.[54] The man (Shoja Azari) lip synchs to a classical tune sung by Mohammad Reza Shajarian, with lyrics drawn from high literature (the works of the thirteenth-century Persian poet and Sufi mystic Rumi); the woman, the singer Sussan Deyhim, in a highly innovative performance, breaks all the rules – musical, social and political – with her wordless panting, hissing and cries, in an emotionally articulate expression that moves from intimate murmurs to wailing, from lamentation to defiance. With this video installation Neshat earned the First International Prize at the Venice Biennale in 1999. *Turbulent*, in addition to capitalizing on singing and music, uncommon in video installations of the time, stands out as a clear exploration of the asymmetry of gender power and the infinite possibilities of a woman's voice.

Appropriation of, and tampering with, traditional aesthetics

Subversive appropriation is a strategy of concealment well suited to an era of censorship. In this category of art making, which may also be termed an aesthetic of dissidence,[55] traditional arts or even history itself are used as Trojan horses for the purpose of indicting the present while dodging the censors. The use of sanctioned aesthetic languages not to affirm identity but rather to undermine authority is a phenomenon that distinguishes contemporary art from that made before the Revolution. Not all appropriation engages with censorship or dissent, however, and not all Iranian artists live within the regime's sphere of influence. This section touches on a range of expressions, including genres and media associated with traditional art, history, and even the iconography of the Islamic Republic.

Manuscript painting

The moribund tradition of 'miniature painting,' a term currently in disrepute,[56] has been resuscitated and transformed by contemporary artists and mobilized for subversive messages. The genre has

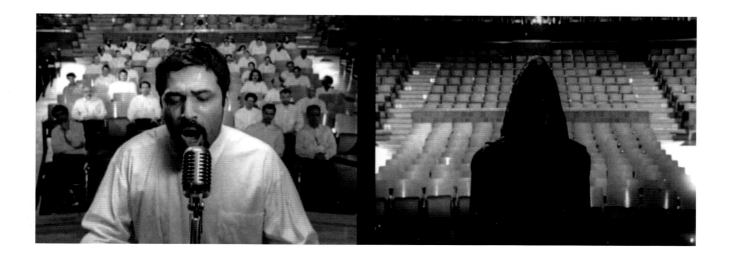

83. Shirin Neshat
Turbulent, 1998
Two-channel black and white
video installation

inspired artists of various nationalities. Manuscript painting was an emancipatory model for avant-garde modernists such as Matisse and Kandinsky, who were searching for alternatives to Western representational art. Contemporary artists too, including Banisadr, Haerizadeh, and the Kashmiri artist Raqib Shaw, have engaged with it in their own idiosyncratic ways. A radically transgressive approach to this practice was initiated by the New York-based Pakistani artist Shahzia Sikander (b. 1969), who appropriated this language with a subversive intention.[57] Defiantly turning to a tradition whose contemporary practitioners were derided as kitsch, Sikander transformed the practice. She has been unprecedentedly bold in her transgressions. In 1988, when Sikander was still a student in Pakistan, she resurrected this marginalized and anachronistic form of expression, which, at best, appealed only to tourists. She violated its conventions and deconstructed its language while at the same time using it to challenge the monopoly of Western modes of expression. With Sikander as a pioneer, global contemporary art has been offered an alternative paradigm of aesthetic communication.[58] Her untraditional approach has been pushed even further by another Pakistani artist, Imran Qureshi, who uses the floor as the support for his delicate depictions of flora and violent drippings of paint.[59]

Farah Ossouli (b. 1953) spent the 1980s and 90s in the isolated artistic atmosphere of Tehran, unaware of Sikander. Unlike Sikander, she conserves the formal coherence of traditional Persian painting. In Tehran around 1986 or 1987, she was apprenticed to Mahmoud Farshchian (b. 1930), a conservative painter of highly ornate paintings in the style of classical Persian painting. Ossouli was not the first woman working in this genre, but she was the first to infuse it with a personal agenda. When she first engaged with classical painting, in

149

the 1980s, the practice, interestingly enough, was encouraged by the conservative authorities, who did not expect this form of expression to be taken up by a woman who would surreptitiously insert feminist messages into it. First in 1991 but then systematically since 2009 she has transplanted iconic images of Western art history into the fabric of Persian painting and contextualized them in the labyrinth of Iranian

84. Farah Ossouli
Ars Poetica, 2009
Gouache on cardboard, 67 x 55 cm
(26½ x 21½")
Collection Behzad Hatam, Tehran

politics. *Ars Poetica* is one example (fig 84). Modern and contemporary black artists, such as Robert Colescott, Kerry James Marshall, Yinka Shonibare, Kehinde Wiley and Mickalene Thomas, to name a few, have appropriated iconic images of Western art history but replaced the figures with black protagonists in order to highlight the lack of black visibility or representation in the West. Ossouli, on the other hand, subjects one of those icons, the Mona Lisa, to experience the ordeals of Iranians in a language familiar to this nation. In this work the subject's serenity and composure belie the injury she displays on her cut throat and the verses inscribed around the border, taken from a poem by Ahmad Shamlou, which roughly translate as 'a tragic suicide compares to the life I have lived.' In a strategy similar to Pouyan's, she uses muted colours, beauty and dainty decorations to soften the pugnacious message. The work was created in 2009, when violence was unleashed on political demonstrators, the death of one of whom, Neda Agha-Soltan, took on metaphoric dimensions.

Violence is also embedded in the paintings of Shiva Ahmadi (b. 1975). Ahmadi belongs to a younger generation than Ossouli, and she never studied Persian painting.[60] Her appropriation of this traditional style did not occur until she left Iran for the US in 1998 and, more specifically, until after the US invasion of Iraq in 2003, which is also when war imagery surfaced in her work. Her childhood years in Iran were strongly affected by the Iran–Iraq War. Ahmadi remembers accompanying her mother, who worked in the medical field, to emergency situations, to hospitals where war-injured bodies with open wounds, transported from the front, lay in beds waiting for blood transfusions. The carnage she witnessed as a child spilled into her work around 2006: explosions stain bloody abstractions and obliterate body parts of living creatures, implying roadside bombings and mines. Death hovers over her scenes, and vultures emerge as the prime victors (fig 85). Unlike the battlegrounds of traditional Persian painting, in which armies of riders charge towards each other, in Ahmadi's representations of massive destruction captured from above, humans are often absent. The land bears no resemblance to traditional painting's 'tiny world of eternally blooming flowers, sweet-smelling zephyrs, gentle people and effulgent light,'[61] as described by Sheila R. Canby. Instead, Ahmadi portrays an Oriental state governed by insanity, a dizzying, damaged world hovering on the blank surface of the paper, a vision rendered with a schizophrenic brush – unbridled in certain sections, obsessively meticulous in others. She scatters her arsenal of motifs, her volley of arrows, wounds, stains of blood, raging flame, and unbalanced animals much as Jackson Pollock dripped his paint. She has mentioned the importance to her of George Orwell's novella *Animal Farm*. Traditional Persian painting abounds with tales

told by animals (the two jackals in the *Kalila wa Dimna*, for instance), a strategy continued in modern times in a 1960s play by Bijan Mofid entitled *The City of Tales*, in which censorship could be bypassed because the critique is delivered by animals.

Why, one may ask, has an Iranian artist living in Michigan chosen to work in the language of 'miniature paintings' – albeit extensively altered – and therefore taken on the risk of being criticized for exoticism, for self-Orientalism? Moreover, why turn to animals when there is no need to dodge censorship? The answer, in my view, resides in a consideration of Ahmadi and others, including Pouyan, as post-Orientalist artists. Addressing a Western audience, Ahmadi affirms her difference from it, her distance, by reclaiming the stereotype of her native culture. Through the politically charged convention of animal actors she articulates a critique of both the bestiality of American foreign policy and the turmoil inside her own country.

85. Shiva Ahmadi
Vulture, 2009
Watercolour, ink and graphite pencil
on paper, 101.5 x 152.5 cm (40 x 60")
Private collection, New Jersey

86a. Nazgol Ansarinia
Rhyme and Reason, 2009
Detail of fig 86b

Carpet

The appropriation impulse stretches to one other quintessentially
Persian object: the carpet. The motifs in *Rhyme and Reason* (2009, figs
86 a–b) by Nazgol Ansarinia (b. 1979) do not follow age-old patterns.
At first glance, the hand-woven carpet appears to be a traditional
medallion style, exhibiting a classic parallel world of idealized beauty –
an image of paradise. Closer scrutiny reveals a repertoire of figurative
motifs that is completely alien to the medium as it is traditionally
practised. Ansarinia, who lives in Tehran, allows contemporary
quotidian events, urban narratives, and street life to creep into this
household item. Repeated all along the border is a motorcyclist
carrying two adults on the back of his motorbike, along with a baby in
front. Instead of a medallion, the very centre of the carpet is occupied
by four large dishes of food, around which congregate three rows of
seated veiled women. The artist explains, 'It is a socializing scene with
women sitting next to each other, chatting, sharing their troubles,
crying, and eating.'[62] The scene represents the more traditional strata
of society, including the working class. In the main field of the carpet,
a street fight surrounded by onlookers alternates with a different slice
of life, that of schoolgirls in uniforms, lined up and facing the school
principal, who holds a megaphone – an object used in the Islamic

Opposite
86b. Nazgol Ansarinia
Rhyme and Reason, 2009
Carpet: hand-woven wool, silk and cotton,
360 x 252 cm (141 x 99")
Collection Abraaj Capital Art Prize, Dubai

Republic to amplify the regime's ideology – in what may be a nod to the early indoctrination of children. These episodes contrast sharply with the party scenes occupying each corner of the carpet: a group of dancing girls and drinking men, in defiance of the sanctioned codes of behaviour. Instead of promoting a traditional mode of thinking, Ansarinia's carpet exposes the clashing lifestyles and ideologies that are a part of life in a megalopolis such as Tehran, with its eight million inhabitants (fourteen million in greater Tehran) and its polarized politics, which became dangerously palpable around the 2009 elections. Ansarinia has since moved away from carpet designs, and now filters her critique through architecture (see page 268).[63]

Afruz Amighi (b. 1974) also began with traditional carpet design. Unlike Ansarinia, who had her silk carpet woven in Tabriz, Amighi invented her own technique and medium, which incorporates light and shadows. She carves patterns with a stencil burner into a woven polyethylene material that is used, according to the artist, by the United Nations in the construction of tents in refugee camps along the Syrian border.[64] She compares her method to drawing with a hot pen.[65] In her artist statements she quotes Gaston Bachelard, writing, 'Not for a second can there be any question of reproducing exactly a spectacle from the past. But I have to relive it entirely in a manner that is new.' Nostalgia is not what motivates Amighi. From the distance of diaspora (she lives in New York), she examines a cultural legacy through the medium of shadows; lights projected through the intricately carved hanging screens create designs on gallery walls, reminiscent of carpets, wall tiles, and at times pages of books. The paradise depicted in traditional Persian carpets, tiles and paintings is disturbed in these representations. In *Poppy Garden* (2007), for instance, hypodermic needles shoot out of the flowers, a reference to the drug addiction that is rampant in Iran.[66] Keys are another ominous object lodged in her paradisiacal landscapes, references to the plastic keys that allegedly were distributed to underage volunteers in suicide missions during the Iran–Iraq War to symbolically open the gates of paradise after their martyrdom. With *1001 Pages* (2009), the third work in a series Amighi calls 'shadow pieces', she won the Jameel Prize, awarded to the winning artist at the Victoria and Albert Museum, in London (fig 87). In the work, a building – the central image nestled in a profusely ornate landscape – serves as a stage for various literary, religious and historical references; together they conjure a rich cultural heritage that is battling nefarious forces to this day. For instance, the legendary bird Simurgh, from Attar's twelfth-century mystical tale *Conference of the Birds*, is portrayed hanging down from a balcony as if it were tortured. Presiding over the scene, a peacock (a bird of paradise), another creature in the cast of characters, shoots 'its feathers like spears

into a ray of eyes that surround it. The peacock, with its pride and vainglory, blinds itself inadvertently,' the artist writes.[67] The deliberately Orientalizing scene carries no nostalgia. Its seductive play of shadows hints at an ongoing tragedy.

While Ansarinia and Amighi's works retain the appearance of an ideal vision of paradise, the hallmark of certain traditional carpets, Farhad Moshiri's represent hell on earth. In his *Flying Carpet*, of 2007, which was inspired by a documentary film on Afghan carpet weavers who incorporate military aircrafts and drones into their designs, he carved a military aircraft from the centre of a stack of thirty-two machine-made Persian carpets (see below, fig 140). Having violated the magical land of Orientalist fables – in reality, territories under US assault – the aircraft rests perfectly intact beside the eviscerated pile. Thus *Flying Carpet* appears to be an indictment of military interventions in the region, be they already accomplished or pending or promised.[68]

Appropriation of history

In addition to traditional arts and crafts, the Qajar period and its kings have been fair game for both modernist and contemporary artists and photographers. The Qajar dynasty, often ridiculed in popular culture for its absurd excesses, has been in disfavour with both the Pahlavis and the Islamic regime. For this reason, it has been adopted as a subject by artists as a sort of subterfuge, allowing them a vehicle for critique while avoiding censorship. During the Pahlavi regime, Ardeshir Mohassess's caricatures of Qajar figures, Ghassem Hajizadeh's use of Qajar photographs as bases for paintings and Kaveh Golestan's Polaroids of surreal Qajar scenes pioneered a trend that has been followed in contemporary times by photographers and other artists. The 1976 series of Polaroids by Golestan (1950–2003) known as *Div va Dad* (a reference to Rumi's weariness with monsters and his longing for humans) featured scenes with an infernal atmosphere, where Qajar kings and their women mingle with bestial inhabitants and morph into vultures and lions.[69] They offered a damning yet playful condemnation of monarchy, from the Achaemenids to the Pahlavis, via the Qajars.

In his series *Rostam 2 – The Return* of 2008 Siamak Filizadeh (b. 1970) depicted the saga of Rostam (the mythic hero from the national epic, the *Shahnameh*), doubling as Rambo, in the style of manuscript paintings and comic books as an expat returning to Iran thirty years after the Islamic Revolution.[70] Now, in *Underground* (2014), through the appropriation of the Qajar past – its excesses, frivolities, cruelties condensed in the portrayal of Naser al-Din Shah as a decadent autocrat – he casts a critical gaze at authority portrayed

with contemporary tools (e.g. motorbikes, cell phones, surveillance cameras) and through the lens of contemporary visual culture (e.g. American cinema, pop concerts). In restaging the past as in an operatic extravaganza he obliquely touches on its contemporary implications. The series of twenty-seven staged colour photographs narrate historical episodes in a highly whimsical and surrealist language. Filizadeh believes that 'Westoxication,' the enslavement of Iran to Western culture and imperialist forces, began with the Qajar monarchy. *The Shah and the British Ambassador* (2014, fig 88), for instance, is a

88. Siamak Feilizadeh
The Shah and the British Ambassador,
From the 'Underground' Series, 2014
Inkjet print on Hahnemühle Photo rag Baryta
315 gr paper, and Diasec mounted with
plexiglass and aluminium, 150 x 100 cm
(59 x 39.3")
Courtesy of Siamak Filizadeh and Aaran
Gallery Tehran

highly satirical yet poignant portrayal of the Shah, posed and dressed half in royal regalia, half as a vulgar European woman, at the mercy of the British ambassador, who holds him with a chain in one hand and a whip in another. While the scene is staged in a rococo room decorated with Qajar paintings, Filizadeh, in tilting the carpet parallel to the picture plane, abides by the perspective found in traditional Persian painting. For this pathetically humiliating scene of impotence and subordination, not without a hint of pride, Filizadeh draws on the Shah's own words who, writing to his prime minister in 1857, said, 'I wished to make them [the British] recognize a limit to their mischief and arrogance. But I did not want to behave like a loose woman who gives in as soon as she is asked to remove her underwear.'[71] The entire series was exhibited at the Aaran Gallery in 2014 and appears in a book published in 2016 by Nazar in Tehran.[72]

A series of photographs by Azadeh Akhlaghi (b. 1978), a research-based project, best illustrates the appropriation of history as a critical strategy. In these digital prints, *By an Eye Witness* (2012) the artist herself appears, as an anachronistic witness, in all the scenes. She stages a number of historical assassinations, from the 1906 Constitutional Revolution to the present, in an ongoing political practice. Her picture of the assassination of the poet and journalist known as Mirzadeh Eshghi in 1924, at the order of Reza Khan, who was soon to ascend the throne as the first Pahlavi king, is a case in point (fig 89).

Other kinds of appropriation

To Persian painting, carpets and history itself, one may add the appropriation of art that has its origin in the West. Photographers, such as Shirana Shahbazi (b. 1974), who lives in Zurich, and Shirine Gill (b. 1947), who divides her time between New York and San Antonio, Texas, have borrowed aesthetic categories from painting and transplanted them into photography. Their work engages more with the notion of photography as a repository of truth and a tool for the distribution of meaning than with any overt political agenda. It can be said that photography from its beginnings aspired 'to purposes other than mere reproduction.'[73] Today, Shahbazi plays with the dual mission of photography as purveyor of reality and its aspiration in the opposite direction. In her earlier explorations, Shahbazi borrowed traditional genres from Western painting and commissioned Iranian sign painters to execute them on walls, or carpet weavers to weave them as carpets. Still life, landscape, and portraiture: the three genres of beaux-arts painting take on different meanings as they migrate from one medium to another.[74] The same image of a young European woman, for instance,

89. Azadeh Akhlaghi
*By an Eye-Witness: Tehran, Mirzadeh Eshghi,
3 July 1924*, 2012
Digital print on photo paper, 110 x 209 cm
(43 x 82")

is seen in a photograph and a carpet exhibited side by side (below, fig 120). The pairing challenges photography's old claim of being the conveyor of an unqualified fixed meaning while at the same time it upsets the conventions of Persian carpet weaving on the one hand and paper as the support of photographic images on the other. More recently, as testified by the works Shahbazi exhibited in *New Photography 2012* at the Museum of Modern Art, she has photographed geometric volumes such as pedestals and thus usurped one more Western aesthetic tradition intimately associated with modernism: geometric abstraction (fig 90). While her abstract images originate in reality, they are subsequently altered to intensify their abstract quality and to distance the final image from its origin, in the process destabilizing any fixed reading.

In *Suite Aquatico* (2009, fig 91) Gill resurrects an abstraction that is related to the early pioneers of photography in the West. Perhaps

Below
90. Shirana Shahbazi
[*Composition-30-2011*], 2011
C-print on aluminium

Opposite
91. Shirine Gill
Suite Aquatico, 2009
Pigment ink print, 81.5 x 122 cm
(32 x 48")

she seeks to confirm the elusive nature of the subject in a craft known for its dubious access to truth, or maybe she is attempting to capture an immaterial sentiment. Detached from theoretical narratives, her intuitive explorations lead her to images of, for example, a vortex of light rushing down a shaft of darkness – perhaps a metaphor for internal searching, or perhaps not. Whatever her intention, the final result does not have an indexical relation to the visible world. Her images are less concrete, never geometrical, and more poetic than programmatic photography in this genre.[75]

Iconography of the Islamic Republic

Some artists have rerouted the signs and symbols of the Islamic regime. The flag and its logo, as well as state-sponsored urban propaganda murals, are some notable examples, much discussed in the literature;[76] the martyrs' fountain at Tehran's Behesht-e Zahra cemetery – with its red-tinted water reminding a nation of the bloody sacrifices of the Iran–Iraq War – is a lesser-known example. The international artist collective Slavs and Tatars (one member of which is of Iranian descent) created red fountains in various public sites around the world in 2012 and 2013. In removing the water from its original geographical and cultural site, its associations with blood, violence, mourning and the sacred are replaced with innocence, sweetness and joy. The Kool-Aid-coloured water,[77] stripped of propagandistic intentions, is a sight that would easily be attractive to children. The work, titled *Reverse Joy*, gives a global connotation to context as generator of meaning. A smaller version of the fountain was included in installations Slavs and Tatars showed indoors in different institutions, including the Museum of Modern Art in New York in 2012 (fig 92). At MoMA, lodged in an installation titled *Beyonsense*, it was the centerpiece of an environment created for collective gathering and reading. In a quiet, restful atmosphere, visitors could view the fountain – a progeny not just of the sinister model in a Tehran cemetery but also of the soothing indoor pools of bygone domestic Persian architecture – while sitting on cushioned benches along the walls, in stark contrast to the generally overcrowded museum with its scarce seating. Entered between hanging Oriental carpets, the space was imbued with a sense of Middle Eastern hospitality or, if a Western reference is preferred, the calm repose reminiscent of the 'soothing armchair,' designed for a tired businessman, cited by Matisse as the goal of his art. Soon, however, it became apparent that in fact one had entered a lair of signs with an agenda. Strategically choreographed, the fountain regained some of its sacral connotations under the neon lighting of a ceiling inspired by Dan Flavin's installation for a mosque in Lower Manhattan. This reference to Flavin laid bare the spiritual dimension or affiliation of light installations normally accepted as minimalist and secular. The green evokes not just Islam but also the rebellious Green political movement in Iran – whose activities peaked around the disputed 2009 election – which appropriated the colour for itself. The apparent tranquility of the environment was furthermore punctured or belied by the guttural sounds (the 'Cyrillic, Hebrew and Arabic letters for [*kh*], the guttural fricative: х, ה, خ, respectively'[78]) calligraphically indicated in dancing strokes around the low-tech, blood-red fountain. One more guttural sound (*gh* or *q*) was illustrated in the position it occupies in the

92. Slavs and Tatars
Projects 98: Beyonsense, 2012
Installation view
The Museum of Modern Art, New York

throat on a board placed reclining against the wall. All these visual and aural signs converged in a reminder of those referents missing from mainstream narratives that privilege Western culture. Together, in the artists' words, they 'highlight a collective, textured, anti-imperialist, sacred one as opposed to the often secularized, individualist one.'[79] Slavs and Tatars created a space where ciphers of the sacred and the secular, the modernist and the anti-modernist, peace here, and turmoil elsewhere, point to the highly complex world we inhabit.

Calligraphy as nemesis

Calligraphy, a traditional form of expression, has played an immense role in the stereotyping of the work of artists from the Middle East. This kind of ethnic art has found commercial success and the acceptance of those who favour perpetuity of tradition rather than its rupture through innovations. Thus contemporary artists have made it the subject of attack on two fronts: form and content. The tradition of calligraphy, exquisitely manicured and precise, is dethroned and replaced with something dishevelled and prosaic. Among the works discussed in this book, such an irreverent approach to writing is evident in Haerizadeh's *Typical Iranian Wedding* (see fig 82), where the 'Vay vay vay' sounds of some popular tune, based neither on high literature nor even on words found in a dictionary, is inscribed across the top. Mimicking the rhythm of cheerful music, the handwriting is sloppily casual, matching the pedestrian content. Parviz Tanavoli, on the other hand, has preserved the beauty of calligraphy, as embodied in the *nasta'liq* script, in a multitude of sculptures spanning almost six decades. Instead he delivers his antagonism through the meaning of the word the script embodies: *heech*, or 'nothingness' (figs 30 and 137).

While calligraphy continues to find a highly lucrative market in Dubai, it also circulates in the hands of its foes. It was in a gallery in Dubai, in fact, that Farhad Moshiri (b. 1963) delivered to calligraphy a multi-faceted blow. Irony, sarcasm and surreptitious critique, concealed as innocuous praise, were the artist's strategy in *Shukran* 2011, (fig 93).[80] In this work, a gentle sweeping line of script undulates as knives and sabers directly pierce the wall. Viewed from a distance,

Opposite, far left
93a. Farhad Moshiri
Shukran, 2011
Knives on plaster wall, dimensions variable
Collection Abu Dhabi Tourism & Culture
Authority

Opposite, left
93b. Detail of 93a

Below
94. Mahmoud Bakhshi
Khatteh Poulsazeh Farsi (*The Money Making Persian Calligraphy*), 2010
Detail of installation view at the Saatchi Gallery, London

it reads *shukran*, meaning 'thank you' in Arabic (not in the artist's native Persian). On one level, *Shukran* may express the artist's gratitude to a Dubai art market that has celebrated his various calligraphic productions. But Moshiri has explored the market not just for profit but also for opportunities for critique. He has said, 'There's always been an element in my work that's self-ridiculing. I play with the idea of marketing and commodification, and this feeds my practice.'[81] It is noteworthy that in *Shukran* Moshiri is offering his thanks in Arabic, planted aggressively into the wall of a major Dubai art gallery. Given the historical animosity between Iranians and their Arab conquerors, the work seems to address the legacy of Arab culture, from its script to its religion to its impact on the Iranian regime. Is Moshiri's thank you candid, or is it a polite formula concealing historical resentment? When asked, the artist replied, 'Sometimes just a simple thank you is enough.'[82] Whatever the case may be, the graciousness of his word is inflected by the hostility inherent to his chosen medium.

With Moshiri we are back in the territory of subversive appropriation. *Khatteh Poulsazeh Farsi* (*The Money Making Farsi Calligraphy*, fig 94), a gigantic installation by Mahmoud Bakhshi (b.

95. Barbad Golshiri
Quod, 2010
Pigment inkjet print on paper, 106.2 x 106.5 cm (41 x 42")

1977) – who, like Moshiri, resides mainly in Tehran – also belongs in this category. As the 2009 recipient of Magic of Persia's Contemporary Art Prize, he was offered a solo exhibition in 2010 at the Saatchi Art Gallery in London, where the work, occupying two large walls, was one of several elements in an elaborate installation.

'Your gaze scans the streets as if they were written pages: the city says everything you must think, makes you repeat her discourse.'[83] These words, which Italo Calvino placed in the mouth of Marco Polo as he visited the empire of Kublai Khan, apply equally to Bakhshi, who emulates the discourse of his city, appropriating the paraphernalia of its visual signs but inscribing his own voice on its fabric (this work could equally have been treated in this chapter's 'Tehran' category). Into a dizzying patchwork of some 120 panels, mostly composed of banners displayed on religious occasions, here and there punctuated with the starry logo of rice gunny sacks and a few silent intervals in blue, the artist weaves his own half-hidden confession in text that is digitally printed on striped fabrics of the type used in Tehran to cover construction sites. Within the ready-made discourse of the city, his text, which is also the title of the work, challenges the commercialization of calligraphy. Bakhshi's treatment of writing is irreverent in that his reference is to low culture: to the digital, to the kind of advertisements that are stencilled on street walls. In this medley of signs, the fragmented phrase collides with cut-up banners, some in the diamond-shaped pattern of the harlequin, with whom the artist claims a strong affinity. Ultimately, through the public vocabulary of flags and banners and their scripted invocations, Bakhshi reformulates a carnivalesque city resounding with the message that Persian writing (meaning calligraphy) is commercial. Ultimately, the question is not just about politics or even calligraphy but rather about the tightrope on which the artist, the harlequin, must walk. The concern is the predicament of art, the position of the artist, and the role of aesthetics in relation to a visual culture with an agenda, be it commercial or political. To what methods can an artist turn in an atmosphere controlled, inside the country, by state signs and mandated allegiances and by confining demands for the production of ethnic art outside? Mimesis as resistance or, in other words, appropriating one's adversary's ammunition may be the answer.

In *Quod* (2010, fig 95), Barbad Golshiri (b. 1982) steers clear of the lightweight humour typical of an artist like Haerizadeh and shuns the spectacle present in the work of Moshiri and Bakhshi. Instead he latches onto the painfully raw: the memoirs of a woman who was imprisoned in the 1980s in solitary confinement. The repeated act of drawing squares within squares, or rather one continuous maze, with a rusty pin she had discovered in her cell empowered her with

96. Barbad Golshiri
Oil on Canvas, 2018
Pigment inkjet print on photo paper,
60 x 90 cm (23½ x 35½")

a new perspective on her life. 'The cell was too dark,' she wrote, 'but I could see a point in the middle of the square that helplessly looked up at me and said: you should testify that I've been a square. You are the only one who knows that I have been and still am a square.'[84] Golshiri reaches beyond the psychology of trauma – the projection of the prisoner's sentiments onto an inanimate drawing – back to an art historical model: Kazimir Malevich's painting *The Black Square* of 1915. The title *Quod* (slang for jail) suggests *quad* (the Latin root meaning 'four'), hence quadrangle, and the work shares its dimensions with Malevich's painting. Within the dark empty cell, doubled as the confines of a square, the prisoner's memoir spirals toward the centre in letters that gradually diminish in size. For the lettering, Golshiri photographed a journalistic type – the exact fonts, he told me, that newspapers used on 16 January 1979, to announce the departure of the monarch, printing a simple *Shah raft* (the Shah left) – a headline devoid of the usual obsequious titles, such as His Majesty, the Light of Aryans, or even his name in full. Obliquely, Golshiri pays his disrespect to the *ancien régime* and recalls the forbidding spaces of Iranian prisons of all periods. In addition he offers an incriminating text that is meant to be read. It is not an aestheticized ornament as in the work of calligraphers and artists such as Neshat. Unembellished, the text communicates an epiphany of vital importance, not praise and not decoration.

For Golshiri, traditional calligraphy as executed today is nothing more than a commodity. To remain true to his message and resist the commodification of his expression, Golshiri stipulated that prospective buyers of *Quod* must be able to read Persian. Golshiri proposes an alternative model for the representation of text that reinstates gravitas, momentous thoughts, and visceral experiences.

The carceral atmosphere is never too far from the artist's imagination, even when photographing the Tehran Museum of Contemporary Art (fig 96). TMOCA owes its existence to the petro-dollars that flowed into the country in the 1970s. Kamran Diba, the museum's founding director and architect, also responsible for acquisitions, commissioned the Japanese artist Noriyuki Haraguchi, who created a pool filled with oil. Titled *Matter and Mind*, the rectangular structure, of Minimalist appearance but pertaining to a Japanese genealogy (the Mono-ha movement), contained the flammable stuff of political upheavals. It was installed at the heart of the museum, as its physical and symbolic core, visible from above but also constituting the grand finale of the sequence of winding galleries that lead to it.

As recounted by Diba, at the official inauguration, on 13 October 1977, the Shah asked him 'What is this?', referring to the pool of oil, which looks like a polished black mirror reflecting the surroundings,

including the window view above, and recalling prison bars through which a distant portion of sky may be seen.[85] Doubting Diba's answer that it was oil, the Shah soiled his hand by dipping it into the liquid. Diba reflects on this incident as a political sign of historical importance.

Oil on Canvas, an intriguing 2018 photograph taken at TMOCA by Golshiri, offers an image from the belly of the beast while also referencing several of the museum's acquisitions: the Hariguchi, predating the 1979 Revolution, and oil-on-canvas portraits of the two Supreme Leaders by the academic painter Keykhosro Khoroush.[86] The paintings, which are hung high up on the wall, are pictured in Golshiri's photograph reflected upside down on the dark surface of Hariguchi's liquid. One of them, the artist surmises, was probably the first acquisition the museum made after the Revolution. The link between the abstract sculpture and the oil paintings is the country's oil-based economy. Reflected in the dark abyss at the museum's heart, oil, history, art and politics commingle.

Golshiri was raised in a literary family; he is the son of the eminent writer Houshang Golshiri. He is himself an author. His attention is drawn to the form and the content of writing but also to speech and above all the voice of victims, their tormentors and, he adds, actors.[87] He has made use of Roman, Arabic and Braille scripts and has written or spoken in his performances words in Latin, Greek, French, English, Arabic and Persian. The supports for these writings have also been diverse: the photographic paper of *Quod*, simulated toilet paper, canvas, his own flesh,[88] and grave markers he has engraved or stencilled with soot, to name a few. His interest in Braille is pertinent here, in that its use by the blind prevents it from being seen as frivolous

Top
97a. Barbad Golshiri
Death Sentence, 2011–13
Engraved marble, 106.8 x 54 x 5 cm (42 x 21.6 x 2"); 106.8 x 56 x 4 cm (42 x 22 x 1½"); 47.2 x 119.5 x 54 x 4 cm (21 5/8 x 1½")
Private collection

Above
97b. Braille detail from fig 36a

visual ornamentation and enables it to partake into what Golshiri calls 'the language of concealment.'[89] It allows for the kind of political art that requires cunning and disguise. Golshiri applies this strategy in a work in which three tombstones are carved not in the calligraphic style customary in Iranian cemeteries but in Braille that is concave, and not in relief (figs 97 a–b). These grave markers, which lie together like dominos, commemorate the deaths of three dissidents. They took place in sequence, one leading to the other. Text survives but calligraphy dies in these grave markers, a genre Golshiri has taken up as his main practice. They are not restricted to floor sculptures. Some are reinvented as floor prints, and a few works incorporate painting and photography. Golshiri's dialogue with death is neither relic-oriented nor of a symbolic order. His will to commemorate is based on opposition to the anonymity imposed on those whose deaths are erased by the system and on a desire to do homage to literary or artistic personalities who have inspired him.

Exhibiting such works outside Iran divests them of the audacity with which they were created. But Golshiri's strategies are diverse, and some of his works are equally compelling when encountered abroad. In Paris he created a sarcophagus for the Iranian artist Chohreh Feyzdjou, who died in that city in 1996, aged forty. Blurring the boundary between art and life (or art and death), Golshiri placed the object, made of wax, not in a museum or a commercial gallery but on Feyzdjou's tomb in the Parisian Cemetery, Pantin. In capital letters he inscribed 'Concession éphémère,' the name of the artist, her life dates (1955–1996), and 2014, the year the work was installed (as a collateral event to the exhibition *Iran: Unedited History*), and left it to erode over time. The work grew out of Golshiri's preoccupation with grave markers as well as Feyzdjou's approach to art and life and her intimacy with death, which is discussed below.

Death and mortality

The theme of death, prominent in Golshiri's work, is expressed throughout Iranian modern and contemporary art. In Shi'i culture, when the lunar calendar returns to *Ashura* every year, mourning for Imam Hosein and the martyrs in Karbala is reignited, fervently re-enacted as if it were a current event. Processions, passion plays, and ceremonies interrupt the routine of ordinary life. The severed hand of Hazrat-e Abbas (so prominent in the iconography of the Saqqakhaneh) and the martyrs glorified in the propaganda art of the 1980s belong to a lineage that is Shi'i in origin. Death is also a subject around which artistic dissidence is active, depicted through images of

matter-of-fact dead bodies in a morgue or wrapped in sacks. These and other works present a counter-argument to glorified martyrdom. The references to death in contemporary art are secular and not necessarily created by artists who are Muslim. Starting in 1972, Siah Armajani (b. 1939), for instance, constructed a number of architectural tombs in his idiosyncratic style, blurring the line between sculpture and architecture, to commemorate writers and philosophers who have inspired him. His tomb series, his gallerist has written,

> pays tribute to twenty-five philosophers, activists, poets, and critical writers who have been foundational voices to Armajani's art and ideology, among them Theodor Adorno, Walter Benjamin, Dietrich Bonhoeffer, John Dewey, Ralph Waldo Emerson, and Walt Whitman. The series embodies the humanist,

98. Siah Armajani
Tomb for Neema, 2012
Concrete, wood, shingles and paint,
139.7 x 426.7 x 152.4 cm (55 x 168 x 60")
Courtesy of the artist and Rossi & Rossi

democratic, and populist ideals that have defined Armajani's multi-faceted vision.[90]

Armajani's tombs are pure inventions of his own, without reference to any tradition of mortuary monuments or even a direct link to the deceased they honour.[91] One of them, *Tomb for Neema* (2012, fig 98), pays homage to Nima Yushij (1897–1960), the founder of modern Persian poetry. Explaining his fascination with this poet, Armajani has written, 'He changed the rhythm and rhyme and took the poetry out of the ritual of the court. He placed it among the people and the masses.'[92] An activist – initially Marxist, then in Mossadegh's National Front movement – Armajani left Iran in 1960 for Minnesota's Twin Cities, never to return except for a single brief visit in 2005, upon President Khatami's invitation. Throughout his oeuvre, Armajani demonstrates his engagement with political thought through the spaces he creates for communal interaction, sites conducive to thinking (e.g. lecture rooms and reading rooms) that speak volumes about his interest in stimulating thought, interaction, and dialogue – the antithesis of totalitarianism.

In Minnesota, Armajani studied philosophy and mathematics. It was only around 1968–70, he says, when he met the American artist Barry Le Va,[93] that he learned that his art practice was called 'conceptual.'[94] He may be the first Iranian (naturalized American) conceptual sculptor. He developed an entire lexicon of industrial and domestic structures that he dissected and reconfigured from different angles. His work is not confined to sculpture, however, though he has worked widely in that mode, from small-scale models, such as his *Dictionary for Buildings* (1974–5), to projects as large as his *Irene Hixon Bridge* (1988), a structure that crosses over a sixteen-lane highway and connects the Walker Art Center's sculpture garden in Minneapolis to the park on the other side.[95] Armajani's language also incorporates 'calligraphy', though with a caveat. If calligraphy means beautiful handwriting, Armajani's is as plain and unadorned as the vernacular architecture he has focused on, and in tune with the language of the ordinary people his politics celebrate. His use of text ranges from quotations of poetry by the loftiest of literary poets (such as Hafez and Rumi) to nursery rhymes and, beyond comprehensible language, to abstract letters with no attachment to words. Armajani belongs to the same generation as the Saqqakhaneh artists. His only contact with them took place in 1962, when Parviz Tanavoli moved to Minnesota. I have made a distinction between the Saqqakhaneh's use of text – where words do not claim an overpowering role but intrude into compositions that, for instance, revolve around religious iconography – and what has been termed calligraphic modernism. In this latter category, which I would define as an all-over composition of abstract

99. Siah Armajani
Written Minneapolis (The Last Tomb), 2014
Felt pen on mylar, 91.44 x 563.88 cm (36 x 18'6").
Collection Lannan Foundation. Promised Gift
to The Menil Collection

letters on large canvases (not necessarily in beautiful handwriting), Armajani emerges as a precursor among Iranian artists. He practiced it modestly before he left Iran but conspicuously afterwards, in the early 1960s[96] when Zenderoudi and Pilaram had not yet embarked on their own versions of calligraphic modernism. Recently he has returned to this mode of expression. *Written Minneapolis (The Last Tomb)* of 2014 (fig 99) is a drawing that sums up the lifetime interests of this artist, including his admiration for Kazimir Malevich, who designed his own coffin, and his attachment to the city where he has lived and loved, which is conceived here as his ultimate residence, the site of his burial. While a sense of aerial perspective was already present in his earlier 'calligraphically modernist' paintings, in this drawing writing articulates bridges and defines the skin of a motley of ghostly architectural shapes inspired by the neighbourhood where his studio is located.[97] He writes, speaks, thinks, and breathes Minneapolis, in Persian. In the lower

right-hand corner, he punctuates the exit from it all with a tomb he designates as his own. As in the work's title, the tomb depicted in the drawing is a parenthetical, peripheral statement, and not the centre of attention. Somewhat reclusive, this diasporic artist is one of the most accomplished sculptors Iran has produced outside its borders.

Feyzdjou, much younger than Armajani, was another non-Muslim expat artist whose work exudes an aura of mortality. Her father changed the original Jewish name Cohen to Feyzdjou. She left Iran in 1975 to settle in Paris, where she died young, at the age of forty.[98] Feyzdjou never created works with a direct reference to death but her entire oeuvre speaks of preparations for an ultimate departure: piles of trunks, crates, rolled-away canvases, labelled boxes and jars, scorched manuscripts – inventories of a lifetime she presented as 'Product of Chohreh Feyzdjou.' 'Thus we enter the world of commerce,' maintains Pennina Barnett[99] – yes, but a morbid sort of commerce, and the type

conceived in overcrowded Persian bazaars and not in slick department stores; the rolled canvases recall the fabric or textile merchants in their *dakkeh*, or bazaar niches (figs 100–1). Feyzdjou had been a student of Christian Boltanski, and she was familiar with his inventories of objects left behind by those who perished in the Holocaust. She also studied the Kabbalah. In Feyzdjou's dark universe, esoteric faith fuses with commerce, art, ethnicity and a psychology in tune with her failing health. Commercial products are rolled like fabric but also like sacred scrolls, like the Torah, like insignia with a half-apparent meaning and a half-hidden significance – markers, perhaps, of the end of something or the beginning of another journey. Death casts its shadow on everything the artist touched; a film of blackness stains a life's production.

Spirituality

Spirituality, especially in the form of Sufi mysticism, is not a stranger to the traditional arts of Persia.[100] It is encountered in every medium and, beyond the visual arts, in music and literature. With contemporary painters we see less of an illustrational or laudatory impulse in relation to a specific brand of mysticism – be it Islamic, Christian or any other – and more often the translation of a profoundly internalized meditative experience through an engagement with grand themes. Writing about the notion of self-transcendence in the West, however, one faces stigma and scepticism. Culturally speaking, narcissism, at least in the US, is less subject to critique (it is even encouraged among children) than self-effacement and modesty. There is also a deeply ingrained secularism among intellectuals, many of whom shy away from spirituality.[101] This cultural reticence has been compounded by the trivialization of these ideas and practices in the guise of New Age thinking espoused by Hollywood icons. Iranian culture, on the other hand, admires self-transcendence and its wisdom. Spirituality need not necessarily be tied to organized religion, as evidenced in today's Iran, where Sufism is not condoned.

Shirazeh Houshiary (b. 1955) and Y.Z. Kami (b. 1956), two diasporic artists – the former living in London, the latter in New York – epitomize the spiritual quest in contemporary Iranian painting. Stylistically different, Houshiary's abstractions and Kami's portraiture are similar in their acceptance of a state of flux, a transient condition that cannot be fixed into one thing or its opposite. At their most magical moments, these artists achieve transcendence by conquering divisive dualities.

Houshiary treads into the territory of monochrome, fugitive, ethereal abstraction so prevalent in American painting (such as Mark

Opposite
100. Chohreh Feyzdjou
Installation view from the *Global/Local* exhibition at the Grey Art Gallery, New York, 2016

Opposite below
101. Chohreh Feyzdjou
Product of Chohreh Feyzdjou, 1992
Installation view from the exhibition, 'Products of Chohreh Feyzdjou', 1992 at the Galerie Patricia Dorfmann, Paris

102. **Shirazeh Houshiary**
Presence, 2000
Aquacryl with silverpoint and graphite
on canvas, 190.5 x 190.5 cm (75 x 75")
The Museum of Modern Art, New York.
Committee on Painting and Sculpture Funds

Rothko's, to name but one), but she gets there through hidden text. In her virginal fields of whiteness, Houshiary erases dualities. She disarms the opposition between something and nothing, between words and silence. The apparent nothingness of a work such as *Presence* (fig 102), a seminal painting in the collection of the Museum of Modern Art, conceals a text consisting of two words that have until recently been the building blocks of all her paintings. Hushed into silence, their identity is never divulged. The Arabic script in which they are formulated is confessed to, but illegible and unseen. Working meticulously with pencil on a canvas stretched on the floor, Houshiary makes marks that register her restrained calligraphic gestures, the pressure of her body against the surface, the focus of her vision, the rhythm of her breath – a notion central to her iconography.[102] She evokes the amorphousness of breath and its contractions and dilations in fugitive images that enter but soon vanish from visibility. The marks are obsessively repeated, like a mantra, or, in Sufi terminology, a *zikr*. Houshiary seems to be engaged in the impossible task of finding and engraving the mirror image and the rhythm of her breath, of the self as mere presence – a self that reflects all.

On the phenomenological level, optical adjustment is required. One moment a halo, an elusive horizontal aura, appears, but soon it sinks back into the nothingness of the white void. Yet instantly it is summoned back into being. An encounter with *Presence*, which vacillates between the visible and the invisible, parallels the miracle that is sight itself.

In this painting and others, colour disintegrates into aura, light and shadow exchange roles, black and white reconcile their difference, form dissolves, materiality evaporates, language retreats, and the original word is transcended. What continues to vibrate is the trace of the activity, like a wavelength whose presence is chased away by absence. Being alternates with not-being, presence is continually chased by its antithesis, absence. *Presence* illustrates the 'impermanence of the visible,' which is how one author defines Sufism.[103] Houshiary takes us deep into a spiritual space where divisions and boundaries collapse in the face of a collective human pulse.

Houshiary is equally an accomplished sculptor. Early examples were introduced in *Magiciens de la terre* – the seminal exhibition of contemporary art organized by Jean-Hubert Martin and held in 1989 at the Centre Georges Pompidou in Paris.[104] She was the only artist of Iranian origin featured.

The concept that animates many of her paintings is evident in some of the artist's sculptures. She placed one of them, titled *Breath*, near a Romanesque church in Münster in 2003 (fig 103). It was installed with a sound system evocative of breathing. That year I described it thus:

103. Shirazeh Houshiary
Breath, 2003
Cast white limestone with internal sound
system, 701 x 127 x 126 cm (275 x 50 x 49")
Sculpture Biennial, Münsterland, 2003

Conceived as an ellipse, static but its shape suggesting
perpetual motion, the limestone-brick tower seemingly swells
and contracts as it whirls away from the earth. Dancing around
itself it restates the theme of the tower echoed twice in the
structure of the church, reiterating an archetypal function. As
links between earth and sky, secular and sacred, towers seem
entrusted with a message or mission. Houshiary and [Pip]
Horne's tower conveys an aspiration: to transcend differences
and spread the news. Such sentiments have motivated the
construction of towers throughout the human narrative: in spirit,
but also in form, *Breath* descends from a lineage stretching from
the biblical Tower of Babel, to Constantin Brancusi's iconic
modernist *Endless Column* (in Tîrgu Jiu, Romania) and beyond,

104. Shirazeh Houshiary
Installation view of *Breath*, 2003
Video

passing on the way through the ninth-century spiraling minaret of the Great Mosque of al-Mutawakkil in Samarra – at the time of this writing an endangered site in Iraq. Today, tragically, no mention of towers escapes the memory of the twin towers in Lower Manhattan. Houshiary and Horne's tower bears witness as memorials do, but humanized, it breathes, and prays too.[105]

Houshiary has turned to the iconography of being/not being, central to Sufism and other Eastern mystical practices,[106] not just in her paintings and sculpture but also in video installations (fig 104). The quivering images that emerge in her abstract paintings are set in motion in the animations in her first video installation, which is also entitled *Breath* (2003). This four-channel video (installed on monitors on four walls) has been shown in a variety of locations, including Venice and Tehran. Here, instead of words, the texture of each pulsating image consists of scintillating particles of light which intensify, fade in the darkness, and return again only to retreat once more. The twin concepts of *fana* (annihilation) and *baqa* (eternal life or remaining in God after annihilation) seem to have deeply informed her thinking. Facing the screens at very close range, you find the intimacy of the self and imagine the trace of your breath, while transcending or losing that very self through the glimpse that is offered of an infinite universe.

In all four directions, prayers of four different religions rise and die with every breath. Now breathing has become vocal. It accompanies spiritual chants anchored in different cultures and religions. Approaching each screen, either the Azan, a choir of Buddhist monks from Japan, a Jewish song to the invisible God, or a composition by the Christian mystic Hildegard of Bingen can be heard. With distance, in the centre of this conjured universe, all the voices come together to remind an amnesiac world of humanity's shared rhythm.

Houshiary's world is not restricted to any single set of beliefs. In many strains of esoteric thinking, appearance must be transcended to reach inner truth. She is equally mindful of other approaches to aesthetics, such as Minimalism. She shares the Minimalists' desire for reduction and for essence, and in her own idiosyncratic way she shares their penchant for repetition. By the same token, in her work the West is not the antagonist to the East, and European Old Masters with their figurative styles are never far from her abstractions.[107] Unconcerned with, and perpetually trying to move beyond, divisive polarities of gender, culture, ethnicity or geography, she seeks release from a world impaired by divisions. She strives for a space shared by all humanity.[108]

More recently, Houshiary has gradually relinquished control of her marks, her grip on the meticulously written but concealed prayers. Instead, she has begun courting chance by allowing poured paint to inscribe its own trajectory. She is moving beyond her previously confidential, internal incantations, her *monajat* (intimate prayers to God) which were committed to a support (canvas or paper) whose dimensions she could physically grasp. Her small works reflected a mirror image of her breath, the larger canvases the perimeters of her outstretched arms. She is releasing her attachment to the word, which she now conceives as energy,[109] and the dimensions that referenced the body. While remaining tethered to grand themes and faithful to her core belief in flux, her rumination no longer emanates from the point of view of human seekers but rather enunciates the universe's logic of cataclysmic change, an ongoing and perennial process of formation, erosion and disintegration. To invoke such dynamics on a cosmic scale, she casts the elements of fire, wind, and water as perpetually shifting and reshaping forces, and, in the case of a work such as *Rift* (fig 105), she captures in abstract terms the push and pull of the flaming energies that lead to the formation of separate continents, possibly susceptible to further transformation. Houshiary offers us a glance into the impassive logic of cosmic evolution.

Kami's figurative paintings are just as complex in genealogy, as lofty in aspiration, and as tenacious and labour-intensive in practice as Houshiary's, but the vehicle of his message differs. While Houshiary attains her spiritual abstractions through concealed text (and now

105. Shirazeh Houshiary
Rift, 2017
Pigment and pencil on white aquacryl on
canvas and aluminium, 190 x 190 x 5 cm
(74¾ x 74¾ x 2")
Private collection

vectors of energy), Kami mobilizes portraiture for his transcendental
goals. They both evoke the ebb and flow of life, Houshiary through
breath and Kami through a transition from matter to spirit.

Traditionally, portraits designate individual identities; Kami's,
while anchored in distinct physiognomies, surpass the specific to
speak about humanity and its fate. Unique and yet part of a collective,
whether viewed as fraternities, tribes, saintly mortals, or simply, in Homi
Bhabha's terms, as 'quotidian mystics,'[110] his subjects face the viewer
with the knowing gaze of a revenant or the averted eyes of a seeker.
Frequently blurred, they are apparitions in flux between being and not
being. Exuding silence, they are the residents of Sohrawardi's *Nakoja-
abad* translated by Henry Corbin into Latin as *mundus imaginalis*, a realm
between matter and soul, between the external and the internal.[111]

Sometimes using the same sitter, Kami alternates between focused renditions and blurred, ethereal representations. Kami's images of a bald man, photographed in a meditation centre and portrayed by him repeatedly for at least a decade, illustrate the fact that psychology or personality – in short, the individual – is not the point. As an aesthete, Kami is concerned with subtle formal variations; as a seeker he is fascinated with states of imperceptible physical action – simple breathing – that harbour intense spiritual exercises. His anonymous subjects, majestic and yet intimate, imposing in size or as small as life, present varying degrees of presence or withdrawal and, in some cases, hover at the threshold of dissolution (fig 106). Each of these portraits originated in a single shot, a fixed pose, yet impermanence or flux is the subject under investigation. The finality of death itself is debunked in a painting portraying the death mask of the French mathematician and theologian Blaise Pascal. It seems to breathe; Kami restores it to life. The painting was exhibited at the Gagosian Gallery in Paris in 2018.

His portraits are repeated. So will the death mask be, the artist says. Repetition is the process through which change is revealed. Repetition parallels the routine of prayers; Kami has entitled an entire series of works *Endless Prayers*. Repetition allows for incremental access to the evanescent goal. To 'meditate [...] with pigments and brushes'[112] is how he describes his practice; it is monastic but also sensuous, as Robert Storr has pointed out.[113]

Kami's aesthetic lineage may be traced back to practices as varied as Fayyum portraiture[114] (funerary imagery painted in Egypt in the first-to-third centuries AD), European Old Master paintings such as works by Piero della Francesca,[115] the serial portraiture of Andy Warhol and Gerhard Richter, and the vein of Iranian modernism I have termed Old Master modernism.[116] The painter Kamal al-Molk first promoted the latter current, which was then pursued by his student, Ali Mohammad Heydarian, who taught Kami's mother, Mahine Youssefzadeh – from whom Kami learned the craft of painting. This aesthetic descendant of Kamal al-Molk turns his observations of this world into meditations on the other, transforming contemporary individuals into inhabitants of the *mundus imaginalis*. Aesthetically erudite but neither pedantic nor plagiarizing, Kami's approach to portraiture is unique in contemporary art.

Imagine a procession of portraits from the nineteenth century to the contemporary era: from the aggrandizing representations of Qajar rulers, to the reformed, humanized version in Kamal al-Molk's *Hall of Mirrors*, to the generically modernist official portraits of the Pahlavi couple – antiquated in their display of imperial pomp yet formally referencing modernity – to Y.Z. Kami's ordinary sitters elevated to a

Opposite
106. Y.Z. Kami
Untitled, 2011–12
Oil on linen, 299.7 x 177.8 cm (118 x 70")
Courtesy of the artist and Gagosian

spiritually transcendental level. Lastly comes Payman Shafieezadeh's suppression of figures of authority, displacing them from the centre to the periphery. This exercise provides insight into the multiple ways artists have addressed the notion of authority through the medium of portraiture, and a telling dialectics of art and power.

The figurative traditions in which Kami thrives are fundamentally incompatible with orthodox Islamic doctrine. As Storr writes in his essay on Kami, the 'ban on mimesis' in 'strict Islamic and Orthodox Jewish religious doctrines' is an act 'preventing aesthetic hubris and aborting blasphemously deceptive marvels.'[117] In modern Iran, however, there has been no 'ban on mimesis.' Today, what is required is conformity in representations to the mandated dress code for women. More importantly, organized religion in Iran does not condone esoteric belief

107. Y.Z. Kami
Black Dome, 2015
Black gesso on linen, 177.8 x 195.6 cm
(70 x 77")
Mohammed Afkhami Foundation

systems; for example, the clergy has adopted anti-Sufi policies. Kami, living in diaspora, does not face those restrictions. His women display full heads of hair and their gazes are not directed towards Mecca. Their prayers are brewing internally. Kami's intention, however, is by no means subversive. His vision does not accommodate binary classifications and critical confrontation. By the same token, to constrict him to Islamic-or-not, one camp versus another, would be to miss the all-inclusive nature of the artist's belief system.[118] This is not to diminish his profound admiration for Rumi or his attachment to certain forms of Islamic architecture, which he has photographed, painted, or evoked in collages, and which constitute the other half of his iconography.[119]

Kami is sustained by esoteric traditions, including Christian Gnosticism, as opposed to organized religion.[120] In addition, he is attentive to the philosophical current embedded in the Jungian approach to alchemy.[121] The process of turning base material into gold, and that of working away from *nigredo* (darkness) to reach the white light of inner truth, involves an arcane practice and language. For Kami, it is the metabolism of alchemy that matters, its quest for transcendence, a transformational process that is echoed in his dome sculptures. In his black domes, the bricks gyrate in a dizzying vortex into an abysmal darkness (fig 107); in contrast, the neatly regimented building blocks in his white domes eventually melt into the central radiating white light, the kind that Corbin, whose writings on Sufism Kami is familiar with, describes as an 'ascent out of cartographical dimensions' towards the centre.[122] Luminosity is materialized not just in the white domes; it reappears in a number of portraits as an inner glow (fig 108). Kami does not literally transcribe an esoteric thought into form; the relation is far more poetic. This artist's undeniable hubris resides in his image-making gifts, in his attending of his creations in their passage from flesh to spirit (and perhaps back), from pigment into breathing portraits, and, for architectural elements, in staging meditative spaces with light and darkness as immaterial protagonists. Such is Kami's journey.

Morteza Ahmadvand (b. 1982) brings a transcendental attitude to organized religion. In his video installation *Becoming* (see below, fig 139), he addresses a plea to the three religions of the Abrahamic tradition: Judaism, Christianity and Islam. He has taken the emblem of each (the Star of David, the Cross and the *Kaaba*) and subjected them to an almost imperceptible formal process; in an animated video, they appear to morph into a perfect sphere, a form that is also materialized in the centre of the space, perhaps as a reminder of the single planet we all inhabit. The chapter began with Banisadr's world in turmoil and it ends with an antidote to the toxic climate we are living in, with a plea to unity.

Opposite
108. Y.Z. Kami
Ava, 2013–14
Oil on linen, 274.3 x 182.9 cm (108 x 72")
Pinault collection

Conclusion

Gradually, the discourse has expanded. When Iranian contemporary art first captured attention in the West, interest and interpretation was narrowly restricted to works relating to gender and Islam. Examination of art made both inside and outside Iran makes it apparent that the gender issue is much more layered than was perceived in the early 1990s, and, more importantly, it coexists with a multiplicity of other equally important themes that have been materialized in media ranging from traditional painting, sculpture and drawing, to video, photography, installation and performance. Here we have presented themes that were either never before recognized or not given the attention they deserve. Subverting local art history (e.g. of carpets, Persian painting and calligraphy), for instance, an important theme never previously accounted for, indicates rupture with tradition rather than continuation of 'Islamic' art. Just as the contamination of Minimalist purity with political content in the West may not be considered as a modernist expression, retaining the appearance of traditional forms as an expedient container of pungent messages might help dissuade those who favour the term 'Islamic' for contemporary art. What you see is not what you see. Tradition and beauty are deceitful devices to seduce and lure the viewers into the crux of the matter where the artist's voice has found a refuge and a platform. Pluralism thrives. Boisterous theatricality, such as Filizadeh's scenarios, coexists with (to borrow a phrase used in relation to Kami and others) the aesthetics of silence.[123] It is imperative not to homogenize the art of Iran into a monolithic entity, or even into two: that made inside the country and that made outside. Stepping beyond boundaries and art historical partisanship reveals that the art is informed by formal, conceptual, spiritual and political concerns, sometimes delivered with a hint of humour, sometimes with gravitas, but always pregnant with a story to tell, a message smuggled in, a pain to share, a battle to win, a transcendence to fulfil.

The artists have found their paths not just through a culturally specific landscape of censorship but also through the minefield of stereotypes. Acceptance into the canon is approaching, as curators and academics in the West embark on projects entitled 'global.' This focus, while welcome, threatens to co-opt the urgency of the artists' messages and use them as token representatives and orphans bereft of history.[124] In the long run, it will be up to them to endure and outlive the vogue for all things Middle Eastern. They conquered far more formidable demons and won battles they engaged with on various fronts. For now, whether satirist, jester, rebel, poet or mystic, resorting to subterfuge, jokes, critique or prayer, they each flavour their concerns in idiosyncratic fashion. In the resulting pluralism resides the elusive democratic space.

Chapter Six
Introducing Iranian Art Abroad: A Curatorial Perspective

In the past couple of decades, institutions in Europe and America have gradually become receptive to Middle Eastern voices. The exhibitions where artists from Asia and North Africa were included have followed various different models: global, regional, diasporic, national, ethnic, contemporary, modern and contemporary, thematic (on the subject of the veil, for example) and, less frequently, monographic. To review every one of them is beyond the purview of this chapter. While alluding to some for context or comparative purposes, I will focus on my own contributions, starting in the early 1990s, when I began my curatorial career at the Museum of Modern Art, in New York. In those days, MoMA categorically rejected exhibitions based on geography, yet focused on the Western hemisphere.

Commercial spaces and biennials should be credited for being the first to represent artists from outside the West – a credit that also bears the stigma of ethnic consumerism, or as one critic calls it, ethnic marketing.[1] Academia too, in spite of its interest in post-colonial discourses, lagged behind. It is only in the past few years that academic curricula have begun to include sweeping introductory surveys of global art, including that of the 'Middle East' (sometimes in the not so distant past misrepresented as contemporary 'Islamic' art).[2]

The task of representing Middle Eastern art in institutions has been arduous for many reasons widely discussed in the literature.[3]

One further reason, we might add, has been the lack of specialists with a geographical focus outside the West. By necessity or design, professionals either in traditional 'Islamic' art or in areas unrelated to art have filled the vacuum during the current vogue for cross-disciplinary studies. The emergence of pioneer curators with a personal background outside the West, even when modern art has not been their specialty, has enhanced awareness. The ultimate moving force behind the change has been economic globalization, the ensuing proliferation of art markets, and the Internet which have exposed the isolationist modus operandi of major institutions.

When I began curating my own exhibitions at the Museum of Modern Art in the early 1990s, 'international' art comprised Western countries only.[4] Just a few years earlier, in 1989, *Magiciens de la terre*, a landmark exhibition at the Centre Georges Pompidou, in Paris, had offered a whole new paradigm to curators. It has gone down in history as the first truly international exhibition of contemporary art.[5] The organizers – Jean-Hubert Martin, above all – broke down the division between centre and periphery, bringing together 100 artists from around the world, including one artist of Iranian origin, Shirazeh Houshiary, who lived and continues to live in London. (Her work has been shown in her native country only once, in the exhibition *Turning Points: 20th Century British Sculpture*, organized by the British Council for the Tehran Museum of Contemporary Art in 2004.) Prior to *Magiciens*, only two Iranian artists had been included in curated international exhibitions: Mohsen Vaziri, whose 1962 sand painting (see above, fig 35) was exhibited in the Carnegie International in 1964, and Siah Armajani, in several exhibitions.[6] His 1970 work *A Number Between Zero and One* was included in the seminal exhibition of conceptual art, *Information*, curated by Kynaston McShine at the Museum of Modern Art in 1970 and again in 1982 at an international survey also curated by McShine.[7] In addition, Iranian delegations, organized by the government, participated in international biennials in Venice, Paris, and São Paulo in the late 1950s and early 1960s.

It was with the emergence in the 1990s, of Shirin Neshat (b. 1957), who had left Iran aged seventeen, five years before the Islamic Revolution, that dealers, and then curators, became attentive to Iranian identity narratives. As discussed in the previous chapter, it was Sonia Balassanian – an Armenian-Iranian artist who studied in New York, returned to Tehran, and then moved back to New York around the time of the Revolution – who first introduced the veil into the iconographic pool in New York in the 1980s. Her early exhibitions took place in alternative galleries, such as Franklin Furnace in the 1980s[8] and Exit Art in the 1990s, venues that soon afterward showed Neshat's work.

My first attempt at introducing an Iranian artist came about with *Readymade Identities*, the group exhibition I curated in 1993. The show

109. Sonia Balassanian
The Other Side II, 1993
Mannequins, fabric, mirrors and floodlights
Installation view of the exhibition *Projects 40: Readymade Identities*, 13 April– 1 May 1993
The Museum of Modern Art, New York

was part of MoMA's *Projects* series, which was supervised by the open-minded curator Robert Storr. I included Balassanian's installation *The Other Side II* (fig 109).[9] At that time she had achieved little recognition outside Iran, where she was known for her abstract paintings. The show received scant critical attention, but it was, arguably, the first fully identity-based group exhibition at that institution and the second instance of work by an Iranian artist exhibited at MoMA (the first being Armajani's, in *Information*).[10] Within the framework of the chosen theme – collective identities based on gender, as manifested in attire – Balassanian's veiled women offered a perspective from an 'Islamic' angle (not from an Islamic position, since Balassanian is not a Muslim). Balassanian placed her protagonists (tall mannequins), facing a wall-to-wall mirror but buried them under chadors that both shielded them from the public gaze and also made the world, including their own reflections, invisible to them. Viewers entered the space through coiling electrical wires on the floor and under blinding,

accusatory, inquisition-style spotlights. As I wrote in the brochure that accompanied the exhibition, rather than illuminating her subjects, the mirrors and lights in Balassanian's installation obliterate them, while making spectators painfully conscious of the unwelcomeness of their gaze.[11] The collective blindness to which Balassanian alludes in this way may be read as either the final revenge of those who stand frozen in an imposed role or the defiance of those who proudly espouse the radical Islamic cause. To navigate this space of shifting signs was to engage in an emotionally charged confrontation in which accusers and accused could not be clearly determined.

While vastly different in scale, ambition and message, *Magiciens de la terre* and *Readymade Identities* belonged to the same model of global representation, in that artists from different cultures and areas of the world were brought together under the same roof and framed by the same theme. *Projects 59: Architecture as Metaphor*, of 1997, and three other *Projects* exhibitions of commissioned banners are additional examples of this genre that I organized at MoMA.[12] In *Architecture as Metaphor*, Y.Z. Kami showed a 1997 diptych of digitally manipulated photographs which picture two medieval domes culled from the Islamic architecture of Iran. They evoke contrasting psychic states: one is an abysmally dark rendition of gyrating bricks and the other a spiral dance culminating in a luminous opening (fig 110).[13]

110. Y.Z. Kami
Untitled (Diptych), 1997
Iris mounted on linen, each 284 x 315 cm
(112 x 124")
Courtesy Gagosian Gallery. Installation view of the exhibition *Projects 59: Architecture as Metaphor*, 8 April–3 June 1997
The Museum of Modern Art, New York

111. Shirin Neshat
I am Its Secret, 1999
Dye sublimation on dacron polyester,
1097.3 x 274.3 cm (432 x 108")
Installation view of *Projects 70: Shirin Neshat, Simon Paterson, Xu Bing*, 1999
The Museum of Modern Art, New York

The three other *Project* exhibitions featured banners commissioned for the Museum's facade, an alternative way to exhibit contemporary art outside the white cube. A zone reserved for the Museum's logo and all that it implies, I thought, would be an ideal venue for artists not generally associated with the MoMA brand. Xu Bing and, later, Shahzia Sikander, Kara Walker and Janine Antoni were quick to see its subversive potential. Neshat based her banner on one of the now-iconic images from *Women of Allah* (fig 111). Doubling as a veil fluttering on the facade of an institution that wished to distance itself from controversial politics, it gained in provocative resonance from its unorthodox location.

Just before her banner went up at MoMA, in November 1999, Neshat won the Venice Biennale's First International Prize for *Turbulent* discussed in the previous chapter.[14] In this video, a female singer emerges as a triumphant voice despite religio-political obstacles. In Neshat's self-portrait on her banner, she was half-concealed under the newly mandatory veil but prominently tattooed with a poem by the freedom-loving feminist poet Forough Farrokhzad (1935–1967). The words speak of a veneration for nature, a visceral oneness with it (its streams her blood, its clouds her thoughts) that is manifestly contradicted by the veil, a cultural convention intended to conceal.

Still, I had to face the reality that MoMA's DNA was not conducive to the representation of artists outside the West and that my endeavours were taking place in an institution without any internal mechanism actively supportive of initiatives concerning art created by non-Western artists. In one of our curatorial meetings, I asked about the museum's policy regarding this category of art. Having vocally noted its absence, I was invited – in what I consider to be the strength of the American system, where problems are confronted rather than swept under the carpet – to research the museum's holdings and exhibition history of non-Western art and to come back with a report. Based on thorough research of the collection, I framed the high concentration on Western art in statistical terms (one or two per cent of holdings in each department represented non-Western art) and offered my own assessment. Here is what I concluded:

> With this report what I hoped to achieve is to open a discussion revolving around Asia and Africa, including the Middle East, and to bring back the 'rest of the world' in [founding director] Alfred Barr's words to the map of our future activities. The problem in the final analysis may not be that there is no interesting art created in Asia and Africa (the market, which is ahead of us, tells us there is) but how do we adjust the internal mechanism to adapt to the shifting realities. My wish is that we reflect the diversity of our time so that we can continue being the greatest museum of modern art and not just the greatest museum of Western modern art.[15]

The response was positive, with just one person raising a preemptive objection to the introduction of a quota system. My position, however, was not a plea for a quota system and token representation but an invitation to greater self-awareness and perhaps the enlisting of curatorial voices with passions of a different kind. In my opinion, no significant change can be expected until a diversified staff, placed in sensitive curatorial positions, and a diversified board of trustees come along.

This research, at the turn of the millennium, coincided with the slow emergence of contemporary non-Western art in non-commercial spaces. *New Chinese Art: Inside Out* (1998–9) with a catalogue edited by Gao Minglu and Okwui Enwezor's *The Short Century: Independence and Liberation Movements, 1945–1994* (2001–2) were two such examples of exhibitions that travelled to New York.[16] In 2001 Rose Issa introduced Iranian modern and contemporary art at the Barbican in London,[17] and I focused on Iranian modernism in the 2002 exhibition *Between Word and Image* at the Grey Art Gallery in New York.[18]

These latter two exhibitions were organized around national representations, different from the global model pioneered in Paris in 1989 and most recently espoused by Okwui Enwezor, Katy Siegel and Ulrich Wilmes, the curators of *Postwar: Art Between the Pacific and the Atlantic, 1945–1965*.[19] Around 1999, Lynn Gumpert, director of the Grey Art Gallery, had invited me to guest curate their holdings of Iranian modern art, collected by Abby Weed Grey in the 1960s and 70s. The resulting exhibition, *Between Word and Image*, was the first to address the topic of Iranian modernism in New York since 1968, when Ehsan Yarshater organized *Modern Persian Painting* at Columbia University.[20] Out of the 200-odd pieces that make up the Grey Collection, I selected fewer than 40 (including figs 10, 22, 30 and 112). I borrowed a few works from MoMA's collection (e.g. figs 8 and 37) and one from the artist Monir Farmanfarmaian (fig 31), who was poorly represented in the collection. 'Another Modernism: An Iranian Perspective,' my essay for the exhibition's catalogue, was coloured by the identity politics of New York in the 1990s. I concluded by stating:

> Most Iranian modernists [...] stayed locked in a dysfunctional relation with the West. Some drowned under its influence, many compromised, a few triumphed, but all endeavored to articulate solutions to vital questions: How to be Persian and modern? Which direction to take: the West or the past, or both? This other modernism, like many of the culturally specific modernisms that emerged around the globe, was neither synchronous nor synonymous with the one constructed in the West. Its impulse being at the same time nationalistic and internationalist, it looked inward as well as outward [...] formal issues were not its primary problems: the fundamental questions of Iranian modernism addressed the notion of identity.[21]

When I returned to the topic in 2013, my thinking had evolved to a broader understanding of Iranian modernism as a pluralist phenomenon created one sensibility at a time.[22] I am less inclined to assign national identity as the prime motivating force animating

Opposite
112. Siah Armajani
Prayer for the Sun, 1962
Oil on canvas, 122.5 x 81 cm (48¼ x 32")
Grey Art Gallery, New York University
Art Collection, Gift of Abbey Weed Grey

Below
113. Installation view of works by Bahman Mohassess from the exhibition *Iran Modern*, 6 September 2013–5 January 2014
Asia Society Museum, New York

every single journey which is as complex and meandering as the itinerary of each individual. With the exhibition *Iran Modern*, which I co-curated with Layla Diba at New York's Asia Society, a net was cast over the entire landscape of modern art before the Revolution. My conceptual contribution to the exhibition was the idea of covering the period not through a chronological survey but rather as a space of pluralism, underscoring some of the major directions Iranian art took during the two decades before the Revolution (figs 113–116). Regrettably the section that displayed works by several Saqqakhaneh artists cannot be illustrated in this book because one of them, Zenderoudi, without offering any explanation, would not authorize me to reproduce the installation shot. Curators should be free to reproduce installation shots of their shows without having to ask for authorization from the artists, especially when dealing with group shows. In my catalogue essay, I traced the trajectory of Kamal al-Molk, an artist of the late nineteenth and early twentieth centuries

Below
116. Installation view of Mohsen Vaziri Moghaddam's Untitled *(Forms in Movement)*, 1970 from the exhibition *Iran Modern*, 6 September 2013–5 January 2014 Asia Society Museum, New York

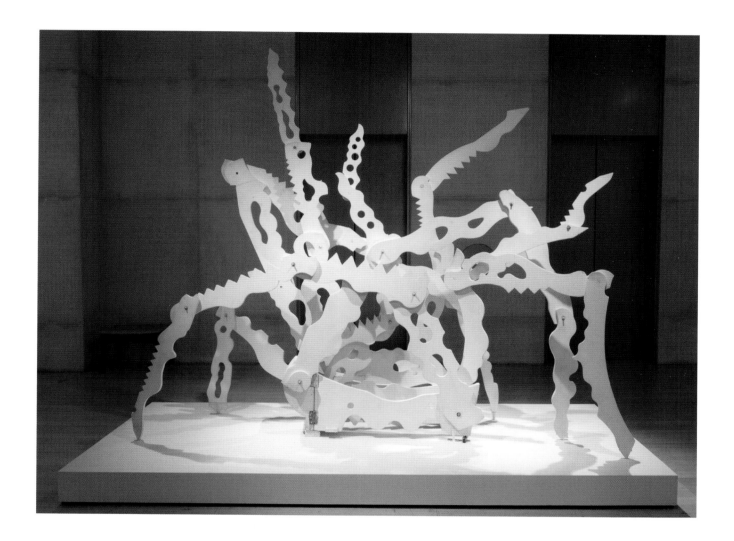

Opposite top
114. Installation view of works by Monir Farmanfarmaian from the exhibition *Iran Modern*, 6 September 2013–5 January 2014 Asia Society Museum, New York

Opposite below
115. Installation view of works by Siah Armajani from the exhibition *Iran Modern*, 6 September 2013–5 January 2014 Asia Society Museum, New York

who espoused a representational mode derived from the West; of Jalil Ziapour, whose vocabulary in the 1950s was imported from the language of Cubism; and of a number of salient Saqqakhaneh artists from the 1960s, who gazed inward but did not retreat into nativism or an antipathy toward the West. I discussed the various concurrent types of abstraction, from Farmanfarmaian's geometry and mirror works to Marcos Grigorian's earth works, neither purely Western in derivation nor inspired by traditional Iranian art, but modern and not borrowed. I presented Mohsen Vaziri Moghaddam and Behjat Sadr as exponents of global abstraction and discussed Abolghassem Saidi's bountiful representations of nature and Sohrab Sepehri's austere desert minimalism, which straddles the representational and abstract modes, an approach equally present in Leyly Matine-Daftary's portraits and objects, which are mere pretexts for dividing the space into flat abstractions. I included Bahman Mohassess, whom I characterized as figurative and rogue, and in a section entitled 'Politics at home and in exile' I dealt with a number of artists, such as Nicky Nodjoumi and Siah Armajani and the photographers Abbas, Bahman Jalali, Rana Javadi and Kaveh Golestan, whose work, overtly or not, conveys sociopolitical consciousness. I qualified this by saying that the artists I had already discussed were not necessarily exempt from political content – that, for instance, the introduction of proletarian culture in Saqqakhaneh could be viewed as a political statement. I also proposed to devote a room to calligraphic works – one more path in the pluralist landscape of Iranian modernism – to be organized by my co-curator.

The purpose of the essay and the exhibition, as I conceptualized it, was to paint a landscape of diversity, to debunk the perception of a 'monolithic modernism that is exotically other, hermetically sealed, and consistently in tune with local agendas or foreign preconceptions.'[23] The intention, I wrote, was 'to humanize and individualize the idiosyncratic stories rather than collectivize them as expressions of a national art.'[24] I believe the goal was achieved by creating, whenever possible or warranted, mini-retrospectives within the exhibition, with the purpose of highlighting the individual contributions and avoiding the fabrication of a generalized, collective identity.

The very positive ripple effect of this exhibition could be immediately noticed in *Artevida* (2014) and *Postwar: Art Between the Pacific and the Atlantic: 1945–1965* (2016), two exhibitions, following the model of global art exhibitions, mounted in Rio de Janeiro and Munich respectively. The curators included works they could have encountered in *Iran Modern*. My selection of Mohsen Vaziri's sculpture (fig 116) for *Iran Modern* and the discussion of it as an interactive piece with no precedents except perhaps in the so-called *bichos* of the Brazilian artist Lygia Clark (although Vaziri's works are organic, not geometric, and of

a much larger scale) might have resonated with the Brazilian organizers of *Artevida*, who borrowed it for their show.[25] As for the Munich exhibition, the selection of their Iranian artworks was directly based on works I presented in *Iran Modern* and, even before that, in *Between Word and Image*.[26]

The early years of the new millennium witnessed the introduction into non-commercial institutions of not just modernist art predating 1979, exemplified by the exhibitions discussed above, but also new Iranian art, either incorporated into a regional model (including the Middle East and North Africa) or presented separately in national exhibitions. The noteworthy early examples in the former category were thematic. *Veil: Veiling, Representations and Contemporary Art*,[27] a traveling exhibition of mostly Arab artists that toured the United Kingdom in 2003–4, included photographs by Shadi Ghadirian, Neshat and Mitra Tabrizian, and a video by Ghazel. *Word into Art: Artists of the Modern Middle East*,[28] curated by Venetia Porter at the British Museum in 2006, focused on text: writing or calligraphy. Out of the seventy-eight (mostly Arab) artists in the show, sixteen were Iranian. The exhibition drew from the museum's holdings, showing mainly works on paper, selected with the idea that they 'spoke of the region and showed continuity with "Islamic" art.'[29] Porter's efforts in collecting, exhibiting and discussing contemporary art of Iranians deserves special recognition.

My first intervention into this regional exhibition category materialized as an exhibition at MoMA entitled *Without Boundary: Seventeen Ways of Looking* (2006), the first instance of a prominent exhibition in a major American institution focusing on the art of diasporic artists from the Islamic world (figs 117–121).[30] Distancing myself from preconceived expectations, I did not wish to present calligraphy, miniature painting, carpets (three categories associated with the rubric 'Islamic'), or even the veil as markers of an Islamic identity. Instead I argued for subversion and dissidence rather than natural 'continuity.' *Islamic or Not*, the essay I wrote for the exhibition catalogue, having been, by necessity, insufficiently firm in its assertions, remained prone to misunderstanding. In an essay I published in 2015, I examined the complexities of this project, described how I implemented my concept, hinted at the difficulties I encountered and responded to the critical misinterpretations.[31] This project benefited enormously from the knowledge and wisdom of two individuals on the advisory board, namely Homi Bhabha and the late Oleg Grabar.

The genesis of the exhibition lay in a trend I first observed in the 1990s: an influx of artists from the Middle East, mostly settling in the West, whose works were beginning to be labelled 'contemporary Islamic art'. This designation infiltrated publications, academia[32]

117. Two works by Y.Z. Kami. Installation view of the exhibition, *Without Boundary: Seventeen Ways of Looking*, 26 February– 22 May 2006
The Museum of Modern Art, New York

207

and, sometimes, auction houses. Its normalization has continued in museums such as the Haus der Kunst in Munich[33] and the Los Angeles County Museum.[34] My position was (and is) that the phrase 'Islamic art' was contaminated by its colonialist past and needed to be problematized, but assertive discrediting of a denomination applied to religion and the regime in Iran made the enterprise politically and institutionally arduous. My problem, however, was not with religion. It was with the neo-Orientalist perceptions of the artists concerned, whose work was being co-opted and misinterpreted. None of the five Iranian artists in *Without Boundary* (Shirazeh Houshiary, Kami, Neshat, Marjane Satrapi, and Shirana Shahbazi) would be considered Islamic inside Iran, where the designation is reserved for the artists aligned with the Islamic regime in the 1980s.

What is Islamic art anyway? I asked this question of Oleg Grabar (1929–2011), the leading authority on the subject and a consultant to the 2006 show, whose answer was, 'Art made in and/or for areas and times dominated by Muslim rulers and populations'[35] – a definition that patently did not apply to the selected diasporic artists in the exhibition. In a walk-through in his company I asked, point blank, if he would call

Below
118. From left to right: Shirazeh Houshiary, *Fine Frenzy*, 2004; Houshiary and Pip Horne, *White Shadow*, 2005; Bill Viola, *Surrender*, 2001. Installation view of the exhibition *Without Boundary: Seventeen Ways of Looking*, 26 February–22 May 2006
The Museum of Modern Art, New York

Opposite top
119. Three works by Shirin Neshat. Installation view of the exhibition *Without Boundary: Seventeen Ways of Looking*, 26 February–22 May 2006
The Museum of Modern Art, New York

Opposite below
120. Four works by Shirana Shahbazi. Installation view of the exhibition *Without Boundary: Seventeen Ways of Looking*, 26 February–22 May 2006
The Museum of Modern Art, New York

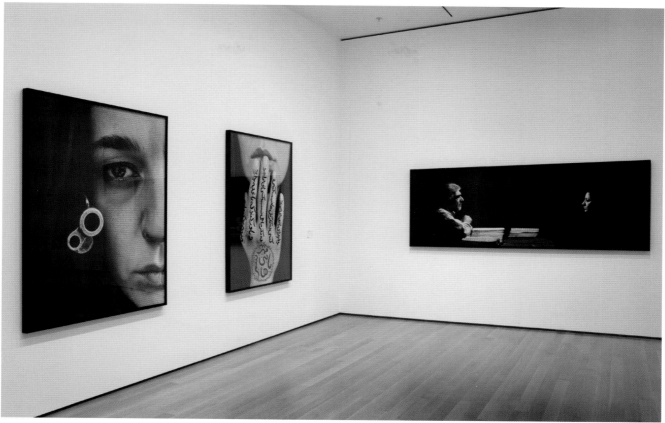

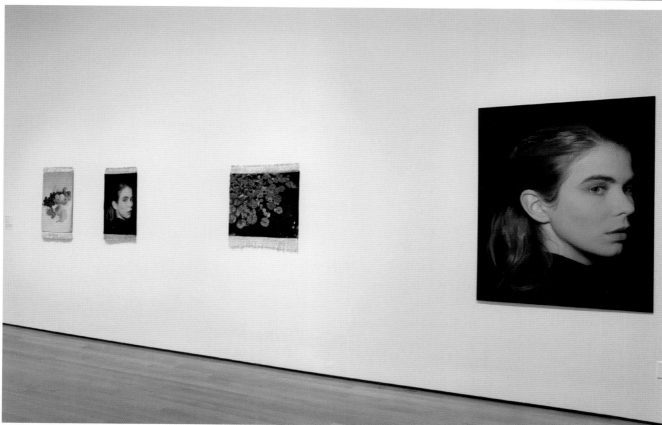

the art in the exhibition Islamic. With no hesitation, Grabar said no.[36] Many scholars and curators with backgrounds in Islamic art, however, have less trepidation in using the term for contemporary works. For instance, to celebrate the hundredth anniversary of the famous 1910 exhibition *Masterpieces of Muhammedan Art*, viewed and praised by artists such as Matisse and Kandinsky, in 2010 an exhibition was mounted in Munich that included a substantial section on contemporary art, presented as contemporary 'Islamic' art. Its organizers, claiming a progressive agenda, wrote: 'This notion of setting equal time to these works of art is a corrective act that rescues Islamic art from the past in which it was typically situated and gives it a space in the modern and contemporary domains.'[37] By means of an academically imposed construct – this time with a politically correct agenda – the myth of a collective Islamic identity is perpetuated. Increasingly, however, the designation is avoided but, to my knowledge, the only scholars of traditional art who categorically dispute it are Souren Melikian and possibly Sheila Blair and Jonathan Bloom.[38]

In contrast to common discourse regarding Islam and modernity, in *Without Boundary* I did not conceive of the selected artists as specifically engaged with modernity; to do so would create an Islamic-

121. Marjane Satrapi
Drawings for *Persepolis* ('Kim Wilde' chapter), 2001. Installation view of the exhibition *Without Boundary: Seventeen Ways of Looking*, 26 February–22 May 2006 The Museum of Modern Art, New York

versus-modern opposition and rely on the assumption that Islam, and by extension artists with an origin in Islamic civilization, are not modern but endeavouring to become so.[39] For instance, the Egyptian artist Ghada Amer – who has almost vindictively worked to contradict the preconceptions of her French teacher in Nice, who expected her to practise traditional calligraphy (she embroidered a shaggy Roman alphabet instead of manicured Arabic script) – cannot be viewed as an Islamic artist confronting or struggling with modernity or asserting any links to Islam. Her story is, rather, that of an Egyptian artist defying the intellectual or cultural limitations of a French instructor. Presumably, he assumed ownership of modernity by virtue of his origin and felt that Amer's place should be within her own separate tradition. Sometimes, as the above case illustrates, the artist's adversary was a European educator with an impaired stereotypical vision. At other times, the work's target was a political entity blind to the humanity of others. The latter was apparent in Emily Jacir's video *Ramallah/New York* (2004 – 5), where scenes taking place in these two cities cannot be distinguished from each other. In the works of the Lebanese artist Walid Raad and the half-Iraqi artist Jananne al-Ani, the struggle is with colonialists (past and present); as expressed by the Pakistani artist Shahzia Sikander, it is with US hegemony. All these adversaries dwell in the West. But sometimes, especially in the case of Iranians, the adversary is local – an 'other' to his or her opponents – whose dictates, edicts and justice artists dispute or must grapple with. Satrapi and Neshat were the only artists who engaged with Islam and modernity, and then only if 'Islam' is qualified to mean the Islamic regime in Iran. Inside Iran they would not be considered 'Islamic' artists. For Houshiary and Kami, the other Iranians in the show, modernity and Islam were simply irrelevant. Their spirituality has such universal dimensions that pinning those artists down to one of the many strains of esoteric traditions that informs their work (such as Christian agnosticism, or even Sufism, for example, which has quite contentious links with institutionalized Islam) is to clip their wings mid-flight. They breathe the same air as the American artist Bill Viola who, because of his spiritual affinity with the Iranian artists, was included in the exhibition. His inclusion advanced the argument against the category of contemporary 'Islamic' art.

The artists in *Without Boundary* tackled a wide spectrum of ideas: from rethinking the viability of painting, to questioning photography's documentary mission, to revising and subverting Islamic aesthetic genres (miniature painting, calligraphy, and carpet making), to critiquing modernist canons; from grand philosophical themes, such as the flux between presence and absence, being and not being, to political themes (gender issues, colonialism, Orientalism, the Islamic revolution in Iran, the Palestinian issue, US intervention in the Middle

East). The heterogeneity was so conspicuous that I argued that the selected artists did not belong together. They did not share the same approach to aesthetics, politics, or spirituality. They did not share the same religion, country, culture, history, artistic language or medium. Some were political, whereas others were not. The works on view reflected the complexity of allegiances, the refusal of identities packaged for easy consumption.

How to recalibrate entrenched preconceptions? How to navigate within an institution averse to polemical positions (as most mainstream American museums are) and yet not retreat into neutrality? How to avoid antagonizing people of faith? The task was treacherous. The critic Tyler Green headlined his review, 'MoMA Keeps the Walls Clean: Islamic Show sans Politics,' a description, I have argued, that is false on both counts.[40] Had Green paid attention to the works in the show, he would have realized that a majority of them contained political messages. To this day, a mention of *Without Boundary* is followed by a comment that the participants (in plural) were critical of the show.[41] In fact, only Neshat, one of seventeen participants, was critical, which is not a bad score. As for the descriptor 'Islamic,' if Green did not understand my arguments, and if other critics believed that I had failed to resolve the 'Islamic' issue, the reason lies precisely in the strategy I chose – of appropriating the language of that which I denounced. In short, I conceived of *Without Boundary* as a sort of Trojan horse, engaging with categories labelled 'Islamic' to demonstrate their subversion of and rupture from tradition, rather than their continuity. In the process, it is my belief, I disrupted the Western canon that dominated at the Museum of Modern Art and placed the Middle East on the map for younger curators. I am proud of these achievements, even if critics failed to understand the message or appreciate the enormity of the obstacles I had to surmount.[42]

Even if the message intended did not appear to be the message received, I firmly believe, a dent was made into the canon and a shadow of a doubt, potentially, cast on Orientalist thinking. The quality of the works helped. Quality is a concept that is in disfavour among many of today's critics but one that I believe in, especially when it is weaponized in favour of inclusion rather than exclusion, for which it was evoked in the past.

Seven years later, I returned to the topic of 'Middle Eastern art' (another problematic designation)[43] with the exhibition *Safar/Voyage: Contemporary Works by Iranian, Arab, and Turkish Artists*, mounted at the University of British Columbia's Museum of Anthropology in Vancouver (figs 122–3).[44] By 2013, many new artists had appeared on the scene, and formerly emerging artists were mature enough for a museum presentation. Out of the sixteen artists in the exhibition, only Kutlug

Right
122. Left: Mona Hatoum, *Hot Spot*, 2006; Right: Farhad Moshiri, *Yek Donya (One World)*, 2007. Installation view of the exhibition *Safar/Voyage: Contemporary Works by Arab, Iranian, and Turkish Artists*, 20 April–15 September 2013 University of British Columbia: Museum of Anthropology, Vancouver

Below right
123. From left to right: Nazgol Ansarinia, *Rhyme and Reason*, 2009; Parviz Tanavoli, *Persepolis II*, 1975–2008; Y.Z. Kami, *Konya*, 2007; Susan Hefuna, *Woman Cairo 2011*, 2011; Mitra Tabrizian, *Tehran 2006*, 2006. Installation view of *Safar/Voyage: Contemporary Works by Arab, Iranian, and Turkish Artists*, 20 April–15 September 2013 University of British Columbia: Museum of Anthropology, Vancouver

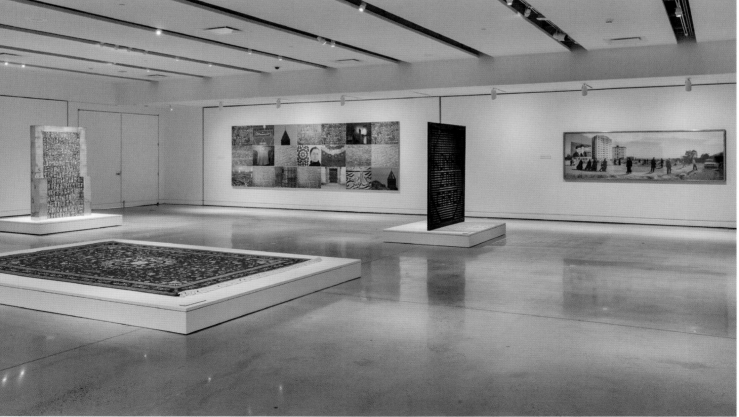

Ataman, Mona Hatoum and Y.Z. Kami had participated in *Without Boundary*.[45] With this fresh opportunity to rethink the subject, I picked a theme – voyage – that could be applied to artists of any origin.

I constructed an odyssey, beginning with the world as represented by a map by Farhad Moshiri, a globe by Hatoum, and a panoramic view of humanity seen from above by Ali Banisadr.[46] The trajectory led to works inspired by cities, following distinct narratives woven around subthemes such as war, revolution, pilgrimage and a politically invested archaeological site. The encounters brought viewers to places such as Baghdad (Adel Abidin), Tehran (Nazgol Ansarinia and Mitra Tabrizian), Cairo (Susan Hefuna), Konya (Kami), and Persepolis (Parviz Tanavoli). Kutlug Ataman revised the notion of Mesopotamia, and Tarek Al-Ghoussein's featureless settings provided a stage for the performance of shifting identities. A number of metaphorical works around the idea of the voyage supplemented the show, expressing Taysir Batniji's longing to return home, Ayman Baalbaki's pressing urge to escape from it, and Raafat Ishak's desire for immigration, for example. Youssef Nabil and Hamed Sahihi tackled life itself, conceived as a voyage, sometimes abruptly terminated in its course, introducing further layers of meaning. Structured as an imaginary travel itinerary, the show made some urgent issues of the region and of our time, as well as the existential concerns of individual artists, vividly apparent.

I thought that with *Safar/Voyage*, the steady stream of introductory exhibitions on art from the Middle East and North Africa might be coming to an end. The ongoing exhibition series of recent acquisitions of Middle Eastern art at the Solomon R. Guggenheim Museum in New York and *Here and Elsewhere*, an exhibition of works by artists with roots in the Arab world (including the Iranian Rokni Haerizadeh who lives in Dubai), mounted at the New Museum in New York in 2014, proved me wrong.[47] Quite perceptively, the introduction in the catalogue for *Here and Elsewhere*[48] offers an analysis of the dilemmas curators face concerning the politics of representation, including the question of framing artists according to their ethnicity, their geography, their cultural specificity or, simply, their individuality. The curators claim a 'corrective impulse,' an urge to compensate for a lack of museum representation, which many curators share, including myself. It is possible that the culturally and politically specific issues that separate the artists of this 'emerging' geography from those of the rest of the world will continue to engender exhibitions that segregate the artists of one region from another, but increased exposure may also diminish the need for collective groupings according to origin.

Returning to the national exhibition model for Iranian art, in my own scholarship, I have separated the modernist from the contemporary. Issa, in her 2001 exhibition at the Barbican;[49] Gumpert,

in *Global/Local: Six Artists from Iran, 1860–2015*, at New York University in 2016;[50] and Catherine David, in *Iran: Unedited History, 1960–2014*, at the Musée de l'Art Moderne de la Ville de Paris in 2014 (sporadically referred to in this book), did not. While Issa's focus was on contemporary art, works predating the Revolution were included. Gumpert visited six artists from different generations. *Unedited History* ambitiously undertook to tackle visual art and politics in Iran from 1960 to 2014. Its lacunae were rationalized with the word 'unedited' in the title. It frustrated a number of visitors' expectations from a museum exhibition of visual arts as opposed to a library exhibition of archival material. The intention might have been to rethink 'art' and 'exhibition.' It was also criticized for a lopsided treatment of politics – for highlighting dissident voices during the Pahlavi regime but remaining muted on opposition to the Islamic regime that followed. But, with a good number of loans coming from TMOCA, how could they have criticized the government?

In the new millennium, Shaheen Merali's *Far Near Distance: Contemporary Positions of Iranian Artists*, mounted at the Haus der Kulturen der Welt in Berlin in 2004, has been among the more ambitious exhibitions focusing solely on the contemporary art of Iran. This exhibition was not restricted to the visual arts (18 artists) but included discussions of film, music, and literature.[51] In the United States, the first large-scale manifestation was a chaotically sprawling exhibition at the now-defunct Chelsea Museum in New York: *Iran: Inside Out: Influences of Homeland and Diaspora on the Artistic Language of Contemporary Iranian Artists*, in 2009.[52] It was followed by collection exhibitions at the Metropolitan Museum of Art and at LACMA.[53] At these two institutions, contemporary art from Iran comes under the purview of their departments of Islamic art (at least until recently). When the mandate is to collect only contemporary art that resonates with traditional art, pluralism suffers, dissidence is diminished, certain media (such as video art) are neglected, and the myth of Islamic art is perpetuated, albeit unintentionally. But change is on the way. By hiring curators of contemporary art, the Freer Sackler Gallery at the Smithsonian and, recently, the Guggenheim and also the Metropolitan museums in New York have divorced the contemporary from the traditional. Clearly, a thorough understanding of the context and art history of Iran would best serve the representation of its art.

Finally, my own contribution to exhibitions of purely contemporary Iranian art may be summarized with two examples: *Action Now*, a group exhibition of Iranian performance art held in Paris at the Cité Internationale des Arts in 2012, and *Rebel, Jester, Mystic, Poet: Contemporary Persians*, organized with the Mohammed Afkhami collection for the Aga Khan Museum in Toronto in 2017.

In the past decade, the frenzied resurgence of art from the Middle East has been in evidence mainly in commercial venues, especially in Dubai. Commercial enterprises have brought visibility to the art, but they have privileged saleable works. To counter this commercial momentum, I opted to exhibit performance art, which still mainly resides outside the commercial circuit. I also chose this genre because it counters stereotypes of Iranian art. Performance art has been around since the Futurist *serate*, in the early years of the twentieth century, but in the past few decades it has resurfaced with greater vigour. Its history in Iran still needs to be traced, but among its early manifestations was an untitled work conceived by Ghazel Radpay (known as Ghazel) and Roxanna Shapour and performed at the Ave Gallery in Tehran on 6 April 1999. A woman lay in the window of the diminutive gallery. She was covered with white fabric and showered with white flowers, while inside the gallery a voice from a television monitor recited numbers: the birth and death dates of young martyrs in the Iran–Iraq War. The arrival of a policeman shut down the show. Furtive performances such as this suit a society in which censorship is alive. Sporadic performances have propped up in galleries and in the city of Tehran at large, but *Action Now* was the first group exhibition of performance art by Iranians, and it took place outside Iran. I commissioned three new works from Amir Baradaran (the only artist from the group who resided abroad, in New York), Barbad Golshiri and Amir Mobed, and I included a pre-existing interactive performance by Neda Razavipour.

Baradaran's astute participatory performance, *Marry Me to the End of Love* (June 2012, figs 124–5), was inspired by a temporary form of marriage, called *sigheh*, that is practiced in some Shi'i communities. The work is related to an unauthorized performance by Baradaran at MoMA in 2010, during the retrospective exhibition of the work of performance artist Marina Abramović. In her performance *The Artist Is Present*, Abramović sat silently in the museum's atrium, staring into the eyes of individual museumgoers, who lined up for the experience of sitting across from her. Baradaran sat across from her twice; he proposed marriage in one session and broke into a Sufi-like Arabic chant in another.[54] In the first session, wearing a long red dress similar to those Abramović wore for the performance, Baradaran managed to upstage the star of the show by crossing the boundary respected by the other participants, who sat quietly during their turn with Abramović. To the unauthorized recording of this performance, in which he inserted himself as a queer man, proposing marriage, and a 'non-resident alien,' a feared Muslim, or simply the 'other,' he gave the title *The Other Artist Is Present*.

In his Paris performance, Baradaran presented participants with a matrimonial contract listing duties that varied from silently staring into each other's eyes to licking honey off a partner's arm to

holding hands and kissing to 'other,' to be specified by the parties and performed for specific durations. A symbolic monetary exchange of a penny or more was included in the contract. The ceremony was inclusive of people of all ages and genders, and Baradaran, acting as the groom, married some 90 people in Paris in June 2010 and many more when the performance was restaged in Berkeley a few months later. He understands this practice as a 'recognition that love and desire are temporal, shifting, and always changing.'[55]

Mischievious and replete with a high dose of humour, this event could not be more different from Golshiri's *L'Inconnu de la scène,* a dark

217

126. Barbad Golshiri
L'Inconnu de la scène, June 28, 2012
Performance at the Cité Internationale
des Arts, Paris

performance, verging on brutal self-mutilation, staged in the Cité's
auditorium (fig 126). The artist/performer, with his head buried in an
oversized megaphone, blindly and gropingly advanced from the edge
of one end of a semicircular stage to the other, with only his toes,
clasping the edge of the stage, as a cue for his trajectory. From inside
the megaphone – a double-edged metaphor for both brainwashing
and dissidence – a pre-recorded choir of mostly female voices
robotically repeated a pseudo-liturgical text, mimicking obsessions
with religious ablutions, rites and regulations. The protagonist
poured milk, devoutly and with fussy concern, to the left side or the
right side of his body, the left or the right side of his genitals. The
performer fanatically obeyed the regulations and demands of the
choir. At one point he was handed a sharp object, with which he tried
to divide his torso into right and left sections. My own reading is that
zealous interpretations of liturgical texts, if pursued to their logical
ends, lead to self-mutilation, even self-sacrifice, as the artist tried to
violently illustrate but was happily prevented by an offstage assistant.
The action ended with the cleansing of the body and mind, not
according to prescribed edicts but through a liberating escape into the
proscribed, the forbidden. Immersing himself in a bathtub filled with a
prohibited liquid, which he also poured into the megaphone,

127. Amir Mobed
The Virus, June 29, 2012
Performance at the Cité Internationale
des Arts, Paris

he managed to drown out the voices reverberating in his head. These
are brief comments on a multilayered narrative that would benefit from
much greater elaboration – possible only if the world was in fact free
from intimidation.

Mobed's performance in *Action Now* was entitled *The Virus*, and
it was mostly free of any action at all (fig 127). Confined in a white
cube the size of his outstretched arms and legs, he froze in a crucified
position for as long as he could endure (over two hours), avoiding any
motion that could pull on the strings that were stretched tightly from
his body hair to nails in the walls, floor, and ceiling of the cube. The
artist appeared dehumanized in the cobweb of his painful existence.
The performance is interactive in its preparation period, during which
assistants glue Mobed's hairs to the strings and attach the strings
to the cube, and at its conclusion, when spectators rush to liberate
the performer from his ordeal with the scissors that the assistants,
cued by the artist, have come out to hang on the sides of the cube.
In between these events, the spectacle of pain evokes martyrdom
and violence which the artist has summarized as a range of 'tensions
and pressures.'[56]

In Razavipour's performance, *Self-Service*, the artist provided
a stage for action but removed herself from the centre of the event

219

(figs 128–9). She laid old Persian carpets on the ground and provided scissors that spectators could use to cut up the textiles in any way they liked; she also left them with the option of not engaging in what they might have considered vandalism. Carpets are a highly treasured Iranian cultural product, and their violation speaks of an assault on tradition – or, conversely, of a liberation from its yoke – but also suggests the potential of violence hiding in every individual. The performance was first mounted at the Azad Gallery, in Tehran, a few months after the 2009 disputed elections and the ensuing street violence. Each reiteration of the act, depending on the context, produces its own series of meanings. *Self-Service* has been presented in Iran, Sweden, India and France, and the varying reactions of the participants have been noted by the artist; those expressed by the Tehran public were published in a small book.[57] The feedback runs the gamut from condemnation of the violence of authorities who hang people in public squares, to the expression of a consciousness of personal guilt in participating in a collective act of violence, to a more philosophical attitude about never being fully aware of whose games you are participating in. These complex nuances noted in Tehran sharply contrast with the reaction of a Frenchwoman who, according to the artist, angrily and aggressively stated during the Paris iteration of the performance that violence and aggression toward art and culture may be normal in Iran, but they are not normal in France.[58]

How one endures, overcomes, or deflects sociopolitical tensions is a common subtext in much of the contemporary art produced by Iranians. Artists' embrace of criticism (both overt and oblique) and their use of humour, poetry and spirituality to counter such pressures was the theme of an exhibition I curated in 2017, at the Aga Khan Museum in Toronto, with the Mohammed Afkhami collection. *Rebel, Jester, Mystic, Poet: Contemporary Persians*, a travelling exhibition, featured twenty-seven works by twenty-three artists and cast a fresh light on the notion of identity, presenting it through the coping and creative mechanisms that define Iranians.[59] I picked 'Persians' over 'Iranians' precisely because of the refuge that denomination provided to those who found themselves in exile after the Revolution and the hostage crisis of the early 1980s. The term, a subterfuge and an attempt at camouflage, allowed Iranians to blend in and thus avoid becoming targets of attack, a strategy that reverberates in contemporary art, where critique may exist within the nooks and crannies of a seemingly apolitical traditional art.

Shiva Ahmadi and Mahmoud Bakhshi's works (p. x and fig 130), the first to be encountered in this exhibition (in Toronto), situated the viewer geographically and politically in a region blessed and cursed with oil, as represented by Ahmadi's oil barrel, and in a country

Opposite
128. Neda Razavipour
Self-Service, 2009/2012
Performance at the Cité Internationale des Arts, Paris

Opposite below
129. Neda Razavipour
Self-Service, 2009/2012
Performance at the Cité Internationale des Arts, Paris

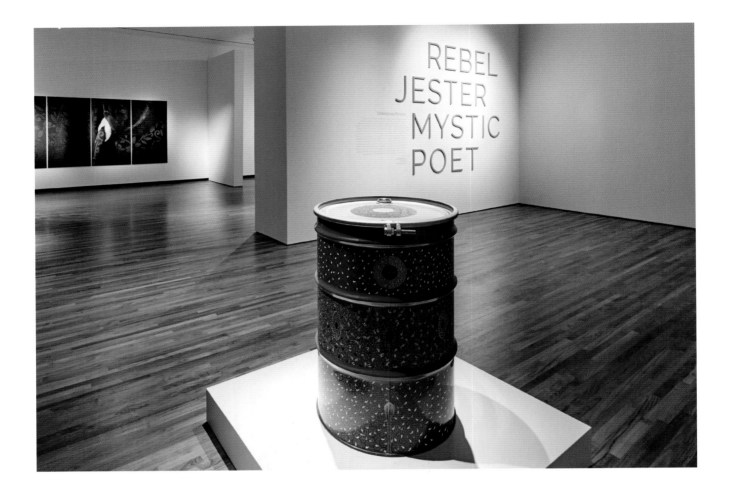

flaunting its Islamic ideology, as reflected by Bakhshi's mechanized logos mounted on cheap tin pedestals. Ahmadi's ornately decorated *Oil Barrel #13* hides within its intricate patterns a bullet hole/bleeding wound and embattled animals with severed heads. With such references, the fetishized object alludes to the connection between the logic of war and the lust for oil. This object stands in a long lineage of critical artworks and film productions, such as Ebrahim Golestan's *A Fire* (1961), that revolve around oil as an incendiary topic. Golshiri's *Oil on Canvas*, discussed in the previous chapter, would be another one. Ahmadi purchased her oil barrel from an oil company in Texas.[60] Bakhshi commissioned chimney-pipe makers[61] in Iran to produce the rudimentary pedestals supporting the logo of the Islamic Republic (the word *Allah*, doubling as a tulip signifying martyrs) depicted in red neon light (for illustration see p. x). Titled *Tulips Rise from the Blood of the Nation's Youth,* a lyric from a revolutionary song, the work is part of Bakhshi's series *Industrial Revolution*, a series title that some fifty years earlier Tanavoli used for a number of his own works. In Tanavoli and Bakhshi, 'industry,' a concept denoting modernization, is sarcastically

130. Foreground: Shiva Ahmadi, *Oil Barrel #13*, 2010; Background: Parastou Forouhar, *Friday*, 2003, Mohammed Afkhami Foundation. Installation view of the exhibition *Rebel, Jester, Mystic, Poet: Contemporary Persians*, February 4-June 4, 2017, Aga Khan Museum, Toronto, 2017

associated with low-tech objects. For Bakhshi, 'industry' also refers to the regime's propaganda apparatus and, in addition, the artist maintains, to contemporary art as a machine that replicates itself.[62] The proportion of critique to propaganda is a relationship viewers need to tackle for themselves, but movingly, when the artist was asked if the work is about propaganda or critique, responded 'I toy with what scares me.'[63]

Entering the next exhibition space meant leaving behind bloody revolutionary fervour and wounded oil containers to face the post-revolutionary world, black and white in appearance but nuanced in intention. The juxtaposition of two highly poetic beach scenes – the video *Sundown*, by Hamed Sahihi (figs 131 a–b), and an iconic photograph by Neshat, drawn from *Rapture* – respectively evoke an epic vision of life and of death, perhaps by hanging, on the one hand, and, on the other, a flock of veiled women choreographed to advance towards the promise the sea might hold, just as migratory birds are programmed to seek elsewhere for nourishment and survival.

131a & b. Hamed Sahihi
Sundown, 2007
Video
Mohammed Afkhami Foundation

The variety of artists' approaches to gender was highlighted by the next sequence of works. Mischievous rebellion was apparent in *The Lady Reappears*, by Monir Farmanfarmaian, the only figurative work she has ever created. This image of a headless woman seductively displaying her shimmering silhouette, tightly wrapped in intricate drapery, was based on a picture the artist found in a fashion magazine and executed in her trademark mirror work. It was flanked by Neshat's photograph and the four-panel work, *Friday*, by Parastou Forouhar, discussed in the previous chapter (fig 132; see also fig 78). Shadi Ghadirian's appropriation of the Qajar period supplemented the commentaries on the contemporary moment. In one of her two exhibited images, two women pose rigidly in a photo studio for their portraits, with their veils concealing their individuality, including their faces (fig 133). On the left side of the image, what the artist has described as an 'action painting' (says the artist) on an easel supposedly denotes the profession of the women, whose restrictive attire leaves little room for any action.

The political-religious content of the exhibition was transcended and drastically transformed in the following space, where Houshiary and Y.Z. Kami embodied the role of mystics, accepting flux as a

Above
132. From left to right: Shirin Neshat, Untitled *(Rapture Series)*, 1999; Monir Farmanfarmaian, *The Lady Reappears*, 2007; Parastou Foruhar, *Friday*, 2003. Mohammed Afkhami Foundation. Installation view of the exhibition *Rebel, Jester, Mystic, Poet: Contemporary Persians*, 4 February–4 June 2017 Aga Khan Museum, Toronto

Opposite
133. Shadi Ghadirian
Untitled *#11*, 1998
C-print, 90 x 60 cm (35½ x 23½")
Mohammed Afkhami Foundation

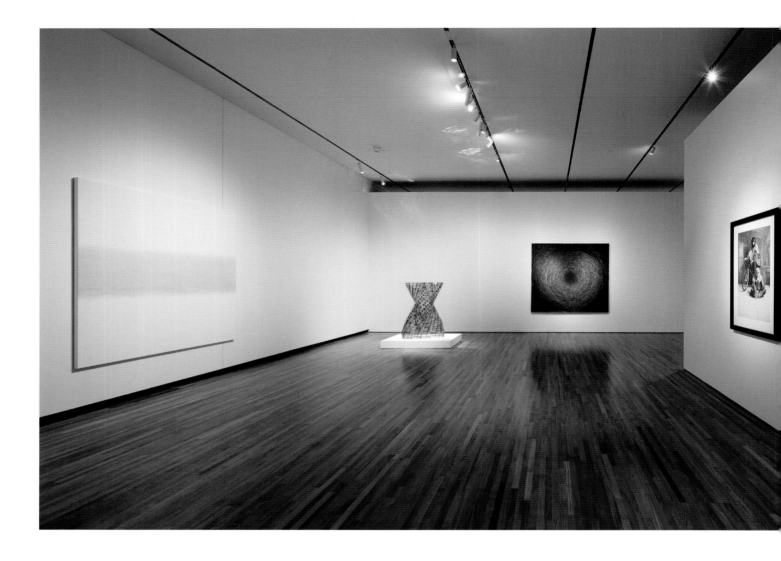

principle and quest as a transcendental exercise (fig 134). Following that, in the adjacent space another radical change in message, mood and tonality greeted viewers, with artworks approaching gender issues but informed by politics drawn from diametrically opposed positions. Shirin Aliabadi's *Miss Hybrid 3* (fig 75), with its humorously subversive message (discussed in the previous chapter), calls attention to the rebellious urban youth who defy mandated identities. Khosrow Hassanzadeh's self-portrait *Terrorist: Khosrow* (pp. xiv-xv), addresses a different adversary: the United States. In a candy-coloured (innocently pink and blue) silkscreen, which bears vestiges of the artist's admiration for Andy Warhol, Hassanzadeh reclaims and debunks the epithet 'terrorist' that was tagged onto men like him and his innocuous family members by George W. Bush when he listed Iran as part of a so-called axis of evil. Hassanzadeh doubles down on his identity by attaching to his self-portrait a certificate clearly spelling out its markers: 'Iranian'

Above
134. From left to right: Shirazeh Houshiary, *Memory*, 2005; Houshiary, *Pupa*, 2014; Y.Z. Kami, *Black Dome*, 2015; Shadi Ghadirian Untitled *#10* and *#11* (from the *Qajar* series), 1998. Mohammed Afkhami Foundation. Installation view of the exhibition *Rebel, Jester, Mystic, Poet: Contemporary Persians*, 4 February–4 June 2017 Aga Khan Museum, Toronto

Opposite
135. Rokni Haerizadeh
We will join hands in love and rebuild our country, 2012
Watercolour and acrylic on paper,
90 x 122 cm (35 ½ x 48")
Mohammed Afkhami Foundation

and 'Muslim.' Equally humorous and politically charged is Rokni Haerizadeh's *We Will Join Hands in Love and Rebuild our Country*, a circus scene in which a donkey composed of entangled human bodies stands on a red balloon. The rider or leader is a turbaned individual recalling the traditional comedic character Molla Nasr al-Din, who rode his donkey backwards – a commentary on a nation building attempt doomed to failure (fig 135).

Camouflage and poetry infuse the delicate images created by Nazgol Ansarinia, Afruz Amighi and Abbas Kiarostami, as well as sculptures by Ansarinia and Timo Nasseri. Ansarinia concealed her sociopolitical messages in a carpet pattern and inside an architectural capital; Amighi wove her critique of the American medical system into an intricate pattern of light and shadows (figs 136–7); Nasseri presented a stylized explosion in a morphology borrowed from *muqarnas*, the traditional vaulting of Islamic architecture (fig 138); and Kiarostami looked away from politics to the sublime simplicity of nature, for solace and peace.

War, the will to power, and religion were tackled directly by Farhad Moshiri, Shahpour Pouyan and Alireza Dayani, the latter

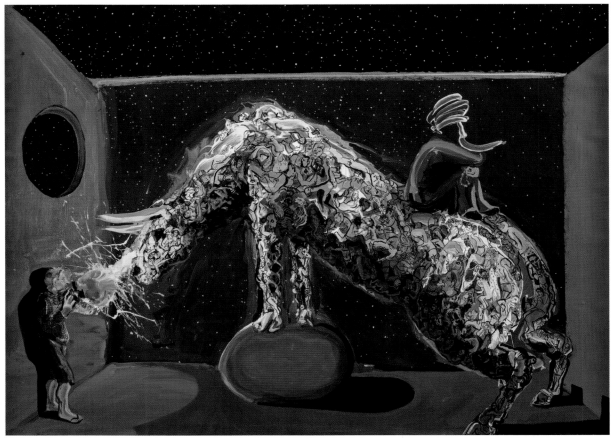

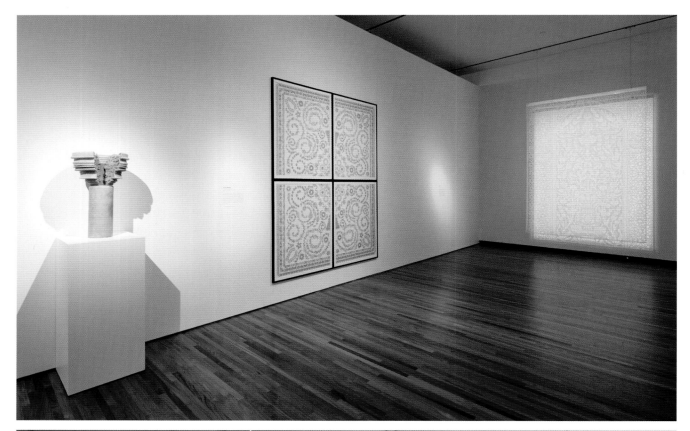

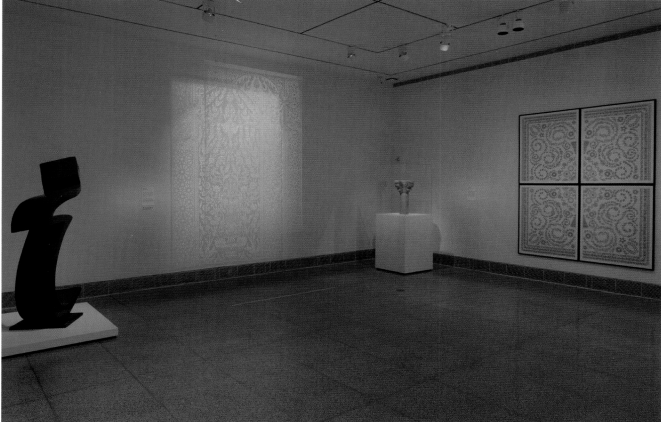

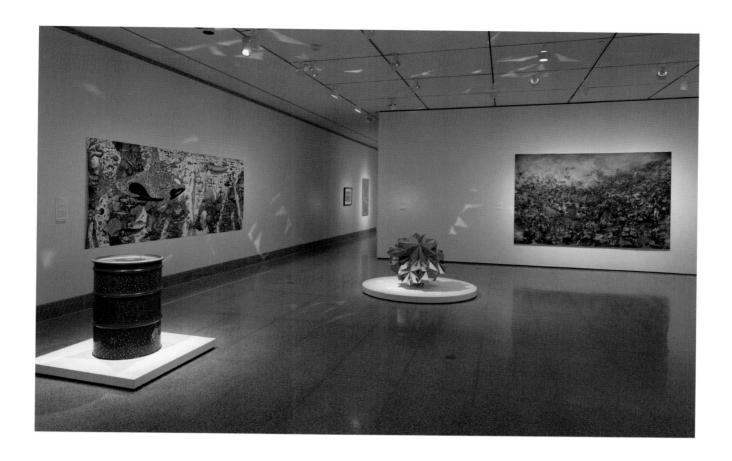

Opposite top
136. From left to right: Nazgol Ansarinia, *Pillars: Article 47*, 2015; Ansarinia, Untitled *II (Pattern series)*, 2008; Afruz Amighi, *Angels in Combat I*, 2010. Mohammed Afkhami Foundation. Installation view of the exhibition *Rebel, Jester, Mystic, Poet: Contemporary Persians*, 4 February–4 June 2017 Aga Khan Museum, Toronto

Opposite below
137. From left to right: Parviz Tanavoli, *Blue Heech*, 2005; Afruz Amighi, *Angels in Combat I*, 2010; Nazgol Ansarinia, *Pillars: Article 47*, 2015; Ansarinia, Untitled *II (Pattern series)*, 2008. Mohammed Afkhami Foundation. Installation view of the exhibition *Rebel, Jester, Mystic, Poet: Contemporary Persians*, 1 July–24 September, 2017 Museum of Fine Arts, Houston, Texas

offering an alternate creation narrative with his 'Eves,' feminine hybrid creatures rising from the bottom of the ocean (fig 138). The exhibition in Toronto concluded with a juxtaposition: a world in turmoil, as represented in Ali Banisadr's painting *We Haven't Landed on Earth Yet*, and its antidote, as proposed by Morteza Ahmadvand's video installation *Becoming* (fig 139). Ahmadvand delivered a message of the utmost importance for the divisive times we are living in (discussed in Chapter Five). Within the narrative unfolding in the exhibition, the traditional aesthetics of calligraphy were represented by the spiritually imbued work *Mohabbat (Kindness)* by Mohammed Ehsai and the multivalent *Heech*, by Parviz Tanavoli (p. 192 and fig 137). This latter work has been viewed in mystical, philosophical and political terms, but also, in my view, as a critique of calligraphy, discussed in Chapter Three. The artist's fetishized signature style, which has circulated since the 1970s and continues to circulate commercially as a commodity in all sizes, colours and mediums, may actually convey a critique of the market it benefits from.

The Aga Khan Museum, with its high-calibre collection of art from Islamic civilizations, offered an ideal context to reflect on the relation of Iranian contemporary art with ideologies and

Page 229
138. From left to right: Shiva Ahmadi,
Oil Barrel #13, 2010; Alireza Dayani
Untitled *(Metamorphosis* series*)* 2009;
Timo Nasseri, *Parsec #15*, 2009; Ali Banisadr,
We Haven't Landed on Earth Yet, 2012.
Mohammed Afkhami Foundation. Installation
view of the exhibition *Rebel, Jester, Mystic,
Poet: Contemporary Persians*, 1 July–24
September 2017
Museum of Fine Arts, Houston, Texas

Left
139. Morteza Ahmadvand
Becoming, 2015
Mohammed Afkhami Foundation. Installation
view of the exhibition *Rebel, Jester, Mystic,
Poet: Contemporary Persians*,
4 February–4 June 2017
Aga Khan Museum, Toronto

231

aesthetic traditions of the past. It challenged one to think in terms of continuity or rupture from tradition and to even call into question the designation 'Islamic' for contemporary art. Specifically, the architecture of the museum – in which the permanent collection was visible, from above, from the space of the temporary exhibition – not only provided the ideal angle from which to view Moshiri's *Flying Carpet*, installed in the permanent collection galleries, but also highlighted how a politically conceptual piece made up of thirty-two stacked machine-made carpets, their centres cut out in the shape of a fighter plane (reminiscent of the Afghan war rugs that inspired the artist), drastically differs from the apolitical, superbly hand-woven mid sixteenth-century Safavid carpet in the museum's collection that they contradict (fig 140). Hell on earth, the reality of war, replaced an idealized vision of paradise.

If I had to single out what I expect viewers to take away from this exhibition I would say that when gender, politics and religion have occupied the headlines in the Western press on Iran, why not listen instead to the most creative voices of Iranians themselves who, on a daily basis, deal with these topics among many others? In the process of listening and looking beyond the surface, it also becomes apparent that contemporary Iranians, while drawing from a rich aesthetic tradition and at times aching to convey politically specific messages, converse in a seductive language that may be understood across boundaries. In a nutshell, this may also be part of my message with this book.

It is imperative to remember that the artists discussed in this publication all have their own singular perspectives and their unique modes of expressing them. Thematic and historical exhibitions, as important as they are, inevitably erase individuality and the complexity of each artist's vision. Monographic exhibitions such as those that have recently underscored the accomplishments of a few artists – including Farmanfarmaian, Tanavoli, Neshat, Kami, Moshiri, and Armajani – are beginning to take place in the US.[64] Many more must follow in order to nourish the democratic space these constantly evolving voices have contributed to building. I am not sure if there is a perfect solution to the issue of representation. As imperfect as my approach has been, it has stemmed more from passion than calculated strategy or ideology. Living through times lacking in nuance and dialogue, I have attempted to draw the attention of a larger public to expressions of very complex and urgent visions. With such an intention, even failure contributes to the aim.

140. Farhad Moshiri
Flying Carpet, 2007
32 stacked machine-made carpets, fighter aircraft 275 x 180 x 44 cm (108 x 70 x 17¼")
carpet stack 300 x 200 x 44 cm (118 x 78 x 17¼")
Mohammed Afkhami Foundation. Installation view of the exhibition *Rebel, Jester, Mystic, Poet: Contemporary Persians*, 4 February–4 June 2017. Aga Khan Museum, Toronto. The work was exhibited in the museum's permanent collection of Islamic arts.

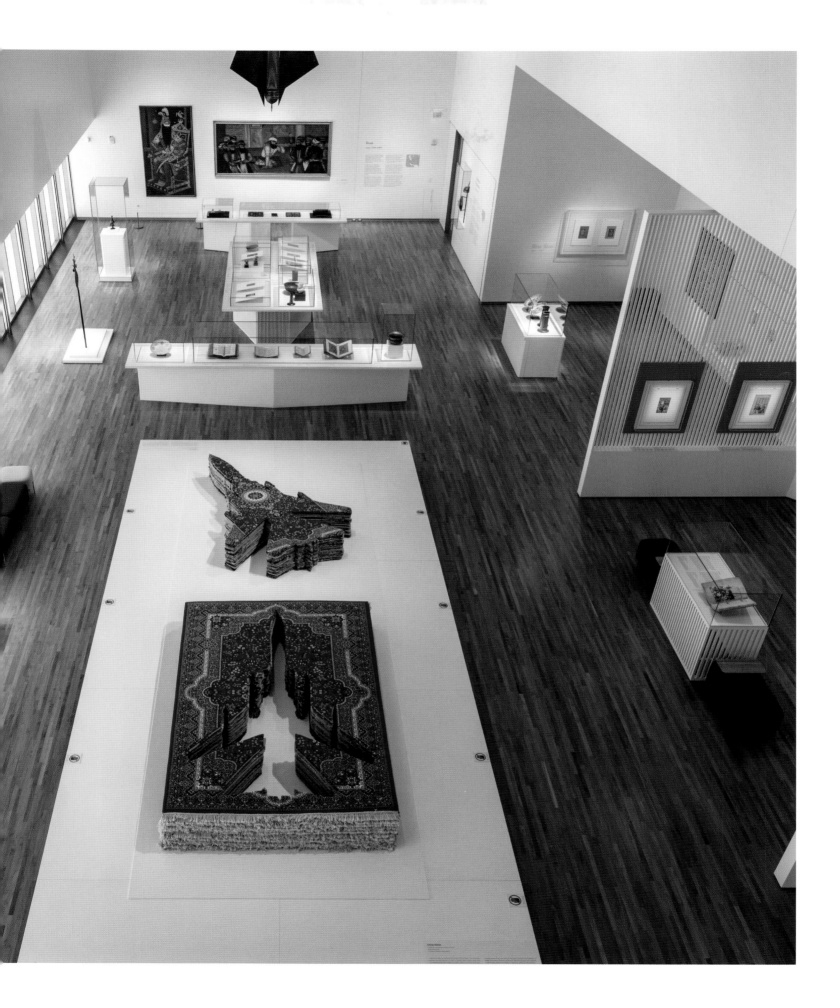

Postscript

The narrative that began in 1896 with Kamal al-Molk's *Hall of Mirrors* ends here, in 2018, with Tala Madani's *The Shadow*. In this journey, which by no means suggests a linear perspective, our point of departure was firmly grounded in a highly specific time period (the late Qajar dynasty), place (Tehran's Golestan Palace), and figure (Naser al-Din Shah); the final destination is a timeless, existential metaphor.

Against a barren backdrop, perhaps a moonscape or an internal mindscape, an infant raises a questioning hand towards the source of the onrushing light that seems to have dissolved the material solidity of the ground on which it crawls. The painting's pictorial language argues for abstraction – shapes in black and white dominate the field – but also for figuration. The tiny body of the child is represented as if viewed from a distant planet, but the figure looms large in the ominous shadow it casts.

Light, which has an illustrious provenance in Western art, from Vermeer, Georges de La Tour, and Caravaggio to James Turrell and Robert Irwin, finds an entirely new purpose in the hands of this contemporary painter. It floods the stage to illuminate a conundrum. It shines on a baby but projects a silhouette in the dimensions of an incubus, as black as the color of fear. In this way the painting connects with the rest of the artist's oeuvre, in which the lighter side of life – silly jokes, infantile behaviour, and innocent actions – is tainted by drama and terror.

Literally, the image awakens maternal anxieties anywhere and everywhere. Metaphorically, it highlights the fragility not just of life but of all aspirational ideologies. Hinting at the dialectic between luminosity and the inevitable shadows it generates, the metaphor, the artist has said, may be applied to a young nation, America foremost, which is facing, in these uncertain times, the menacing specter of sinister politics.

Tala Madani
The Shadow, 2018
Oil on linen, 203.2 x 203.2 cm (80 x 80")
Courtesy the artist and 303 Gallery,
New York

Notes

Prologue

1 Kirk Varnedoe, Chief Curator of Painting and Sculpture, Deborah Wye, Chief Curator of Drawings and Illustrated books, and Robert Storr, Curator of Painting and Sculpture, were among those who told me how informative the exhibition was for them.

2 Akbar Tadjvidi, *L'Art moderne en Iran* (Tehran: Ministère de la Culture et des Arts, 1967); and Hamid Keshmirshekan, *Contemporary Iranian Art: New Perspectives* (London: Saqi, 2013).

3 After guiding visitors to the 2013 exhibition *Iran Modern* at Asia Society in New York, for which I had selected a great number of three-dimensional works (Ahmad Aali, Siah Armajani, Bahman Mohassess, Parviz Tanavoli and Mohsen Vaziri), I would ask what aspect was most surprising to them. The answer an American curator, who went on to give a retrospective to Tanavoli, gave me was most enlightening. She said: sculpture.

4 See below, Chapter Four, note 2.

5 Talinn Grigor, *Contemporary Iranian Art: From the Street to the Studio* (London: Reaktion Books, 2014).

6 Neil Fauerso, '"Rebel, Jester, Mystic, Poet: Contemporary Persians" at the MFAH,' *Glasstire*, August 8, 2017.

Chapter 1

1 There have been three calendars in use in Iran: the Persian solar calendar, the Arabic or Islamic lunar calendar, and the Gregorian calendar. The Persian solar calendar, though it marks the Hegira of Muhammad from Mecca to Medina, begins on the first day of spring with festivities and rituals pertaining to the pre-Islamic Zoroastrian period. This calendar was dropped by the last Shah, who in 1976 introduced the new Imperial calendar (Shahanshahi) – its year zero marking the reign of Cyrus the Great of the Achaemenid dynasty. The Shahanshahi calendar was abandoned with the rise of the Revolution.

 Parts of this book are based on the author's essay 'Another modernism: An Iranian perspective,' published in Shiva Balaghi and Lynn Gumpert, eds, *Picturing Iran: Art, Society and Revolution* (London: I.B.Tauris, 2002), which accompanied an exhibition at New York University's Grey Art Gallery in 2002, co-curated by this author and Lynn Gumpert. An earlier version of the current chapter was published as 'Redefining modernism: Pluralist art before the 1979 Revolution,' in Fereshteh Daftari and Layla Diba, eds, *Iran Modern*, (New York: Asia Society Museum and New Haven: Yale University Press, 2013). Surveys focusing on Iranian modernism have been for the most part published in Persian. The first true art historical account, however, appeared in French: Akbar Tadjvidi, *L'Art moderne en Iran* (Tehran: Ministère de la Culture et des Arts, 1967) to coincide with Mohammad Reza Shah's coronation in 1967. Karim Emami, Javad Mojabi, Ru'in Pakbaz and Ehsan Yarshater have all contributed to the field. The most recent publication on the subject in Persian is Javad Mojabi, *Navad sal no avari dar honar-e tajassomi-e Iran* (*Ninety Years of Innovation in the Visual Arts of Iran*), 2 vols. (Tehran: Peikareh Publication, 2016). Hamid Keshmirshekan's *Contemporary Iranian Art: New Perspectives* (London: Saqi, 2013), published in English and subsequently translated into Persian, covers both modern and contemporary art, but it is labelled contemporary. Long after the completion of this chapter I received Alice Bombardier's excellent *Les pionniers de la Nouvelle peinture en Iran* (Bern: Peter Lang, 2017) which I have acknowledged in my footnotes.

2 Catherine David claims that modernity continued uninterrupted. See the catalogue of her 2014 exhibition in Paris, *Unedited History: Iran 1960–2014* (Paris: Musée de la Ville de Paris, 2014), p. 9.

3 A recent example is Hamid Keshmirshekan; see his *Contemporary Iranian Art*.

4 Hannibal Alkhas's painting *Dedicated to the Revolution* was featured in the first exhibition the Tehran Museum of Contemporary Art organized after the Revolution. See *Re-opening Exhibitions* (Tehran: Tehran Museum of Contemporary Art, November 1979), n.p. In more recent years he is recognized as one of the four most influential teachers of his time. See Iman Afsarian, 'Chera in chahar nafar? (Why these four individuals?)' *Herfeh Honarmand*, no. 27 (Winter 2008), pp. 91-94.

5 *The Graphic Art of the Islamic Revolution* (Tehran: The Publication Division of the Art Bureau of the Islamic Propagation Organization, 1985); Mustafa Goodarzi, ed., *A Decade with Painters of the Islamic Revolution* (Tehran: Art Center of the Islamic Propagation Organization, 1989); 'The effects of war on contemporary Iranian painting: A roundtable,' *Tavoos*, no. 2 (Winter 2000), pp. 190-212; Peter Chelkowski and Hamid Dabashi, *Staging A Revolution: The Art of Persuasion in the Islamic Republic of Iran* (London: Booth-Clibborn Editions, 2000); Zahra Rahnavard, ed., *Contemporary Iranian Art and the Islamic World* (Tehran: Al-Zahra University, 2002).

6 Hal Foster, Rosalind Krauss, Yve-Alain Bois, and Benjamin Buchloh, *Art Since 1900* (New York: Thames and Hudson, 2004).

7 Alfred H. Barr, Jr, *Cubism and Abstract Art* (New York: The Museum of Modern Art, 1936).

8 Barr seems to have been aware of the influence of 'Islamic' art on artists such as Henri Matisse and Franz Marc. In 1951, when he curated *Matisse: His Art and His Public*, he recounted the importance of Matisse's visit to an exhibition of Islamic art in Munich in 1910. See Alfred H. Barr, *Matisse: His Art and His Public* (New York: The Museum of Modern Art), p. 109. On the influence of Persian art on Matisse, see Fereshteh Daftari, *The Influence of Persian Art on Gauguin, Matisse, and Kandinsky* (New York and London: Garland, 1991).

9 These works, however, were almost all exhibited only when they were first acquired in the early 1960s, as 'recent acquisitions,' but then never taken out of the storage again. The only exception is an untitled 1963 work by

Marcos Grigorian, accessioned in 1965 and not exhibited until the autumn of 2000, in *Matter*, one of the Open Ends series of exhibitions marking the new millennium at The Museum of Modern Art. A few of these acquisitions saw the light of day later in 2017, half a century after they were acquired, as a gesture of protest by the museum directed at Donald Trump's executive order, known as the travel ban or Muslim ban. For instance, Charles Hossein Zenderoudi's *K+L+32+H+4. Mon père et moi (My Father and I)* was displayed in the Matisse room and a sculpture by Tanavoli, which had been kept in the Study Collection, was upgraded and placed in a room in company with Kandinsky, Kirchner, and Boccioni, all dating from the early part of the twentieth century. While the total lack of connection between the Iranians and the context where they were exhibited gave weight to the museum's protest, by the same token, one may argue, it highlighted MoMA's non-inclusive narratives which, at least until now, have not incorporated other modernisms.

10 Barr, *Cubism and Abstract Art*, p. 11.

11 Ibid.

12 On the falsity of such claims and of the existence of intercultural exchanges, see Bert Winther-Tamaki, 'The Asian dimensions of postwar abstract art: calligraphy and metaphysics,' in Alexandra Munroe, ed., *The Third Mind: American Artists Contemplate Asia, 1860–1986* (New York: Solomon R. Guggenheim Museum, 2009), pp. 145-57. Greenberg is quoted on page 145.

13 See Henry Corbin, *The Man of Light in Iranian Sufism* (New Lebanon, New York: Omega Publications, 1994).

14 Morteza Goudarzi, *Jost o jou-ye hoviyat dar naqqashi-ye mo'aser-e Iran* (Tehran: Entesharat-e Elmi va Farhangi, 1385 [2006]), pp. 40-41.

15 Kamal al-Molk's portrait of Henri Fantin-Latour (see Ahmad Soheili Khansari, *Kamal-e Honar (Perfection of Art): Life and Works of Mohammad Ghaffari Kamal al-Molk (1847–1940)* (Tehran: Elmi and Soroush, 1989), plate, p. 269) is so similar to the French artist's *Self-Portrait* of 1883, which entered the Uffizi

collection in 1895, that it seems likely that Kamal al-Molk copied it during his sojourn in Florence.

16 See below, Chapter Five.

17 Fereydoun Adamiyyat, quoted in Ali Mirsepassi, *Intellectual Discourse and the Politics of Modernization: Negotiating Modernity in Iran* (Cambridge: Cambridge University Press, 2000), p. 62.

18 Abbas Milani, 'Modernity in the land of the Sophy,' in *Lost Wisdom: Rethinking Modernity in Iran* (Washington, DC: Mage, 2004), p. 9.

19 For a history of photography in Iran and a treatment of Kamal al-Molk's relation to it, see Chahryar Adle with Yahya Zoka, 'Notes et documents sur la photographie iranienne et son histoire,' *Studia Iranica* 21 (1983), pp. 249-80.

20 See *Modern Persian Painting* (New York: Columbia University, 1968), n.p., the catalogue of an exhibition organized by Ehsan Yarshater, with an introduction by Karim Emami.

21 See Daftari, 'Another modernism,' pp. 41-44 . For a general introduction to this artist, see Ahmad Ashraf's entry 'Kamal al-Molk, Mohammad Gaffari,' in *Encyclopedia Iranica*, vol. XV, fascicle 4 (New York: Encyclopaedia Iranica Foundation[, 2010]).

22 Ali Dehbashi, ed., *Yad- nameh-ye Kamal al-Molk /A Memorial on Kamal-o-Molk* (Tehran: Behdid, 1999), p. 313.

23 Paul Gauguin, 'Préceptes.' *L'Art moderne*, no. 28 (10 July 1887), p. 219.

24 For a systematic study of the Iranian art Gauguin could have seen and his views regarding the subject matter, see Chapter 1 in Daftari, *Influence of Persian Art*. For the type of Persian carpets Gauguin could have seen and remembered, see ibid., fig. 24 (a Tabriz carpet from the Albert Goupil Collection, acquired by the Musée des Arts Décoratifs from the Goupil sale in 1888) and a carpet illustrated in Gaston Migeon, *La Collection Kelekian: Etoffes et tapis* (Paris: Librairie Centrale des Beaux-Arts, Emile Lévy, [1908]), fig. 51.

25 See Kamal al-Molk's memoirs in Dehbashi, *Kamal al-Molk*, p. 26.

26 On the lewd commissions requested by Mozaffar al-Din Shah, which the artist declined to execute, see ibid., p. 23.

27 See Mohammad Ali Foroughi's memoirs of the artist, ibid., p. 109.

28 See *Daedalus* 129, no.1 (Winter 2000), special 'Multiple Modernities' issue. See also Modjtaba Sadria, ed., *Multiple Modernities in Muslim Societies* (Geneva: Aga Khan Award for Architecture, 2009).

29 Javad Mojabi, *Pioneers of Contemporary Persian Painting: First Generation* (Tehran: Iranian Art Publishing, 1998), p. 126.

30 In his memoirs, the Shah recounted a visit to the Louvre in 1900, where he saw Kamal al-Molk in the act of copying. See Khansari, *Kamal-e Honar*, p. 23. Khansari identifies the work as Titian's *The Entombment of Christ, c.*1520.

31 See Qadi Ahmad, *Calligraphers and Painters: A Treatise by Qadi Ahmad, son of Mir-Munshi (circa A.H. 1015/A.D. 1606)*, trans. V. Minorski (Washington, DC: Freer Gallery of Art Occasional Papers, 1959), p. 177.

32 A study into the possible cultural link to the Shi'i notion of *taqlid* ('emulation') of a *mujtahid* (qualified jurist) chosen as a *marja'-i taqlid* ('source of emulation') may not be without merit. For a description of these practices, see Farhad Daftary, *A History of Shi'i Islam* (London and New York: I.B.Tauris in association with The Institute of Ismaili Studies, 2013), pp. 89-90.

33 For a review of the literature around this debate, see Daftari, 'Another modernism,' pp. 43-44 and n. 12.

34 Karim Emami, 'Post-Qajar painting,' in Ehsan Yarshater, ed., *Encyclopaedia Iranica*, , vol. 2 (London and New York: Routledge and Kegan Paul, 1987), p. 641.

35 Akbar Tadjvidi, *L'Art moderne en Iran* ([Tehran]: Ministère Iranien de la Culture et des Arts, 1967); Ru'in Pakbaz, *Naghashi-ye Iran: az diruz ta emruz* (Tehran: Narestan, 2000); Mojabi, *Pioneers of Contemporary Persian Painting*.

36 Tadjvidi, *L'Art moderne*, p. 4.

37 Al-e Ahmad, Jalal, *On the Services and Treasons of Intellectuals* (Tehran: Ferdows, 1372 [1993]), p. 480.

38 Mehrzad Boroujerdi, *Iranian Intellectuals and the West: The Tormented Triumph of Nativism* (Syracuse, New York: Syracuse University Press, 1996), pp. 12 and 14.

39 Ibid., p. 14.

40 Michael Axworthy, *A History of Iran:*

Empire of the Mind (New York: Basic Books, 2008), p. 226.

41 Ibid., p. 232 and n. 19S.

42 On the socialist movement in the 1940s, see Ervand Abrahamian, *A History of Modern Iran* (Cambridge: Cambridge University Press, 2008), pp. 107-113.

43 The gallery remained open for less than a year, from the autumn of 1949 until soon after Dr Reza Giorgiani's death in April 1950, which occurred as he finished quoting Omar Khayyam at the conclusion of a lecture in the gallery. The exact dates relayed to me by Mahmud Javadipour, one of the three founders of the gallery, were 2 Mehr 1328, to 25 Tir 1329. See Daftari, 'Another modernism,' n. 29. On Giorgiani's lecture and sudden death, see Mojabi, *Pioneers of Contemporary Persian Painting*, p. 196, and 'Marg-e yek ostad-e daneshvar.' *Mehregan* (18 April 1950).

44 Reza Giorgiani, 'Namayeshgah-e honarha-ye ziba-ye Iran.' *Sokhan*, 3rd period, no. 1 (Farvardin 1325 [March–April 1946]), p. 24.

45 Ibid., pp. 24-29. On Frederick Tallberg, see Peter Chelkowski, 'Graphic arts.' *Encyclopedia Iranica*, http://www.iranica.com/articles/graphic-arts.

46 Abrahamian, *A History of Modern Iran*, p. 113.

47 For an illustration, see *Dar miyan-e raz-e moshtaghan* (Tehran: Farhangestan-e Honar, 1383 [2004]), p. 50, ill. 12.

48 Conversation with the author, 2011.

49 Alice Bombardier draws a parallel between Zahak, the Arab invader, and the five-year Russian occupation of northern Iran which ended in 1946. She justifies the inclusion of Ziapour's painting, which she interprets as a nationalist anti-Soviet statement, in VOKS (the Soviet Society for Cultural Relations with Foreign Countries), for aesthetic reasons: its stylistic allegiance to Socialist Realism. See Bombardier, *Les pionniers de la Nouvelle peinture en Iran*, pp. 195-196. On pp. 196-197 and ill. 13, Bombardier misidentifies *The Flood Stricken* of 1947, the painting Javadipour had presented for his diploma, as an untitled work (for illustration, see Yaghoub Emdadian, ed., *Pioneers of Iranian Modern Art: Mahmoud*

Javadipour (Tehran: Tehran Museum of Contemporary Art, p. 21), and argues for a source identical to Ziapour's *Kaveh the Blacksmith*. But as its actual title confirms, the painting is about the ravages of a flood. Javadipour painted his *Kaveh the Blacksmith*, an oil on cardboard, a few years earlier, in 1944. For an illustration, see *Dar miyan-e raz-e moshtaghan* , p. 50.

50 The artist confirmed to me that the year of his birth was 1920, not 1921, as is widely maintained. Communication with the author, April 2014.

51 Manoucher Yektai and Monir Shahroudy (later known as Monir Farmanfarmaian) were among the first Honarkadeh students to migrate to the United States. Personal communication from Manoucher Yektai to the author, 1 April 2 2011.

52 In 2002, I offered an explanation to the question 'Why in the late 1940s would an Iranian artist militantly espouse Cubism, a style that had been invented nearly forty years earlier?' See Daftari, 'Another modernism,' p. 47. Writing in 2017, Alice Bombardier reiterates the same question and her answers concur with mine. See Bombardier, *Les pionniers*, pp. 201-203.

53 Information relayed by Andras Riedlmayer, Bibliographer, Aga Khan Program, Fine Arts Library, Harvard University. For specific details, see Bombardier, *Les pionniers*, pp. 140-141.

54 See Chapter 12, 'Picasso's 'Red Period': America's response to Picasso's politics,' in Gertje R. Utley, *Picasso: The Communist Years* (New Haven and London: Yale University Press, 2000).

55 Mojabi, *Pioneers of Contemporary Persian Painting*, p. 17.

56 The other three artists were Bahman Mohassess, Manuchehr Sheibani, and Mohsen Vaziri.

57 See Daftari, 'Another modernism,' p. 85, n 29.

58 Jalal Al-e Ahmad, 'Namayeshgah-e naghashi dar Apadana,' *Mehregan*, no. 5 (March 7, 1950), pp. 4-5. I would like to thank the late Mahmud Javadipour, one of the three founders of the Apadana Gallery, for making his archives accessible to me.

59 In 'Another modernism' I cited the illustration sources for Ziapour's lost paintings: *Kaveh's Uprising* and the *Public Bath*, but I did not illustrate them. See p. 85, n. 26.

60 Ibid., p. 4. The comment may be about a painting which is currently at the Tehran Museum of Contemporary Art. For an image, see Daftari and Diba, *Iran Modern*, p. 19, fig. 3.

61 'Interview with Jalil Ziapour,' *Honar*, no. 17 (Spring 1368 [1989]), n.p.

62 Interview with Jalil Ziapour by Houshang Azadivar for a documentary film, summer 1989, www.ziapour.com, accessed 20 June 2018.

63 Mojabi, *Pioneers of Contemporary Persian Painting*, p. 22.

64 See the review of the 1962 Tehran Biennial in *Sokhan*, period 13, no. 1 (1962), p. 118.

65 J[ames] S[chuler], 'Yektai [Review of one-person exhibition at the Poindexter Gallery].' *Art News* 56, no. 8 (December 1957), p. 12.

66 Personal communication to the author, 2 April 2011.

67 An abundant series of mostly laudatory reviews of his one-person exhibitions may be found in *Art News* and *Arts Magazine*, to name only two. Examples listed chronologically are: F[airfield] P[orter], 'Yektai [Borgenicht].' *Art News* 53, no. 2 (April 1954), p. 54; P[arker] T[yler], 'Yektai [Associated American Artists].' *Art News* 55, no. 8 (December 1956), p. 11; I[rving] H. S[andler], 'Manoucher Yektai.' *Art News* 58, no. 10 (February 1960), pp. 43 and 57; E.C.M., 'Four landscape painters.' *Art News* 59, no. 3 (May 1960), p. 15; Pierre Schneider, 'Art News from Paris: Witches, caldrons, magicians; Yektai.' *Art News* 60, no. 2 (April 1961), p. 48; I[rving] H. S[andler], 'Manoucheh Yektai.' *Art News* 61, no. 3 (May 1962), pp. 10-11; Pierre Schneider, 'Art news from Paris.' *Art News* 62, no. 7 (November 1963), p. 46; T[homas] B. H[ess], 'Yektai [Poindexter].' *Art News* 63, no. 7 (November 1964), p. 10.

68 Hilton Kramer, 'The figures of Yektai.' *Arts Magazine* 36, no. 10 (September 1962), p. 37.

69 T[homas] B. H[ess], 'Yektai.' *Art News* 63, no. 7 (November 1964), p. 10.

70 Pierre Schneider, 'Art news from Paris,' *Art News* 62, no. 7 (November 1963), p. 46.

71 J[ames] S[chuyler], 'Reviews and Previews: Yektai.' *Art News* 56, no. 8 (December 1957), p. 12.

72 E.C.M., 'Four landscape painters.' *Art News* 59, no. 3 (May 1960), p. 15.

73 T[homas] B. H[ess], 'Yektai.' *Art News* 63, no. 7 (November 1964), p. 10.

74 P[arker] T[yler] mentions Persia and van Gogh in 'Yektai at the Association of American Artists.' *Art News* 55, no. 8 (December 1956), p. 11.

75 Personal communication, August 2013.

76 Personal communication, April 2014.

77 S[idney] T[illim], 'Yektai.' *Arts Magazine* 34, no. 5 (February 1960), p. 56.

78 Annette Michelson, 'Paris.' *Arts Magazine* 35, nos. 8-9 (May–June 1961), p. 19.

79 Hilton Kramer, 'The figures of Yektai,', p. 36.

80 Personal communication to the author, 2 April 2014.

81 Ibid.

82 Ibid.

83 For an illustration of Romain Gary's portrait see Daftari and Diba, *Iran Modern*, pl. 94.

84 Thomas McEvilley, *Manoucher Yektai: Paintings 1951–1997*, catalogue of an exhibition curated by Donna Stein (East Hampton, New York: Guild Hall Museum, 1998).

85 Ibid. p. 5.

Chapter 2

1 See Jessica Morgan and Flavia Frigeri, eds., *The World Goes Pop* (New Haven, Connecticut and London: Yale University Press and Tate Modern, 2015), p. 230. Tanavoli was the only artist associated with the Saqqakhaneh that was included in this exhibition.

2 These generalizations might include, for instance, viewing Charles-Hossein Zenderoudi's early revision of the coffee-house tradition and his post-1965 Saqqakhaneh period, when he focused on calligraphy, as expressions of the Saqqakhaneh movement. The coffee-house-inspired linocuts and the later calligraphic modernism rely on pre-existing aesthetic traditions, whereas in the short-lived period of the Saqqakhaneh, Zenderoudi plucked his motifs from sources previously unexplored either in folk art or calligraphy

3 The review, titled 'A new Iranian school,' is reprinted in *Karim Emami On Modern Iranian Culture, Literature, and Art*, ed.Houra Yavari, compiled by Goli Emami (New York: Persian Heritage Foundation, 2014), pp. 160-162. Among further treatments of this movement (not a school) by Emami, see 'Art in Iran xi: Post-Qajar painting,' in *Encyclopaedia Iranica*, 2, Fasc. 6, 1986, pp. 640-646; and 'Saqqakhaneh school revisited,' in *Saqqakhaneh* (Tehran: Tehran Museum of Contemporary Art in affiliation with The Shahbanou Farah Foundation, 1977) n.p.

4 See Cyrus Zoka, 'Namayeshgahhay-e naqqashi,' *Sokhan*, 14ᵗʰ period (Tir 1342/ June 1963), pp. 114-116.

5 Ibid., p. 116

6 Emami, *Karim Emami On Modern Iranian Culture*, p. 162.

7 To learn more on Golpaygani, see his official website for the *Sepid bar Sepid* (White on White) exhibition held in 1975 at the French cultural centre in Tehran. In the 1970s, to paraphrase the artist and critic Aydin Aghdashloo, Golpaygani blurred the boundary between typography and calligraphy.

8 *Saqqakhaneh*, texts by Karim Emami and Peter Lamborn Wilson (Tehran: Tehran Museum of Contemporary Art in affiliation with The Shahbanou Farah Foundation, 1977).

9 See *Ille Biennale de Teheran: Exposition de peinture et sculpture* (Tehran: Le Secrétariat d'Etat aux Beaux-Arts, 1962), pp. 43 and 131. Both Pilaram's *Laminations* and Zenderoudi's *K+L+32+H+4. Mon père et moi (My Father and I)* are works on paper and in the collection of the Museum of Modern Art, New York.

10 Zenderoudi and his family, who is now managing him, have not granted this author (or others) the permission to illustrate his works. When asked for an explanation that could be quoted here they offered none. I believe this decision has already harmed the representation of this artist in major projects such as the *Iran Modern* exhibition at the Asia Society Museum in 2013 and this scholarly publication. Had the artist collaborated, just as he did when I was curating his works and writing an essay for a 2002 exhibition held at the Grey Art Gallery in New York, he would have benefited from a far more in-depth treatment. Thus, regrettably, his series of stylized images of headless martyrs and a scroll, an early masterpiece of Zenderoudi's Saqqakhaneh period, all in private collections, must be left out. References to them may be found in the essays I wrote for the exhibitions at the Grey Art Gallery and Asia Society. For the images of the works discussed in this chapter, which I restricted to easily accessible public collections, I suggest to readers the following museum sites: www.moma.org, www.greyartgallery.org and www.britishmuseum.org.

11 The story of this painting was related to me in April 2001 by the artist. He has not responded to my recent art historical queries. Aside from the museum sites listed above, for an alternate source of illustration of Zenderoudi's *K+L+32+H+4. Mon père et moi (My Father and I)*, see Daftari, 'Another modernism,' in Shiva Balaghi and Lynn Gumpert, eds, *Picturing Iran, Art, society and Revolution* (London and New York: I.B.Tauris, 2002), p. 66, and Daftari, 'Redefining modernism,' in Daftari and Diba, *Iran Modern*, p. 32.

12 See S.P.H., 'When Does Guarding an Artist's Legacy Go Too Far?', *The Art Newspaper*, no. 298 (February 2018), pp. 39–40.

13 Mehrzad Boroudjerdi, *Iranian Intellectuals and the West* (Syracuse, New York: Syracuse University Press, 1996), p. 65. For the influence Fardid and Jalal Al-e Ahmad exerted on the Revolution, see Laura Secor, *Children of Paradise: The Struggle for the Soul of Iran* (New York: Riverhead Books, 2016).

14 Ibid., p. 66.

15 Reza Baraheni, *Qessehnevisi* (Tehran: Ashrafi, 1969), p. 465. Quoted in Boroujerdi, *Iranian Intellectuals and the West*, p. 67

16 Boroujerdi, *Iranian Intellectuals and the West*, p. 68.

17 Communication to the author, 2014.

18 See 'Goftogu'i ba naqqashan-e javan,' *Sokhan*, nos 11–12 (Mordad–Shahrivar 1343/August–September 1964) and the poster announcing a 1964 seminar on contemporary, traditional and international art, organized by Tanavoli. For an illustration, see Fereshteh Daftari, 'Redefining modernism,', p. 26. For examples of critical responses to the issue of westernization in the arts see also Daftari, 'Another modernism,' pp. 62-63, note 35, and p. 67, note 40.

19 Abbas Amanat, 'Iranian identity boundaries: A historical overview,' in Abbas Amanat and Farzin Vejdani, eds, *Iran Facing Others: Identity Boundaries in a Historical Perspective* (New York: Palgrave Macmillan, 2012), pp. 1-33.

20 For a progressive point of view among Islamic intellectuals exemplified by Abdolkarim Soroush, see Secor, *Children of Paradise*, pp. 114-115.

21 Ali Mirsepassi, *Intellectual Discourse and the Politics of Modernization: Negotiating Modernity in Iran* (Cambridge: Cambridge University Press, 2000), p. 127.

22 A copy of the mission statement was given to me in 2000 by Marcos Grigorian when I was researching and co-curating the exhibition *Between Word and Image* at the Grey Art Gallery, New York.

23 See the following, in Persian: Nadia Bonyadloo, *Saqqakhanehha-ye Tehran* (Tehran: Pishin Pajouh, 2002), pp. 90-91.

24 For a full description of *saqqakhaneh* and their symbolisms, see the reprint of Peter Lamborn Wilson, 'The Saqqa-khaneh,' in Daftari and Diba, *Iran Modern*, pp. 231-233. This text was originally published in the exhibition catalogue *Saqqakhaneh* (Tehran Museum of Contemporary Art, 1977), n.p.

25 Iftikhar Dadi, 'Rethinking calligraphic modernism,' in Kobena Mercer, ed., *Discrepant Abstraction*, (London and Cambridge, Massachusetts: Institute of International Visual Arts and The MIT Press, 2006), p. 95.

26 An example of Jazeh Tabatabai's *pardeh*, painted on canvas and dated 1957, was reproduced in *Saqqakhaneh* (Tehran: Museum of Contemporary Art, 1977), n.p. The *pardeh* (a linocut on cloth) by

Zenderoudi exhibited in *Iran Modern* at the Asia Society, New York, in 2013, was not reproduced in the catalogue, but a detail of a slightly different version may be found in Daftari, 'Another modernism,' in *Picturing Iran*, p. 34. Both versions of the linocut were sold in 1960 and probably executed that same year – a date confirmed to this author by Marcos Grigorian, who taught the technique of linocut to Zenderoudi and who exhibited the *pardeh* at the Fine Arts School of Tehran in an exhibition visited by Queen Farah Pahlavi. Grigorian showed me a photo of the Queen's visit, which he dated to 1960, based on the fact that she was pregnant at the time. On the photocopy he gave me, he has written by hand, 'H.I. Majesty Farah Pahlavi visiting Fine Arts School of Tehran, 1960.' The year 1960 also appears in the chronology of the 2001 retrospective of the artist at TMOCA, p. 125.

27 See colour plate in *Saqqakhaneh*, 1977, n.p. Emami contributed a text to the catalogue, but it is not clear whether he had any role in the selection of the works.

28 Author's archives. A copy of the artist's unpublished biography was given to the author in January 2000. Grigorian calls the folk artists troubadours because the presentation of the paintings was accompanied by poetic recitations.

29 Laleh Bakhtiar, 'Religious inspiration in the expressions of art forms,' in *Religious Inspiration in Iranian Art*. Preface by Layla Soudavar Diba, texts by Laleh Bakhtiar and Aydin Aghdashlou (Tehran: Negarestan Museum, 1978). For an illustration of the work, see p. 22.

30 Ruyin Pakbaz and Yaghoub Emdadian, eds., with Tooka Maleki, *Pioneers of Iranian Modern Art: Charles-Hossein Zenderoudi* (Tehran: Tehran Museum of Contemporary Art, 2001), p. 125. Two versions of the catalogue exist. I was told that, disputing certain dates, the artist demanded a revised version. I have both editions, one that reproduces the 'pardeh' with no date and the other one specifying 1960. I am not sure which edition was approved by the artist.

31 For a description of a work influenced

by the format of a *shahr-e farang* (literally 'city of the Franks,' meaning Europeans) used by ambulant entertainers, see Daftari, 'Redefining modernism,' in Daftari and Diba, *Iran Modern*, p. 32.

32 For a description of Saqqakhaneh artists, sources and works, see Daftari, 'Another modernism,' pp. 67-77.

33 Daftari, 'Redefining modernism,' p. 32.

34 I would like to thank Yaghoub Emdadian for the information regarding Mansour Ghandriz's interest in Klee and Miró.

35 Karim Emami, 'Modern Persian artists,' in Ehsan Yarshater, ed., *Iran Faces the Seventies*, (New York, Washington, London: Praeger Special Studies, 1977), p. 351. For a more recent use of this denomination, see Hamid Keshmirshekan, 'Neo-traditionalism and modern painting: The Saqqakhaneh school in the 1960s,' *Iranian Studies*, vol. 38, no. 4 (December 2005), pp. 607-630. The pitfall of lumping together artists who resorted to anything traditional in nature is evident in Ehsan Yarshater's 'Contemporary Persian Painting' where he attaches the Saqqakhaneh artists (in his terms the 'Good old days school') to 'earlier exponents of this school' such as Ziapour, Kazemi, and Javadipour. See Yarshater's essay in *Highlights of Persian Art*, Richard Ettinghausen, ed. (Boulder, Colorado: Westview Press, 1979), pp. 363-77.

36 See Daftari, 'Redefining modernism,' in Daftari and Diba, *Iran Modern*, p. 30, where, borrowing from Thomas Crow's writings on Jasper Johns, I have drawn a parallel between the ubiquitous Shi'i motifs and the flag.

37 Kameran [sic] Diba, 'Iran,' in Wijdan Ali, ed., *Contemporary Art from the Islamic World*, (London: Scorpion Publishing Ltd., 1989), p. 153.

38 The following description of the commissioned works was relayed in an email from Hamid Ladjevardi to the author, 12 August 2014: 'there were 2 works by Arabshahi: one at the entrance hallway from the street (etchings on red brick which I recall may have been of the city plan of Kashan) and one in the conference room (plaster work with

some *kahgheli* rendition. Ali probably has a better memory of it than me). Zenderoudi (commissioned by Ali on behalf of Behshahr) rows of colorful vertical wooden spaces with chains hanging down from them was in a hallway on the ground floor. Tanavoli's work (commissioned by Ali) was on another hallway on the ground floor of the bldg (black concrete work).'

39 See Abby Weed Grey, *The Picture is the Window, the Window is the Picture: An Autobiographical Journey* (New York: New York University Press, 1983).

40 His choice of paper rather than canvas and pen instead of oil paint, Zenderoudi confided to me in 2001, was not aesthetic but made out of financial necessity.

41 Grey, *The Picture is the Window*, p. 66.

42 Ibid., p. 52.

43 Akbar Tadjvidi, *Exhibition of Iranian Contemporary Paintings: "Ameri, Darrudi, Djavadipour, Esfandiari, Ghandriz, Golzari, Hamidi, Kazemi, Malek, Momayyez, Oveysi, Sadr, Tanavoli, Zenderoudi "*([Tehran]: Sazeman-e Sam'i va Basari-ye Honarha-ye Ziba-ye Keshvar [1962]), n.p. A review of the exhibition appeared in *St. Paul Pioneer Press*, 23 June 1962. A list of all the cities, institutions and dates (from 1962 to 1966) of this travelling exhibition are kept with the above items in the Abbey Weed Grey archives, transferred to the Bopst Library in New York.

44 See *Inaugural Exhibition: Selections from the Ben and Abby Weed Grey Foundation Collection of Contemporary Asian and Middle Eastern Art* (New York: New York University Grey Art Gallery and Study Center, 1975) and Balaghi and Gumpert, *Picturing Iran: Art, Society and Revolution*, the catalogue of the exhibition titled *Between Words and Image* at the Grey Art Gallery.

45 *Inside Out: New Chinese Art*, curated by Gao Minglu and organized by the San Francisco Museum of Modern Art and the Asia Society, New York, opened in 2000. *The Short Century: Independence and Liberation Movements in Africa, 1945–1994*, organized by Okwui Enwezor, was shown at MoMA PS1, New York, in 2002.

46 *Art in Iran*, text by Karim Emami (Tehran: Iran–America Society, 1965).

The twenty-two artists were Abdolah Ameri, Mas'ud Arabshahi, Ardeshir Arjang, Sadegh Barirani, Bahman Borujani, Abdolreza Daryabeigi, Ahmad Esfandiari, Monir Farmanfarmaian, Bahman Forsi, Javad Hamidi, Mansoureh Hosseini, Mahmoud Javadipour , Kamran Katuzian, Sima Kuban, Manucher Mo'tabar, Faramarz Pilaram, Changiz Shahvaq, Marie Shayans, Jazeh Tabatabai, Sadegh Tabrizi, Parviz Tanavoli and Parviz Varjavand. Only five of them were associated with the Saqqakhaneh movement.

47 This was the most substantial exhibition to date on the subject of Iranian modern art. Out of seventy-three works, ten were by Saqqakhaneh artists. See Ehsan Yarshater and Karim Emami, *Modern Persian Painting* (New York: Center for Iranian Studies, Columbia University, 1968).

48 Before the advent of Saqqakhaneh, Iranian contemporary art was featured in international biennials. For example, Iran was represented by the following artists at the 1958 Venice Biennial: Edik Ayvarian, Ahmad Esfandiary, Monir Farmanfarmaian, Hassan Gaemi, Marcus Grigorian, Massood Karim, Sirak Melkonian, Artoun Minassian, Malek Siroosse, Manouthchehr Sheybani, Sohrab Sepehri, Mohsen Vaziri, Rostam Voskanian, Ashot Minassian, Parviz Tanavoli and Farzami Kooros. Grigorian was the organizer of the exhibition.

49 See Daftari, 'Redefining modernism,' pp. 32–33.

50 See note 26.

51 An article in *Ettelaat*, a major newspaper of the day, reports on the Queen's visit to the Atelier Kaboud, where Tanavoli's paintings and sculptures were on view. See *Ettelaat*, no. 10671 (12 Azar 1340 [1961]), page number is not legible.

52 Negar Diba, TMOCA curator before the revolution, reminds me that, for the inauguration of I.M. Pei's East Wing building, a few works from the Western collection, including Willem de Kooning's *Woman III* (exchanged in 1994 with pages from the 16th-century Shah Tahmasp Shahnameh) were lent

by TMOCA to the National Gallery in Washington, DC. Email to author, dated 16 July 2014. Before that, the Private Secretariat had also lent André Derain's *Composition (L'Age d'Or)* to *Fauvism: The Wild Beasts and Its Affinities*, an exhibition curated by William Rubin at the Museum of Modern Art, New York, in 1976.

53 The contemporary art comprised some forty paintings and sculptures. Paintings were listed as by Massoud Arabshahi (two works), Nasser Assar, Mahine Azima, Sadegh Barirani, Bijan Bassiri, Iran Darroudi, Abdolreza Daryabeigi, Heshmat Djazani, Mansour Ghandriz, Marcos Grigorian (two works), Ghassem Hadjizadeh, Maryam Javaheri, Kamran Katouzian (two works), Hossein Kazemi, Reza Mafi, Hossein Mahjoobi, Leyly Matine-Daftary, Bahman Mohassess (two works), Gholam-Hossein Nami (two works), Nasser Ovissi (two works), Faramarz Pilaram (two works), Jafar Roohbakhsh, Behjat Sadr, Abol-Ghassem Saidi (two works), Sohrab Sepehri, Massoumeh Seyhoun, Mohsen Vaziri and Hossein Zenderoudi (two works); sculpture by Bahman Mohassess (two works), Jazeh Tabatabai and Parviz Tanavoli (two works). See the following catalogues: *Salon d'Automne 1973* (Paris: Grand Palais, 17 October–19 November 1973); *Collections particulières de Sa Majesté l'Impératrice d'Iran* (Brussels: Palais des Beaux-Arts, 30 January 1973); *Iran Sehabanusu Majeste Farah Pahlavi'nin Ozel Koleksiyonu Sergisi* (Ankara–Istanbul, 1974); and *Zbirca njenog veličanstva carice Iran* (Belgrade: Muzej Savremene Umetnosti Beograd/Musée d'Art Moderne Belgrade: 23 May—10 June 1974). These exhibitions did not have a curator but this author, who served as an art consultant in between graduate degrees at Columbia University, was placed in charge of travelling the exhibition to all its five venues and installing it in Ankara and Istanbul.

54 See *Art moderrne iranien*, preface by Rou'in Pakbaz (Basel: International Art Fair 7, 1976). The catalogue notes that organization of the exhibition was carried through by the Private Secretariat and the Committee of

Iranian Modern Art, listed as the following: Aydin Aghdashloo, Maryam Ansary, Abdolreza Daryabeigi, Mahmoud Djavadipour, Parviz Kalantari, Ali Ladjevardi, Gholam-Hossein Nami, Faramarz Pilaram, Masoumeh Seyhoun, Ghobad Shiva and Donna Stein.

55 Kamran Diba was officially appointed director in early 1976 and resigned from the museum around the end of October 1978. Email from Negar Diba to the author, May 9, 2016

56 On his life and work, see Reza Daneshvar, *A Garden Between Two Streets: 4001 Days in the Life of Kamran Diba* (Paris: Edition Alborz, 2010), in Persian. On 'Rasht 29,' founded by Karnran Diba, Roxana Saba and Parviz Tanavoli, see Sohrab Mohebbi, 'Rasht 29: A cultural oasis in Central Tehran,' *Bidoun*, 20 (Spring 2010), pp. 46-49.

57 Negar Diba, email to the author, 16 July 2014.

58 Rose Issa, Ruyin Pakbaz and Daryush Shayegan, *Iranian Contemporary Art* (London: Booth-Clibborn Editions, 2001).

59 See Daftari, 'Redefining modernism,', pp. 33-34, and her lecture, 'Fereshteh Daftari opens a discussion on modern art from Iran,' 10 September 2013, Asia Society Museum, New York.

60 *A Retrospective Exhibition of Works of Saqqakhana Movement* (Tehran: Tehran Museum of Contemporary Art, 20 August–12 November 2013).

61 Ruyin Pakbaz and Yaghoub Emdadian, eds, *Charles-Hossein Zenderoudi* (Tehran: Tehran Museum of Contemporary Art, 2001), exhibition held in November 2001; Ruyin Pakbaz and Yaghoub Emdadian, eds. *Massoud Arabshahi.* (Tehran: Tehran Museum of Contemporary Art, 2001), exhibition held in December 2001; Ruyin Pakbaz and Yaghoub Emdadian, eds. *Parviz Tanavoli* (Tehran: Tehran Museum of Contemporary Art, 2003), exhibition held in 2003.

62 *Unedited History:1960–2014* (Paris: Musée d'art moderne de la ville de Paris, 2014).

63 We do not know if Bahman Mohassess accepted the invitation for a large-scale portrait commission willingly or reluctantly. In any case it did not meet with the Shah's approval.

Chapter 3

1 For the holdings of work by Siah Armajani at the Grey Art Gallery in New York, see https://greyartgallery.nyu.edu.

2 On Armajani, see Ziba Ardalan, ed., *Siah Armajani: An Ingenious World* (London: Parasol Unit, 2013). Works in two exhibitions in New York (*Between Word and Image*, Grey Art Gallery, 2002, and *Iran Modern*, Asia Society Museum, 2013) helped Iranians abroad become familiar with Armajani's work. He briefly visited Iran in 2005 and in 2016 Abanbar, a Tehran gallery, showed two works in the group exhibition *Mass Individualism* (2016). To my knowledge, TMOCA does not yet own a work by this artist. For an excellent evaluation of Armajani's work, see Murtaza Vali, 'Siah Armajani: Return to exile,' *Artasiapacific* 69 (July–August 2010): 102-111. A forthcoming touring retrospective is planned for the Walker Art Center, Minneapolis in 2019.

3 See below, Chapter Four.

4 Jazeh Tabatabai (1930–2008) deserves a mention for his sculptures of found objects welded into whimsical robotic creatures. The current literature is lacking in any serious scholarly attempt to understand his oeuvre. I offered one interpretation in 'Another modernism: An Iranian perspective,' an essay I wrote on the occasion of *Between Word and Image*. See its exhibition catalogue, *Picturing Iran: Art, Society, and Revolution*, p. 80.

5 The covers of a number of his publications are illustrated in Lisa Fischman and Shiva Balaghi, eds., *Parviz Tanavoli* (Wellesley, Massachusetts: Davis Museum at Wellesley College, 2015), pp. 166-167.

6 Tanavoli has published in Persian the first volume of a survey on sculpture in Iran. While referencing the ancient period, this book is devoted to unearthing the rare instances of what might be called sculpture during the Islamic period. See Tanavoli, *A History of Sculpture in Iran: Islamic Period* (Tehran: Nazar, 1392 [2013]). Another volume, on the modern period, is planned.

7 In multiple statements and interviews

Tanavoli has confirmed his identification with Farhad.

8 In his survey of sculpture in Iran, Tanavoli provides a fascinating photograph by the Armenian-Georgian Russian-born Antoin Sevruguin (1830–1933), representing the Qajar king Naser al-Din Shah posing with his retinue in front of an equestrian statue of himself. See ibid., pp. 150-151. The photograph is now at the Arthur M. Sackler Gallery, Washington, DC.

9 Finding an exact date is not a possibility at this stage.

10 Tanavoli, e-mail to the author, August 27, 2014.

11 For an illustration of a Safavid lock and key similar to the enlarged example *The Poet* carries in its hands, see Tanavoli, *Locks from Iran: Pre-Islamic to Twentieth Century* (Tehran: Bon-gah Publication, 2007; first edition 1976), p. 106 (in Persian).

12 Ibid., p. 20, fig 26.

13 Tanavoli in David Galloway, *Parviz Tanavoli: Sculptor, Writer and Collector* (Tehran: Iranian Art Publishing, 2000), p. 79.

14 Communication to the author, 13 October 2016.

15 Information to the author by Parviz Tanavoli, 13 October 2016.

16 Information to the author by Parviz Tanavoli, Tehran, June 2014.

17 The title and the date were given to the author in an email from the artist, 3 November 2013.

18 Tanavoli in Galloway, *Tanavoli*, p. 58.

19 See Tanavoli, *Atelier Kaboud* (Tehran: Bon-gah Publication, 2005).

20 Tanavoli in Galloway, *Tanavoli*, p. 94.

21 Interview with the author, Tehran, June 2014.

22 Tanavoli in Galloway, *Tanavoli*, p. 82.

23 Personal communication to the author, 2012.

24 Karim Emami, 'Tanavoli turns 'Popper',' *Kayhan International*, November 8, 1965. Reprinted in *Karim Emami On Modern Iranian Culture, Literature and Art*, ed. Houra Yavari, compiled by Goli Emami with an introduction by Shaul Bakhash (New York: Persian Heritage Foundation, 2014), p. 200.

25 Email to the author, 4 November 2013.

26 The biblical episode concerns Aaron and the Pharaoh, but in recounting the miracle to this author Tanavoli referred to Moses and the Pharaoh.

27 On the two versions of *Oh Persepolis* see Daftari, 'Passport to elsewhere,' in Daftari and Jill Baird, eds., *Safar/Voyage: Contemporary Works by Arab, Iranian, and Turkish Artists* (Vancouver: Douglas & McIntyre and Museum of Anthropology at the University of British Columbia, 2014), pp. 20-21; Daftari, 'Redefining modernism: Pluralist art before the 1979 Revolution,' in Daftari and Layla Diba, eds., *Iran Modern* (New York, New Haven, Connecticut, and London: Asia Society Museum in association with Yale University Press, 2013), p. 34; Daftari, lecture given at the opening of *Iran Modern*, September 10, 2013, transcript posted on Asia Society's website: http://asiasociety.org/new-york/fereshteh-daftari-opens-discussion-modern-art-iran.

28 I can vouch to have been the person who introduced the two artists in the early 1970s when Pomodoro travelled to Iran to be commissioned by the Private Secretariat of the Queen.

29 On the Shiraz Art Festival (1967–1977), a yearly event that brought avant-garde and traditional performance arts to Iran, see Vali Mahlouji, 'L'Espace contesté: La métapolitique du Festival des Arts de Shiraz-Persepolis,' *Iran: Unedited History, 1960–2014* (Paris: Musée d'Art Moderne de la Ville de Paris, 2014). An English version of this exhibition catalogue was published for its next venue: MAXXI in Rome (11 December 2014–29 March 2015).

30 Unpublished open letter to *Le Monde*, dated 14 December 1971, quoted by Vali Mahlouji, 'L'Espace contesté', p. 54. English trans. in Robert J. Gluck, *The Shiraz Festival: Avant-Garde Arts Performance in the 1970s Iran*, p. 220, quod.lib.umich.edu, retrieved 9 September 2014.

31 When asked by email what his impressions of the Shiraz Festival were, Wilson answered, 'One of the highlights in my career, as a theatre maker, was the creation and performance of KA MOUNTAIN AND GUARDenia [...] a story about a family and some people changing. That was commissioned by the Shiraz Festival in 1973. The continuous performance lasted 7 days and 7 nights. It brought together over 500 people from many diverse nations. I created a prologue for the 7 day play, that consisted of a modern tower of the bible. Among the participants in the prologue were students, highly critical of the Shah and his regime. It was surprising that there was no censorship. The festival was very open to all of my ideas in creating this unique and highly unusual work.' My query was sent to Robert Wilson care of Margery Arent Safir, who sent me Wilson's reply by email, 26 September 2012. I would like to thank Arent Safir for acting as an intermediary. The above research was meant for the text I wrote for the 2013 publication of the exhibition *Safar/Voyage: Contemporary Works by Arab, Iranian, and Turkish Artists*. Due to an editorial error it never made it into the final publication. For greater detail regarding Tanavoli and Persepolis, see that publication, pp. 20-21.

32 Conversation with the author, 2012.

33 Elaine Sciolino, *Persian Mirrors: The Elusive Face of Iran* (New York: Free Press, 2000), p. 168.

34 Daniel Belasco, 'In the spirit of Nothing: Parviz Tanavoli's 'Heech' and the international aesthetics of Pop.' Belasco sent me this paper in 2005 when he was a doctoral candidate at the Institute of Fine Arts at New York University.

35 Anon., 'Asar-e monhat-e farhang-e imperialisti ra bezedaim,' *Sobh-e Azadegan* (22 December 1979), n.p.

Chapter 4

1 For a highly perceptive assessment of art during the first two decades after the Revolution, see Samila Amirebrahimi, 'Faraz va forudha-ye do daheh naqqashi-ye Iran,' *Herfeh Honarmand*, no. 29 (Summer 2009), pp. 116-129.

2 Anonymous, 'Introduction,' in *Namayeshgahha-ye bazgoshai* (Tehran: Bonyad-e Farhang o Honar-e Iran, Aban 1358 [1979]), n.p. The catalogue first gives a cursory overview of art in Iran from the second half of the fourteenth century to the first quarter of the twentieth century. It skips the entire Pahlavi era; the next chapter treats the work of four photographers (Abbas Attar, Bahman Jalali, Kaveh Golestan and Mohammad Saiyad) followed by a section on revolutionary graffiti, some caricatural drawings, and realist cinema. Of special interest is the translation of the text not just into English but also into Arabic.

3 Mona Hadler, 'Sculpture in postwar Europe and America, 1945–59,' *Art Journal* 53, no. 4 (Winter 1994), p. 17.

4 G. Roger Denson, 'Colonizing abstraction: MoMA's *Inventing Abstraction* show denies its ancient global origins,' *Huffington Post: Arts and Culture*, 15 February 2013, http://www.huffingtonpost.com/g-roger-denson/colonizing-abstraction-mo_b_2683159.html.

5 Ibid.

6 See Fereshteh Daftari, 'Redefining modernism: Pluralist art before the 1979 Revolution,' in Daftari and Layla Diba, eds, *Iran Modern* (New York: Asia Society, 2014), pp. 72–73.

7 She has recently added Shahroudy, her maiden name, to her name.

8 Adolph Loos, an Austrian architect, viewed ornamentation as contrary to modernity, a belief he expounded in a 1910 lecture entitled 'Ornament and crime,' written in 1908.

9 See Daftari, 'Redefining modernism.' In this essay I assert that Farmanfarmaian's 'return to the self' – a sentiment or even an ideology prevalent in the 1960s and 70s – was executed in a language different from that of the Saqqakhaneh just as it was different from the type of abstraction I refer to as 'global abstraction', meaning the abstraction pursued by Mohsen Vaziri and Behjat Sadr. Pluralism in Iranian modern art, even within the oeuvre of a single artist, was the point of the essay. It puzzles me to see it misconstrued by one author as merely a 'nod to political correctness,' perhaps meaning a *dépassé* notion of difference. Instead she adopts a trendy term and proposes an 'itinerant narrative equal to her [Farmanfarmaian's] itinerant biography'

as a better and more insightful mode of looking at the artist's work. See Media Farzin, 'The art of Monir Shahroudy Farmanfarmaian in historical context: An illustrated slide show,' in Suzanne Cotter, ed., *Monir Shahroudy Farmanfarmaian: Infinite Possibility: Mirror Works and Drawings* (Porto, Portugal: Serralves, 2014), p. 147.

10 Morteza Goudarzi, in his book *Jost o juy-e hoviyyat dar naqqashi-ye moaser-e Iran* [Searching for identity in Iranian contemporary painting], published in Tehran in 1996 and reprinted in 2006, leaves out any discussion of women artists before the Revolution. Without any discussion he illustrates only three works by women painters: one of each by Parvaneh Etemadi, Mansoureh Hosseini and Firouzeh Saberi.

11 Morteza Goudarzi, *Tarikh-e Naqqashi-ye Iran az aghaz ta asr-e hazer* [History of Iranian painting from the beginning until today's era] (Tehran: Semat, 2011), pp. 121, 123-124. In this sweeping survey, he acknowledges the paintings of two women: Iran Darroudi and Zahra Rahnavard.

12 Ru'in Pakbaz, *Naqqashi-ye Iran: az diruz ta emruz* [Iranian painting: from yesterday to today] (Tehran: Narestan, 2000), pp. 185-219. He names only Mansoureh Hosseini, Parvaneh Etemadi and Behjat Sadr, and illustrates none. Pakbaz's meticulous observation of modern art in Iran and his ongoing research for a multivolume encyclopaedia of art make him a formidable source of information.

13 Farmanfarmaian's mirror balls – such as the one at the Andy Warhol Museum, Pittsburgh – and the sphere within a triangle within a square exhibited at the Denise René Gallery, Paris in 1977 and illustrated in its brochure are examples of her sculptures. For the Warhol Museum mirror ball, see Daftari and Diba, ed., *Iran Modern*, plate 20. For the latter work, see cover of *Monir Farmanfarmaian*, text by Donna Stein. Exhibition brochure (Paris: Galerie Denise René, April 1977). In recent years the artist has increased her production of three-dimensional objects.

14 Robin Wright, 'Two female artists and The Revolution,' *New Yorker*, 15 September 2015, www.newyorker.com/culture/culture-desk/two-iranian-artists-and-the-revolution?intcid+mod-latest.

15 Farmanfarmaian's name is nowhere mentioned in the seminal articles on the group. For a bibliography and a chapter on the movement, see Irving Sandler, *Art of the Postmodern Era* (New York: Harper Collins, 1996), pp. 141-63.

16 See Daftari and Diba, *Iran Modern*, plate 21.

17 Ibid., fig. 16.

18 See Daftari, *Rebel, Jester, Mystic, Poet: Contemporary Persians* (Toronto and London: Aga Khan Museum and Black Dog Publishing, 2017), pp. 20, 90-91. The work appears in the installation shot of this exhibition illustrated in the present book, fig 132.

19 Monir Farmanfarmaian and Zara Houshmand, *A Mirror Garden: A Memoir* (New York: Anchor Books, 2007), p. 186.

20 Ibid., p. 186.

21 Ibid.

22 Thanks are due to Donna Stein for sharing her research with me and quoting from her correspondence with Marcia Hafif. The 1975 date is also given in Cotter, *Infinite Possibility*, p. 18.

23 Farmanfarmaian cited one example to me, but requested that the name of the building's owner not be mentioned.

24 The most recent author being Suzanne Cotter in *Infinite Possibility*, p. 20.

25 Farmanfarmaian has denied this influence on several occasions in conversation with me.

26 Frank Stella, 'Questions for Stella and Judd,' interview by Bruce Glaser. Broadcast in February 1964 on WBAI FM, New York, the interview was edited by Lucy Lippard for *Art News* 65, no. 5 (September 1966), p. 59.

27 See Daftari, 'Redefining modernism,' p. 36, fig. 16, and plates 20–23.

28 Marcos Grigorian gave me a copy of the 1958 Tehran Biennial catalogue that he had hand notated long ago. Above the name and title of Farmanfarmaian's *Abstract* (a work in an unspecified medium), he had written, in Persian, 'winner of the gold medal.'

29 For the exhibition brochure, see Donna Stein, *Monir Farmanfarmaian* (Paris: Galerie Denise René Rive Gauche, April 1977).

30 See Rose Issa, Ruyin Pakbaz and Daryush Shayegan, *Iranian Contemporary Art* (London: Barbican Art Galleries, 2001).

31 See Rose Issa, *Monir Shahroudy Farmanfarmaian: Mosaics of Mirrors* (Tehran: Nazar Research and Cultural Institute, 2006).

32 See Hans Ulrich Obrist and Karen Marta, eds, *Monir Shahroudy Farmanfarmaian: Cosmic Geometry* (Bologna and Dubai: Damiani and The Third Line, 2011).

33 See *Modern Persian Painting*, foreword by Ehsan Yarshater, introduction by Karim Emami (New York: Center for Iranian Studies, Columbia University, 1968), cat. nos. 15–16, not illustrated. Given the indicated 'oil on glass' medium, these must have been examples of reverse glass painting.

34 See *New York University Grey Art Gallery and Study Center: Inaugural Exhibition* (New York: New York University, 1975) and Daftari, 'Another modernism: An Iranian perspective,' in Shiva Balaghi and Lynn Gumpert, eds, *Picturing Iran: Art, Society and Revolution* (London and New York: I.B.Tauris, 2002), p. 57, fig. 19; and pp. 78-80.

35 The work by Farmanfarmaian I borrowed for the show was then titled *Eight Times Eight*; in more recent publications it is called *Geometry of Hope*.

36 Daftari, 'Another Modernism,' p. 80. For the essays by Dave Hickey mentioned in the excerpt, see Hickey, *The Invisible Dragon: Four Essays on Beauty* (Los Angeles: Art Issues Press, 1993).

37 Thanks are due to Maryam Ekhtiar for providing the dates of the exhibition.

38 See Daftari, 'Another modernism,' p. 36 and plate 20.

39 Telephone conversation with the author, 2 October 2012.

40 For an example, see *New York Times*, 1 April 1956.

41 For images, see Daftari and Diba, *Iran Modern*, plates 22–23.

42 Cotter, *Infinite Possibility*. The exhibition travelled to the Solomon R. Guggenheim Museum, New York in 2015. Two recent exhibitions at the Guggenheim Museum exemplify this

commitment: *Zarina: Paper Like Skin* (2013) and *V.S. Gaitonde* (2014).

43 The only precedent, a low-profile one, was *Parviz Tanavoli: Bronze Sculpture*, mounted in 1976 at the Grey Art Gallery.

44 Mohsen Vaziri, telephone conversation with the author, January 2015.

45 Piero Dorazio, quoted in *Roma–New York: 1948–1964* (New York: Murray and Isabella Rayburn Foundation, 1993), p. 99. See also Daftari, 'Redefining modernism,' p. 35.

46 See Behjat Sadr, 'The life is a collage,' interview by Narmine Sadegh on the occasion of the artist's retrospective at the Tehran Museum of Contemporary Art, in Javad Mojabi, Yaghoub Emdadian and Tooka Maleki, eds. *Pioneers of Iranian Modern Art: Behjat Sadr* (Tehran: Tehran Museum of Contemporary Art, 2004), pp. 20-25. See also Daftari, 'Redefining modernism,' p. 35.

47 Sadr, 'The life is a collage,' p. 22.

48 Akbar Tajvidi, *Exhibition of Iranian Contemporary Paintings Sponsored by Fine Arts Administration of Iran, Ian America Society and Friends of Middle East*[, 1962], n.p.

49 Morad Montazami and Narmine Sadeg, eds. *Behjat Sadr: Traces* (Paris: Zaman Books, 2014), p. 162.

50 Ibid., p. 85.

51 Vaziri, telephone conversation with the author, 5 January 2015.

52 Werner Haftman, *The Mind and Work of Paul Klee*, trans. Mohsen Vaziri Moghaddam (Tehran: Soroush Press, 1999).

53 Vaziri, telephone conversation with the author, 5 January 2015.

54 Vaziri, untitled text in *Vasiri: 1955–75 Retrospective* (Tehran: Takht-e Jamshid Gallery, 1975), n.p.

55 Cited in 'L'Exposition Mohsen Vaziri,' *Journal de Teheran*, 25 Juillet 1962, reproduced in *Vasiri: 1955–75 Retrospective*, n.p.

56 Sadr, quoted by Roberto Melli in *Behjat Sadr* (Rome: Galleria Il Pincio, 1957), n.p. I have taken slight liberty in translating the quote from Italian.

57 Sadr in conversation with Narmin Sadegh in 'The life is a collage,' p. 148/21.

58 See Pierre Guéguen, 'Cave architecture,' and Nicole van de Ven, 'Recognition through the play of paint and light,' reprinted in Mojabi, Emdadian and Maleki, *Pioneers of Iranian Modern Art: Behjat Sadr*, pp. 9 and 10.

59 The statement comes from a speech Sadr made in 1994, reprinted in Montazami and Sadeg, *Behjat Sadr: Traces*, p. 38.

60 In a letter to the author, dated 7 March 2001, Sadr wrote, 'Unfortunately in the last ten years, because of illnesses, I have been obliged to work sitting down.'

61 Sadr in conversation with Narmine Sadeg, in Montazami and Sadeg, *Behjat Sadr: Traces*, p. 219.

62 To my knowledge, this was the first time an Iranian artist was invited by Western curators to participate in a major international group exhibition.

63 For the sculpture's wall label in *Iran Modern*, I wrote, 'Unlike the Brazilian artist Lygia Clark, whose small geometrically abstract *Bichos* of the early 1960s are also meant to be manipulated but which are devoid of organic references, Vaziri's sculpture recalls a pre-historic or tentacled primeval creature able to expand into the horizon or contract into a compact dormant form.'

64 Steve Erickson, 'What set him spinning,' *New York Times Book Review*, 16 August 2015, p. 16. This is a review of Haruki Murakami's two-novel volume *Wind/Pinball*.

65 See Daftari, 'Marcos Grigorian: A rooted nomad,' in *Marcos Grigorian: Earthworks* (New York: Leila Heller Gallery, 2011).

66 For images, see Marcos Grigorian, *The Gate of Auschwitz* (New York and Yerevan: Printinfo, 2002).

67 For images, see Daftari and Diba, *Iran Modern*, plate 28, and Donna Stein, *Marcos Grigorian: The Earthworks* (New York: Gorky Gallery, 1989), plates 70-1.

68 There are many aerial photographs in Grigorian's archives, which I was shown in 2011 by Michel Protiva, the artist's nephew.

69 Janet Lazarian, 'Goftogu ba Marco Grigorian,' *Bokhara*, no. 16 (1379 [2000]), p. 258.

70 See Daftari and Diba, *Iran Modern*, plate 28.

71 Interview with the author, January 2000.

72 Ebrahim Golestan, conversation with the author, 2013.

73 His realistic appropriations of ready-made objects, too, refer to the culinary diet of peasants and the working class (the *dizy abgousht*) as well as their rudimentary tools, such as sieves and *zambeh*s (barrows).

74 For an image of this work, see Stein, *Marcos Grigorian*, pp. 87–88, or Daftari and Diba, *Iran Modern*, p. 38, fig. 17.

75 Grigorian in an interview with Javad Mojabi, published in *Tamasha*, no.61, 1386 [2007] a photocopy of which the artist gave to this author. Reprinted in Javad Mojabi, *Navad sal no-avari dar honar-e tajassomi-ye Iran* (Tehran: Sareban Gallery, 1394 [2015]), vol. 2, pp. 325-329.

76 Sirak Melkonian, conversation with the author, 2014.

77 Nami has mentioned this anecdote in all his interviews including in a session with myself. It is not clear if he was familiar with Alberto Burri's similar experimentations, the 'hunchbacks' of the first half of the 1950s. His friend Grigorian, who had studied in Italy, would have certainly been familiar. Both, however, created works reminiscent of Burri's intentional cracks, or craquelure.

78 Entitled 'Volume and Environment,' but better translated as 'Volume and Surface.'

79 Gholamhossein Nami no longer remembers the poet's name. Nami, conversation with the author, December 2014. For illustrations of all four sides, see Ali Reza Sami-Azar, *Gholamhossein Nami* (Tehran: Boom Gallery, Private Collection, 2014), pp. 70-73.

80 See Javad Mojabi, 'Didari az namayeshgah-e Abi' (Farvardin 1354 [1975]), p. 20. On grounds of decency, the reviewer refrains from describing the work. Grigorian gave me a photocopy of this review, but I have been unable to identify the magazine. The general tone of the article is highly negative towards the conceptual art in the show, which included another

transgressive work, Morteza Momayez's rolls of toilet paper.

81 Morteza Momayez had exhibited his knives before, in 1975, at the Iran America Society, at the fourth exhibition of the Azad group.

82 The incident is well known. My information is based on Nami's account, as conveyed to me by the artist in Tehran, December 2014.

83 The work is sketched but not illustrated in the exhibition catalogue. My description is that relayed to me by Nami in Tehran, December 2014.

84 The English title of the exhibition was *Volume and Environment 2*.

85 The artist's recollection regarding the 1964 date is probably correct yet puzzling. The work was not reproduced or exhibited anywhere before the 1977 Wash Art Fair and the introduction of conceptual thinking did not emerge in Iran until the 1970s.

86 See Daftari, 'Redefining modernism,' p. 40.

87 For images of these works, see *Art moderne Iranien: Salon International d'Art '76 Bâle, Suisse*, pp. 101, 103.

88 Peter Chelkowski and Hamid Dabashi, *Staging A Revolution* (London: Booth-Clibborn Editions, 2000), p. 134.

89 See Sadr's statements in Morad Montazami and Narmine Sadeg, eds, *Behjat Sadr: Traces* (Paris: Zaman Books, 2014), p. 164. Vaziri told me in a phone conversation that the only political work he had made was one painting of young Communist military men who had been executed in the 1950s. Vaziri was never a member of any political party and he had claimed to despise all totalitarian regimes.

90 See Daftari, 'Redefining modernism,' pp. 39-40 and plates 62–3. For more recent works, see Octavio Zaya, *Nicky Nodjoumi* (Hong Kong: Mike Weiss Editions, 2004).

91 See Vali Mahlouji, 'L'Archéologie de la décennie finale,' in *Iran: Unedited History, 1960–2014* (Paris: Musée d'Art Moderne de la Ville de Paris, 2014), pp. 52-71. Photographs by Kaveh Golestan were planned to appear in the exhibition *Iran Modern*, at the Asia Society, New York in 2013, but the loan was withdrawn at the last minute.

92 Sarah McFadden, 'The museum and the revolution,' *Art in America* 69, no. 8 (October 1981), p. 11 and n. 19. The logic of the market eventually furnished TMOCA with examples of Claes Oldenburg's work. Ibid., p. 11.

93 For example, Pierre Restany. Restany's coverage of the newly built museum referred to it as the 'Museo imperiale' (Imperial museum). See Restany, 'DAZ Planners : Museo imperiale,' *Domus*, no. 579 (February 1978), pp. 14-17.

94 Kamal al-Molk stated that his portrait of Naser al-Din Shah in the *Hall of Mirrors* (1895–6) was an imposed commission and not in tune with his own interests. He had nothing but contempt for the next king, Mozaffar al-Din Shah, who asked him to paint lascivious subjects, such as so-and-so in a sexual position. See Ali Dehbashi, ed., *Yad- nameh-ye Kamal al-Molk*, ed. (Tehran: Behdid, 1999), pp. 23 and 26.

95 See *Bahman Mohassess: Scultura, Pittura, Grafica, Teatro*. Text by Enrico Crispolti and aphorisms by Bahman Mohassess (Rome: Societa Editrice Romana, 2007), p. 220. Trans. by the author.

96 Mehdi Vishkai is, to my knowledge, one of the few painters to have portrayed the Pahlavi royal family. Tanavoli remembers that Mehrdad Pahlbod, the Minister of Culture, commissioned Jalil Ziapour to paint the Shah's portrait. He also recalls a portrait of Queen Farah Pahlavi painted by Pilaram. Tanavoli, in conversation with the author, 2015. One more example is the Shah's portrait painted by Yektai. I wish to thank Salman Matinfar for bringing this work to my attention.

97 According to his daughter Shaherezad Vishkai, Mehdi Vishkai was not political. Shaherezad Vishkai in conversation with the author, August 2015.

98 Vishkai, interview in Javad Mojabi, *Pioneers of Persian Painting: First Generation* (Tehran: Iranian Art Publishing, 1998), pp. 224-225.

99 Daftari, 'Redefining modernism,' p. 38.

100 I am deeply indebted to Raana Farnoud for this and other information and insights she has shared with me about art after the Revolution.

101 The organization originated in the activities of three students – Kazem Chalipa (b. 1957), Hosein Khosrojerdi (b. 1957) and Habib Sadeghi (b. 1955) – from the Fine Arts department of Tehran University. In 1978 they held their first group exhibition at the Hoseini-ye Ershad, in Tehran. The Hoseini-ye, a religious meeting hall, is commonly associated with Dr Ali Shariati, whose inflammatory lectures there in the late 1960s and early 1970s ideologically paved the way for the Revolution. The choice of this location as an exhibition area stemmed from the Islamic, anti-monarchist sentiments of the group. The above information comes from an interview I conducted in 1987, in Tehran, at the 'Howzeh' with Chalipa, Khosrojerdi and Iraj Eskandari (b. 1956).

102 For my opposition to the use of the descriptor 'Islamic' for modern and contemporary art, see Daftari, 'Introducing art from the Middle East and its diaspora into Western institutions: Benefits and dilemmas,' in Hamid Keshmirshekan, ed., *Contemporary Art from the Middle East: Regional Interactions with Global Art Discourse* (London: I.B.Tauris, 2015), pp. 187-202.

103 For examples of Surrealist painting, see *Rami Jamarat (Stoning of the Devil at the Hajj Ceremony)* and *The Entombment of Hearts*, both 1984, by Habib Sadeghi. The former, showing Cubist influences, depicts a pilgrim to Mecca displaying the image of the *Kaaba* on his chest. He is engaged in the ritualistic act of stoning the Devil and warding off evil from his heart. The latter painting speaks of dehumanization: petrified pseudo-humans are carrying a casket filled with hearts. For an image of the former, see *A Decade with Painters of the Islamic Revolution* (Tehran: Art Center of the Islamic Propagation Organization, 1989), p. 108; for the latter, see *Tavoos Magazine*, no. 2 (Winter 2000): 196.

104 I would like to thank Hamed Yousefi for identifying the Surat. See http://corpus.quran.com/translation.jsp?chapter=9&verse=111 and http://corpus.quran.com/translation.jsp?chapter=61&verse=4.

105 Entitled *Mirhossein Mousavi, The Painter*, the documentary video is available on the Internet at https://vimeo.com/88804508.

106 Images of the former may be viewed on the Grey Art Gallery's website. For works in the collection of TMOCA, see *The Iranian Collection of the Tehran Museum of Modern Art* (Tehran: Tehran Museum of Contemporary Art, 2006), cat. nos 246–7.

107 The essay is in the Grey Art Gallery archives, turned over to the NYU's Bopst Library and it is analyzed by Hamed Youssefi. It was first brought to my attention by Sohrab Mohebbi, in the early preparatory stages for the 2013 exhibition *Iran Modern*, mounted at Asia Society, New York.

108 Hamed Yousefi, email to the author, 6 March 2015: 'What particularly grasped my attention in Mousavi's statement for his 1967 exhibition at Ghandriz gallery was its terminology. In the very first page, where he sets the theoretical ground for his peculiar understanding of modernism, Mousavi uses three words in English – accident, Taoism, Zen. The employment of this particular terminology in the context of modern art immediately brings John Cage to mind. Cage was an early, and by far the most prominent, figure who articulated a theory of "accident" in art based on Taoism. My understanding was verified when I saw one of the paintings in that exhibition. The painting is called Musical Notations (attached), and is exactly the only painting that Ms. Grey purchased and brought home – possibly a painting which could epitomize the body of works presented in that exhibition of 1967. That painting, put next to the artist's statement, gave me confidence to make the case for a *potential* connection with Cage in Mousavi's statement.'

109 For an image of this sculpture by Zahra Rahnavard, see Zahra Rahnavard, ed., *Contemporary Iranian Art and the Islamic World* (Tehran: Al-Zahra University, 2002), p. 100.

110 Ibid., p. [2].

111 Zahra Rahnavard, 'Global presence with a national-Islamic identity,' in Rahnavard, *Contemporary Iranian Art*, p. 9.

112 Ibid., p. 78.

113 Ibid.

114 Fariba Adelkhah, *Being Modern in Iran* (New York: Columbia University Press, 2004).

115 For Farideh Lashai's descriptions of her detention, see her nonlinear autobiographical publication in Persian, *Shal bamu*, 4th ed. (Tehran: Baztab Negar, 1381 [2002])

116 Raana Farnoud, conversation with the author, summer 2014.

117 Claire Bishop, *Artificial Hells: Participatory Art and the Politics of Spectatorship* (London and New York: Verso, 2012), p. 12.

118 Abbas Milani, *Lost Wisdom: Rethinking Modernity in Iran* (Washington DC.: Mage, 2004), p. 42.

119 Katayoun Beglari-Scarlet asked Abbas Kiarostami for the date when he started focusing on trees. The interpretation of the reason why he did so is mine.

120 Parenthetically, the critical dimension of such a strategy went unnoticed by MoMA when it mounted Kiarostami's retrospective in 2007. While the films and video installations were presented on the premises of MoMA in Manhattan, the photography component of the show, probably considered too conservative, was exhibited at PS1 in Queens, at the time a location with lesser prestige than the museum's midtown location. By the same token Kiarostami following a local and personal logic never attempted to keep up with new photography in the West.

121 'Doubt and uncertainty: Farideh Lashai in conversation with Golnaz Mahdavi,' *Art Tomorrow*, no. 8 (Spring 2012), pp. 132-135.

122 In various publications I have seen illustrations in which the head of the woman is magnified and juxtaposed onto her body to hide her nudity. See *Mofid*, no. 7 (1366 [1987]), p. 43.

123 For his War Series, see especially *Nosratollah Moslemian*, introduction by Ruyin Pakbaz (Tehran: Nazar Publications, 2005), p. 14.

124 For a comprehensive treatment of the artist's oeuvre, see Hamid Keshmirshekan, ed., *Kourosh Shishegaran: The Art of Altruism* (London: Saqi Books, 2016).

125 See Kourosh Shishegaran, interview by Behnam Kamrani and Mohammad Bagher Ziai, *Art Tomorrow*, no. 3 (Winter 2011): 186.

126 I am indebted to Barbad Golshiri for bringing the work of Asareh Akasheh to my attention. I am most grateful to him and the artist, who generously made her time available to me.

127 See Daftari, 'caraballo-farman,' in *Greater New York 2005* (New York: P.S.1 Contemporary Art Center in collaboration with the Museum of Modern Art, 2005), pp. 108-109. The following discussion of the work of Leonor Caraballo and Abou Farman borrows from that earlier essay.

128 Farman, email to the author, 24 September 2015. For a discussion of the political content of other works by the duo, see Talinn Grigor, *Contemporary Iranian Art: From the Street to the Studio* (London: Reaktion Books, 2014), pp. 180-181. See also *Iran: Inside Out* (New York: Chelsea Art Museum, 2009), p. 37.

129 Conversation with the author, Tehran, March 2016.

130 Communication to the author, 2015.

131 For biographical details, see 'Sohrab Sepehri,' *Encyclopaedia Iranica*, http://www.iranicaonline.org/articles/sepehri-sohrab.

132 Aydin Aghdashloo, 'In Tararane-ye Mokarrar-e atr agin,' *Herfeh Honarmand* 3, no. 16 (Summer 2006), p. 128. See Daftari, 'Redefining modernism,' p. 38 and p. 43 footnote 76.

133 Farideh Lashai, interview with the author, Tehran, 2007.

134 Abolghassem Saidi, email to the author, 24 August 2015.

135 For an image, see Hossein Amirsadeghi, ed., *Different Sames: New Perspectives in Contemporary Iranian Art* (London: TransGlobe Publishing, 2009), p. 87. In Tehran (January 10, 2010) he told me that he chose the colour red for his background so as not to conjure sky or nature.

Chapter 5

1 In my research I am deeply indebted

to numerous individuals, but above all to the artists and the following galleries and gallerists in Tehran: Abanbar (Salman Matinfar), Aun (Afarin Neyssari), Azad (Rozita Sharafjahan), Etemad (Mina and Amir Hossein Etemad), Mah (Shahnaz Khonsari), and especially Aaran (Nazila Noebashari).

2 The bibliography is too vast to be documented here, but some pioneering publications with a focus on Iranian art and photography of the past twenty-five years are: Shaheen Merali, Martin Hager, Rose Issa, and Tirdad Zolghadr,eds, *Entfernte Nähe/Far Near Distance: Neue Positionen iranishcer Künstler/Contemporary Poisitions of Iranian Artists* (Berlin: Hausder Kulturen der Welt, 2004); *Iran: Inside Out: Influences of Homeland and Diaspora on the Artistic Language of Contemporary Iranian Artists* (New York: Chelsea Art Museum, 2009); Rose Issa, ed., *Iranian Photography Now* (Ostfildern: Hatje Cantz Verlag, 2008); and Hossein Amirsadeghi, ed., *Different Sames: New Perspectives in Contemporary Iranian Art* (London: Thames and Hudson with Transglobe Publishing, 2009). More recent publications include Abbas Daneshvari, *Amazingly Original: Contemporary Iranian Art at Crossroads* (Costa Mesa, California: Mazda Publishers, 2014) and the exhibition catalogue *Global/Local: Six Artists from Iran, 1960–2015*, ed. Lynn Gumpert (New York: Grey Art Gallery, New York University, 2016).

3 Hamid Keshmirshekan, *Contemporary Iranian Art: New Perspectives* (London: Saqi, 2013).

4 See 'The Contemporary Period,' in Ru'in Pakbaz, *Naqqashi-e Iran az diruz ta emruz* (Tehran: Narestan, 1379 [2000]). Within the era he calls contemporary, Pakbaz ties the onset of modernity to the constitutional movement in the early twentieth century.

5 Talinn Gregor, *Contemporary Iranian Art: From the Street to the Studio* (London: Reaktion Books, 2014).

6 I had a first-hand experience with this issue while working on an exhibition I organized at The Museum of Modern Art: *Without Boundary: Seventeen Ways of Looking* (2006). During the several years it took for my proposal to go through the exhibition committee, the selected artists, with the exception of three or four, went from anonymity to celebrity. Thus the contemporary constantly collapses into the recent past it is always rushing to become.

7 Ibid., p. 9.

8 See Keshmirshekan, *Contemporary Iranian Art*, p. 309

9 See Abbas Amanat's introduction to Abbas Amanat and Farzin Vejdani, eds, *Iran Facing Others: Identity Boundaries in a Historical Perspective* (New York: Palgrave Macmillan, 2012). Identity was a question pursued by the modernists, who asserted a national and individual aesthetic identity, but not necessarily along the lines of gender or exile. Just as the modernists may not be homogenized as formalists, the diasporic artists of today display such a pluralism of expression that the 'identity' umbrella cannot cover them all.

10 The core material in this section comes from lectures I have given in various institutions, including the Los Angeles Museum of Contemporary Art (2011), Columbia University (2011), and Christie's Education (2013, 2015, 2017 and 2018).

11 See *Ali Banisadr: One Hundred and Twenty Five Paintings*, text by Robert Hobbs and interview with Boris Groys (London: Blain|Southern, 2015), p. 13. For further reading see Fereshteh Daftari, 'Voices of evil: A common world order,' in *Ali Banisadr* (Paris: Galerie Thaddaeus Ropac, 2010); *Ali Banisadr: We Haven't Landed on Earth Yet*, text by Maryam Ekhtiar (Salzburg: Galerie Thaddaeus Ropac, 2012); and *Ali Banisadr: Motherboard*, text by Jeffrey Deitch (New York: Sperone Westwater, 2014).

12 At least three exhibitions on this theme were held at Tehran's Aaran Gallery and Azad Gallery in 2010. One more was mounted at the Aaran gallery in 2015.

13 Salar Abdoh, ed. and transl. *Tehran Noir* (Brooklyn, New York: Akashic Books, 2014). See also his *Tehran at Twilight* (Brooklyn, New York: Akashic, 2014).

14 Rahmani, email to the author, 11 December 2015.

15 Fayez, interview with the author, 5 January 2016.

16 Fayez wrote the statement in 2010 for an exhibition on the theme of Tehran to explain his project *My Expired Utopia*. The exhibition *Tehran Virtual or Real* opened on 29 January 2010, at the Aaran Gallery, but it was shut down the next day.

17 See Homayoon Askari Sirizi, 'Capital in capital letter,' in *Arash Hanaei: 'Capital'* (Tehran: Aaran Gallery, 2009); and *Iran: Unedited History, 1960–2014*, (Paris: Musée d'Art Moderne de la Ville de Paris, 2014).

18 Vince Aletti, 'Newsha Tavakolian,' *The New Yorker*, 13 May 2013, p. 12.

19 Lisa Larson Walker, 'Newsha Tavakolian's "Look" Series: Photo of a Young Iran, *The Daily Beast*, 2 May 2013.

20 On Tabrizian, see *Mitra Tabrizian: Another Country*, with essays by Homi K. Bhabha, David Green, and Hamid Naficy (Ostfildern, Germany: Hatje Cantz, 2012); Daftari, 'Passport to elsewhere,' in Fereshteh Daftari and Jill Baird, eds, *Safar/Voyage: Contemporary Works by Arab, Iranian, and Turkish Artists* (Vancouver: D&M Publishers and Museum of Anthropology at the University of British Columbia, 2013), pp. 18, 116.

21 Tabrizian, email to the author, 29 December 2015.

22 Tabrizian in T.J. Demos and Rose Issa, *Mitra Tabrizian: This Is That Place* (London: Tate Publishing, 2008), p. 1.

23 The Situationist International (SI) was composed of social revolutionaries, including avant-garde artists. It is best known for its influence on the revolts in Paris in May 1968 and for the writings of its political theorist Guy Debord. *Détournement*, or hijacking, was one of its subversive strategies, whereby the signs of the system were appropriated and turned against the system itself.

24 For an illustration see Daneshvari, *Amazingly Original*, p. 67.

25 See Judith K. Brodsky and Ferris Olin, eds., *The Fertile Crescent: Gender, Art, and Society* (New Brunswick, New Jersey: The Rutgers University Institute for Women and Art, and New York: DAP, 2012) and Daneshvari's chapter 'Expressions of gender in contemporary

Iranian art,' in *Amazingly Original*, pp. 83-117.

26 See Ali Banuazizi, *Ardeshir Mohassess: Closed Circuit History* (Washington DC: Mage Publishers, 1989), and Shirin Neshat and Nicky Nodjoumi, eds, *Ardeshir Mohassess: Art and Satire in Iran* (New York: Asia Society, 2008).

27 See Daftari, 'Redefining modernism: Pluralist art before the 1979 Revolution,' in Daftari and Diba, eds., *Iran Modern*, p. 40. For illustrations see plates 47 and 29.

28 On women's rights in Iran during the Pahlavi regime, see Mahnaz Afkhami's publications *Women and the Law in Iran (1967–1978)*, compiled with an introduction by Afkhami (Bethesda, Maryland: Women's Center of the Foundation for Iranian Studies, 1994); and 'Sunlight, open windows, and fresh air: The struggle for women's rights in Iran,' in Melissa Chiu and Melissa Ho, eds, *Shirin Neshat: Facing History* (Washington, DC: Hirshhorn Museum and Sculpture Garden, Smithsonian Books, 2015), pp. 39-51.

29 For further reading, see Haleh Afshar, *Islam and Feminisms* (London: McMillan, 1999); David A. Bailey and Gilane Tawadros, eds., *Veil: Veiling, Representation, and Contemporary Art* (London: inIVA, 2003); Azadeh Moaveni, *Lipstick Jihad: A Memoir of Growing Up Iranian in America and American in Iran* (New York: Public Affairs, 2006); Afsaneh Najmabadi, *Women with Mustaches and Men Without Beards: Gender and Sexual Anxieties of Iranian Modernity* (Berkeley, Los Angeles, London: California UP, 2005); and Marjane Satrapi. *Persepolis: The Story of a Childhood* (New York: Pantheon, 2003).

30 See *Sonia Balassanian. Hostages: A Diary*, with text by Robert Hobbs (New York: Elise Meyer Gallery, 1980). For reviews, see Kay Larson, 'Reports from the front,' *The Village Voice*, 2–8 July 1980, p. 60, and Mina Roustayi, 'Sonia Balassanian,' *Arts Magazine* 55, no.1 (September 1980): 5. *The Other Side*, the first version of Balassanian's installation with veiled mannequins, was exhibited at the Sculpture Center in New York and, in a different version, in 1993 at the Southeastern Center for Contemporary

Art in Winston-Salem, North Carolina.

31 See Deborah Wye, *Committed to Print: Social and Political Themes in Recent American Printed Art* (New York: The Museum of Modern Art, 1988).

32 Martha Wilson, 'Staging the Self (Transformations, Invasions, and Pushing Boundaries),' in Gunhild Boggreen and Rune Gade, eds, *Performing Archives/Archives of Performance* (Copenhagen: University of Copenhagen, 2013), p. 340.

33 See the brochure by Fereshteh Daftari, *Projects 40: Readymade Identities* (New York: The Museum of Modern Art, 1993).

34 In footnotes (2006), one interview (2009), and various lectures, I have acknowledged this fact. In 2014, it was noted in Grigor, *Contemporary Iranian Art*, pp. 213-215.

35 See Chiu and Ho, eds, *Shirin Neshat: Facing History*, pp. 14-15.

36 For the entire series see *Shirin Neshat: Women of Allah*, with texts by Francesco Bonami, Hamid Dabashi, and Octavio Zaya (Turin: Marco Noire Editore, 1997).

37 See the brochure by Fereshteh Daftari, *Projects 70: Shirin Neshat, Simon Patterson, Xu Bing* (New York: The Museum of Modern Art, 1999).

38 See a review of her 2015 retrospective at the Hirshhorn Museum, Philip Kennicott, 'It's written all over their faces,' *Washington Post*, May 15, 2015.

39 Azadeh Moaveni, *Lipstick Jihad*.

40 Xerxes Cook, 'Blonde faith,' *Tank* 6, no. 2 (2010): 74.

41 Fayyazi, email to the author, 19 February 2010.

42 See Brodsky and Olin, eds., *The Fertile Crescent*, pp.100-105.

43 Communication to the author, 13 January 2010.

44 For images see Catherine Millet, ed., 'L'Iran dévoilé par ses artistes,' *Art Press*, no. 17 (May–July 2010).

45 On Khosrow Hassanzadeh, see Mirjam Shatanawi, ed., *Tehran Studio Works: The Art of Khosrow Hassanzadeh* (London: Saqi, 2007). On *Terrorist: Khosrow*, a different work from the *Terrorist* series, see Daftari, *Rebel, Jester, Mystic, Poet: Contemporary Persians* (London: Black Dog Publishing and Toronto: Aga Khan Museum, 2017), pp. 24-26.

46 Communication to the author, 7 September 2016.

47 On Pouyan see, Murtaza Vali, 'From phallus to part-object,' in *Shahpour Pouyan: PTSD* (Dubai: Lawrie Shabibi, 2014).

48 Amei Wallach, 'Awaiting Armageddon,' *Art in America*, vol. 104, no. 10 (November 2016), p. 112.

49 In an email dated 1 January 2016, Pouyan explains that this master is a descendant of the professional metalsmith who worked for the Qajar King Fath Ali Shah. He produced armour for the 1971 celebrations at Persepolis marking the 2500th anniversary of the Persian empire. For a discussion of a *Projectile*, see Daftari, *Rebel, Jester, Mystic, Poet*, p. 28.

50 Pouyan, e-mail to the author, January 1, 2016.

51 Their first joint U.S. museum exhibition took place at the ICA Boston (December 16, 2015–March 27, 2016).

52 See discussions of Shirin Aliabadi, Monir Farmanfarmaian, Shadi Ghadirian, Rokni Haerizadeh, and Khosrow Hassanzadeh in Daftari, *Rebel, Jester, Mystic, Poet*, pp. 15-37.

53 Information to the author, email of 18 April 2018.

54 See Ameneh Youssefzadeh, 'Veiled Voices: Music and censorship in Post-Revolutionary Iran,' in Patricia Hall, ed., *The Oxford Handbook of Music Censorship* (Oxford: Oxford University Press, 2018), pp. 657-674.

55 See Maureen Spillane Murov, 'An aesthetics of dissidence: Reinaldo Arenas and the politics of rewriting,' *Journal of Caribbean Literature* 4, no. 1 (Fall 2005), pp. 133-48. Abbas Milani, in a course at Stanford University called Aesthetics of Dissent: The Case of Islamic Iran, discusses post-revolutionary film, fiction and music.

56 The designation 'miniature painting' is in disrepute. As explained by Souren Melikian the expression implies 'they are independent works of art standing on their own.' See Assadullah Souren Melikian, 'Prince Sadruddin Aga Khan: A collector in an age of connoisseurship,' in Henry S. Kim et al., *Pattern and Light: Aga Khan Museum*, (New

York: Skira Rizzoli and Toronto: Aga Khan Museum, 2014). 'Persian painting' is suggested as a substitute. The new designation, however, is flawed when applied to artists such as Shahzia Sikander who looks back not only to Persian painting but also to Indian painting (Islamic Mughal and Buddhist Basohli). Where used, I retain the quotation marks.

57 See 'Shahzia Sikander in conversation with Fereshteh Daftari,' in Nigel Prince, ed., *Shahzia Sikander: Intimate Ambivalence* (Birmingham: Ikon Gallery, 2008). For images of her works see also Daftari, *Without Boundary*, plates 9–11.

58 See Daftari, 'Islamic or not,' in *Without Boundary*, pp. 14-15.

59 For his floor painting, Qureshi won the Primary Prize at the 10th Sharjah Biennial in 2011.

60 See Daftari, 'Shiva Ahmadi: Altered miniatures,' *Canvas* 7, no. 2 (March–April 2011), pp. 177-85. My discussion of Ahmadi here is largely based on that essay.

61 Sheila R. Canby, *Persian Painting* (London: The British Museum Press, 1993, 2008), p. 7.

62 Ansarinia, email to the author, 11 February 2011. The section on Ansarinia is based on Daftari, 'Passport to elsewhere,' pp. 16–19.

63 Ansarinia presents a critique of the opulent Roman- and Renaissance-inspired architecture that is mushrooming in the affluent parts of Tehran in a series of works entitled *Pillars*. See *Nazgol Ansarinia*, with text by Media Farzin (Dubai: Green Art Gallery, 2015), and Daftari, *Rebel, Jester, Mystic, Poet*, p. 27.

64 Amighi, email to the author, 10 January 2016.

65 Email to the author, 15 June 2017.

66 No high-resolution image exists of *Poppy Garden*, which prompted me to nominate Amighi for the Jameel Prize. Instead I will discuss a different shadow screen, one that takes its inspiration from a variety of Islamic aesthetic traditions.

67 Amighi, email to the author, 14 August 2017.

68 See Daftari, *Rebel, Jester, Mystic, Poet*, pp. 28-29 and Dina Nasser-Khadivi, ed., *Farhad Moshiri* (Milan: Skira, 2016).

69 A black and white image may be viewed in the exhibition catalogue of *Iran Modern*. See Hamid Severi, 'A remarkable oversight: Iranian art photography of the 1960s and 1970s,' in Daftari and Diba, eds., *Iran Modern*, p. 101, fig. 59.

70 Both the Los Angeles County Museum and the Metropolitan Museum in New York, have acquired works from the *Rostam* series. LACMA has acquired the entire series, the Metropolitan one work. See the museums' websites for further information and images.

71 Quoted in Abbas Amanat, *The Pivot of the Universe: Nasir al-Din Shah and the Iranian Monarchy, 1831–1896* (Berkeley and Los Angeles: University of California Press, 1997), p. 299. See also the description of *The Shah and the British Ambassador* in *Siamak Filizadeh: Under Ground* (Tehran: Aaran Gallery, 2014), pp. 11-12.

72 See Linda Komaroff and Behzad Khosrawi Noori, *Underground: Siamak Filizadeh* (Tehran: Nazar Art Publication, 2016).

73 Simon Baker and Emmanuelle de l'Ecotais, with Shoair Mavlian, eds. *Shape of Light: 100 Years of Photography and Abstract Art.* (London: Tate Publishing, 2018), p. 14.

74 For a brief discussion of Shahbazi's earlier work, and for images, see Daftari, *Without Boundary*, pp. 18-19, plates 19–20 . For her abstractions, see Tirdad Zolghadr, 'Shirana Shahbazi,' https://www.parkettart.com/downloadable/download/sample/sample_id/486.

75 See Lyle Rexer, *Edge of Vision: The Rise of Abstraction in Photography* (New York: Aperture, 2009), p. 198.

76 See the entry on Mahmoud Bakhshi Moakhar in *Raad O Bargh: 17 Artists from Iran*, text by Vali Mahlouji (Paris: Galerie Thaddaeus Ropac, 2009), pp. 24-27; Grigor, *Contemporary Iranian Art*, p. 190-191; and Daftari, *Rebel, Jester, Mystic, Poet*, p. 30. Also see discussion of Arash Hanaei's works in this chapter.

77 Payam Sharifi (Slavs and Tatars) described it thus in an email to the author, 16 June 2017.

78 Communication to the author, email, 15 June 2017.

79 Communication to the author, email,

6 July 2017

80 This description of the work is based on Daftari, 'Passport to elsewhere,' pp. 13-14.

81 Farhad Moshiri, interview with Antonia Carver, 'Every society has its taboos,' *The Art Newspaper*, no. 191 (May 2008), p. 49.

82 Ibid.

83 Italo Calvino, *Invisible Cities* (1972), trans. William Weaver (New York: Harcourt Brace Jovanovich, 1974), p. 14. In this section I draw from the text I wrote (*City of Tales Updated*) for Bakhshi's exhibition brochure for, *The Engaged Artist: Influences of Graphics on Sculpture in Middle Ages* (London: Saatchi Gallery, 2010).

84 Golshiri gives this quotation in 'Barbad Golshiri on Malevich,' *Tate Etc.* (blog), August 15, 2004, http://www.tate.org.uk/context-comment/articles/barbad-golshiri-on-malevich.

85 Reza Daneshavar, *A Garden Between Two Streets: 4001 Days in the Life of Kamran Diba in Conversation with Reza Daneshvar* (Paris: Elborz Editions, 2010), p. 153.

86 I would like to thank Golshiri for the information.

87 Golshiri, communication to the author, January 2016.

88 At the 2011 Moscow Biennial, Golshiri presented the performance *Cura; The Rise and Fall of Aplasticism*, in which he exposed a wound on his body inscribed with a sentence in Braille.

89 Golshiri, email to the author, 18 January 2016.

90 Alexander Gray Associates, press release for an exhibition of a number of these tombs, New York, 4 September–18 October 2014.

91 See Armajani's interview with Janet Kardon, 'Siah Armajani: American Observer and Visionary,' in Ziba Ardalan, ed., *Siah Armajani: An Ingenious World* (London: Parasol Unit, 2013), pp. 73-74.

92 Siah Armajani quoted in *Siah Armajani: The Tomb Series* (New York: Alexander Gray Associates, 2014), p. 2.

93 Armajani studied at Macalester College in Saint Paul. Barry Le Va taught at the Minneapolis College of Art and Design.

94 I included his early conceptual work in

the *Iran Modern* exhibition and explained in the text that '*A Number Between Zero and One*, featured in "Information" – one of the most seminal exhibitions on conceptual art held in 1970 at The Museum of Modern Art, New York – recasts the status of art neither as a handmade object nor as a commodity for retinal delectation.' See Daftari, 'Redefining modernism,' p. 39.

95 For images see, *Siah Armajani: An Ingenious World*, pp. 62, 114-125.

96 One example was featured in *Iran Modern*. For illustration, see plate 9.

97 Email to the author, 28 August 2017.

98 On Feyzdjou, see Julia Pelta Feldman, 'Chohreh Feyzdjou,' in *Global/Local: Six Artists from Iran, 1960*, pp. 56-65.

99 Pennina Barnett, 'Reading Black: The Products of Chohreh Feyzdjou,' *Women's Art Magazine*, no. 66 (September–October 1995), p. 24.

100 See Laleh Bakhtiar, *Sufi: Expressions of the Mystic Quest* (London: Thames and Hudson, 1976). For a more recent publication, see the catalogue for an exhibition held at the Museum of Fine Arts in Houston, Ladan Akbarnia with Francesca Leoni, *Light of the Sufis: The Mystical Arts of Islam* (New Haven and London: Yale University Press, 2010).

101 Robert Storr confessed his own 'deep-seated secularism' in writing his brilliant essay on Y.Z. Kami's spirituality. See Robert Storr, 'Every time I feel the spirit …,' in *Y.Z. Kami: Paintings* (New York: Gagosian Gallery, 2014), p. 26.

102 For an essay on the subject of breath and Shirazeh Houshiary's sculpture of the same title, see Daftari, 'And the whole earth was of one language, and of one speech – Genesis 11,' in *Skulptur Biennale, Münsterland 2003*, ed. Saskia Bos (Freiburg im Breisgau: Kreis Warendorf, 2003), pp. 139-43. My discussion of Houshiary borrows from that earlier essay. See also Daftari, 'Beyond Islamic roots – Beyond modernism,' in *RES*, no. 43 (Spring 2002), pp. 175-86; and Daftari, 'Islamic or not,' in *Without Boundary*, pp. 10-27.

103 Oliver Leaman, *Islamic Aesthetics: An Introduction* (Notre Dame, Indiana: University of Notre Dame, 2004), p. 8.

104 In addition to Jean-Hubert Martin et al., eds, *Magiciens de la terre*, (Paris: Editions du Centre Pompidou, 1989), see *Magiciens de la terre: Retour sur une exposition légendaire* (Paris: Éditions Xavier Barral/Centre Pompidou, 2014), p. 158-159. Additionally, see Daftari, 'Passport to elsewhere,' in Daftari and Jill Baird, eds, *Safar/Voyage: Contemporary Works by Arab, Iranian, and Turkish Artists* (Vancouver: Museum of Anthropology, University of British Columbia, 2013), pp. 9-10 and footnotes 4-8.

105 Daftari, 'Shirazeh Houshiary/Pip Horne,' in *Skulptur Biennale Münsterland 2003* (Düsseldorf: Grafische Gestaltung, 2003), p. 142. Much of the discussion of Houshiary's work is drawn from this source.

106 See Annemarie Schimmel, *Mystical Dimensions of Islam* (Chapel Hill: The University of North Carolina Press, 1975).

107 Francisco de Zurbarán's painting *The Veil of Veronica* (1631–6) and Antonello da Messina's *Our Lady of the Annunciation* (*c*.1475–6) have haunted her abstractions. See Mel Gooding, 'A Suite for Shirazeh Houshiary,' in *Shirazeh Houshiary* (London: Lisson Gallery, 2008). For images see pp. 14 (Zurbarán), 19 (Antonella da Messina), and 32-33 (Houshiary paintings).

108 See Daftari, 'Beyond Islamic roots – Beyond modernism,' *RES*, no. 43 (Spring 2003): p. 183.

109 Personal communication, 2 November 2017.

110 Homi Bhabha, 'Another country,' in Daftari, *Without Boundary*, p. 31.

111 See above, Chapter One

112 See Ziba de Weck Ardalan, 'Interview with Y.Z. Kami,' in *Y.Z. Kami's Endless Prayers* (London: Parasol Unit, Koenig Books, 2008), p. 39.

113 Storr, 'Every time I feel the spirit …,' p. 21.

114 See Faye Hirsch, 'The watchful portraits by Y.Z. Kami,' in *Portraits of Y.Z. Kami* (Ithaca, NY: Herbert F. Johnson Museum of Art, Cornell University, 2003).

115 See Daftari, 'Islamic or not,' in *Without Boundary*, pp. 23–24.

116 See above, Chapter One.

117 Storr, 'Every time I feel the spirit …,' p. 7

118 Glenn Lowry, director of the Museum of Modern Art, with a doctoral degree in Islamic art and keen interest in contemporary art, subscribes to a different viewpoint. In a lecture given by him on 13 October 2006, and subsequently published as a booklet, an untitled painting by Kami I had exhibited a few months earlier in *Without Boundary* (see page 207) is discussed in the following terms: '[It] deals not with Islamic art per se but with the idea of Islamic mysticism, and, in particular, with the Sufi tradition of spiritual development.' See Glenn Lowry, *Oil and Sugar: Contemporary Art and Islamic Culture*, (Toronto: Royal Ontario Museum, 2009), p. 38. Respectfully, I disagree with Lowry's reading. The monumental female sitter, unveiled, eyes half closed, centered upon her axis, bears no resemblance not just to Islamic art but to Sufi meditative practices either. The anonymous female subject, photographed by the artist, is a practitioner of a Hindu or the Shamatha technique of meditation, as was recognized by the artist Bill Viola, who visited the exhibition.

119 *Konya* (2007), a multi-panelled work named after the place where Rumi settled and died, and where his mausoleum has become a shrine visited by devotees, clearly illustrates Kami's homage to the mystic and to Mahin Tajadod, the teacher who initiated him in the ways of the Sufi master. On *Konya*, see Ziba de Weck Ardalan, 'Interview with Y.Z. Kami,' p. 40, and Daftari, 'Passport to elsewhere,' pp. 21–22.

120 On *In Jerusalem*, Kami's only body of work about representatives of organized religion, see Storr, 'Every time I feel the spirit …,' pp. 8-9, 12.

121 See Nathan Schwartz-Salant, ed., *C.G. Jung on Alchemy* (London: Routledge, 1995).

122 Henry Corbin, *The Man of Light in Iranian Sufism*, 1971, trans. Nancy Pearson (New Lebanon, New York: Omega Publications, 1994), p. 5.

123 Kimberly Vrudny, 'Aesthetics of silence,' *Arts: The Arts in Religious and Theological Studies*, vol. 28, no.2 (Spring 2017), pp. 4-5.

124 A commendable project such as the exhibition *Postwar: Art Between the Pacific and the Atlantic, 1945–1965* is regrettably

marred with inaccuracies due to a lack of expertise in Iranian modern art amongst its organizers and contributors to the catalogue and the guide. Artists such as Monir Farmanfarmaian, Marcos Grigorian, Behjat Sadr and Mohsen Vaziri, who would have strengthened the discussion of global post-war abstraction are simply left out. Grigorian is misrepresented in that he is considered to be an artist from a generation 'interested in reconciling the ancient Persian culture with the formal language of modernism, deploying the motifs and techniques of folk art and craft traditions in new ways.' See R[achel] W[etzler] 'Marcos Grigorian,' in *Exhibition Guide. Postwar Art Between the Pacific and the Atlantic, 1945–1965* (Munich: Haus der Kunst, 2016), p. 62. The description does not apply to Grigorian who was one generation older than the Saqqakhaneh artists (Charles-Hossein Zenderoudi and Parviz Tanavoli) and not interested in what he is purported to have been. The description applies to Zenderoudi, not discussed along those lines, and to Tanavoli who was not represented in the exhibition. Another mistake by the same author (D[aniel] L[entini]) concerns the description of monarchy and Sufism as 'two of the dominant forms of authority in Iran.' The author might have meant Shiʿism and not Sufism. See ibid., p. 234. Aside from this *Exhibition Guide*, see also the main catalogue with the same title, edited by Okwui Enwezor, Katy Siegel, and Ulrich Wilmes, the curators of the exhibition. They contextualize the Zenderoudi drawing as an example of 'cosmopolitan modernism' while nowhere in the numerous texts of the catalogue is the Saqqakhaneh movement, which rehabilitated and privileged the local and which the artist helped create, ever analyzed or even mentioned.

Chapter 6

1 Tirdad Zolghadr's target, made evident in an exhibition that traveled from Geneva to Tehran, included curatorial projects. See *Bazar-yabi-e qomi* (*Ethnic Marketing*). Geneva: Centre d'Art Contemporain, 2004/2006.

2 Contemporary 'Islamic' art has been taught at Princeton University and at the University of Minnesota (Shirin Neshat and Mona Hatoum were included), and scholarly events continue under that same designation. The phrase, however, is being increasingly disputed. See 'Global Trends in Contemporary Islamic Art' at the University of Lisbon in 2014, 'What Is Contemporary Islamic Art?' at the CAA conference in 2015 (although there the phrase was not problematized), and 'Process in Modern and Contemporary Islamic Art,' a conference held in 2018 at the University of Michigan.

3 For a synopsis of the problems see Natalie Bell and Massimiliano Gioni in collaboration with *Bidoun* magazine, eds., *Here and Elsewhere* (New York: New Museum, 2014).

4 *An International Survey of Recent Painting and Sculpture* (17 May–19 August 1984), the last attempt to mount an international exhibition at MoMA, comprised 166 artists, all of Western origin with the exception of the two expatriate artists, Siah Armajani living in the United States and Anish Kapoor in England.

5 Jean-Hubert Martin, ed. *Magiciens de la terre* (Paris: Editions Centre Pompidou, 1989). For a postscriptum to this exhibition, see Jean-Hubert Martin, 'Postface,' *Magiciens de la terre: Retour sur une exposition légendaire* (Paris: Editions Xavier Barral and Editions Centre Pompidou, 2014), pp. 376-379; see also Jean-Hubert Martin, interview with Benjamin H. D. Buchloh, 'Interview,' *Third Text*, no. 6 (Spring 1989), pp. 19-27, and Rashid Araeen, 'Our Bauhaus, others' mudhouse,' *Third Text*, no. 6 (Spring 1989), pp. 3-16.

6 For a list of group and solo exhibitions Armajani participated in, Ziba Ardalan, ed. *Siah Armajani: An Ingenious World* (London: Parasol Unit, 2013), pp. 187-189.

7 The Vaziri painting and Armajani's *A Number Between Zero and One* were exhibited in *Iran Modern*, held at Asia Society Museum, New York, in 2013. See the catalogue, plates 10 and 88.

8 Her exhibition *Black, Black Days* took place at Franklin Furnace in November–December 1982.

9 The other participating artists were John Armleder, Sue Etkin, Ann Hamilton, Maurizio Pellegrin and Fred Wilson. See above, Chapter Five.

10 In addition, works by Hossein Zenderoudi and Faramarz Pilaram, acquired from the Venice Biennale in 1962, were exhibited at MoMA, 27 May–2 November 1964, as part of a *Recent Acquisitions* exhibition. They were not shown again until 2017, when they were displayed as part of the protest against Donald Trump's executive order banning artists from Muslim majority countries.

11 See *Projects 40: Readymade Identities* (New York: The Museum of Modern Art, 1993), n.p.

12 The three other exhibitions are *Projects 70: Shirin Neshat, Simon Patterson, Xu Bing* (2000), *Projects 70: Jim Hodges, Beatriz Milhazes, Faith Ringgold* (2000), and *Projects 70: Janine Antoni, Shahzia Sikander, Kara Walker* (2001). The *Projects* exhibitions discussed in this chapter do not include the American and European artists I have shown at MoMA.

13 The artists in *Architecture as Metaphor* were James Casebere, David Deutsch, Y.Z. Kami, Toba Khedoori, Bodys Isek Kingelez and Langlands & Bell. See Daftari, *Architecture as Metaphor* (exhibition brochure) (New York: The Museum of Modern Art, 1997). In 2018 Kingelez was given a substantial exhibition at MoMA.

14 *Turbulent* was offered to MoMA before it was shown by Eugenie Tsai at the Whitney Museum of American Art at Philip Morris in 1998 but with museum exhibitions being scheduled at least a year ahead of time there was no immediate opportunity to show this video.

15 Notes from the paper presented to the curatorial forum on April 18, 2001. A copy was submitted to the Museum's archives. I need to underline that my job at MoMA centered on Western art, a subject I am excluding from this book. It should also be noted that outside curatorial affairs, Jay Levenson,

Director of the International Program, should be amply credited for his many initiatives forging connections between MoMA and the world. A recent example is the publication of *Modern Art in the Arab World: Primary Documents*, published in 2018.

16 *New Chinese Art: Inside Out* opened in New York at the Asia Society and P.S.1 Contemporary Art Center in 1998, and *The Short Century*'s last stop was P.S.1 Contemporary Art Center, in 2002.

17 Rose Issa, Ruyin Pakbaz and Daryush Shayegan, *Iranian Contemporary Art* (London: Booth-Clibborn Editions, 2001).

18 Lynn Gumpert, director of New York University's Grey Art Gallery, invited me to co-curate with her an exhibition drawn from the collection of Mrs. Abby Weed Grey, a bequest to the institution. See Shiva Balaghi and Lynn Gumpert, eds, *Picturing Iran: Art, Society, and Revolution* (London: I.B.Tauris, 2002). For the record, contrary to the misleading impression that the exhibition's publication of the same name leaves the reader with, Lynn Gumpert and I were the only two co-curators of the exhibition. The names of the editors, the acknowledgments' signatories and the sequence of the essays would have the reader believe otherwise.

19 See Okwui Enwezor, Katy Siegel and Ulrich Wilmes, eds., *Postwar: Art Between the Pacific and the Atlantic, 1945–1965* (Munich, London, New York: Prestel, 2016). For comments on this exhibition see above, Chapter 5, note 125.

20 Yarshater, Ehsan, ed. *Modern Persian Painting* (New York: Columbia University, 1968).

21 Published in Balaghi and Gumpert, eds, *Picturing Iran*, p. 81-82.

22 Daftari, 'Redefining modernism: Pluralist art before the 1979 Revolution,' in Daftari and Layla Diba, eds., *Iran Modern*, (New York, New Haven, Connecticut, and London: Asia Society Museum in association with Yale University Press, 2013), pp. 25-43.

23 Ibid., p. 41.

24 Ibid.

25 *Artevida* was organized by Adriano Pedrosa and Rodrigo Moura. As of this writing, its catalogue has not been published. My discussion of the sculpture featured on the wall label for the work and in the lecture I gave at the opening, a recording of which may be found on Asia Society's website.

26 For images of works by Siah Armajani, Marcos Grigorian and Charles Hossein Zenderoudi, see Okwui Enwezor et al, *Postwar: Art Between the Pacific and the Atlantic, 1945-1965*.

27 David A. Bailey and Suzanne Cotter, eds., *Veil: Veiling, Representations and Contemporary Art* (London: Institute of International Visual Arts in association with Modern Art Oxford, 2003).

28 Venetia Porter, *Word into Art: Artists of the Modern Middle East* (London: British Museum, 2006).

29 Porter, 'Introduction,' ibid., p. 14.

30 See Holland Cotter, 'What does Islam look like?', *The New York Times* (Sunday 26 February 2006), Section 2, pp. 1, 36; Daftari, ed., *Without Boundary: Seventeen Ways of Looking* (New York: Museum of Modern Art, 2006). The show brought together a generation of contemporary artists younger than Farmanfarmaian and included the following women: Ghada Amer, Jananne Al-Ani, Mona Hatoum, Shirazeh Houshiary, Emily Jacir, Shirin Neshat, Marjane Satrapi, Shirana Shahbazi and Shahzia Sikander. The men included Kutlug Ataman, Y.Z. Kami, Rachid Koraïchi, Raqib Shaw, Walid Raad and the two Americans, Mike Kelley and Bill Viola. In 2004, as *Without Boundary* was being scheduled at MoMA, the Krannert Art Museum at the University of Illinois at Urbana-Champaign mounted the exhibition *Beyond East and West*, which included six of the artists in *Without Boundary*, plus one other.

31 Daftari, 'Introducing art from the Middle East and its diaspora into Western institutions: Benefits and dilemmas,' in Hamid Keshmirshekan, ed., *Art from the Middle East: Regional Interactions with Global Art Discourses* (London: I.B.Tauris, 2015), pp. 187-202.

32 See Daftari, 'Islamic or not,' in *Without Boundary*, p. 26 note 2.

33 See Chris Dercon and Avinoam Shalem, eds, *The Future of Tradition – The Tradition of Future* (Munich: Haus der Kunts/Prestel Verlag, 2010), and the critique of this exhibition in Daftari, 'Introducing art from the Middle East,' pp. 189-191.

34 *Islamic Art Now: Contemporary Art of the Middle East*, an exhibition held at the Los Angeles County Museum in 2015–16.

35 Quoted in Daftari, 'Islamic or not,' p. 10 and footnote 4.

36 For Glenn D. Lowry's take on *Without Boundary*, see 'Gained in translation,' *Art News*, March 2006, pp. 121-125.

37 Avinoam Shalem and Eva-Maria Troelenber, 'Changing views: The 1910 Exhibition as a pictorial turn,' in Dercon et al., *The Future of Tradition*, p. 15. See also Daftari, 'Introducing art from the Middle East,' pp. 189-192.

38 Souren Melikian-Chirvani, 'When cultural identity is denied,' *The New York Times* (9 March 2012); Sheila S. Blair and Jonathan M. Bloom, 'The mirage of Islamic art: Reflections on the study of an unwieldy field,' *Art Bulletin*, 85, no. 1 (March 2003), p. 175; Daftari, 'Introducing art from the Middle East,' pp. 190 and 191; Daftari, *Rebel, Jester, Mystic, Poet: Contemporary Persians. Works from the Mohammed Afkhami Collection* (London: Black Dog, 2017), p. 35 n. 5. Also see, Silvia Naef, "Questioning a successful label: How 'Islamic' is contemporary Islamic art?" in R. Oliveira Lopes and G. Lamoni, eds., *Global Trends in Modern and Contemporary Islamic Art* (Lisbon: Centro de Investigação e Estudios em Belas Artes, 2015), pp 95-107.

39 See an author such as Fariba Adelkhah, *Being Modern in Iran* (New York: Columbia University Press, 2000).

40 Tyler Green, 'MoMA keeps the walls clean: Islamic show sans politics,' *New York Observer*, 3 April 2006. For a more detailed explanation of my rebuttal, see Daftari, 'Introducing art from the Middle East,' pp. 195-197.

41 See for instance Andrea K. Scott, 'Out of Place: Artists from the Middle East, North Africa, and their diasporas, at the New Museum,' *The New Yorker*, 25 August 2014. In this article, as in others, it is mentioned that participants were unhappy with the show. Let it be clear that only Neshat fits this description.

Emily Jacir's contention (her name has appeared in this context in some articles) related to an article published outside the parameter of the exhibition and not to the exhibition or to this author. Jacir wrote to me after the opening to say, 'It is indeed a real honor to have been included in your exhibition. You should all be proud of yourselves. The show looks fantastic.' Email dated 1 March 2006.

42 It must be also recognized that an institution such as MoMA is an easy target for critics, because its curators, who are far better informed about the institution's flaws than outside observers, must follow the MoMA protocol of not acting in a confrontational manner. I have seen a number of Middle Eastern or Iranian art exhibitions in a variety of institutions where the selection and the presentation left a lot to be desired, and yet they were embraced by critics.

43 See Derek Gregory, 'Middle of what, East of where?' in Daftari and Jill Baird, eds., *Safar/Voyage: Contemporary Works by Arab, Iranian, and Turkish Artists* (Vancouver: D&M Publishers and Museum of Anthropology at the University of British Columbia, 2013), pp. 39-51.

44 Ibid. I was co-editor of the book but sole curator of the exhibition.

45 Seventeen artists were selected, but at the very last moment, citing health issues, Kader Attia pulled out. He would have had to travel far to Vancouver to execute his wall painting.

46 This section on *Safar/Voyage* derives from my essay 'Introducing art from the Middle East,' p. 199. See also Daftari, 'Passport to elsewhere,' in *Safar/Voyage*, pp. 8-31.

47 Natalie Bell and Massimiliano Gioni in collaboration with *Bidoun* magazine, eds., *Here and Elsewhere* (New York: New Museum, 2014). For a review of other exhibitions of Middle Eastern art, see Media Farzin, 'Exhibit A: On the history of Contemporary Arab art shows' in the same publication, pp. 89-97.

48 Bell and Gioni, 'Here and elsewhere,' pp. 17-32.

49 Rose Issa, Ruyin Pakbaz and Daryush Shayegan, *Iranian Contemporary Art* (London: Barbican Art, Booth-Clibborn Editions, 2001).

50 Lynn Gumpert, ed., *Global/Local: Six Artists from Iran, 1960–2015* (New York: New York University, 2016).

51 Shaheen Merali and Martin Hager, eds., *Entfernte Nähe: Neue Positionen iranischer Künstler/Far Near Distance: Contemporary Positions of Iranian Artists* (Berlin: Haus der Kulturen der Welt, 2004).

52 Till Fellrath and Sam Bardaouil, *Iran: Inside Out: Influences of Homeland and Diaspora on the Artistic Language of Contemporary Iranian Artists* (New York: Chelsea Art Museum, 2009). In their following projects (exhibitions and texts) they have amply remedied the flaws of this beginners' misstep.

53 *Contemporary Iranian Art in the Permanent Collection*, The Metropolitan Museum of Art, New York, 2012, and *Islamic Art Now: Contemporary Art of the Middle East*, Los Angeles County Museum, 2015–16. No exhibition catalogues were published for these two shows.

54 To watch the videos of these performances, see amirbaradaran.com.

55 Artist's description of the performance for his Facebook page, communicated to the author by email, 13 June 2012.

56 Communication to the author, Paris, June 2012.

57 Lili Golestan, *Tigh o tar o pud: Goftegu-ye Lili Golestan va Neda Razavipour* (Tehran: Saless, 2016).

58 Email to the author, 18 December 2016. It should be noted that *Action Now* took place within the framework of an Iranian arts festival organized by Margery Arent Safir. The other components of the festival included a video program curated by Amirali Ghassemi and Sandra Skurvida, a section on photography curated by Barbad Golshiri, and contemporary art organized by Leila Heller.

59 See Daftari, *Rebel, Jester, Mystic, Poet*. In the summer of 2017 the exhibition travelled to the Museum of Fine Arts, Houston.

60 Communication to the author by email, 24 January 2017.

61 Communication to the author by email, 21 January 2017.

62 Communication to the author by email, 21 January 2017.

63 Artists Symposium at the Aga Khan Museum, Toronto, 27 May 2017.

64 See *Monir Shahroudy Farmanfarmaian. Infinite Possibility: Mirror Works and Drawings, 1974–2014* (Porto: Serralves, 2014). The exhibition traveled to the Guggenheim Museum in New York in 2015. See also Lisa Fischman and Shiva Balaghi, eds., *Parviz Tanavoli* (Wellesley, Massachusetts: Davis Museum at Wellesley College, 2015), and Melissa Chiu and Melissa Ho, eds., *Shirin Neshat: Facing History* (Washington, DC: Hirshhorn Museum and Sculpture Garden, 2015). *Y.Z. Kami: Endless Prayers* was held at LACMA (19 November 2016–19 March 2017). *Farhad Moshiri: Go West*, first solo show of the artist, opened at the Andy Warhol Museum in October 2017 and *Siah Armajani: Follow This Line*, after its run at the Walker Art Center (8 September–13 December 2018) will travel to the Met Breuer in New York.

Select Bibliography

Abrahamian, Ervand. *A History of Modern Iran* (Cambridge: Cambridge University Press, 2008).

Afkhami, Mohammed, ed. *Honar: The Afkhami Collection of Modern and Contemporary Art*. Texts by Sussan Babaie and Venetia Porter (London: Phaidon, 2017).

Aghaee, Ehsan. *A Retrospective Exhibition of Works of Saqqakhana Movement* (Tehran: Tehran Museum of Contemporary Art, 20 August–12 November 2013).

Ahmad Aali: Selection of Works, 1961–2009 (Tehran: Nazar, 2010).

Akbarnia, Ladan, with Francesca Leoni. *Light of the Sufis: The Mystical Arts of Islam* (New Haven and London: Yale University Press, 2010).

Akhlaghi, Azadeh. *By an Eye Witness*, Introduction by Hamid Dabashi (Tehran: Mohsen Gallery, 2013).

Aletti, Vince. 'Newsha Tavakolian.' *The New Yorker*, 13 May 2013, p. 12.

Ali, Wijdan, ed. *Contemporary Art from the Islamic World* (London: Scorpion Publishing Ltd., 1989).

———. *Modern Islamic Art* (Gainesville, Florida: University Press of Florida, 1997).

Amanat, Abbas and Farzin Vejdani, eds. *Iran Facing Others: Identity Boundaries in a Historical Perspective* (New York: Palgrave Macmillan, 2012).

Amirsadeghi, Hossein. *Different Sames: New Perspectives in Contemporary Iranian Art* (London: Thames and Hudson with Transglobe Publishing, 2009).

Ardalan, Nader, and Laleh Bakhtiar. *The Sense of Unity: The Sufi Tradition in Persian Architecture* (Chicago: University of Chicago Press, 1973.)

Ardalan, Ziba, ed. *Siah Armajani: An Ingenious World* (London: Parasol Unit, 2013).

Art moderne iranien, Preface by Rou'in Pakbaz (Basel: International Art Fair 7, 1976).

Ashraf, Ahmad, with Layla Diba. 'Kamal al-Molk, Mohammad Gaffari,' in *Encyclopedia Iranica*, vol. XV, Fascicle 4 (New York: Encyclopaedia Iranica Foundation [2010]).

Azimi, Negar, ed. *Rokni Haerizadeh: Fictionville* (London: Koenig Books, 2014).

Bailey, David A. and Gilane Tawadros, eds. *Veil: Veiling, Representation, and Contemporary Art* (London: inIVA, 2003).

Bakhtiar, Laleh. *Sufi: Expressions of the Mystic Quest* (London: Thames and Hudson, 1976).

———. 'Religious inspiration in the expressions of art forms,' in *Religious Inspiration in Iranian Art*. Preface by Layla Soudavar Diba, texts by Laleh Bakhtiar and Aydin Aghdashlou (Tehran: Negarestan Museum, 1978).

Balaghi, Shiva, and Lynn Gumpert, eds. *Picturing Iran: Art, Society, and Revolution* (London: I.B.Tauris, 2002).

Balassanian, Sonia. *Portraits of Sonia Balassanian* (New York: S. Balassanian, 1983).

Banuazizi, Ali. *Ardeshir Mohassess: Closed Circuit History* (Washington DC: Mage Publishers, 1989).

Barnett, Pennina. 'Reading Black: The products of Chohreh Feyzdjou.' *Women's Art Magazine*, no. 66 (September–October 1995), p. 24.

Barr, Alfred H. *Cubism and Abstract Art* (New York: The Museum of Modern Art, 1936).

Bell, Natalie, and Massimiliano Gioni in collaboration with *Bidoun* magazine, eds. *Here and Elsewhere* (New York: New Museum, 2014).

Bombardier, Alice. *Les pionniers de la Nouvelle peinture en Iran* (Bern: Peter Lang, 2017).

Bonami, Francesco, Hamid Dabashi and Octavio Zaya. *Shirin Neshat: Women of Allah* (Turin: Marco Noire Editore, 1997).

Boroujerdi, Mehrzad. *Iranian Intellectuals and the West: The Tormented Triumph of Nativism* (Syracuse, New York: Syracuse University Press, 1996).

Brill, Dorothée, Joachim Jäger and Gabriel Montua. 'The Tehran Modern: A short introduction to the book,' in *The Tehran Modern: A Reader about Art in Iran since 1960* (Berlin: Nationalgalerie, 2017).

Brodsky, Judith K., and Ferris Olin, eds. *The Fertile Crescent: Gender, Art, and Society* (New Brunswick, New Jersey: The Rutgers University Institute for Women and Art, and New York: DAP, 2012).

Bui, Phong. *Nicky Nodjoumi: Chasing the Butterfly and other Recent Paintings* (New York: Taymour Grahne Gallery, 2013).

Canby, Sheila R. *Persian Painting* (London: The British Museum Press, 1993–2008).

Carver, Antonia. 'Farhad Moshiri, interview with Antonia Carver: Every society has its taboos.' *The Art Newspaper*, no. 191 (May 2008), p. 49.

Celant, Germano, and Anna Costantini. *Roma–New York: 1948–1964* (New York: Murray and Isabella Rayburn Foundation, 1993).

Chelkowski, Peter, and Hamid Dabashi. *Staging A Revolution: The Art of Persuasion in the Islamic Republic of Iran* (London: Booth-Clibborn Editions, 2000).

Chiu, Melissa, and Melissa Ho, eds. *Shirin Neshat: Facing History* (Washington, DC: Hirshhorn Museum and Sculpture Garden, Smithsonian Books, 2015).

Collier, Lizzy Vartanian. 'Gallery girl meets Afruz Amighi.' https://gallerygirl.co/2017/12/28/gallery-girl-meets-afruz-amighi.

Cook, Xerxes. 'Blonde faith.' *Tank* 6, no. 2 (2010), p. 74.

Corbin, Henry. *The Man of Light in Iranian Sufism*, 1971, trans. Nancy Pearson (New Lebanon, New York: Omega Publications, 1994).

Cotter, Suzanne, ed. *Monir Shahroudy Farmanfarmaian: Infinite Possibility: Mirror Works and Drawings, 1974–2014* (Porto, Portugal: Serralves, 2014).

Dadi, Iftikhar. 'Rethinking calligraphic modernism,' in Kobena Mercer, ed., *Discrepant Abstraction* (London and Cambridge, Massachusetts: Institute of International Visual Arts and The MIT Press, 2006).

Daftari, Fereshteh. *The Influence of Persian Art on Gauguin, Matisse, and Kandinsky* (New York and London: Garland, 1991).

———. *Projects 40: Readymade Identities* (New York: The Museum of Modern Art, 1993).

———. *Projects 59: Architecture as Metaphor* (New York: The Museum of Modern Art, 1997).

———. *Projects 70: Shirin Neshat, Simon Patterson, Xu Bing* (New York: The Museum of Modern Art, 1999).

———. 'Another modernism: An Iranian perspective,' in Shiva Balaghi and Lynn Gumpert, eds., *Picturing Iran: Art, Society and Revolution* (London: I.B.Tauris, 2002).

———. 'Beyond Islamic roots – Beyond modernism.' *RES*, no. 43 (Spring 2003), pp. 175–186.

———. 'And the whole earth was of one language, and of one speech – Genesis 11,' in Saskia Bos, ed., *Skulptur Biennale, Münsterland 2003* (Freiburg im Breisgau: Kreis Warendorf, 2003), pp. 139–143.

———. 'caraballo-farman,' in *Greater New York*

2005 (New York: P.S.1 Contemporary Art Center in collaboration with the Museum of Modern Art, 2005), pp. 108-109.

———. *Without Boundary: Seventeen Ways of Looking.* With texts by Daftari, Homi Bhabha and Orhan Pamuk (New York: Museum of Modern Art, 2006).

———. 'Shahzia Sikander in conversation with Fereshteh Daftari,' in Nigel Prince, ed., *Shahzia Sikander: Intimate Ambivalence* (Birmingham, UK: Ikon Gallery, 2008).

——— . *City of Tales Updated [Mahmoud Bakhshi]* (London: Saatchi Gallery, 2009).

———. 'Voices of evil: A common world order,' in *Ali Banisadr* (Paris: Galerie Thaddaeus Ropac, 2010).

———. 'Marcos Grigorian: A rooted nomad,' in *Marcos Grigorian: Earthworks* (New York: Leila Heller Gallery, 2011).

———. 'Shiva Ahmadi: Altered miniatures.' *Canvas* 7, no. 2 (March–April 2011), pp. 177–85.

———. 'Passport to elsewhere,' in Daftari and Jill Baird, eds., *Safar/Voyage: Contemporary Works by Arab, Iranian, and Turkish Artists* (Vancouver: Douglas & McIntyre and Museum of Anthropology at the University of British Columbia, 2013).

———. 'Redefining modernism: Pluralist art before the 1979 Revolution,' in Daftari and Layla Diba, eds., *Iran Modern* (New York, New Haven, Connecticut, and London: Asia Society Museum in association with Yale University Press, 2013).

———. 'Introducing art from the Middle East and its diaspora into Western institutions: Benefits and dilemmas,' in Hamid Keshmirshekan, ed., *Contemporary Art from the Middle East: Regional Interactions with Global Art Discourse* (London: I.B.Tauris, 2015), pp. 187-202.

———. *Rebel, Jester, Mystic, Poet: Contemporary Persians: Works from the Mohammed Afkhami Collection* (Toronto and London: Aga Khan Museum and Black Dog Publishing, 2017).

Daftari, Fereshteh, and Layla Diba, eds. *Iran Modern* (New York, New Haven, Connecticut, and London: Asia Society Museum in association with Yale University Press, 2013).

Daftary, Farhad. *A History of Shi i Islam* (London and New York: I.B.Tauris in association with The Institute of Ismaili Studies, 2013).

Dagen, Philippe. 'Where the painting wants to go,' in *Ali Banisadr In Medias Res* (Paris:

Galerie Thaddaeus Ropac, 2015).

Daneshvar, Reza. *A Garden Between Two Streets: 4001 Days in the Life of Kamran Diba* (Paris: Edition Alborz, 2010).

Daneshvari, Abbas. *Amazingly Original: Contemporary Iranian Art at Crossroads* (Costa Mesa, California: Mazda Publishers, 2014).

David, Catherine, ed. *Unedited History: Iran 1960–2014* (Paris: Musée de la Ville de Paris, 2014).

Deitch, Jeffrey. *Ali Banisadr: Motherboard* (New York: Sperone Westwater, 2014).

Demos, T.J., and Rose Issa. *Mitra Tabrizian: This Is That Place* (London: Tate Publishing, 2008).

Denson, Roger G. 'Colonizing abstraction: MoMA's *Inventing Abstraction* show denies its ancient global origins.' *Huffington Post: Arts and Culture*, 15 February 2013, http://www.huffingtonpost.com/g-roger-denson/colonizing-abstraction-mo_b_2683159.html.

Dercon, Chris, León Krempel and Avinoam Shalem, eds. *The Future of Tradition – The Tradition of Future: 100 Years after the Exhibition of Muhammadan Art in Munich* (Munich: Haus der Kunst, Prestel, 2010).

Ekhtiar, Maryam. *Ali Banisadr: We Haven't Landed on Earth Yet* (Salzburg: Galerie Thaddaeus Ropac, 2012).

Emami, Karim. 'Modern Persian artists,' in Ehsan Yarshater, ed., *Iran Faces the Seventies* (New York, Washington, DC and London: Praeger Special Studies, 1977).

———. 'Post-Qajar painting,' in Ehsan Yarshater, ed., *Encyclopaedia Iranica* , vol. 2 (London and New York: Routledge and Kegan Paul, 1987), p. 641.

———. 'Saqqakhaneh School revisited,' in *Saqqakhaneh*. With text by Peter Lamborn Wilson (Tehran: Tehran Museum of Contemporary Art in affiliation with The Shahbanou Farah Foundation, 1977).

Emdadian, Yaghoub, ed. *Pioneers of Iranian Modern Art: Mahmoud Javadipour* (Tehran: Tehran Museum of Contemporary Art, 1389 [2010].

Enwezor, Okwui, Katy Siegel and Ulrich Wilmes, eds. *Postwar: Art Between the Pacific and the Atlantic, 1945–1965* (Munich: London, New York: Prestel, 2016). See also *Exhibition Guide. Postwar: Art Between the Pacific and the Atlantic, 1945–1965* (Munich, London, New York: Prestel, 2016).

Farhad Moshiri: Go West. Texts by Mitra M. Abbaspour, Shiva Balaghi and Jose Diaz (Pittsburgh: The Andy Warhol Museum, 2017).

Farjam, Lisa. 'Look again,' in *Unveiled: New Art from the Middle East* (London: Booth-Clibborn Editions, 2009).

Farmanfarmaian, Monir, and Zara Houshmand. *A Mirror Garden: A Memoir* (New York: Anchor Books, 2007).

Farzin, Media. *Nazgol Ansarinia: Surfaces and Solids* (Dubai: Green Art Gallery, 2015).

Fauerso, Neil. '"Rebel, Jester, Mystic, Poet: Contemporary Persians" at the MFAH.' *Glasstire*, 8 August 2017.

Fellrath, Till, Sam Bardaouil, Leila Taghinia-Milani Heller and Anthony Downey. *Iran Inside Out: Influences of Homeland and Diaspora on the Artistic Language of Contemporary Iranian Artists* (New York: Chelsea Art Museum, 2009).

Fischman, Lisa and Shiva Balaghi, eds. *Parviz Tanavoli* (Wellesley, Massachusetts: Davis Museum at Wellesley College, 2015).

Foster, Hal, Rosalind Krauss, Yve-Alain Bois and Benjamin Buchloh. *Art Since 1900* (New York: Thames and Hudson, 2004).

Galloway, David. *Parviz Tanavoli: Sculptor, Writer and Collector* (Tehran: Iranian Art Publishing, 2000).

Galloway, David, John Curtis et al. *Parviz Tanavoli and the Lions of Iran* (Tehran: Nazar Publication, 2017).

Ghazbanpour, Jassem. *Life and Nothing More ...* (Tehran: Tiss Publishers, 2016).

Goodarzi, Mostafa, ed. *A Decade with Painters of the Islamic Revolution* (Tehran: Art Center of the Islamic Propagation Organization, 1989).

Gordon, Joy L. *Inaugural Exhibition: Selections from the Ben and Abby Weed Grey Foundation Collection of Contemporary Asian and Middle Eastern Art* (New York: New York University Grey Art Gallery and Study Center, 1975).

The Graphic Art of the Islamic Revolution (Tehran: The Publication Division of the Art Bureau of the Islamic Propagation Organization, 1985).

Green, Tyler. 'MoMA keeps the walls clean: Islamic show sans politics.' *New York Observer*, 3 April 2006.

Gregory, Derek. 'Middle of what, East of where?' in Daftari and Jill Baird, eds., *Safar/Voyage: Contemporary Works by Arab,*

Iranian, and Turkish Artists (Vancouver: D&M Publishers and Museum of Anthropology at the University of British Columbia, 2013), pp. 39-51.

Gresh, Kristen. *She who Tells a Story: Women Photographers from Iran and the Arab World* (Boston: Museum of Fine Arts, 2013).

Grey, Abby Weed. *The Picture is the Window, the Window is the Picture: An Autobiographical Journey* (New York: New York University Press, 1983).

Grigor, Talinn. *Contemporary Iranian Art: From the Street to the Studio* (London: Reaktion Books, 2014).

Grigorian, Marcos. *The Gate of Auschwitz* (New York and Yerevan: Printinfo, 2002).

———. *Earthworks*. Text by Donna Stein (New York: Gorky Gallery, 1989).

Gumpert, Lynn, ed. *Global/Local: Six Artists from Iran, 1960–2015* (New York: Grey Art Gallery, New York University, 2016).

Hall, Stuart. 'The way we live now,' in *Mitra Tabrizian: Beyond the Limits* (Essen: Museum Folkwang Essen, 2004).

Hamedi, Mohammad Hassan, ed. *Iranian Contemporary Artists: Jazeh Tabatabai* (Tehran: Nezhat, 2007).

H[ess], T[homas] B. 'Yektai [Poindexter].' *Art News* 63, no. 7 (November 1964), p. 10.

Hobbs, Robert. *Sonia Balassanian. Hostages: A Diary* (New York: Elise Meyer Gallery, 1980).

Hobbs, Robert, and interview with Boris Groys. *Ali Banisadr: One Hundred and Twenty Five Paintings* (London: Blain|Southern, 2015).

Hosseini Rad, Abdol-Majid, Iradj Eskandari and Kazem Chalipa. *The Iranian Collection of the Tehran Museum of Contemporary Art* (Tehran: Tehran Museum of Contemporary Art, 2006).

Houshmand, Zara, and Monir Shahroudi Farmanfarmaian. *Selected Works of Monir Shahroudy Farmanfarmaian, 1979–2008* (Tehran: Nazar, 2008).

Independent Artists Group Publications [Massoud Arabshahi, Abdolreza Daryabeigi, Marcos Grigorian, Sirak Melkonian, Morteza Momayez, Gholamhossein Nami, Faramarz Pilaram]: *Abi (Blue Works): B. Boroujani, M. Ehsai, M. Farmanfarmaian, C. Shahvagh* (Tehran: Takht-e Jamshid Gallery, 1975). *Gonj va gostareh/Volume and Environment*. (Tehran: Iran–America Society, 1975). *Gonj va gostareh 2/Volume and Environment 2*

(Tehran: Saman Gallery, 1976).

The International Art Fair '76: Modern Iranian Art. Organized by the Private Secretariat of the Shahbanou of Iran and the committee of contemporary art. Introduction by Ruyin Pakbaz. (Basel: 1976).

Issa, Rose. *Monir Shahroudy Farmanfarmaian: Mosaics of Mirrors*. Foreword by Frank Stella (Tehran: Nazar Research and Cultural Institute, 2006).

———, ed. *Iranian Photography Now* (Ostfildern: Hatje Cantz Verlag, 2008).

———, ed. *Shadi Ghadirian: Iranian Photographer* (London: Saqi Books, 2008).

Issa, Rose, Ruyin Pakbaz and Daryush Shayegan. *Iranian Contemporary Art* (London: Barbican Art Galleries, 2001).

Kamansky, David, and Mina Sadegh. *Contemporary Persian Art: Expression of Our Time* (Pasadena: Pacific Asia Museum, 1984).

Kamrani, Behnam, and Mohammad Bagher Ziai. 'Kourosh Shishegaran: Interview.' *Art Tomorrow*, no. 3 (Winter 2011), p. 186. This issue features further articles by Abbas Daneshvari and Alireza Sami-Azar.

Kennicott, Philip. 'It's written all over their faces.' *Washington Post*, 15 May 2015.

Keshmirshekan, Hamid. 'Neo-traditionalism and modern Iranian painting: The Saqqakhaneh School in the 1960s.' *Iranian Studies*, vol. 38, no. 4 (December 2005), pp. 607-630.

———. *Contemporary Iranian Art: New Perspectives* (London: Saqi, 2013).

———, ed. *Contemporary Art from the Middle East: Regional Interactions with Global Art Discourse* (London: I.B.Tauris, 2015).

———, ed. *Kourosh Shishegaran: The Art of Altruism* (London: Saqi Books, 2016).

Komaroff, Linda, and Behzad Khosrawi Noor. *Underground: Siamak Filizadeh* (Tehran: Nazar Art Publication, 2016).

Kramer, Hilton 'The figures of Yektai.' *Arts Magazine* 36, no. 10 (September 1962), p. 37.

Krifa, Michket. *Regards persans: Une révolution photographique* (Paris: Editions des musées de la ville de Paris, 2001).

Leaman, Oliver. *Islamic Aesthetics: An Introduction* (Notre Dame, Indiana: University of Notre Dame, 2004).

Lermer, Andrea, and Avinoam Shalem, eds. *After 100 Years: The 1910 Exhibition 'Meisterweke muhammedanischer Kunst' Reconsidered* (Leiden and Boston: Brill, 2010).

Logsdail, Nicholas, ed. *Smell of First Snow* (London: Lisson Gallery, 2015).

Lowry, Glenn. 'Gained in translation.' *Art News*, March 2006, pp. 121-125.

———. *Oil and Sugar: Contemporary Art and Islamic Culture* (Toronto: Royal Ontario Museum, 2009).

McEvilly, Thomas. *Manoucher Yektai: Paintings 1951–1997*. Catalogue of an exhibition curated by Donna Stein (East Hampton, New York: Guild Hall Museum, 1998).

McFadden, Sarah. 'The museum and the Revolution.' *Art in America* 69, no. 8 (October 1981), pp. 9-16.

Madoff, Steven Henry. *Y.Z. Kami* (New York: Gagosian Gallery, 2008).

Mahdavi, Golnaz. 'Doubt and uncertainty: Farideh Lashai in conversation with Golnaz Mahdavi.' *Art Tomorrow*, no. 8 (Spring 2012), pp 132-135.

Mahlouji, Vali. *Raad O Bargh: 17 Artists from Iran* (Paris: Galerie Thaddaeus Ropac, 2009).

Martin, Jean-Hubert et al., eds. *Magiciens de la terre* (Paris: Editions du Centre Pompidou, 1989). See also *Magiciens de la terre: Retour sur une exposition légendaire* (Paris: Éditions Xavier Barral/Centre Pompidou, 2014).

Melli, Roberto. *Behjat Sadr* (Rome: Galleria Il Pincio, 1957).

Merali, Shahin, Martin Hager, Rose Issa and Tirdad Zolghadr, eds. *Entfernte Nähe/Far Near Distance: Neue Positionen iranishcer Künstler/Contemporary Poisitions of Iranian Artists* (Berlin: Hausder Kulturen der Welt, 2004).

Michelson, Annette. 'Paris.' *Arts Magazine* 35, nos 8–9 (May–June 1961), p. 19.

Milani, Abbas. *Lost Wisdom: Rethinking Modernity in Iran* (Washington, DC: Mage, 2004).

Miles, Ned Carter. 'Echo's Chamber: Afruz Amighi.' http://artasiapacific.com/Magazine/WebExclusives/EchoChamber.

Miremadi, Manijeh. *Gholamhossein Nami: Selected Works, 1963–1994*. Conversation with Morteza Momayez (Tehran: Iranian Art Publishing, 1996).

Mirsepassi, Ali. *Intellectual Discourse and the Politics of Modernization: Negotiating Modernity in Iran* (Cambridge: Cambridge University Press, 2000).

Mitra Tabrizian: Another Country. With essays by Homi K. Bhabha, David Green and Hamid Naficy (Ostfildern, Germany: Hatje

Cantz, 2012).

Moaveni, Azadeh. *Lipstick Jihad: A Memoir of Growing Up Iranian in America and American in Iran* (New York: Public Affairs, 2006).

Mohassess, Bahman. *Bahman Mohassess: Scultura, Pittura, Grafica, Teatro.* Text by Enrico Crispolti and aphorisms by Bahman Mohassess (Rome: Societa Editrice Romana, 2007).

Mohebbi, Sohrab. 'Rasht 29: A cultural oasis in Central Tehran.' *Bidoun*, 20 (Spring 2010), pp. 46-49.

Mojabi, Javad. *Pioneers of Contemporary Persian Painting: First Generation* (Tehran: Iranian Art Publishing, 1998).

Mojabi, Javad, Yaghoub Emdadian and Tooka Maleki. *Pioneers of Iranian Modern Art: Behjat Sadr* (Tehran: Tehran Museum of Contemporary Art, 2004).

Montazami, Morad, and Narmine Sadeg, eds. *Behjat Sadr: Traces* (Paris: Zaman Books, 2014).

Morgan, Jessica, and Flavia Frigeri, eds. *The World Goes Pop* (New Haven, Connecticut, and London: Yale University Press and Tate Modern, 2015).

Nasser-Khadivi, Dina, ed. *Love Me, Love Me Not: Contemporary Art from Azerbaijan and Its Neighbours* (Venice: 55th Venice Biennale, 2013).

———, ed. *Farhad Moshiri* (Milan: Skira, 2016).

Neshat, Shirin, and Nicky Nodjoumi, eds. *Ardeshir Mohassess: Art and Satire in Iran* (New York: Asia Society, 2008).

O'Brien, David, and David Prochaska. *Beyond East and West: Seven Transnational Artists* (Urbana-Champaign: Krannert Art Museum at the University of Illinois, 2004).

Obrist, Hans Ulrich and Karen Marta, eds. *Monir Shahroudy Farmanfarmaian: Cosmic Geometry* (Bologna and Dubai: Damiani and The Third Line, 2011).

Oliveira Lopes, R. and G. Lamoni, eds., *Global Trends in Modern and Contemporary Islamic Art* (Lisbon: Centro de Investigação e Estudios em Belas Artes, 2015).

Ossouli, Farah. *Hafiz in My Dream: Paintings by Farah Ossouli* (Tehran: Imam Ali Museum, 1386 [2007]).

Pakbaz, Ruyin. *Nosratollah Moslemian* (Tehran: Nazar Publications, 2005).

Pakbaz, Ruyin and Yaghoub Emdadian, eds. *Charles-Hossein Zenderoudi*, (Tehran: Tehran Museum of Contemporary Art, 2001).

———. *Massoud Arabshahi* (Tehran: Tehran Museum of Contemporary Art, 2001).

———. *Houshang Pezeshknia, Sohrab Sepehri, Hossein Kazemi* (Tehran: Nazar, 2001).

———. *Parviz Tanavoli* (Tehran: Tehran Museum of Contemporary Art, 2003).

Pakbaz, Ruyin, and Yaghoub Emdadian, eds, with Tooka Maleki. *Pioneers of Iranian Modern Art: Mohsen Vasiri* (Tehran: Tehran Museum of Contemporary Art, 2004).

P[orter], F[airfield]. 'Yektai [Borgenicht].' *Art News* 53, no. 2 (April 1954), p. 54.

Porter, Venetia. *Word into Art: Artists of the Modern Middle East* (London: British Museum, 2006).

———. 'The Persian period,' in Ziba Ardalan, ed., *Siah Armajani: An Ingenious World* (London: Parasol Unit, 2013).

Porter, Yves. 'Au pays du Simorgh,' in *Kiarostami and Ahmadvand: Regards Persans* (Paris: Musée de la Chasse et de la Nature, 2013).

Rahnavard, Zahra, ed. *Contemporary Iranian Art and the Islamic World* (Tehran: Al-Zahra University, 2002).

Re-opening Exhibitions: November 1979 (Tehran: Tehran Museum of Contemporary Art, 1979). Text in Persian, Arabic, and English.

Restany, Pierre. 'DAZ Planners: Museo imperiale.' *Domus*, no. 579 (February 1978), pp. 14-17.

Rexer, Lyle. *Edge of Vision: The Rise of Abstraction in Photography* (New York: Aperture, 2009).

Rose, Andrea, ed. *Isthmus: Shirazeh Houshiary* (Grenoble: Magasin-Centre national d'art contemporain, 1995).

Roustayi, Mina. 'Sonia Balassanian.' *Arts Magazine* 55, no.1 (September 1980), p. 5.

Royaee, Sina. *Heech: Parviz Tanavoli* (Tehran: Bon-gah Publications, 2011).

Sahihi, Hamed, Javad Mojabi et al. *Dreamer: Hamed Sahihi 2000–2015* (Tehran: Nazar, 2017).

Salon d'Automne 1973 (Paris: Grand Palais, 17 October—19 November 1973); *Collections particulières de Sa Majesté l'Impératrice d'Iran* (Brussels: Palais des Beaux-Arts, January 30, 1973). Exhibition travelled to: *Iran Sehabanusu Majeste Farah Pahlavi'nin Ozel Koleksiyonu Sergisi* (Ankara–Istanbul, 1974); and *Zbirca njenog veličanstva carice Iran* (Belgrade: Muzej Savremene Umetnosti Beograd/Musée d'Art Moderne Belgrade: 23 May–10 June 1974).

Salsali, Ramin. *Pantea Rahmani*. Dubai: Salsali Private Museum, 2012.

Sami-Azar, Alireza. *Snow White: Abbas Kiarostami* (Tehran: Boom Gallery, 2012).

S[andler], I[rving] H. 'Manoucher Yektai.' *Art News* 58, no. 10 (February 1960), pp. 43 and 57.

Satrapi, Marjane. *Persepolis: The Story of a Childhood* (New York: Pantheon, 2003).

———. *Persepolis 2: The Story of a Return* (New York: Pantheon, 2004).

Schimmel, Annemarie. *Mystical Dimensions of Islam* (Chapel Hill: The University of North Carolina Press, 1975).

Schwartz-Salant, Nathan, ed. *C. G. Jung on Alchemy* (London: Routledge, 1995).

Shatanawi, Mirjam, ed. *Tehran Studio Works: The Art of Khosrow Hassanzadeh* (London: Saqi, 2007).

Shahbazi, Shirana. *Shirana Shahbazi: Then Again* (Göttingen: Steidl; Winterthur: Fotomuseum Winterthur, 2011).

Sherrill, Sarah B., ed. *Parviz Tanavoli: Poet* (Tehran: Bon-gah, 2014).

Shirin Neshat: Women of Allah. Texts by Francesco Bonami, Hamid Dabashi and Octavio Zaya (Turin: Marco Noire, 1997).

Siah Armajani: The Tomb Series (New York: Alexander Gray Associates, 2014).

Siah Armajani (New York: Alexander Gray Associates, 2016).

Siamak Filizadeh: Under Ground (Tehran: Aaran Gallery, 2014).

Sirizi, Homayoon Askari. 'Capital in capital letter,' in *Arash Hanaei: 'Capital'* (Tehran: Aaran Gallery, 2009).

Slavs and Tatars. *Molla Nasreddin: The Magazine that Would've, Could've, Should've* (Zurich: JRP Ringier, 2011).

Souren Melikian, Assadullah. 'Prince Sadruddin Aga Khan: A collector in an age of connoisseurship,' in Henry S. Kim et al., *Pattern and Light: Aga Khan Museum* (New York: Skira Rizzoli and Toronto: Aga Khan Museum, 2014).

Stein, Donna. *Monir Farmanfarmaian* (Paris: Galerie Denise René, April 1977).

———. *Manoucher Yektai: Paintings, 1951–1997* (East Hampton, New York: Guild Hall Museum, 1998).

Stella, Frank. 'Questions for Stella and Judd,' interview by Bruce Glaser. Broadcast in February 1964 on WBAI FM, New York, the interview was edited by Lucy Lippard for *Art News* 65, no. 5 (September 1966), p. 59.

Storr, Robert. 'Every time I feel the spirit ...,' in *Y.Z. Kami: Paintings* (New York: Gagosian

Gallery, 2014).

Tadjvidi, Akbar. *Exhibition of Iranian Contemporary Paintings Sponsored by Fine Arts Administration of Iran, Iran America Society and Friends of Middle East* […], ([Tehran:] Sazeman-e Sam'i va Basari-ye Honarha-ye Ziba-ye keshvar[, 1962]).

———. *L'Art moderne en Iran* (Tehran: Ministère de la Culture et des Arts, 1967).

Tavakolian, Newsha. *The Fifth Pillar: The Hajj Pilgrimage* (London: Gilgamesh Publishing, 2012).

Vali, Murtaza. 'Siah Armajani: Return to exile.' *Artasiapacific* 69 (July–August 2010), pp. 102-111.

———. Murtaza Vali. 'From phallus to part-object,' in *Shahpour Pouyan: PTSD* (Dubai: Lawrie Shabibi, 2014).

Vasiri: 1955–75 Retrospective (Tehran: Takht-e Jamshid Gallery, 1975).

Wallach, Amei. 'Awaiting Armageddon.' *Art in America*, vol. 104, no. 10 (November 2016), pp. 108-113.

Wick, Oliver, and Jérôme Sans. *Farhad Moshiri* (Brussels: Rodolphe Janssen; Dubai: The Third Line; Paris: Galerie Perrotin; Salzburg: Thaddaeus Ropac, 2010).

Wilson, Martha. 'Staging the self (transformations, invasions, and pushing boundaries),' in Gunhild Boggreen and Rune Gade, eds, *Performing Archives/Archives of Performance* (Copenhagen: University of Copenhagen, 2013).

Winther-Tamaki, Bert. 'The Asian dimensions of postwar abstract art: Calligraphy and metaphysics,' in Alexandra Munroe, ed., *The Third Mind: American Artists Contemplate Asia, 1860–1986* (New York: Solomon R. Guggenheim Museum, 2009).

Wintsch, Susann, 'I can't get no sleep,' in Axel Langer, ed., *The Fascination of Persia: The Persian–European Dialogue in Seventeenth Century Art and Contemporary Art of Tehran* (Zurich: Sheidegger and Spiess, 2013).

Wye, Deborah. *Committed to Print: Social and Political Themes in Recent American Printed Art* (New York: The Museum of Modern Art, 1988).

Yarshater, Ehsan, ed. *Modern Persian Painting*, Introduction by Karim Emami (New York: Columbia University, 1968).

———'Contemporary Persian Painting' in Highlights of Persian Art, Ehsan Yarshater and Richard Ettinghausen, eds. (Boulder,

Colorado: Westview Press, 1979), pp. 363-77.

Yavari, Houra, ed. *Karim Emami on Modern Iranian Culture, Literature, and Art*, compiled by Goli Emami with an introduction by Shaul Bakhash (New York: Persian Heritage Foundation, 2014).

Zaferani, Azadeh. *Mass Individualism: A Form of Multitude (Siah Armajani, Shahab Fotouhi, Babak Golkar, Shirazeh Houshiary, Y.Z. Kami, Avish Khebrezadeh, Arash Mozafari, Timo Nasseri, Newsha Tavakolian)* (Tehran: An-anbar Gallery, 2016).

Zanganeh, Lila Azam, ed. *My Sister, Guard Your Veil; My Brother, Guard Your Eyes: Uncensored Iranian Voices* (Boston: Beacon Press, 2006).

Zaya, Octavio. 'Elective affinities,' in *Nicky Nodjoumi* (New York: Mike Weiss Editions, 2004).

Sources in Persian

Aghdashloo, Aydin. 'In Tarane-ye Mokarrar-e atr agin.' *Herfeh-ye Honarmand* 3, no. 16 (Summer 2006), p. 128.

Amirebrahimi, Samila. 'Faraz va forudha-ye do daheh naqqashi-ye Iran.' *Herfeh-ye Honarmand*, no. 29 (Summer 2009), pp. 116–29.

Afsarian, Iman. 'Chera in chahar nafar? (Why these four individuals?)' *Herfeh-ye Honarmand*, no. 27 (Winter 2008).

Al-e Ahmad, Jalal. *On the Services and Treasons of Intellectuals* (Tehran: Ferdows, 1372 [1993]).

———. 'Namayeshgah-e naghashi dar Apadana.' *Mehregan*, no. 5 (7 March 1950), pp. 4-5.

Anon., 'Asar-e monhatt-e farhang-e imperialisti ra bezedaim.' *Sobh-e Azadegan* (December 22, 1979), n.p.

Anon. 'Introduction,' in *Namayeshgahha-ye bazgoshai* (Tehran: Bonyad-e Farhang o Honar-e Iran, Aban 1358 [1979]), n.p.

Bagherzadeh, Hamid, ed. *Kamal al-Molk: Honarmand-e Hamisheh zendeh* (Tehran: Ashkan, 1997).

Bonyadloo, Nadia. *Saqqakhanehha-ye Tehran* (Tehran: Pishin Pajouh, 2002).

Dar miyan-e raz-e moshtaqan, Preface by Mohsen Zare (Tehran: Farhangestan-eh Honar, 1383 [2004]).

Dehbashi, Ali, ed. *Yad- nameh-ye Kamal al-Molk/A Memorial on Kamal al-Molk* (Tehran: Behdid, 1999).

Giorgiani, Reza. 'Namayeshgah-e honarha-ye ziba-ye Iran.' *Sokhan*, 3rd period, no. 1 (Farvardin 1325 [March-April 1946]).

'Goftogu'i ba naqqashan-e javan,' *Sokhan*, nos. 11–12 (Mordad–Shahrivar 1343/ August–September 1964).

Golestan, Lili. *Tiq o tar o pud: Goft o gou-ye Lili Golestan va Neda Razavipour* (Tehran: Saless, 2016).

Goudarzi, Morteza. *Jost o jou-ye hoviyyat dar naqqashi-ye* moather-e Iran (Tehran, Sherkat-e entesharat-e Elmi va farhangi, 1385 [2006]).

———. *Tarikh-e Naqqashi-ye Iran az aghaz ta asr-e hazer* [History of Iranian painting from the beginning until today's era] (Tehran: Semat, 2011).

'Interview with Jalil Ziapour.' *Honar*, no. 17 (Spring 1368 [1989]), n.p.

Khansari, Ahmad Soheili. *Kamal-e Honar (Perfection of Art): Life and Works of Mohammad Ghaffari Kamal-ol-Mol (1847–1940)* (Tehran: Elmi and Soroush, 1989).

Lashai, Farideh. *Shal bamu*, 4th ed. (Tehran: Baztab Negar, 1381 [2002]).

Mojabi, Javad. *Navad sal no- avari dar honar-e tajassomi-ye Iran (Ninety Years of Innovation in the Visual Arts of Iran)*, 2 vols (Tehran: Peikareh Publication, 2016).

Pakbaz, Ru'in. *Naghashi-ye Iran: az diruz ta emruz* (Tehran: Narestan, 1379 [2000]).

Sohrab Sepehri: shaer naqqash (Tehran: Sepehr, [1359/1980]).

Tanavoli, Parviz. *Locks from Iran: Pre-Islamic to Twentieth Century* (Tehran: Bon-gah Publication, 2007; first edition 1976).

———. *Atelier Kaboud* (Tehran: Bon-gah Publication, 2005).

———. *A History of Sculpture in Iran: Islamic Period* (Tehran: Nazar, 1392 [2013]).

Zoka, Cyrus. 'Namayeshgahha-ye naqqashi.' *Sokhan*, 14th period (Tir 1342/ June 1963), pp. 114-116.

Note

The following magazines, either bilingual or in English, should be consulted for a wealth of material on Iranian modern and contemporary art: *Art Tomorrow* (Hamid Keshmirshekan, ed.), *Bidoun* (Negar Azimi, ed.), *Canvas* (Ali Khadra, ed.) and *Tavoos* (Manijeh Mir-Emadi, ed.).

Photography credits

Index

Page numbers in *italics* refer to figures; 'n' after a page number indicates the endnote number.